AMERICAN MARINE PAINTING

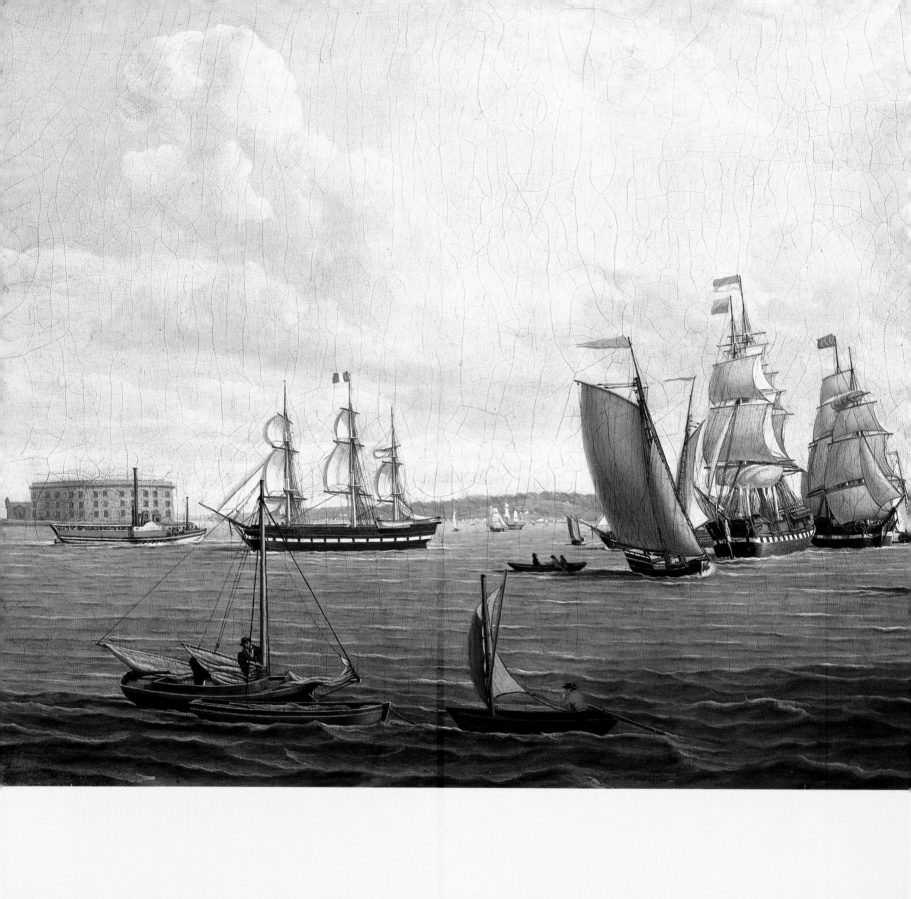

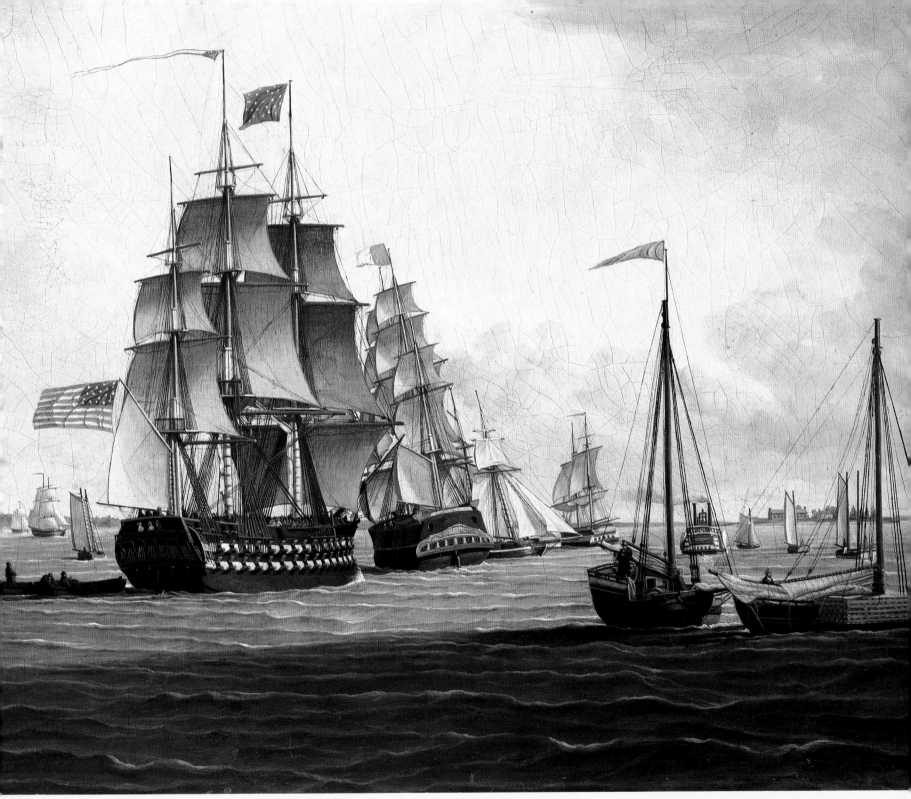

AMERICAN MARINE PAINTING

JOHN WILMERDING

HARRY N. ABRAMS, INC., PUBLISHERS, NEW YORK

For Lila, Heidi, and Amanda
and Andrew, Alexander, and Nicholas

Project Director: Margaret L. Kaplan
Editor: Eric Himmel
Designer: Judith Michael

The poem on page 168 is reprinted by permission of the publishers
and the Trustees of Amherst College from Thomas H. Johnson, Editor,
The Poems of Emily Dickinson, Cambridge, Mass.:
The Belknap Press of Harvard University Press, Copyright, 1951, 1955,
by The President and Fellows of Harvard College

Library of Congress Cataloging-in-Publication Data

Wilmerding, John.
American marine painting.

Rev. ed. of: A history of American marine painting.
1st ed. 1968.
Bibliography: p. 198
Includes index.
1. Marine painting, American. 2. Marine painting—
19th century—United States. 3. Marine painting—20th
century—United States. I. Wilmerding, John. History
of American marine painting. II. Title.
ND1372.5.W55 1987 758′.2′0973 87–1135
ISBN 0–8109–1861–7

Second Edition 1987

Times Mirror Books

Printed and bound in Japan

CONTENTS

I will now speak of another component of scenery,
without which every landscape is defective
—it is water.
THOMAS COLE

And let them have the sea
Who want eternity.
MARSDEN HARTLEY

BOOKS BY JOHN WILMERDING

Fitz Hugh Lane, American Marine Painter
A History of American Marine Painting
Pittura Americana dell'Ottocento
Fitz Hugh Lane
Robert Salmon, Painter of Ship and Shore
Audubon, Homer, Whistler and 19th Century America
Winslow Homer
The Genius of American Painting (with others)
American Art
American Light: The Luminist Movement (with others)
American Masterpieces from the National Gallery of Art
An American Perspective (with others)
Important Information Inside
Andrew Wyeth: The Helga Pictures
American Marine Painting (second edition)

WHY undertake a separate history of marine painting in America? In recent years several aspects of American art have been explored in ever greater depth. While there is a wealth of critical work still to be done, especially in the first half of the nineteenth century, we are fortunate in having a good start in several areas. General histories may be as difficult to do well as refined scholarly biographies or intensive period studies, and it is perhaps at these two extremes that critical writing is thinnest. But in between a whole range of more limited and relatively thorough studies has successfully appeared. Various types of painting have their historians—Wolfgang Born on landscape and still life, Jean Lipman on primitive and folk art, W. P. Belknap on portraiture in the Colonial period. The other media have in some measure also received special attention, as in Harry Peters' *America on Stone* and Albert Gardner's *Yankee Stonecutters*. There are appropriate studies of types and schools of painting within the American tradition, notably E. P. Richardson and the romantic period and others on groups like the Hudson River School. Writing on American architecture includes broad cultural histories and fine individual monographs.

Generally speaking, interpreters of American art have tended to break down the category of landscape painting into the pure landscapes of the mountains and open spaces (for example, the Rocky Mountain School and the artists of the Indian's West), paintings of rivers and inland waterways (the Hudson River School and painters of Niagara Falls or similar natural wonders), and views of shorelines, harbors, or the open sea. This last area seems sufficiently distinct in itself to warrant special treatment. We may define marine painting as a type that comprises views of sea, harbor, and shore. It includes shipping, fishing, or sailing. Its history will usually preclude paintings of inland waters, except for some appropriate examples from the Hudson River School, and will focus foremost on "saltwater" painting.

By comparison to the other areas of American art, marine painting as such has been neglected. Rather than subordinated to the general heading of landscape, marine painting belongs on an equal level of related, coherent interest. Often the two areas run parallel to each other: seldom is one an integral part of the other. We have cousins here, or brothers perhaps, but not parent and child. By considering such a relationship the meaning of the contribution of each to American art history may be made more clear than before. Marine painting had special problems and characteristics of its own; for example, as a type of painting it was freer from contemporary precedent than, say, landscape painting, which frequently felt the alternative pressures of idealization, illustration, or literary motifs. The American, for a variety of reasons, came to judge art largely on moral grounds; his interest was in the story a picture told or preached. The artist for the most part was not expected to be concerned with aesthetic problems for their own sake. This narrative baggage became cumbersome to America's first native landscape painters, and often weighed down even more our artists traveling abroad. Paradoxically, then, it was the painters working independently in their own landscape who resolved creatively problems of space and design, form, or light and color. Because marine painting was less bound to precedent than other genres for subject or manners of painting, it often permitted experimental and fresh expressions.

An interesting, because typical, attitude toward American marine painting is that of William Howe Downes. It is a critical point of view that has largely prevailed until recently. Straightway in an article of 1931 in the *American Magazine of Art* he wrote, "If there is a specialty in which American painters have attained an undeniable preeminence, it is marine painting." He goes on to cite the long tradition of Dutch and British seascape painting, and dismissing Turner for his flashiness, asserts that Winslow Homer has carried the American school to new heights of achievement. The argument is significant in its disregard of any earlier American work; he makes brief allusion to early primitive work, calling our marine painting a relatively modern art. Allegedly, William T. Richards is our first American sea painter of any known reputation, and he cleared the way artistically for the next generation. Aside from Homer, the list comprises now much-faded names—Alexander Harrison, Charles H. Woodbury, Paul Dougherty, and Frederick Waugh. Ample illustrations of the work of William Ritschel, Rockwell Kent, Emil Carlsen, Frank

K. M. Rehn, and Edward Moran round out the discussion. These are mostly "academic" views of anonymous coastlines and stretches of empty ocean, done in harsh colors for dramatic effects and with little interest in composition. Many call these "calendar views" and it is not surprising that such painting has since passed out of taste. What is remarkable is the critical attitude that long prevailed toward the first half of the nineteenth century, a view that has overlooked this significant and rich period in our art history.

Painters of the sea and shore many times pursued the same effects as their inland neighbors; equally, they gave evidence of greater independence and originality. Marine painting in America stands in close relationship to both the maritime economy and social conditions of the country, as shipping, trade, and the War of 1812 illustrate. With obvious reference to the country's development, this study of marine painting will address itself foremost to the Atlantic coast, especially New England, and will extend from the period of colonization up to the age of steam and past. Often the American seascapist was isolated from the mainstream of artistic development, but not without the rewards of heightened imaginativeness and freedom of expression. Such a history has therefore to be selective in introducing the biographies of unknown figures while reappraising the work of known artists. Examination of prints and drawings will be included whenever these media have special relevance to the history of marine painting or to the development of a particular artist.

The sources for this special genre of art may be found primarily in English painting of the seventeenth and eighteenth centuries, and later in the great tradition of Dutch marine painting and, to a lesser degree, French Romantic painting also of the seventeenth and eighteenth centuries. The story begins in portraiture, in the less noticed but telling vignettes of the backgrounds. It steadily moves from the Colonial sidelines onto the broad arena of a republican nation, as likenesses of people yield to likenesses of places. The early nineteenth century signals the coming-of-age of American painting, and of major interest will be the artist's successive concerns for topography, narrative and documentary illustration, and the materials or methods of painting for their own sake. The American Romanticism which flowered from austere eighteenth-century roots provides the direction for much of our subsequent production, including that which interested W. H. Downes. To romantic temperaments the symbolism of the seashore was just as stirring as the unfolding of the continent to the westward. Here was the edge of an awesome space, a constant reminder of the forces of nature; here a sense of the unknown and even, to Americans at one time, an intimation of the divine.

AMERICA'S consciousness of the sea preceded even its consciousness of self. The first conceptions, and then experiences, of the New World were virtually those of an open horizon. As the early explorers viewed their maps and charts, and crossed the vast expanses of water to the unknown hemisphere, the ocean voyage impressed itself upon them as an ever-pressing physical fact as well as spiritual calling. Journeying to the west, where the sun always set, carried the promise of golden riches. Whatever expectations and hopes the voyagers held, in leaving their tribulations behind or in aspiring to new wealth and well-being beyond the known horizon, the sense of space extending before them and ever outward was all-pervasive. That knowledge of primal purity, nourishment, and expansiveness would endure as fundamental to the shaping of the New World and the awareness of self evolved by the nation claiming the discovered continent.

Thus, it would be natural for the nineteenth-century settlers who began to migrate west from the established cities on the eastern seaboard to see their travel in similar terms. They, too, were on voyages of discovery and ambition, and their means were prairie schooners "sailing" across amber waves of grain, as our national hymn describes, from sea to shining sea. By extension, in our own time we have maintained these navigational metaphors as we send off astronauts in spaceships to explore the seas of the moon and the compass of a still-expanding universe. The romance, awe, and promise of a challenging frontier have come to be central to American nature, both in the sense of national character and geography.

These ideas remain as the major underpinnings for this study of American marine painting, that branch of our pictorial arts devoted to life at the shore and at sea. In its earliest manifestations concern was primarily with recording the experience of exploration, discovery, and colonization. This meant foremost celebrating the acts of individuals and, subsequently, the events of early national history as it related to the defense and prosperity of our sea frontiers. As the major settlements took hold and grew, life at the shore offered subjects both of commerce and leisure, indices of the young republic's self-confident

optimism and claim of providential destiny. Through much of the nineteenth century the full American landscape took on the essential spiritual metaphors first defined by the sea, especially its glowing, limitless horizon and prospect of rewarding abundance. Even as American art in the twentieth century has become increasingly engaged in the various diversions of modernism, many of these themes continue to shape our cultural identity. At the same time, the story of America's painting has almost continuously involved relationships beyond itself, first through the ongoing absorption and transformation of parental European styles as native artists trained abroad or European artists immigrated to America, and later by the reengagement of native painters with international movements. As such, American art at large and specifically the history of the nation's marine painting delineate both the country's outer geography and inner character.

With relatively minor modifications the original text of this volume, first published nearly twenty years ago, arguably still holds its own. A number of small editorial changes have been made, to refine the narrative, clarify previously neglected or unknown areas, or update information, including the bibliography, in the light of recent scholarship. During the last two decades at least two major exhibitions have been devoted to this general subject: the Whitney Museum of American Art's *Seascape and the American Imagination* in 1975, with a substantial catalogue by Roger Stein, and *American Marine Painting* organized by the Virginia Museum of Fine Arts in 1976. In addition, illuminating monographic exhibitions have been mounted on most of the important artists discussed here, sometimes focusing on major aspects of their art, more often surveying entire careers. That process of research, new information, and reevaluation of course goes on, and were one just beginning to address this subject now, perhaps the treatment of single artists or key works might shift in relative emphasis or depth of interpretation. But in overall structure this study happily remains intact, still provocative one hopes, useful, and holding out a subject (now greatly enhanced by the profusion of colorplates) of glorious and lasting appeal.

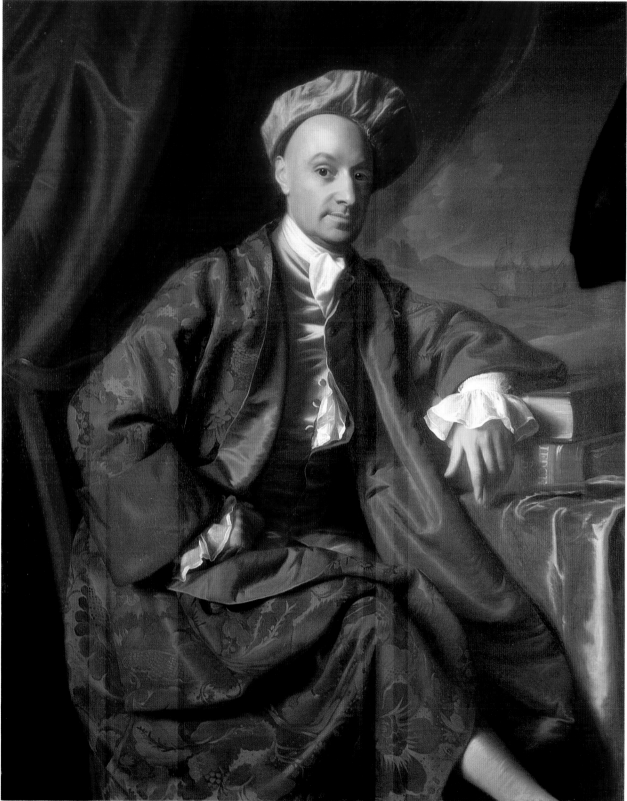

1 JOHN SINGLETON COPLEY.
Nicholas Boylston. 1767.
Oil on canvas, 49 × 40″.
Harvard University Portrait Collection.
Bequest of Ward Nicholas Boylston

The Contribution of Portrait Painting

THE sixteenth and seventeenth centuries on the American continent unfold the story of the European immigration. Bringing the tastes and prejudices of the Old World with them, settlers directly began to build a native culture. The sources of an indigenous art may be traced to these early pioneers who brought from England and the Continent the craft of painting, just as they had other skills of building shelters or organizing communities. The harsh necessities of the first generations allowed little time to devote to art, a pleasurable activity that Puritan opinion felt should have subordinate attention. As they developed, American art and culture reflected the changing, but continual, relationship between Old World and New.

In the New World everything began at the shores. The early settlements were concentrated on the major harbors or rivers of the North American coast, and only gradually did their activities penetrate the interior. Spiritual demands and physical wants preempted other concerns; crude churches and dwellings rose from the first cut forests. When these men did attend to the wilderness, they would inaugurate a long history of alternate fights and love affairs with nature. Nature turned out to be as terrifying as she was alluring. Realism of need was to be the inseparable handmaiden of reverie. Not to be dismissed are the peculiar qualities of New England, including a hard soil and climate, which conditioned the character of their early portraiture, and later, marine painting when it appeared in its own right. There is a consequent strength and literalness in the outlook of this period, under the abiding Puritan notion that God regulates everything in the universe. The writer, historian, or artist was therefore obliged to record every event and detail, since everything must have some significance in God's world. It was man's business to relate facts, but not to select them for interpretation.[1] One senses this feeling in the first works of the American limners: every aspect, accoutrement, and component of the portraits is almost equal in interest. The whole is an accumulation of details, vigorously, if crudely, executed.

The first half of the eighteenth century saw the transition from the religious focus to a business orientation that was characterized by a firm attachment to the American soil.[2] As far as painting is concerned, the sitter sought in the first instance to obtain a likeness of himself that would outlast his own mortality, and in the second a likeness that conveyed his individuality. Excepting the occasional topographical view by the early explorers, portraiture was the primary type of art produced in this society conditioned by endurance and courage. As a work-bound people, the colonists created an economy of commercial wealth and mercantilism, on which any interest in culture, art, and learning would depend. Prosperous merchants in the seaboard towns consequently were among the first to support portrait painting. Their prosperity derived from shipbuilding, which in turn aided expansion of trade, especially with the West Indies.[3] Thus maritime adventures and religious disciplines were the principal early shapers of Colonial life.

The settlers did not consciously seek to establish predominantly maritime communities.[4] Especially in Massachusetts, the unyielding soil and stone inevitably turned seaward the attentions of those who had to make a living. Shipbuilding began its long and illustrious career in Massachusetts in the 1630s, and within three decades it was the major industry of most coastal ports. With English shipping trade concentrated in New England and the Dutch in New Amsterdam a thriving economy developed. But the prosperities of shipbuilding and foreign trade were further augmented by the rise of various fishing industries, of which whaling would become one of the most notable. Coincidentally, both English and non-English immigration prodded a continual expansion of the Colonies at this time. By the close of the seventeenth century the first signs of foreign artistic talents were evident.

But not merely was the shape of American business and intellectual activity conditioned by Europe; so too was the shape of our physical environment. Colonization of the New World took place just as the medieval order of Europe was breaking down and the Renaissance was beginning. First medieval and, later, Baroque English art and architecture were the prototypes that were followed here. Lewis Mumford has characterized the New England village as the embodiment of the European medieval tradition. Around the meeting house each community organized its often feudal life. The steep-

2 THOMAS SMITH (attributed). *Major Thomas Savage.* c. 1679. Oil on canvas,
42⅛ × 37⅛″. Museum of Fine Arts, Boston. Bequest of Henry Lee Shattuck
in memory of the late Morris Gray

gabled houses with strong Gothic detailing expressed architecturally
the communal sense of spareness and of devotion to God.

The first portraits painted in this country were also in the medieval
tradition. The first chapter of any history of American art will relate
that the earliest paintings or prints done here were by missionaries
and explorers. Jacques LeMoyne, John White, and Champlain all

made notable sketches in the mid-sixteenth century of the shoreline of
the New World. But such portraits and views as were done were
usually by artists fully trained before their arrival, and they did not
seek in their work to create new forms. Little is known about the
training of the first limners here, and documentary evidence about
likenesses painted in New England during the seventeenth century is
scarce.[5] Louisa Dresser has estimated that there are only about two
dozen seventeenth-century portraits painted in this country which may
be authoritatively attributed, and of these there are but a handful that
include marine views.[6] The portrait of Major Thomas Savage
attributed to Thomas Smith is one of the most interesting because it
shows one of the very earliest views of Boston Harbor and Beacon
Hill in the background (figure 2). Savage was born in England about
1606, and sailed for Boston in April 1635, where he was merchant,
captain, and Speaker of the General Court. A barely visible
inscription on the right center side of the painting indicates it was
done in 1679, three years prior to Savage's death. The arms and the
costume are English, as is the pose and the manner of painting.[7] It is
here, in such background vignettes, that the first marine and
landscape views by native artists appeared.

Another familiar seventeenth-century portrait is the *Self-Portrait* by
Thomas Smith (figure 3). Like the well-known group of portraits of the
Gibbs children, the Freakes, and John Wheelright, Captain Smith's
Self-Portrait also dates probably from the last quarter of the
seventeenth century, but unlike this other group it is less in the hard
medieval tradition. The flat, two-dimensional qualities characteristic
of the Freakes and Ann Pollard have yielded to later Baroque
concerns with three-dimensional modeling. The painting is in the
tradition of Rubens and Van Dyck and their English successor Lely.[8]
Not only is there more concern for facial expression, but the
landscape is more fully developed and illusionistic than in earlier
attempts. Noticeable is the use of full lighting on the face to model
form and to suggest personality. A similar luminosity suffuses the
background, which recalls the air- and light-filled views of the
Lowlands by many seventeenth-century seascapists. The pose and
costume likewise reflect a Flemish manner, indicating the whole irony

of such portraiture. "The style was wholly inappropriate to American life, and yet few Americans sensed the fact. Our best people were painfully eager to do the 'right thing' by European standards."[9] The paradox of one style being so fully transplanted to a foreign milieu was not only accepted but pursued throughout the eighteenth century, until the American Revolution caused both political and artistic breaks.

Directness and unpretentiousness describe the best of early American portraiture, for all of its derivativeness, and like other Colonial crafts of tombstone carving and silvermaking, the work of the limners achieved full and fine expression in the eighteenth century. Here the flat decorativeness of the medieval style fully yielded to the Renaissance and Baroque manners of Dutch, Flemish, and English portraiture. Architecturally, the Georgian style came to predominate as a reflection of the newly emerging merchant class in general and the professional architect in particular. In the eighteenth century for the first time in painting we may similarly distinguish individual personal styles and follow the development of specific artists' careers. While portraiture still belonged within the Puritan ethic of concern for the individual, it now also expressed the affluence and professionalism of business tastes. During the first decades of the century a fresh influx of painters from abroad brought new life to Colonial art: Gustavus Hesselius (1711), Peter Pelham (1726), and John Smibert (1729). Pelham settled in Boston, bringing with him the techniques of English mezzotint engraving. The significance of his arrival lies not only in what was to be his important contribution to the training of Copley, but more broadly in underlining the direct role English mezzotints played as sources for most Colonial portraitists.

In the late 1940s Waldron Phoenix Belknap, Jr., illuminated his study of the relationship between English engravings and American paintings with the discovery that "particularly British mezzotints had either served as exact models to the painters of the entire Colonial period, or had otherwise exerted a pervasive, continuous influence upon them. The breadth and importance of this factor had never before been suspected."[10] In one instance a mezzotint of the *Earl of Exeter* after Sir Godfrey Kneller served as the source for Gerardus

3 THOMAS SMITH. *Self-Portrait.* c. 1690. Oil on canvas, 24½ × 23¾". Worcester Art Museum, Massachusetts

Duyckinck's painting of *Joseph Hallet* (figure 4).[11] The later artist employed the same pose and general layout, but made subtle changes for the sake of his portrayal. Duyckinck changed the shape of the background view itself; he moved the figure slightly to the left, toned down the exuberant folds of cloth covering the body, and moved the curls of the wig behind the shoulders. The marine view is unusually developed, even if subordinated to its role of suggesting the sitter's profession or interests.

Sir Godfrey Kneller was among a number of English artists who

4 **Gerardus Duyckinck** or **Pieter Vanderlyn** (attributed). *Joseph Hallett.* c. 1728. Oil on canvas, 49½ × 40¼″. The New-York Historical Society

prominence: Nathaniel Emmons, Joseph Badger, John Greenwood, John Singleton Copley, Robert Feke, and Benjamin West, most of whom were known to have derived paintings from prints.[12] Until recently the critical role of prints in the careers of important American artists has been little discussed. Not only did painters derive formats for portraiture from English prints, but later many like Thomas Birch employed engraved views of seascapes and landscapes as sources for their own compositions. The graphic training of some also contributed strongly to their subsequent work, from Copley in the eighteenth century to Winslow Homer in the nineteenth and George Bellows in the twentieth.

Within the conventions and style of portrait painting as it came primarily from the English, American artists in the eighteenth century managed a fair degree of variety and individuality. Taken together, they suggested through their sitters an aristocratic and learned world. This was the "Splendid Century" in France and Europe, the legacy of the Renaissance and Baroque. Though the American world and its spokesmen may not have been so grand or elegant, these ideals carried over into portraiture up to the time of the Revolution. A glance across the range of types and manners of painting at midcentury will help to clarify both what American painters derived from external sources and what they personally achieved in their own right.

Three basic types of portraiture were popular: the full-length, the three-quarter-length, and the seated figure. Within these types there is a wide qualitative range of handling by both well and lesser known artists. The standing, full-length portrait was the least attempted, probably because it had the most direct associations with royal poses of European painting, and was not readily adapted to the interests or status of American patrons. Badger's portrait of *Captain Lieutenant John Larrabee* illustrates the most common standing type for persons in naval careers (figure 5). Larrabee was the commanding officer of Castle William in Boston harbor;[13] he poses with his weight on the right leg and holds up a large spyglass. This accessory and the marine view to the right unequivocally reveal his profession. Badger has made an effort to relate the figure to the associative background by suggesting he is actually standing in the landscape itself. Another

exercised a wide influence on American painters, and the sources for paintings by West, Copley, and Peale may in several cases be traced back to engravings after Kneller. During the early part of the eighteenth century a group of American-born painters came to

device, often used by Smibert, had the figure gesture pointedly to his sailing vessels in the distance. The traditional backdrop was usually an ambiguous curtain or a wall, its effect intended to throw the figure into relief and thereby focus interest on him. The foliage to the left of Captain-Lieutenant Larrabee partly serves this purpose. Although Badger has placed the ships on the horizon, thereby establishing a straight-on view between figure and seascape, the space remains unconvincing; one is not able to distinguish clearly between the ground on which the figure stands and the background. The result is a curtain backdrop effect that lends itself to an ambivalent focusing of attention.

One of the great eighteenth-century standing portraits is Robert Feke's *Brigadier General Samuel Waldo* at Bowdoin College (figure 6). Facing his figure in the opposite direction from Badger's, Feke otherwise employs similar compositional motifs. But his is at once a more natural and a more monumental achievement. Born in Boston at the end of the seventeenth century, Waldo was a prosperous merchant and land owner in Maine, as well as the successful commander of a regiment during the siege of Louisburg in 1745. That beleaguered city is probably the one shown in the background of the painting. A battery in the foreground fires across the water, while in the middleground the remains of sunken ships break the surface of the water. Waldo stands confidently and imposingly, his coat a strong dark red decorated with brilliant touches of gold braiding. A great tree to the right curves in echo to the central form of the figure. This was Feke's largest canvas, and he has accomplished a dramatic portrait while integrating masterfully the figure and the landscape.

Feke was capable of portraying his figures with a consistent sense of proportion, an ability few other artists until Copley could master. American art historians have often called Feke the best Colonial painter in America before Copley, and with good reason.[14] Feke could at his best compete very favorably with the later artist. Information

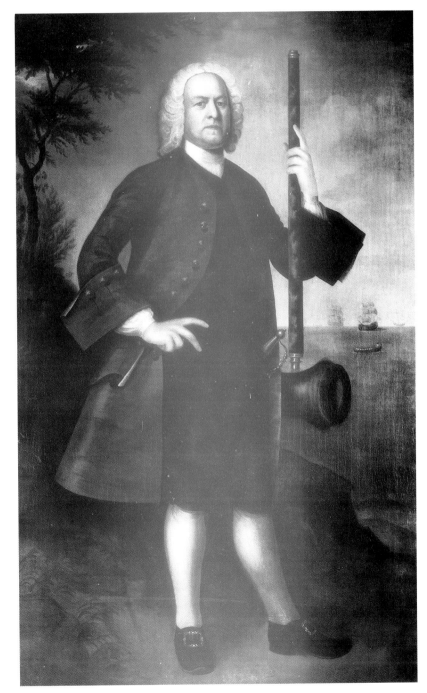

5 JOSEPH BADGER. *Captain Lieutenant John Larrabee.* c. 1686–1762. Oil on canvas, 83⅜₆ × 51⅛″. Worcester Art Museum, Massachusetts

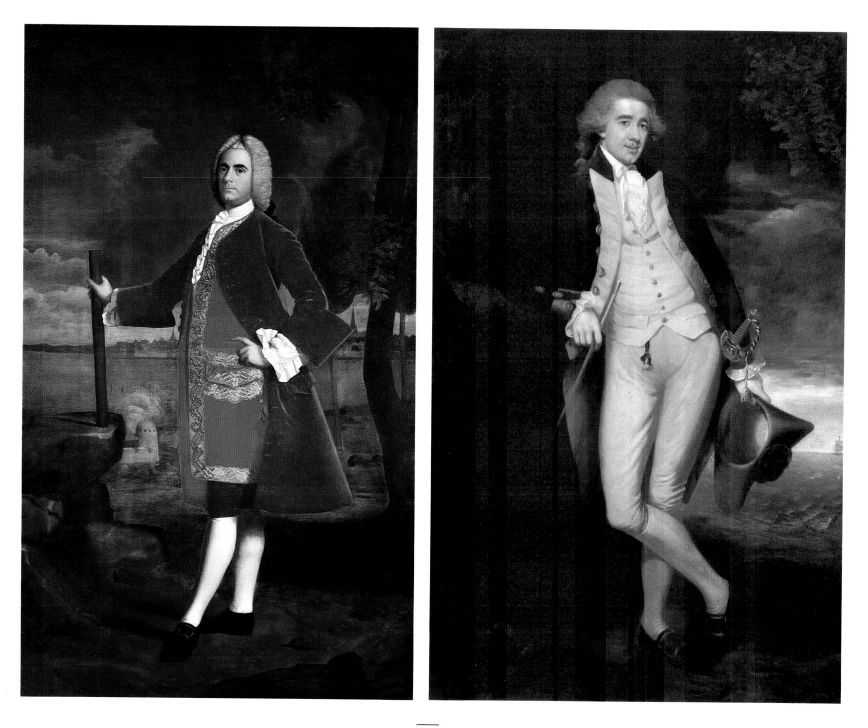

and documentation about his life are relatively scanty, and often speculative, leading historians occasionally to develop ideas not always supportable.[15] His birth is placed around 1705, within a couple of years of Emmons and Badger; facts about his youthful years and any early training are negligible. He married and settled down to work in Newport during the 1740s, with occasional visits to Philadelphia and Boston. Looking at his portraits, one may fairly say that he drew well with a restrained sense of color, was generally more adept at painting men than women, and along with Smibert, was among the first to paint group portraits in this country.[16] Artistically, he is the connecting link between Smibert and Copley, between the generations of Hesselius and West.

Reconciliation of the full-length pose and a setting was not always easy. A portrait by Mather Brown shows the limited development of this format in the early nineteenth century (figure 7). A good but not major painter, Brown left the Colonies for London in 1780 to avoid army service. The outcome of the Revolution forced him to remain in England where he entrenched himself in British painting. His portrait of *Admiral Home Riggs Popham* goes to some effort to integrate the landscape setting with the contemporary character of the subject. Popham's jaunty pose is clearly derivative of Gainsborough, and indicates the new tendency toward naturalness and immediacy. Like his predecessors, Brown has not fully resolved the spatial setting; that is, the relationship of interior to exterior. Although the work is clearly a studio painting, Brown in other instances attempted to suggest that his figure was actually standing out of doors. Beyond a few liberties with the convention, portraitists could push no further, and major changes would not come until the pervading supremacy of portraiture was challenged at the end of the eighteenth century.

Opposite, far left:
6 ROBERT FEKE. *Brigadier General Samuel Waldo.* c. 1749.
Oil on canvas, 96¾ × 60¼″. Bowdoin College Museum of Art, Brunswick, Maine.
Bequest of Mrs. Lucy Flucker Knox Thatcher
Opposite, left:
7 MATHER BROWN. *Admiral Home Riggs Popham.* 1788.
Oil on canvas, 74½ × 47½″. National Portrait Gallery, London

The second, more prevalent convention for portraits was the three-quarter-length pose. The likeness of *Thomas Lawrence* by an unknown artist employs both the window onto the background marine and the accessories of compass, rule, and globe in the foreground (figure 8)

8 ANONYMOUS. *Thomas Lawrence.* c. 1720–1730. Oil on canvas, 44¼ × 35″. Historical Society of Pennsylvania, Philadelphia

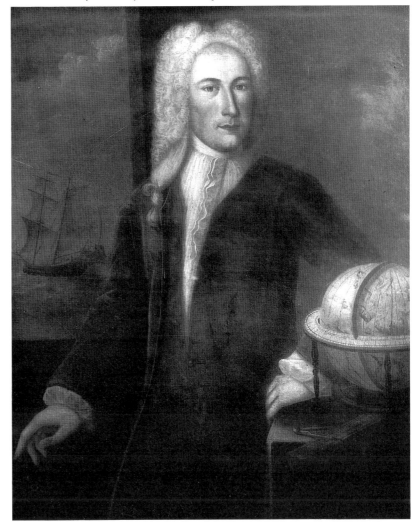

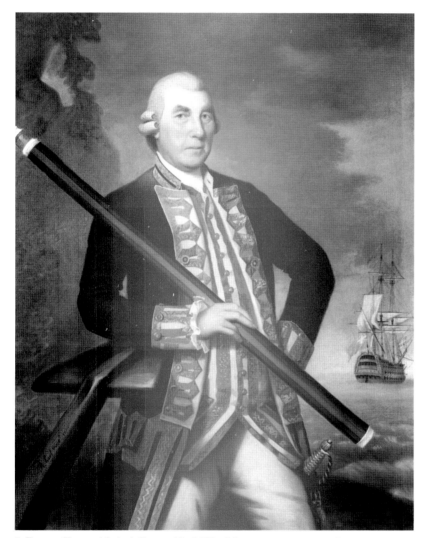

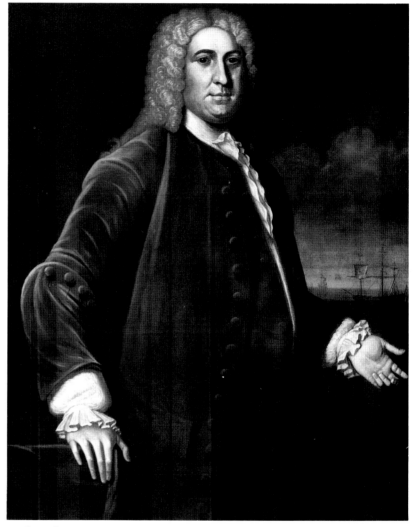

9 RALPH EARL. *Admiral Kempenfelt*. 1783. Oil on canvas, 50 × 39″.
National Portrait Gallery, London

10 JOHN SMIBERT. *Peter Faneuil*. c. 1742. Oil on canvas, 42½ × 39″.
Massachusetts Historical Society, Boston

The subject stands at the center of the diagonal line running between these two areas of interest. Ralph Earl's *Admiral Kempenfelt* (figure 9) essays the same solution as Badger's standing *Captain Lieutenant Larrabee* (figure 5). The admiral stands in a simulated outdoor setting

with the shoreline close behind. Once again, the ship at sea, telescope, and anchor make obvious the subject's occupation. But just as one feels a sense of personality in the figure's face, he is also aware of the developed marine view whose space and light contributes

to the character by seeming to surround him from behind. This also reflects the tendency of American artists at about the time of the Revolution to seek new forms, and Earl along with Copley, Stuart, and others anticipates new modes of painting that shortly come to the fore.

Smibert painted a number of portraits in this style, too, of which his *Peter Faneuil* is an example (figure 10). Critics have repeatedly noticed that Smibert was not usually successful in his full-length portraits; the legs were too short, the feet too long or awkwardly placed.[17] Equally, observers praise the seated and three-quarter-length subjects as strong and coherent. They were often more personal, in large part because less rigidly derived from Kneller's formulas.

Smibert had been born in Edinburgh in 1688, and was apprenticed as a youth to a house painter. He soon left for London where he worked at the painting of coaches and at copying pictures for art dealers. More independent by 1717, he left for Italy to copy the old masters and to study portraiture seriously. The London of the 1720s to which he shortly returned was dominated by Kneller, and it is understandable that Smibert turned, as had others of his generation, to the established British portraitist for standards of painting. Smibert's well-known acquaintance at this time also with Dean Berkeley led, in 1729, to his invitation to go to the New World. Not long after the dean's idea to found a college in Bermuda collapsed, Smibert settled in Boston where he is believed to have painted his unusual early panorama, *A View of Boston*, 1738 (figure 11). Here he also struck up an early working association with Peter Pelham. Regardless of whether the two had known each other in London a few years before, Pelham was soon engraving several of Smibert's paintings.

The painter's involvement in prints raises an interesting note about his work, documented only in one of the five extant letters by Smibert.[18] During the course of writing to his friend Arthur Pond, a dealer in London in whose care Smibert had left a few paintings, he requested some supplies. At the conclusion of his list of desired goods was

A set of ships published by Lempriere and sold by H. Toms in Union court Holborn.

These ships I want sometimes for to be in a distant view in Portraits of Merchts etc who chuse such, so if there be any better done since send them. but they must be in the modern construction . . .[19]

Whether the portrait of Faneuil incorporates such prints is impossible to say. What is significant is the specific concern that these vignettes be as accurate as possible. Indeed, in the view beyond the figure Smibert has drawn an unusually full and large representation of the ship. Though costume and pose are strongly reminiscent of Kneller, the painting is independently vigorous and convincing. Out of such care for precision and accuracy later emerged the marine view in its own right.

Alongside Smibert, John Greenwood appears weak in defining planes of depth, establishing relationships of various components to each other, or creating a focus of interest. Greenwood's portrait of *Colonel Benjamin Pickman* shows a standing figure in a shorter than usual format that could almost mistakenly suggest a sitting position (figure 12). In quality this artist's work can be uneven, although here he has convincingly caught the sitter's features, and has rendered a simple but accomplished marine view in the background. Greenwood was born in 1727 into an industrious family of Boston shipwrights. His work in this country is not extensive. He was painting by 1745, and seven years later had left for Surinam. He next showed up in Amsterdam and later in London. *Colonel Benjamin Pickman* has the flat modeling and dominating head that were frequently typical of his manner.[20] Within the familiar vista one observes a firm draftsmanship and a sense of depth. Alan Burroughs asserts that Greenwood copied both Smibert and Robert Feke, and in his poorer efforts has been confused with Badger.[21] Like them he painted ships as a part of several portraits. He is also known for several marine drawings which have an interest of their own.

Joseph Badger's seated portrait of *James Bowdoin I* introduces the third major category of portrait types (figure 13). Although Badger has here returned to the more conventional window view of earlier English portraiture, his handling of the marine scene is generally adroit and

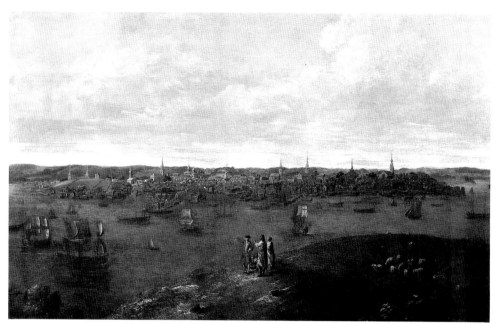

11 JOHN SMIBERT. *A View of Boston.* 1738. Oil on canvas, 30 × 50″.
Photograph courtesy of Childs Gallery, Boston and New York

his command of the figure is forceful. The seated pose seems to have relaxed both the figure and the artist, for the result is at once more economical and more telling than in the grander postures.

Badger is not a major artistic figure. Nor was he to Dunlap and Tuckerman when they wrote their histories in the nineteenth century. He passed his career, which began about 1740, primarily in Boston, where he was contemporary to the brighter lights of Blackburn and Feke and was ultimately eclipsed by Copley in the 1750s. Still, his *Bowdoin* portrait is among his best and a good example of its type.[22]

John Singleton Copley forecasts a new chapter in American art. That his portraits of the American period also belong to the tradition of English conventions is undisputed. He, too, borrowed from English mezzotints, undoubtedly stimulated by his stepfather Peter Pelham. Like Badger and others he borrowed costumes and poses, and occasionally copied his own works. The Harvard-owned version of *Nicholas Boylston* served just such a purpose (figure 1). But Copley was often weaker when he introduced backgrounds than when he did not. Being concerned entirely with the visual reality before him, he

was not always as adept as Smibert at incorporating views from prints. This difficulty is apparent here. Compared to the painting of the figure, the marine view is hesitant and unpolished. Boylston was a Boston merchant, a benefactor of Harvard, and the founder of the Boylston Professorship of Rhetoric and Oratory. These various activities are appropriately suggested by the marine view, costume, and books. A replica is now in Boston's Museum of Fine Arts, painted without the square-rigged vessel. Other changes are apparent as well. Instead of contrasts of value and strong lighting which mark the second, Copley has chosen for this version a more diffused lighting which goes further in playing across various surfaces of silk such as the tablecloth, Boylston's hat and clothing.[23] The distant view is not successful, and one senses Copley's dissatisfaction with the convention. Significantly, the pose itself is more individualized and less derivative than in paintings by Copley's predecessors. One feels a new sense of the personality and psychology of the sitter being conveyed in the very manner of painting and choice of posture. This breakdown of the formal conventions that had narrowed portraiture up

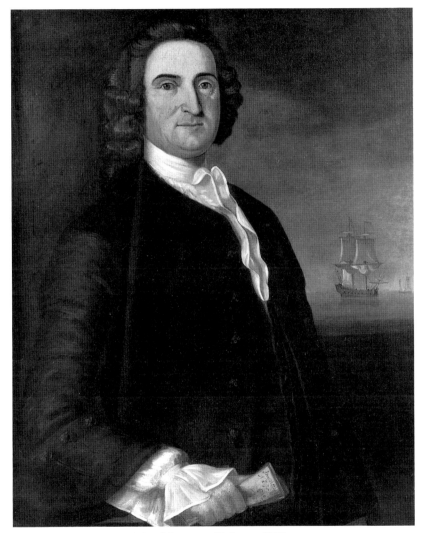

12 JOHN GREENWOOD. *Colonel Benjamin Pickman*. 1760s.
Oil on canvas, 36 × 28″. Essex Institute, Salem, Massachusetts

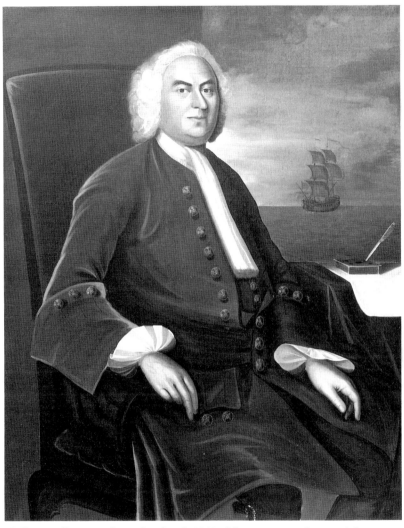

13 JOSEPH BADGER. *James Bowdoin I*. 1747. Oil on canvas, 50¼ × 40¼″.
Bowdoin College Museum of Art, Brunswick, Maine.
Bequest of Mrs. Sarah Bowdoin Dearborn

to this time forecasts a new direction. Copley's sensitivity to visual reality in figure and setting would lead him to make paintings of people that were more than just portraits. The fact that we refer to his familiar painting *Boy with a Squirrel* by that title is indicative that it

is more than only a portrait of Henry Pelham. These new interests in American painting were symptomatic of the whole generation. Copley was not alone in his interest in contemporary history, but joined West and Peale and others in doing history paintings for the first time.

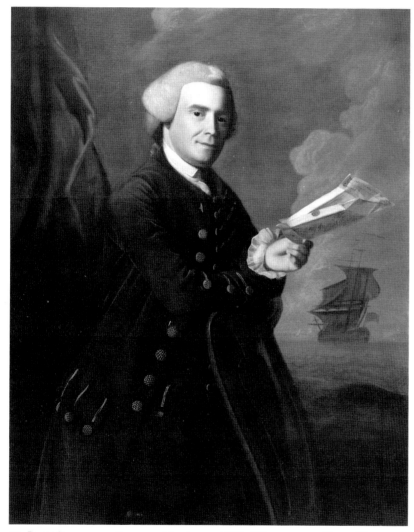

14 JOHN SINGLETON COPLEY. *John Amory*. 1768. Oil on canvas, 50 × 40".
Museum of Fine Arts, Boston. M. and M. Karolik Collection of American Arts

Copley's achievement seems the more extraordinary when one knows how brief his period of self-training was. Of course, he was aware of the work of many of his predecessors. But not long after he began painting his first important portraits in the 1750s, he came to combine remarkable technical command with perception of character.

He was at his best in the decade before the outbreak of the Revolution, developing a control of line and color that was always telling. The forms are clear and forceful, the stuffs and textures palpable. More than anyone before he could model subtly yet strongly. His facility for drawing and for composing on contrasts of values had initial stimulation from Pelham. To this Copley soon added an awareness of how colors work together, both independently and in the light of each other's reflection.

Dating from little more than a year after the Boylston portrait, the painting of *John Amory* in the Boston Museum of Fine Arts shows Copley with a more accomplished and integrated marine view to the right of the figure (figure 14). The artist borrowed the posture from a portrait by Thomas Hudson of the English marine painter Samuel Scott, whose personality will be felt again later in American art (see chapter eight).[24] The painting of both the figure and the sailing vessel suggests an interest in visual accuracy that will lead Copley to paint a decade later *Watson and the Shark*, the first full marine painting in its own right by an important American artist. The point is that Copley makes the transition from art that was only portraiture with occasionally interesting background views to views for their own sake. Because of Copley American portraiture became more personal and relaxed. Charles Willson Peale's *Samuel Mifflin*, for example, has a local flavor in the costume, and a personal touch in the pose and proportions of the figure (figure 15). The pomposity of conventional formulas has given way to a concentration on the sitter's personality, and the artist introduces a certain originality to the background as well as to the pose and accessories—all reflecting that American artists were at last seeking fresh subject matter and new manners of painting.

Although English portrait conventions persisted into the nineteenth century, it is no surprise that the next step would find artists who began as portraitists but soon turned to landscape and seascape painting. Michele Felice Cornè, Thomas Birch, and Robert Salmon came from Europe around the turn of the century, and like many native artists found it necessary to begin making a living by painting portraits. Their early portraits have a definite individuality and

straightforwardness. The sitters are still clearly within the tradition under discussion, but their feeling is more American, not so pretentious and unsuited in their painted roles as sitters previously had seemed. Cornè soon turned to wall paintings and overmantels, and to the portraits of ships; Birch to the depiction of the events of the War of 1812; and Salmon to the portraits of places (see chapters six, seven, and eight).

It remains to mention the occasional variation within the genre as it developed here from English prototypes. Benjamin West's *The Adrian Hope Family of Sydenham* is one of the few group portraits with a marine view in the distance. It belongs to the critical period of the last decades of the eighteenth century, in company with the work of Copley and Stuart, when new intellectual and artistic ideas burst forth in the Republic.

Much was drab and insular about American culture in the first half of the eighteenth century. Gradually self-consciousness and ambition created a new atmosphere of increasingly democratic individualism. With the casting off of the monarchy went the accompanying trappings of Sir Godfrey Kneller's stereotypes. Republican replaced Tory. A sense of country superseded a sense of colony.[25] The idea of freedom stimulated new thought and action. Besides the changes that occurred artistically, an American literature began to appear. Satire, sermon, tract, and meter had new vitality in the mouths and hands of the Republic's wits, prophets, or heroes.

By contrast to Europe the Renaissance and Baroque came swiftly and in concentrated form to America. After the Revolution the classical style became the Federal image. The Roman Republic was supposed to rise again architecturally and politically on American shores. Nearly a century stretches between the portrait of *Major Thomas Savage* and Copley's *John Amory*. Out of that one hundred years emerged the first interests in landscape and seascape views, the source of a native marine painting as a genre unto itself. *John Amory* introduces a world of well-trained native or naturalized painters who continue an academic tradition in their own terms. *Major Thomas Savage* represents the earliest style prevalent in this continent, the medieval tradition. The two-dimensional decorativeness of the earliest

15 CHARLES WILLSON PEALE. *Samuel Mifflin.* 1777. Oil on canvas, 49¾ × 39¾″. The Metropolitan Museum of Art, New York

paintings is kept alive by the so-called primitive painter, the indigenous folk artist. At the same time that native academic schools grew to prominence the indigenous folk art tradition contributed its own style to the mainstream of American art.

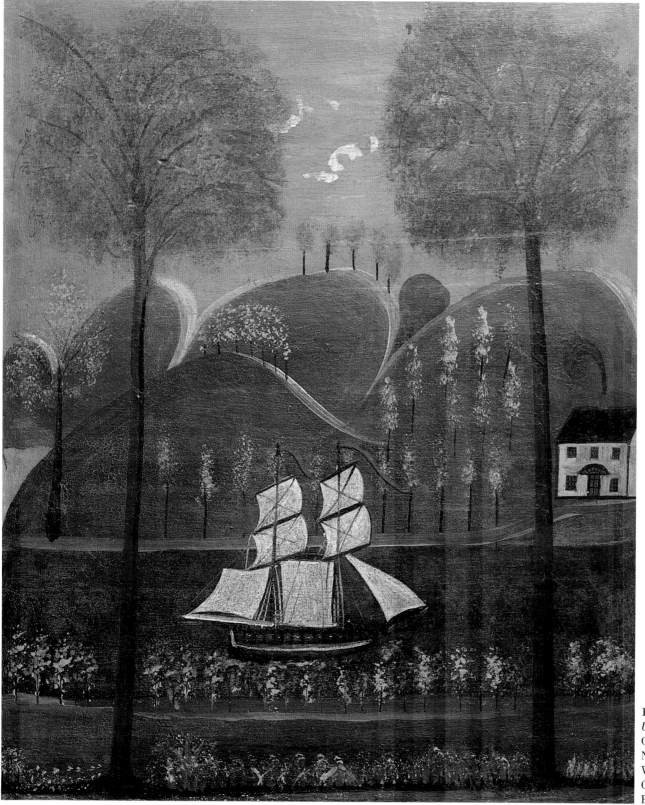

16 ANONYMOUS.
Under Full Sail. c. 1825–50.
Oil on plaster, 26 × 20¾″.
National Gallery of Art,
Washington, D.C.
Gift of Edgar William and
Bernice Chrysler Garbisch

CHAPTER TWO
The Folk Art Tradition

AMERICAN primitive painting, so-called, is an area of study perhaps best seen as a unit.[1] It transcends the other usual chronological or stylistic limits imposed upon discussions of American art. Although it is by definition out of the mainstream of academic painting, the indigenous folk tradition gives at the same time a clear indication of what is peculiarly American about our art. Within the folk tradition lies a wide range of activities demanding differing degrees of training and sophistication. It includes the arts created primarily for their decorative value, such as theorem painting, signboards and wall painting, fireboards and overmantels, and weathervanes; and some that required beyond decorativeness a certain technical training, such as scrimshaw, shipcarving, tombstone cutting, and silversmithing. But all are characteristically native, if not in origin, then in development. American primitive painting achieved a vigor and strength of design that reflected the optimism and power of a newly independent nation; its sculptural arts also exhibited a precision and vitality that were especially American. Two twentieth-century developments in American art seem to be similar indigenous phenomena. It is not misguided to see Alexander Calder's mobiles as descendants in the vernacular tradition of early American weathervanes, or the choice of Pop Art of everyday subject matter in the light of nineteenth-century sign painting. Surely the cigar store Indian and the ship figurehead share with Marisol's assembled and painted figures a common interest in wit and craftsmanship.

Two points about American primitive painting must be noted directly: that it flourished primarily in the first three quarters of the nineteenth century and that folk artists were not alone in being self-taught.[2] Although the decorative abstraction that characterizes this painting is stylistically similar to the flat patterning of American portraiture in the medieval manner, the period of folk painting came as a separate, indigenous movement nearly two centuries later. As distinct from the earlier conventions of portraiture inherited from Europe, nineteenth-century folk painting belonged to the rise of America's own craft tradition. The work by these artists is distinguished not so much by being self-taught—since many of our leading academic artists were equally untrained in any formal sense—but by being concerned more with abstract design than with illusionism. Primitive paintings were conceptual rather than optical, and thus their standard of success was not in the simulation of a believable three-dimensional space, but in the quality of decorative design. The interest is not in observed but in felt reality, and how that reality is abstracted and organized. Good primitive painting may be recognized by the vitality of the abstract design, and in this it rises above the merely crude or naive.[3]

Seascapes and harbor views frequently appeared in wall decorations by folk artists of the late eighteenth and early nineteenth centuries (see, for example, *Under Full Sail*, figure 16); later, ship portraits, especially of the clippers, appealed for their grace of design and the decorative possibilities in the draftsmanship of rigging; and historic naval events provided the sources for many painters, academic and primitive alike. Having been submerged during the seventeenth and eighteenth centuries by European styles, the native vernacular tradition did not emerge independently until the nineteenth. By this time portraiture was on the decline and other subjects were becoming popular. Portraits were done but less often than views of nature and scenes of everyday life. Just as in the earlier portraits in the medieval, Renaissance, or Baroque styles, the artist employs symbols or attributes to distinguish his subject. But the view into depth is flatter than in the academic counterpart; the surface is stressed, as is the pattern that forms make upon the surface. The artist is unconcerned with the proportion of limbs to each other or any visual perspective. He relies, rather, on strong outlines, flat patterns of color, and bold contrast of light and dark. Economy and directness are essential in transmitting the character of the subject. Naturalistic modeling by a painter like Copley reveals certain aspects of an individual; simplicity and expressive abstraction of forms speak differently for the primitive painter.

Everything that was possible to decorate, the American primitive artist turned his attention to; fresh subjects and types of painting began to flourish. Of these wall painting was one, offering the painter wide opportunities to depict pridefully views of local geography. The work of Rufus Porter and his followers will suggest how widespread

17 RUFUS PORTER. *The Voyage of the "Potomac".* c. 1832–33. Wall mural. Elwin Chase House, Topsham, Vermont

often favored by Cornè, he chose typically American farm and river scenes. They are primitive in the sense of being not topographical but composite vistas. On this point he himself observed:

In finishing up scenery, it is neither necessary nor expedient, in all cases, to imitate nature. There are [*sic*] a great variety of beautiful designs, which are easily and quickly produced with the brush, and which excel nature itself in picturesque brilliancy, and richly embellish the work, though not in perfect imitation of anything.[7]

His early style is characterized by generally light drawing, sharp and arbitrary shading, and limited coloring. In his later work one notes a looser handling, greater variety of design, more bold and varied coloring, and more interest in perspective. His first group of wall panels in southern New Hampshire dates to around 1825 the second in Maine and Massachusetts to 1830–35, and the last in eastern Massachusetts to 1838–40. After this date he evidently tired of painting and turned entirely to journalism.[8] Typical of Porter's early period are flat cut-out shapes of cliffs in the background and vessels on the water. Another common device is a huge tree dominating the foreground plane. Typically, Porter uses his trees to cut boldly and dramatically through the center of the foreground, dividing, yet giving coherence to the abstract design (see figure 17).

The discovery of Porter frescoes in two rooms of a house in the "Bulfinch Row" at Orford, New Hampshire, revealed the artist in his most pleasing and characteristic manner. They are decorated with islands, hills, sailing and steam vessels, and all sizes of trees and plants. Porter blended the imaginative foliate forms with an actual awareness of the rolling hillsides of the upper Connecticut valley. The sky, a uniform pale blue, fades into a soft yellow at the horizon, just as in the summer months the glow of sunlight lingers over the ridges of·the New Hampshire and Vermont hills at twilight. He crowns an occasional hill with his favored grouping of three buildings, which he often topped, rather formally, with chimneys or a cupola. In the case of a now destroyed house in Lyme, New Hampshire, the group of buildings was the Georgian halls known as Dartmouth Row in Hanover.

such panel decorations were in eighteenth- and nineteenth-century New England houses.

The career of Rufus Porter has unusual significance. He is our first important mural painter. He pioneered the production of portraiture on a large scale, and popularized American scenes in wall painting.[4] By contrast, before 1850 most other fresco painting depicted European scenes as the marine views of M. F. Cornè readily show (see chapter six).[5] More prolific than any of the other New England muralists, Porter worked in Massachusetts, Vermont, New Hampshire, and Maine.[6] Born in 1792 he lived to an old age of ninety-two years, meanwhile learning and executing all types of house, sign, and portrait painting. He also cut silhouettes, produced a camera obscura, published a book, and edited magazines. But about twenty years of his mature life, from 1824 to 1845, he devoted to the painting of scenic wall panoramas. Spurning the views of Mediterranean ports

The walls of the Colburn House in Westwood, dating from 1838, are signed both R. and S. T. Porter, indicating that Rufus had some assistance in his late work from his son Stephen Twombly. Another relative, Jonathan D. Poor, nephew to Rufus, was responsible for a landscape painted in the Priest House in Groton, Massachusetts, as his name signed on a steamboat testifies. From other wall paintings credited to Poor, Jean Lipman and Nina Fletcher Little believe that Poor was active primarily in the decade of the 1830s.[9] His format and brushwork are close to his uncle's, and one can readily see the extent of Rufus Porter's popularity and influence.

In a manner somewhat similar to Porter's is the wall painting by Orison Wood of about 1830 at the Old Cushman Tavern in Webster Corner, Maine. Whether or not it is influenced by Porter is unknown; it is more primitive than most of Porter's work, but enjoys a fancifulness of its own. The components of the design are especially flat and imaginatively arranged. The giant trees, in contrast to Porter's designs, fill the upper sections of the mural, and Wood has arbitrarily exploited the great difference in scale between the tall trees that divide the immediate foreground and the repeated forms of the small evergreens which dot the islands in the distance.

For the most part these designs were intentionally decorative. But on at least one occasion Porter turned to a subject of political and historical interest.[10] Adorning the upstairs hall of a house in Topsham, Vermont, is an offshore view painted in bright colors with a ship prominently placed in the center. With typical disregard for visual reality Porter flattened the image out, rendering the broadside and the stern of the vessel in the same plane, and painting her pennants and ensign waving in opposite directions. Barely legible on the pennant flying from the mainmast is the name of the vessel, *Potomac*, and on the pennant on the foremast the name of her captain, Downes.

The secretary of the navy had in May 1831 ordered the *Potomac* under Downes's command to Sumatra where he was to take reprisals against the natives for an earlier attack on an American trading vessel. When the action became known in the United States, it stirred strong opinions both for and against Downes. After a Congressional investigation, which adds a note of enduring topicality, the captain was acquitted, though he never commanded a vessel again. The event is interesting as a reflection of Jacksonian enthusiasm, and its significance must have had a special appeal to Porter, a sailor turned artist.

With the close of Porter's active career in the mid-1840s comes the virtual end of decorative wall painting in New England—and a signal for the coming decline of decorative painting in general. Still, Rufus Porter had made an important contribution to American art, and to our marine painting in particular, by his independence from the conventional styles or ideas of his time. He commands attention if only because of his penchant for American scenes portrayed in a consciously personal and abstract mode.

But before being overtaken once again by native academic artists, the primitive folk artist turned his attention to other subjects of marine interest. Just as artists had earlier done figure portraits, so now they turned to portraits of ships, and later to what amounted to portraits of buildings, estates, or noteworthy locales. In a delightful painting called *The Plantation*, c. 1825 (figure 18), the artist has combined a view of a ship sailing along the shore of a handsome estate with several houses, trees, and interconnecting roadways—all piled on top of each other in a flat pattern that looks more like a map than any view into depth. With a happy abandonment of any consistent scale, modeling, or point of view, this naive artist has achieved a brightly colored and animated design. But he shows an intuitive control in the play of various patterns, as in the sails, houses, roadways and tree limbs. Several repeated rhythms help to unify the whole composition: for example, the outline of the willow at the lower left and the edge of the pond "behind" it, or the more ample rhythms of the curving road, hillside, and lower branches of the flanking trees.

The primitive painter must have found a particular excitement in the clipper ships that appeared shortly before midcentury. The *Ship "Arkansas" Leaving Havana* illustrates the pleasure that the artist has taken in the dominating pattern of the sails of these large and graceful vessels (figure 19). Working almost exclusively in silhouettes,

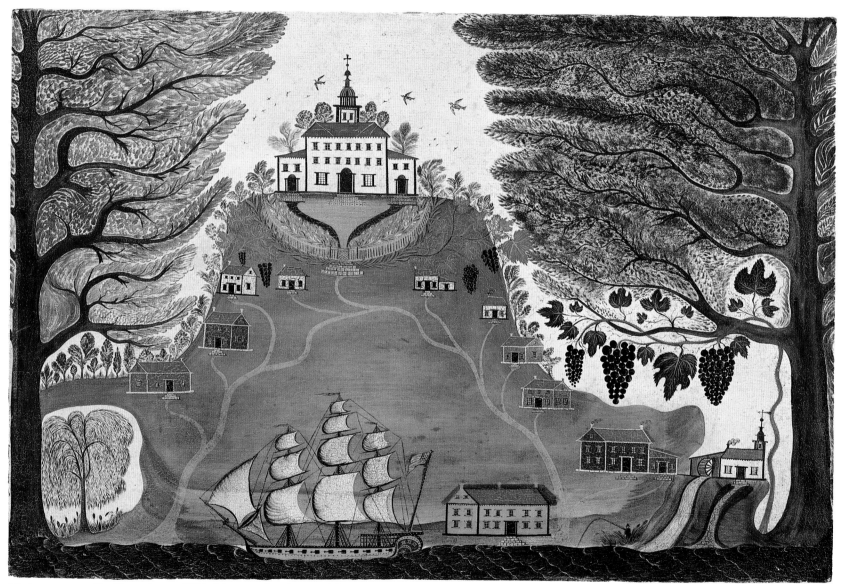

18 ANONYMOUS. *The Plantation.* c. 1825. Oil on panel, 19⅛ × 29½″.
The Metropolitan Museum of Art, New York.
Gift of Edgar William and Bernice Chrysler Garbisch

Opposite, above:
19 A. HASHAGEN. *Ship "Arkansas" Leaving Havana.* 1847. Oil on canvas, 22⅛ × 28⅝″.
National Gallery of Art, Washington, D.C. Gift of Edgar William and Bernice
Chrysler Garbisch
Opposite, below:
20 THOMAS CHAMBERS. *Looking North to Kingston.* 1840s. Oil on canvas, 22½ × 30″.
Smith College Museum of Art, Northampton, Massachusetts

he delighted in arbitrary colors and almost abstract patterning. The clipper lies in the center of the harbor with all sails set, as if the artist wanted to show the characteristics of both the vessel under way and the specific features of the harbor setting. While there is an attempt to integrate some of the landscape components into the design, everything is subordinate to the oversize silhouette of the clipper. The artist viewed most objects conceptually from their most characteristic aspect. The manner of painting often combined an interest in expressive patterns for their own sake with a sense of depth and naturalism.

One semiprimitive painting strikes this balance between design and observation: the anonymous but highly personal *Meditation by the Sea* (figure 21). Dated by the costume from midcentury, it possesses an individual freshness and interest lost in many more grandiose contemporary efforts. The crisp patterns and somewhat haunting quality of the picture remind one of the later French primitive painter Henri Rousseau. The colors are cool and subdued, and combine with the open areas of the composition to express the appropriate sense of meditative calm. In one critic's description, the foreground waves are rising as a result of the figure's hypnotic stare.[11] Equally, this may be a primitive manner of showing waves cresting naturally in sequence; down the beach a second set of waves is beginning to rise around the rocks. In any case, the artist has convincingly and simply held together a depth that is optical and a flat design that is more abstract.

The work of Thomas Chambers continues this semiprimitive style in more elaborate views of specific places. Born in England in 1815 and active in the decades around midcentury, he did river landscapes, harbor views, and open sea marines; because only a small percentage is signed, the number of attributed works ranges from two to four dozen.[12] Like so many American painters of the early nineteenth century, Chambers came from abroad to settle and work in the young country. These foreign-born artists (see chapters six, seven, and eight) would make a major contribution to the development of a native American art, just as again during the 1940s a wave of immigrating artists from Europe would shape the formulation and direction of a new American art in the twentieth century.

21 Anonymous. *Meditation By The Sea.* c. 1855. Oil on canvas, 13½ × 19½".
Museum of Fine Arts, Boston. M. and M. Karolik Collection

22 Thomas Chambers. *Staten Island and the Narrows.* c. 1835–55.
Oil on canvas, 22 × 30¼". The Brooklyn Museum, New York. Dick S. Ramsay Fund

By 1834 Chambers appears in the New York City directories as a "landscape painter," a specialization he pursued in 1838 when he listed himself as a marine painter. During the early forties he moved to Boston, in whose directories he appeared after 1843. A few years later finds him listed simply as "artist," and in 1850 he is designated a portraitist although no portraits by him are now known.[13] His name does not appear in Boston after 1851, but two paintings of the War of 1812 are dated 1852. By this time his whereabouts is unknown.

Chambers's earliest documented work is the *Recapture of H.M.S. "Hermione"* of 1835. The scene depicted is the aftermath of a mutiny that had occurred in Puerto Rico in 1797. The English artist R. Dodd executed a print of the subject two years later, and from this or one like it by another contemporary Chambers doubtless derived his version.[14] This reusing of a composition by another artist is a recurring note in Chambers's career, yet such a fact in this earliest work did not disguise his own capacity for originality. Chambers works in flat areas of color, strongly highlighting the crests of waves, sail edges, and critical lines of the ship. Although he understood ship rigging, he was more interested in the qualities of a flat design, as his treatment of sails, clouds, and waves shows.

Chambers's mature and most familiar style informs his view of *Looking North to Kingston* (figure 20). Here he satisfactorily arranged variously shaped and sized patterns, while creating a believable sense of depth in both the foreground road and the receding levels of landscape in the background. His interpretation of the scene includes a romantic sense of place typical of the Hudson River School (see chapter four). Like Thomas Doughty and the more professional artists in that group, Chambers strongly felt the influence of W. H. Bartlett's printed views of 1840 then popularly circulating. As a number of his other paintings were so derived, this too doubtless had its source in a Bartlett print.[15] Nevertheless Chambers always had sufficient originality to enliven his own interpretation with imaginative rhythms.[16] Though his colors generally are harsh and arbitrary, he was able to control his disregard for naturalism in a way that lent strength and coherence to his paintings.

Both primitive and academic artists were discovering new subjects in the coast and countryside near them, and through their art

attempted to convey or interpret the special mood of the setting before them. As the young American Republic expanded its trade and population, her ports and harbors became ever more important; with the turn of the nineteenth century artists increasingly found interest in topographical views. These were in the tradition of the first explorers who produced the first charts and coastline views of the New World's shores. But the enthusiasm for local subject matter was a part of the rising self-confidence of the new country.

The War of 1812 brought the first maritime actions of national scale since the Revolution, and as such offered fresh material for artists. The primitive painter's interests lay not so much in showing specific vessels in action or in naturalistically capturing the effects of light, air, and water as they exchanged shots, but in the expressive possibilities of design. Interest in maritime events and activities remained strong through the following decades. Bold, flat patterns inform these scenes with a sense of action and excitement. Strong

24 THOMAS CHAMBERS. *Felucca off Gibraltar*. Mid-nineteenth century. Oil on canvas, 22⅛ × 30⅛″. National Gallery of Art, Washington, D.C. Gift of Edgar William and Bernice Chrysler Garbisch

23 THOMAS CHAMBERS. *Packet Ship Passing Castle Williams, New York Harbor*. c. 1845. Oil on canvas, 22¼ × 30⅛″. National Gallery of Art, Washington, D.C. Gift of Edgar William and Bernice Chrysler Garbisch

colors and sharp linear rhythms convey a mental impression of the subject, rather than any realistic equivalent of a specifically observed moment. The painter emphasizes the patterns made by the hulls, rigging, and repeated pennants. We do not look for accuracy of light and water conditions or for visually correct spatial relationships. The charm and vigor of the effect come instead from the linear and coloristic designs (see figures 22–24).

An emerging interest, however, in accurately recording visual reality pointed the way to a new American art that gradually overshadowed the folk artist. Transplanted from Europe, new styles, subjects, and manners of painting developed indigenously in the academic tradition. Problems of optical naturalism increasingly engaged the sensitive viewer of nature. Fresh techniques and subjects appeared early: with Copley and West a radical, but symptomatic, transition from portrait to history painting was taking place.

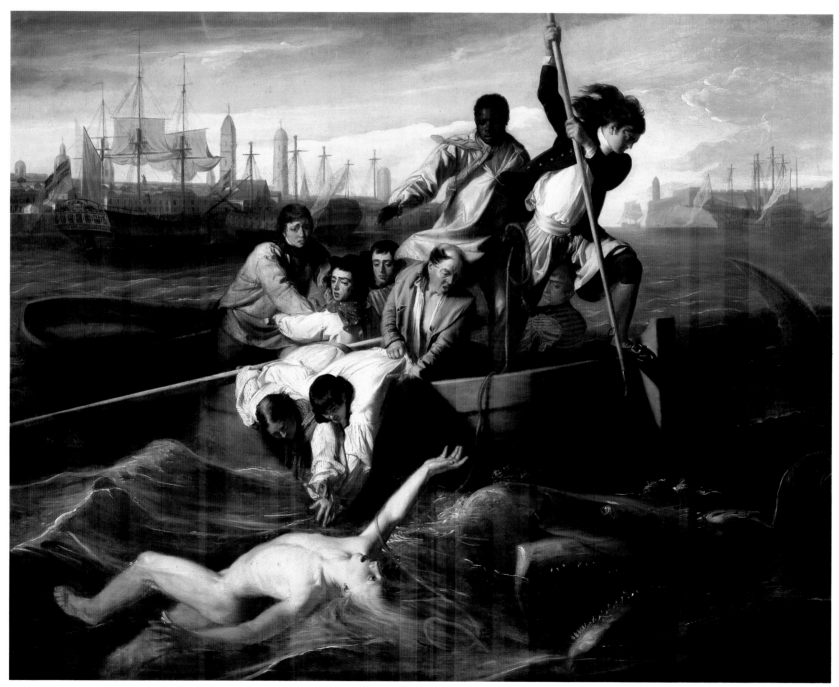

25 JOHN SINGLETON COPLEY. *Watson and the Shark.* 1778. Oil on canvas, 71¾ × 90½″. National Gallery of Art, Washington, D.C. Ferdinand Lammot Belin Fund

The Contribution of History Painting

THE decade of the American Revolution included a broader revolution in the history of American art. At its beginning in 1771 came Benjamin West's *Penn's Treaty with the Indians* and *The Death of General Wolfe*; toward its close in 1778 came Copley's versions of *Watson and the Shark* (figure 25). The period saw a significant transition in the subject matter of painting. As the idea of the American Republic took hold, a new taste for the local and for the contemporary emerged in response. Copley's large historical canvases of the late seventies and eighties, notably the *Death of Lord Chatham* and the *Death of Major Pierson*, also prefigured the flourishing of Neoclassical and Romantic painting in the next generations. French Romanticism and political thought began to draw attention away from our English origins. Rousseau and the French Revolution soon exercised subtle influence on our own intellectual outlook and economic philosophy.[1] Coming little more than a decade after our own War of Independence, the French Revolution had a wide creative impact. It not only reinforced the democratic ideals that had been unfettered by independence, but furthered the sense that an indigenous American culture could successfully rise in challenge to Europe's.

The American Revolution assisted in forcing contemporary events to the fore of public consciousness, and because it was a war by the Colonies, it made citizens geographically aware of the coast. The threat to maritime interests focused much of the war's activity in the ports and harbors of New England. And with the end of the fighting the resumption of foreign commerce breathed new life into her cities. Fur trade in the Northwest, tea and textiles in the Orient, and shipbuilding at home soon enlarged the maritime interests of the new nation. Above all, to the American artist significant moments in contemporary history seemed now to be not only valid but vital subjects for his canvases. The implications of history painting meant that marine art in particular would document an important portion of early American naval history, large areas of the coastline, and significant activities occurring there.

The first signs of artistic ferment surrounding the Revolution appeared in the work of Americans who completed their mature careers abroad. Although Benjamin West was not the first to depict contemporary events and dress his figures in modern costume, his lifelike manner and feeling for place were strikingly convincing.[2] In using the conventional posture of a pietà for the figure of General Wolfe he was able to instill an emotional immediacy which, however grand, was effectively patriotic. Neoclassical though his manner was under the influences of Winckelmann and Mengs, his historical paintings were distinct breaks with contemporary convention. Arriving in London when portraiture was supreme in the hands of Reynolds, Gainsborough, and Romney, West achieved a far-reaching artistic influence through the patronage of George III and the training of countless pupils, including Charles Willson Peale and John Trumbull. Striking as the relative realism of his modern historical scenes was to his time, it was the work of the first American artist to study abroad and gain a reputation outside America.

While West may not be classified as a marine painter, he did paint the dramatic *Storm at Sea* now belonging to the Pennsylvania Hospital in Philadelphia. A decade before he sailed for Italy in 1760 he had painted a prophetic *Landscape with Cow* (figure 26). An early work of his youth in Philadelphia, it combines childlike fantasy in the

26 BENJAMIN WEST. *Landscape with Cow.* 1747–1752. Oil on panel, 26¾ × 50¼″. Pennsylvania Hospital, Philadelphia

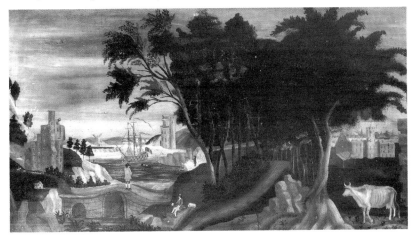

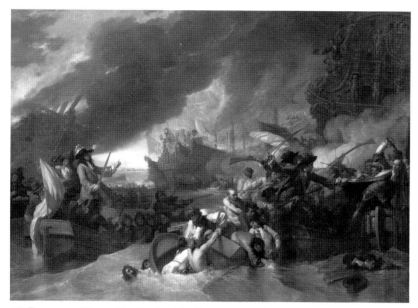

27 BENJAMIN WEST. *The Battle of La Hogue.* 1778. Oil on canvas, 60⅛ × 84⅜″.
National Gallery of Art, Washington, D.C. Andrew W. Mellon Fund

background castles with observant realism in the rendering of the cow
and foliage. Its interest in landscape with a harbor vista forecasts his
own *Penn's Treaty with the Indians* some twenty years later and similar
versions of Philadelphia views by the seascapist Thomas Birch in the
early nineteenth century (see chapter seven). West's historical and
mythological paintings are also important for the innovations they
introduced, for example, the dramatic realism of his *The Battle of La
Hogue* of 1778 (figure 27).

Copley was born in 1738 only a few months before West. Copley's
career also took him to Europe, where in his later years he suffered a
certain artistic decline. He did not leave the Colonies until forced by
his Tory sympathies on the eve of the Revolution. Beyond this, West
had convincingly persuaded him to leave the confining environment of
portrait painting, and turn to more challenging endeavors in the
tradition of the old masters and the antique. The accumulation of
paintings he had executed before the mid-seventies proved him a

master of realism. His brushwork showed a sure sense for textures,
and his direct observation of reality made him the best painter
America had yet produced. Because *Watson and the Shark* comes at
the juncture of his American and English careers, it is a culmination
of sorts of his best early style (figure 25). It is also the first true
marine painting of singular importance by an American artist.

The story behind the painting is familiar. Brook Watson, while
swimming in Havana harbor, had a leg bitten off by a shark, but was
rescued by shipmates and went on to live an illustrious life. This does
not suggest a momentous historical event. The subject does, however,
have its own heroic romance. Copley renders it with a classical
structure derived from the Renaissance and a realism of detail that
was as forthright as his best individual portraits had been. There are
several versions and studies of the subject; the three best known are
in Boston, Washington, and Detroit, and have some noteworthy
differences. The artist seeks to portray ideal virtues, such as courage
and valor, and he succeeds in translating the antique into modern
idiom.[3]

The original painting was a commission from Watson himself to
commemorate the gruesome scene of his youth. It created wide
excitement at the Royal Academy exhibition in 1778, especially
among the newspaper reviewers. In his choice and treatment of the
subject Copley was presenting a history painting significantly different
from that of Benjamin West. West's paintings were more strictly based
on classical conventions, both in subject matter and in composition.
In the story of Watson and the shark Copley was not so concerned
with historical importance as with contemporary realism. But Copley
was not unconscious of earlier artistic sources, relying as he seems to
have done on the posture of *The Gladiator* in the Villa Borghese for
the figure of Watson and more generally on engravings after Rubens'
Lion Hunt for the general grouping of Watson's rescuers.[4]

The Detroit version of *Watson and the Shark* is vertical in format,
by which it tends to stress the foreground activity of the figures in the
boat as they attempt to fend off the shark. The strong verticality of
the pyramidal structure cuts off much of the distant view, the sense of
drama being enhanced through the bold cloud shapes and dark stormy

lighting. The view is lower and closer to the subject in the Boston and Washington versions. The horizontal composition encourages the eye to read around the figures on either side; the lower perspective and greater detail bring the background much closer to the observer. The drama of the action receives greater emphasis by being pushed forward to the bottom edge and given a full third of the canvas. The painting of the water and of details of the ships in these paintings shows Copley to be master of the genre. More than an expressive characterization of the figures or a feeling for solid forms, he has painted a marine subject with visual accuracy and individual grandeur. For these reasons this subject stands as the critical signal of the decline of portraiture and the rise of an independent landscape and marine painting in both Europe and America.

Once these liberties in subject matter and outlook had been taken, artists were soon ready to paint nature more freely. Within the Neoclassical grand style of the later Copley and West were the seeds of a larger romanticism that was about to come into full artistic force. The career of Washington Allston is that of our first full-scale Romantic artist, and the note of reverie that he struck at the opening of the nineteenth century would continue to its end in such spiritual descendants as William Page, George Inness, Albert Ryder, John La Farge, James Whistler, and Elihu Vedder.[5]

By way of introduction to the work of Allston an interpolation on Joshua Shaw is necessary, since Shaw's painting *The Deluge* (figure 28) was for over half a century incorrectly attributed to Allston.[6] The misattribution was in part due to the fact that at one point the painting belonged to Allston's father. Many early American art historians in the twentieth century, including Alan Burroughs, E. P. Richardson, James Thomas Flexner and Virgil Barker, listed the work as by Allston. However, an unidentified newspaper review in 1813 described the painting as unmistakably one of four exhibited by Shaw in that year at the British Institution. In fact, not long after another critic pronounced it superior to a painting by Turner of the same subject.[7]

Shaw was born in England about 1777, making him Allston's almost exact contemporary. He pursued sign painting as a means of livelihood until he became sufficiently accomplished as a landscape painter to earn his own reputation. During the early decades of the nineteenth century he exhibited at the Royal Academy and the British Institution. *The Deluge* belongs to this early period before 1817 when he came to the United States. On the one hand, it has an overabundant melodrama that is lacking in Allston's work; on the other, it lacks Allston's luminous glazing which came to mark the latter's mature style. What is significant is that it represents, in common with Allston's work, the romantic direction of European and American painting in the opening years of the nineteenth century.

The source of *The Deluge* is the seventh chapter of Genesis, which tells of Noah and the Ark:

And the waters prevailed exceedingly upon the earth; and all the high hills, that were under the whole heaven, were covered. . . .
And all flesh died that moved upon the earth, both of fowl, and of cattle, and of beast, and of every creeping thing that creepeth upon the earth, and every man:
And in whose nostrils was the breath of life, of all that was in the dry land, died.

The version had its likely precedent in Poussin's late painting of the same theme, which itself looked back to that of Annibale Carraci.[8] With its inspiration going back to the Baroque, the painting was also an inevitable reflection of the eighteenth century's conception of the sublime. Most of Sir Edmund Burke's components of the sublime scene are apparent here: obscurity, power, privation, vastness, difficulty, light, and sound. The sense of terror is enhanced by the enshrouding blackness and surrealistic lighting. The omnipresence of almighty power is felt in the desolation and destruction arising from superhuman causes. Strong and sharp transitions from light to dark complement the violent crashing of waves and shrieking of wind.

Relying on the stark contrast of the infinitely dark sky and destructive wind-driven waves, Shaw makes the lifeless bodies seem the more derelict in their nudity before nature. The highlighted birds in the sky, the snakes and the baying dog, only add to the sense of crushing terror and pervading wildness. Different from Copley's

28 JOSHUA SHAW. *The Deluge*. c. 1813. Oil on canvas, 48¼ × 66″. The Metropolitan Museum of Art, New York. Gift of William Merrit Chase

29 WASHINGTON ALLSTON. *Rising of a Thunderstorm at Sea*. 1804. Oil on canvas, 38½ × 51″. Museum of Fine Arts, Boston. Everett Fund

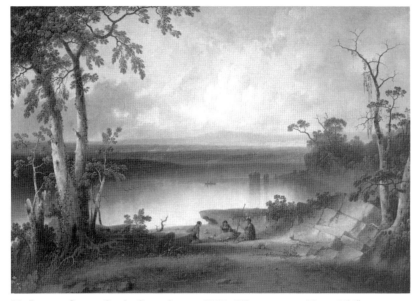

30 Joshua Shaw. *On the Susquehanna.* 1839. Oil on canvas, 39 × 55½″.
Museum of Fine Arts, Boston. M. and M. Karolik Collection

Watson and the Shark which conveys a mood of bizarre terror through
a specific event, *The Deluge* seeks to transmit the feeling of a more
generalized setting and more universal condition. The classical
structure of Copley's composition was symptomatic of his interest in
idealized virtues; this work explores the inner and mysterious world of
the imagination.

If *The Deluge* was a dramatic demonstration of the sublime, then
Shaw's later work in America showed a clear exposition of the
beautiful. After his arrival in 1817, he settled in Philadelphia, though
he was soon traveling through the countryside. From the many
sketches that Shaw made on these trips John Hill made engravings
which he published in 1820 as *Picturesque Views of American Scenery.*
The foreword to the first issue confirmed that the vistas of the
American Republic contained therein "present to the eye every variety
of the picturesque and sublime."[9] Shaw's *On the Susquehanna* of 1839
is typical of his American work (figure 30). It is probably the painting
that he exhibited at the National Academy of Design in 1843 under

this name and again at the American Art Union in 1846. It is
interesting in its recording of the American Indian; in this instance
three Indians are grouped at the shore of a lake around a freshly slain
deer. This concern with depicting accurately the actions and customs
of the Indian, combined with the expression of sympathetic
ennoblement, related Shaw to the better known images by A. J.
Miller, George Catlin, and Seth Eastman.[10]

The ingredients are all those of the beautiful landscape: regular,
even transitions from darks to lights and from one plane of space to
another; no violent contrasts or demonstrations of nature's awesome
powers. One's feelings are meant to dwell on calm and well-being,
rather than on desolation and fear. Shaw's later paintings illustrate
that he was fully capable of employing the various conventions of
painting that he had inherited from an earlier age. He was equally
adept at rendering the ideal, the imaginary, and the actual. Drawing
on compositions by Phillipe de Loutherbourg and J. C. Ibbetson,
Shaw shared definite stylistic concerns with another English-American
artist, Robert Salmon (see chapter eight). Shaw's adaptation of the
sublime and the beautiful also would find a parallel in still another
English-born American artist, Thomas Cole (see chapter four).

Washington Allston was a close contemporary of Shaw. As the
major artistic figure of the turn of the nineteenth century, he stands as
a transition between the generation of Copley and West and that of the
Hudson River School. His romantic landscapes and seascapes are the
direct forbears of the later group's romantic interpretations of local
geography (see chapter four).

Though Allston is equally well known for his portraits and
mythological subjects, he painted a large number of landscapes; a
smaller number include marine themes, and a handful are full
seascapes, such that in his work we may pursue for the first time the
development of one artist's marine painting. Great variety informs his
style, partly because it changed as he studied new techniques and
partly because it was so personal. An unusual early work is *A Rocky
Coast with Banditi* (figure 31).[11] Signed and dated 1800, the year he
graduated from Harvard, it may have been done in Cambridge, but is
in any case an important example from before the artist's first trip
abroad. Even in this he strikes the note of mystery and romance that

will continue throughout much of his later work. As an undergraduate Allston was already painting portraits, as well as allegorical and biblical scenes.[12] This clearly youthful work displays a haunting view of strangely shaped cliffs and the unknown activities of banditi near their boat. It is a simple but highly imaginative conception.

When in Paris in 1804 on his first trip to Europe, Allston painted *Rising of a Thunderstorm at Sea* (figure 29). Here he reenacts an observed spectacle of nature. Although one sees the storm arising, he also feels it will pass. The impending doom and infinite blackness which characterize *The Deluge* and Allston's late *Ship at Sea in a Squall* are missing here. In Allston's full seascapes man is insignificant in nature, but he is not terrorized by her. His little ships toss among waves their own size, and sea and sky seem limitless. The view reflects Allston's discovery of the stormy seascapes of Joseph Vernet, a figure influential in the careers of many younger marine painters, including Antoine Roux and Thomas Birch (see chapters six and seven).[13] These ships caught in the coming storm anticipate the more specific vessels in the midcentury seascapes of Robert Salmon, Fitz Hugh Lane, and James E. Buttersworth (see chapters eight, ten, and twelve). Coming at the opening of the nineteenth century, *Rising of a Thunderstorm at Sea* is the first major statement of the Romantic seascape in American art. Its delineation of nature's awesome power and beauty establishes a central nineteenth-century theme that culminates in the work of Winslow Homer (see chapter thirteen).

During his years in Europe Allston discovered the rich colorism of Titian's portraits, and sought to develop a similar method of glazes and broken color in his own work. Soon his paintings possessed a glowing luminosity and softness of textures. A few years after his return to Boston in 1808 Allston did *Coast Scene on the Mediterranean* (figure 32) from memory. Its beached sailboats and dominating sunset sky take on a romantic poignance from the fluid glazes and contrasts of tone. The sky takes up two thirds of the composition, a device probably derived from Vernet. The artist, however, filled the years of this brief Boston stay and the next few in his second London visit with portraits and some biblical scenes. Soon after returning to Boston in 1818 for a second time—for good— Allston painted another Italian view from memory, the familiar

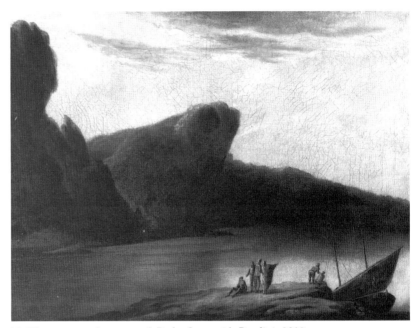

31 WASHINGTON ALLSTON. *A Rocky Coast with Banditti.* 1800. Oil on canvas, 14 × 19″. Museum of Early Southern Decorative Arts, Winston Salem, North Carolina

Moonlit Landscape (figure 33). Not strictly a marine painting, it merits comment here because of its inclusion of marine elements in a romantic manner that will anticipate a later generation of painters. Especially productive for the artist was this first year back from Europe, in which he painted several other well-known works, including *The Flight of Florimell, Beatrice, Italian Shepherd Boy*; and in the following year *Jeremiah Dictating His Prophecy of the Destruction of Jerusalem to Baruch the Scribe* and *Saul and the Witch of Endor.*

As a painting of color and light *Moonlit Landscape* is a major stylistic advance over earlier works, besides being acutely prophetic of the Luminist, atmospheric paintings of midcentury. The semiclassical structure of parallel receding planes and of generally balanced symmetry still underlies the work, but the range and use of tonal contrasts are more taut. Allston gives great care to the

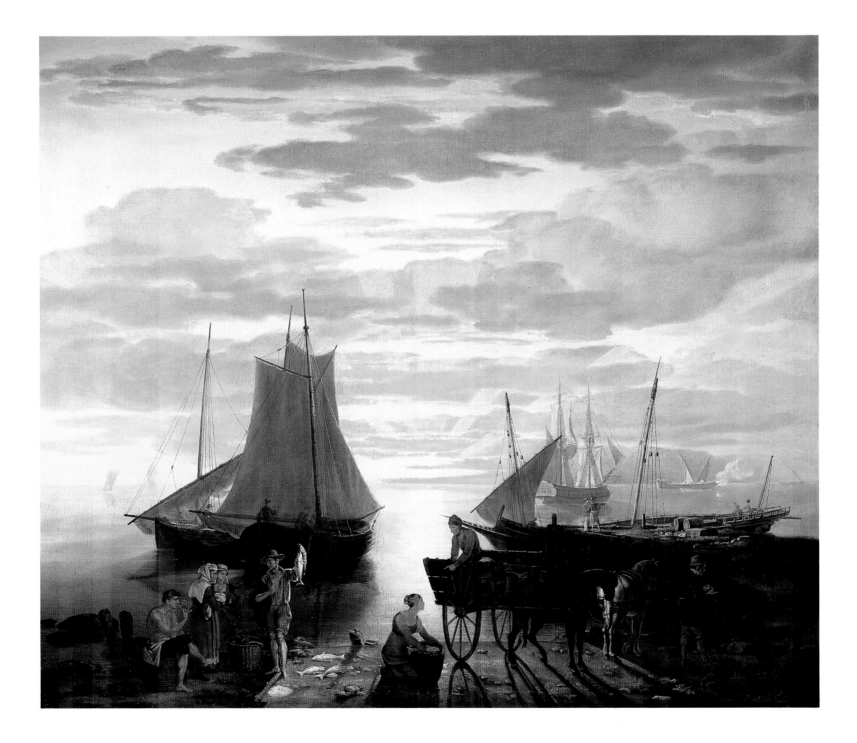

displacement of the evocative silhouettes. The same sense of the sublime and the magical that endowed his early painting remains, but the sense of scale and the brooding light contribute a new immediacy. Nature overpowers, but she is gentle and meditative. This mood and format would provide one source for the more topographical moonlight marines of Robert Salmon, George Loring Brown, and Fitz Hugh Lane some thirty years later; it would leave an even later legacy in the haunting works of Albert Ryder.

Among Allston's late unfinished works is the remarkable marine *Ship at Sea in a Squall* of around 1837 (figure 34). It is a large chalk drawing on brown-primed canvas, and though unfinished as a painting, has a completeness of feeling. Through the free, rhythmic chalk lines Allston achieves a sense of space and motion. Light, air, and water seem to have the familiar luminosity; nature continues to be

Opposite:
32 WASHINGTON ALLSTON. *Coast Scene on the Mediterranean.* 1811.
Oil on canvas, 34 × 40″. Columbia Museum of Art and Science, South Carolina.
Gift of Dr. Robert W. Gibbes

33 WASHINGTON ALLSTON. *Moonlit Landscape.* 1819. Oil on canvas, 24 × 35″.
Museum of Fine Arts, Boston. Gift of Dr. W. S. Bigelow

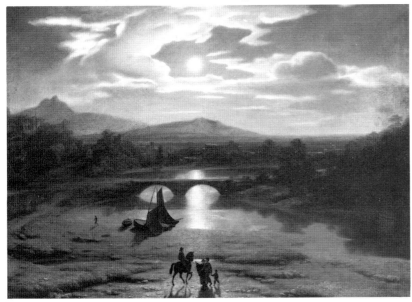

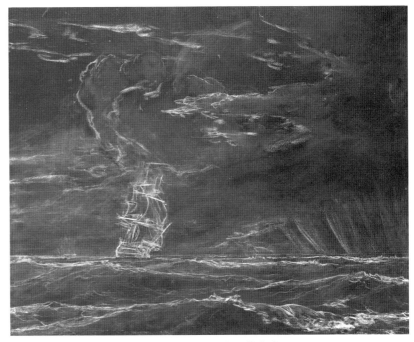

34 WASHINGTON ALLSTON. *Ship at Sea in a Squall.* Before 1837.
White chalk on brown-primed canvas, 48⅛ × 60″. Washington Allston Trust,
on loan to the Fogg Art Museum, Harvard University, Cambridge, Massachusetts

solemn and grand; and the eerie ghost ship sails a magical seascape that is profoundly evocative. Compared to his earlier paintings this is notably uncluttered with mythological baggage. The statement Allston makes here is imaginative and personal. Such a personal response to nature was, for him, lifelong; his career coincided with the first major expressions of Romanticism in all the American arts. Cooper, Bryant, and Emerson all began to publish in the 1820s and thirties, signifying that the day of the poet and philosopher was coming. The settling of the nation's business by Jefferson and the getting on with that business in a hurry by Jackson lent fresh interest to the physical promise of the continent. As the springtime of New England unfolded, a generation of painters known as the Hudson River School transformed Allston's romantic idealism into a specifically American expression.

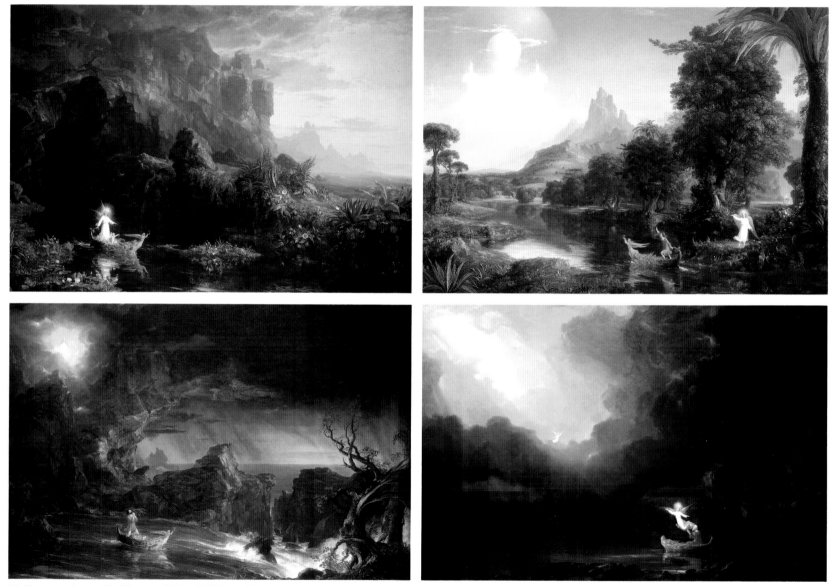

35 THOMAS COLE. *The Voyage of Life: Childhood, Youth, Manhood, and Old Age.* 1842.
Oil on canvas, four canvases: top, 52⅞ × 77⅞″; and 52⅞ × 76¾″; bottom,
52⅞ × 79¾″; and 52½ × 77¼″. National Gallery of Art, Washington, D.C.
Alisa Mellon Bruce Fund

The Hudson River School: First Generation

THE coming of Romanticism finally swept away the eighteenth century in America. The rise of a new middle class, the War of 1812, the glorification of the individual contributed decisively to shaping the character of the country in the first part of the nineteenth century. In one sense John Quincy Adams represented the world that was passing: the America of the Revolution and the young Republic; just as Andrew Jackson would come to represent the period then beginning: the United States independent of England and growing vigorously on her own. Some saw the campaign of 1820 as posing aristocracy versus democracy, intellect versus intuition, and sterility versus power to act.[1] In fact, the liberal intellects of Jefferson, Franklin, and the Adamses had left much in the way of literary, scientific, and artistic encouragement for the generations just assuming power. But it was the enthusiasm of self-discovery that stimulated these new energies. To Americans the power and potential of a working democracy seemed to be mirrored, even glorified, in the natural beauty of the continent itself.

The rapid industrial expansion of the East increased awareness of active river valleys and ports in the same way that the speculative opening up of the West later drew attention to the grandeur of the plains and the Rockies. There was a romance in the psychology of expansion itself, as an economically minded middle class overtook the cultured aristocracy.[2] And in literature another subtle change was that the essay and the short story now replaced the sermon. Oratory, called America's only continuing tradition at that time, wielded power in the Senate where it once had in the pulpit.[3] This shift of interest paralleled exactly the decline of portraiture and the rise of landscape.

The political climate set the tone of ferment. Jackson grew more confident and imaginative as his popularity took hold.[4] The common man who felt his own kind was in the White House sensed a new excitement in the air; on a deeper level the process of self-discovery led to a new consciousness of the American mind and culture. The building of roadways and canals, no less than the appearance of Poe's or Hawthorne's dark tales, created a romantic sense of expectation throughout the country and especially in New England. Boston in particular was active. Washington Allston and George Ticknor had brought back from Europe their respective versions of the grand style. George Bancroft and Richard Henry Dana were writing and editing, while also encouraging the younger poets. Yet the writing of history belonged with history painting to the older generation. The younger group, of which Longfellow and Irving were also a part, signaled the coming of a poetry and story of sensation and perception. Writer and painter alike sought to approach nature as closely as he could, and in doing so to reveal something of both his personal observation and response. Significantly, the association between writer and painter was close at this moment. The friendship between William Cullen Bryant and Thomas Cole was symbolic of that association.

One expression of the romantic spirit was Transcendentalism, which led in modified form to the Utopian movements of midcentury. The Industrial Revolution contributed to economic and social disorder, and in Utopian communities individuals hoped they might find their liberal ideals best expressed. The ideals of Transcendentalism evolved from the Puritan tradition; this new movement glorified the soul which had been overshadowed by a rationalist point of view in the late eighteenth century.[5] But the Transcendental and Utopian groups also rose in protest against the ruthlessness of an industrial civilization.[6]

Industrial life may have had a further effect on painting.[7] Where artists had formerly painted or engraved views of the activities around urban ports, they now sought the solitude of empty coasts, inland rivers, and isolated mountains. Such marine views as there were, outside events of the War of 1812, mostly depicted harbor panoramas or shipbuilding on the wharves. The artist sought increasingly to idealize the untouched areas of coast and countryside. When he painted his views, they took on moral overtones, as for Thomas Cole, or they became expressions of personal moods, as for Thomas Doughty and J. F. Kensett. Frequently, artists explored new modes of painting and composition to translate their feelings about what they saw.

The materialism of business contributed to a cult of nature in the now closely allied areas of literature and painting. Emerson, Thoreau, and Bryant were of course the leading literary spokesmen; Thomas Cole and the Hudson River School, the artistic counterparts. Nature

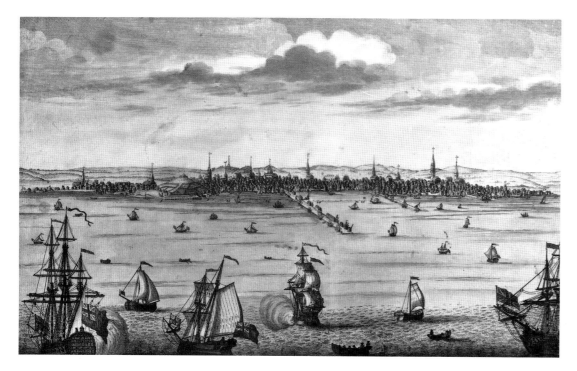

36 I. CARWITHAM (after William Burgis).
A South East View of the Great Town of BOSTON in New England in America. Eighteenth century. Engraving, 12 × 18″. Historic Deerfield, Inc., Deerfield, Massachusetts. Gift of Joseph Verner Reed

was imbued with the divine, and her high priests tried to show reverence through their art. The decade of the 1830s was the highpoint of their movement, but their creative drive was sustained well into the 1840s in some of Emerson's and Thoreau's best writing and in Cole's series of *The Voyage of Life* (figure 35).

Before giving closer attention to Cole's career, we ought to review the genre of American scenic views. The history of topographical views goes back to the first explorers of the continent who drew the early settlements and ports on the coast. The emergence of a definite taste for topographic views comes in the eighteenth century with William Burgis, whose drawings of harbors were later engraved for popular distribution. Known to have depicted New York harbor and Harvard College, Burgis also drew Boston harbor. The engraving after his drawing (figure 36) reveals his conscious attempt at a unifying aerial perspective, while it also records accurately the pertinent details of geography.

The direct descendants of the Burgis views were the prints of American scenery by W. H. Bartlett in the mid-nineteenth century. More pertinent to the shipping activities of the early decades of the century are the views made in the 1830s by John Hill, James Pringle, and W. J. Bennett (figures 37 and 89). Up to this time the painting of portraits was most esteemed by artist and patron, and only with the arrival of the Romantic period and Andrew Jackson's democracy did Americans look with any intensity at the events or places around them. Bennett's views of Boston portray a very different world from that of either Burgis or the eighteenth-century primitive painter. The observer is much closer to the life depicted in the harbor. The point of view is lower, giving the spectator a sense of involvement in the bustling scene. Details of shipping, architecture, and geography are extensive. Bennett, considered one of the best topographic artists of New York before 1850, suggests the feeling of a specific American locale by meticulously recording the life of the busy port.[8]

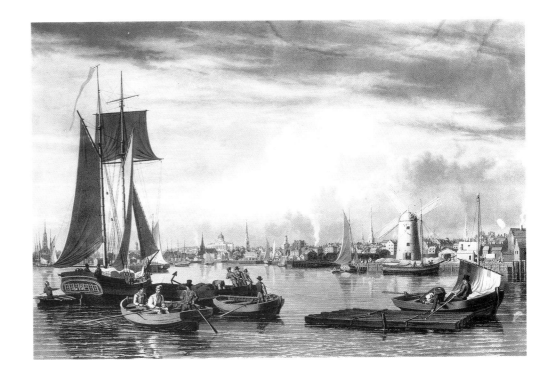

37 WILLIAM JAMES BENNETT.
Boston from City Point near Sea Street. 1833.
Etching and aquatint, hand colored, 21¼ × 27¼".
The New York Public Library,
Astor, Lenox and Tilden Foundations. Prints Division

As artistic interest shifted to the quiet groves of nature inland, it came to focus on the area of the Hudson River Valley. Almost every artist painted there—the unknown, the little known, and the famous. The term Hudson River School was a name given to the group, Worthington Whittredge reported, by a "savage critic who wrote for the *New York Tribune*."[9] But like other names for artistic movements, Impressionism and Cubism, this one, said derisively, soon became approbative. Perhaps Asher B. Durand best caught the feeling of the period in his painting of his friends Cole and Bryant, *Kindred Spirits* (New York Public Library). There the two leading spokesmen stand on the jutting rock deep in the woods, discussing the relationship of man and nature. Much of the painting of this group was less lofty. Many artists simply wanted to record the river landscape with a common concern for capturing nature accurately.

The worship of nature became intense in the writing and painting of the period. This was more than man's nature: it was God's, and man need only be self-reliant, in Emerson's terms, to find sufficient spiritual fulfillment in the presence of this wilderness. Significantly, two of the best known celebrations of nature both appeared in 1836, Emerson's essay *Nature*, and Cole's series of paintings *The Course of Empire*. Artists led the way in pitting nature against civilization, the first seen as beautiful and virtuous, the second as ugly and evil. This latter was slowly encroaching on nature's primordial purity, and it was the artist's obligation both to record American scenery accurately and to laud the pristine uniqueness of the continent before it was changed. Cole summarized the feelings of his generation in his monumental *The Course of Empire*, in which he stressed the moral of turning to the inspiration of nature. He succeeded so well that the *New York Evening Mirror* termed his death in 1848 "a national loss."[10]

Cole's paintings vary considerably in their transmission of factual observation and literary idealization. At his best he was able to use

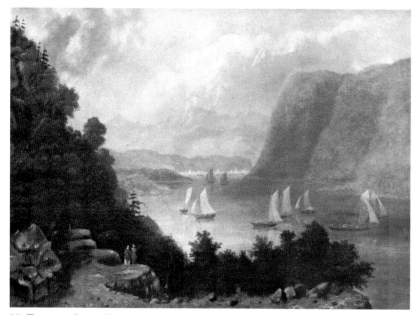

38 THOMAS COLE. *View of North River*. 1830s. Oil on canvas, 22 × 29½″.
Wadsworth Atheneum, Hartford, Connecticut. Bequest of James B. Hosmer

color and light in his paintings to convey a special atmosphere or
mood. In Cole's own work it is possible to see the two sides of
Romantic painting in general. Constantly in his work ran the conflict
between the objective view and the idealized composition with moral
overtones.[11] Contemporary taste sought a middle ground in
demanding American views but with elevating sentiments. Asher B.
Durand and Thomas Doughty attempted more the objective
observation of nature, as their tendency to close-up, detailed views
bears out. By contrast Cole tended to compose panoramically, imbuing
nature with picturesque qualities. His views frequently became
grandiose, imaginative schemes, through which he could not only
proclaim the immanence of the divine in nature but narrate a moral
as well.

A similar contrast exists between the writing of Emerson and
Thoreau. Where the former struck lofty philosophical themes, the
latter recorded the details of nature that he observed close at hand.[12]

While the poetry of Bryant corresponds in its lyric descriptions of
American scenery to Cole's Hudson River paintings, Emerson also
embodied the energy of new romantic forces. Look at almost any
major paintings of the 1830s or forties by Cole and listen at the same
time to Emerson:

While the student ponders this immense unity, he observes that all things
in Nature, the animals, the mountain, the river, the seasons, wood, iron,
stone, vapor, have a mysterious relation to his thoughts and his life; their
growths, decays, quality and use so curiously resemble himself, in parts and
in wholes, that he is compelled to speak by means of them.[13]

View of North River (figure 38) illustrates the quieter, less common
side of Cole; it is a painting clearly within the documentary tradition
of the Hudson River School. It appears to be accurate in the visual
recording of nature. Unlike lesser artists in the group Cole captures
here a refined sense of the luminous light and the crystalline air. He
modestly employs the Claudian mode of a dark foreground stage with
sharply silhouetted foliage to enframe the tunneled passage into the
background. Man is insignificant in the face of nature, a sentiment
perfectly expressed through the picturesque formula. What can the
observer feel but the highest sentiments in this reverential
contemplation of nature? For Cole and his contemporaries the Hudson
River was more than a locale; it was a state of mind.

Cole's *The Course of Empire* and *The Voyage of Life* series represent
the other extreme in his painting. Both groups include marine
elements, but do not fit into the usual definitions of any particular
genre. Each series was the result of a commission. The tolerant
patron Luman Reed invited the first; the collector Samuel Ward
agreed to the later set after Reed had died. In Europe Cole had been
inspired by the works of Claude Lorrain, John Martin, and Salvatore
Rosa. Moralizing on the self-destructive capacities of human vanity,
Cole chose for *The Course of Empire* the format of a panoramic view
seen in successive stages. He made clear his idealizing intentions
through the composite of ancient architecture as it rose and fell in the
face of nature. The perspective harbor view was exemplified in
Claude, the frenzied action tortuously frozen in John Martin's wild

harborscapes, and the dramatic effects of light and clouds in Rosa's violent storms at sea. This was the Cole who delighted in the Roman campagna with its melancholy glow of the past. But it was also the Cole who saw the respective virtues of civilization and raw nature. The animated palette, huge composition, and ambitious scale of the series all satisfactorily connoted his pious sentiments.

Cole continued this scale in *The Voyage of Life* series (figure 35), but was more obvious about his deepening religious sentiments. It is interesting that at the time he was commencing work on the paintings in 1840, he made note in a letter of the recently invented daguerreotype. The newspapers, he recalled, were announcing that the new mechanical device would render the work of painters unnecessary. But Cole had faith in his own conclusion: "that the art of painting is a creative, as well as imitative art, and is in no danger of being superseded by any mechanical contrivance."[14] Painting for him would always go beyond the superficial objectivity of a photograph. Like many of Cole's conceptions for paintings in his last years, the subject of *The Voyage of Life* was a cyclical one, beginning with infancy and running through youth and manhood to old age. Typical is the romantic consciousness of time's passing, of the inevitability of change, of man's own mutation and transience in the larger scheme of history. The four paintings in the series are replete with symbols, most of which the artist described himself: in the first scene of *Childhood*, an infant emerges in a boat from out of a grotto. An angel guides the boat, while figures of the Hours are carved on the prow, reminders at once of a divine presence and the notion of time's course. The stream of life, having issued out of the mysterious womb of the past, now proceeds toward the Ocean of Eternity.

Cole presents a scene of more panoramic dimensions in the next painting, to suit the widening range of vision and ambition in youth. The young man is now alone, the guardian angel stands aside at the bank, and an imaginary castle fills the distant sky, emblematic of youthful aspirations. Turbulence and challenge greet the middle-aged voyager of the third scene. With the tiller of his boat now gone, he is forced to look heavenwards for assistance. Cole is saying that while life is full of trouble, man can ride the stormy waters by means of his faith in a superior power. In the final painting of *Old Age* the voyager leaves earthly shores behind and sets sail on the open seas of Eternity. As the heavens part in a blaze of golden light, the angel appears again to welcome the Christian whose life of suffering now gives way to immortal bliss.[15]

As in *The Course of Empire*, so here Cole used his device of focusing all of the paintings in the series around a repeated element, in this case the figure in the boat, seen from varying points of view. Details like rocks and foliage also reappear, but change their forms to accompany the age of the voyager. At the start the flowers and trees are massed in a luxuriant growth, later turning to gnarled branches and blasted trunks, and finally to a barren rocky ledge. Similarly, the lighting also adjusts to the meaning: at first cool and fresh as at the start of a new day; then broad and brilliant, flooding the whole landscape as at midmorning; next dramatic, turbulent, stormy, and strong in contrasts; and lastly, mystical, visionary, and heavenly, not unlike the effect of a stained-glass window. Several decades later another Romantic visionary artist would turn to painting the theme of man's lonely voyage. Albert Ryder called this theme "toilers of the sea" (figure 160).

These two major series by the leader of the Hudson River School are outstanding documents of the taste in painting of this period. But the actual direction native American painting was taking more all the time was that of objective observation. Cole was a last representative of an older romanticism that began with Copley and reached its peak in Allston. Cole's smaller works done in the Catskills and New England were closer to what some of his contemporaries were doing and to what the younger generation of Hudson River painters would do. Cole himself continued to record actually observed scenes right alongside of his moralizing compositions. On a trip to Maine near the end of his life he painted *Frenchman Bay, Mount Desert Island, Maine* (figure 39) which combines some of the turbulence and drama of *The Course of Empire* and *The Voyage of Life* with the precision and accuracy of careful firsthand observation.

Just after he had agreed to take on Frederic Church as his only pupil, Cole set off for Maine in late August of 1844 on a sketching

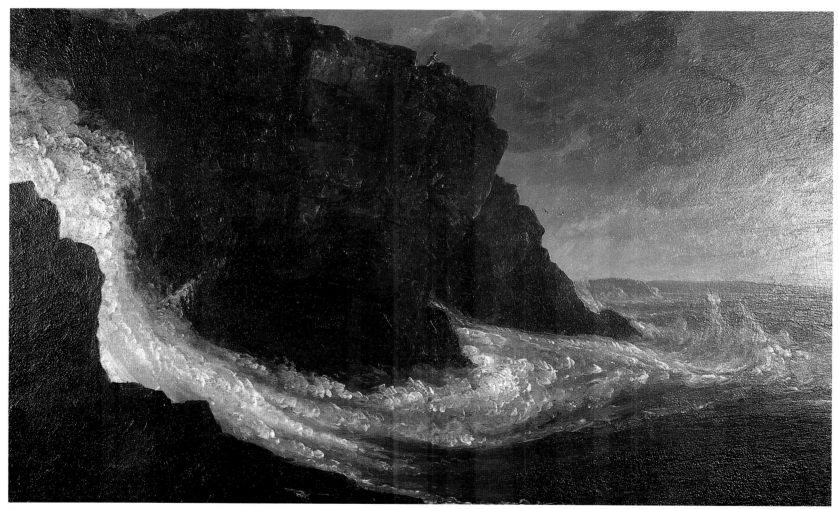

39 THOMAS COLE. *Frenchman Bay, Mount Desert Island, Maine.* c. 1845.
Oil on canvas, 14 × 23″. Albany Institute of History and Art, New York
Opposite:
40 THOMAS DOUGHTY. *Desert Rock Lighthouse.* 1847. Oil on canvas, 27 × 41″.
Newark Museum, New Jersey. Gift of Mrs. Jennie E. Mead

trip along the coast of Mount Desert. Commenting on the "fine views of Frenchman Bay on the left, and the lofty peaks of Mount Desert on the right," Cole painted both inland and coastal views on his trip.[16] The headlands in *Frenchman Bay* are those called Otter Cliffs, and

Cole has taken the liberty of tilting them forward slightly to enhance their menacing quality. Not a large canvas, it is filled with the bold forms of the rocks, the crashing breakers, and the windy sky. Man is still insignificant in the face of this raw outcropping of nature: a small

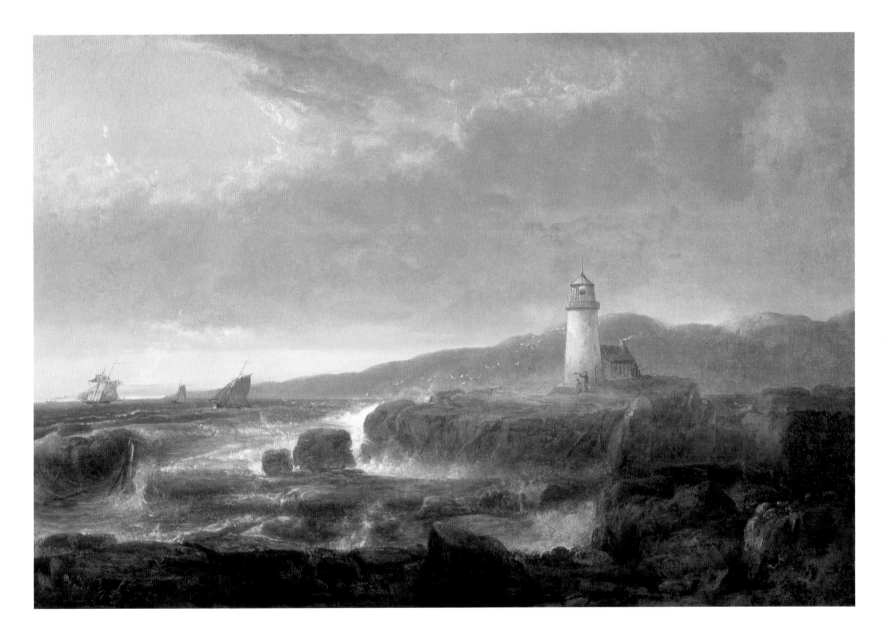

figure peers over a rock at the top of the cliff and a lone sailboat, her sails reefed, plows dangerously close to the lee shore.

Following Cole to Mount Desert within the next decade would be Benjamin Champney, Thomas Doughty, Frederic Church, Sanford R. Gifford, John Kensett, and Fitz Hugh Lane (figures 40, 51, 109, 140). These men maintained Cole's interest in this rocky coast, but their attention to nature lost much of the character of cult worship that pervaded painting in the 1830s. The need for moralizing

slackened toward midcentury, and many artists struck off on their own. Partially this was due to the fact that art had now gained a limited popular acceptance. Even if it meant having to make a living by painting portraits or executing commissioned engravings on the side, the artist was nevertheless freer than ever before to experiment on his own.

Not just did his interest in nature as he saw it continue, but the painter increasingly found himself challenged by the less tangible conditions of nature. He sought in painting to reproduce specific optical effects of light and air. His work was still documentary, but it now began to lose the injected overtones of narration or morality. Truth to his visual perceptions provided him with sufficient stimulation, and American art would deal with these problems for most of the rest of the nineteenth century.

An important literary aside deserves introduction here. The writing of James Fenimore Cooper presents a patriotic romanticism that is very close to the rise of native landscape and seascape painting. As the shoreline views and sea paintings of J. F. Kensett, Robert Salmon, and Thomas Birch are the first body of American marine art, and forecast the culminating achievements of Homer and Ryder in the second half of the century, so the appearance of Cooper's early sea fiction is the harbinger of Melville's *Moby Dick* several decades later. In the decades following the War of 1812 sea ballads of American origin and subject matter gained new popularity, while about the same time some of the Hudson River artists were beginning to paint along the New England coast. Cooper's sea novels were the first to join patriotic, maritime, and romantic themes.[17] The sea was a powerful natural force; a sailing vessel was a structure that combined beauty with utility, and in this wilderness setting man could come to terms with himself. Cooper's interest in the maritime past soon stimulated other short stories dealing with contemporary nautical events. Here as elsewhere there were two approaches, the one represented in the young Richard Henry Dana's *Two Years Before the Mast*, which realistically told of contemporary life at sea; the other represented by Cooper's stories like *The Crater* and *The Sea Lions*, which were high romantic visions in allegorical form. Indeed, Cooper in all likelihood derived *The Crater* from Cole's *The Course of Empire*. Besides the moralizing treatment of history, Cooper "also adopts Cole's use of a topographical reference point as a means of giving continuity to the description of drastic change."[18]

It was the note of realism that became the more prominent just before midcentury. The romanticism of Cooper and Cole was essentially one of reverie on the past, and artistic sentiment was turning more to the romance of the present. A few painters in the Hudson River group also did an occasional pure marine. Though their attempts were tentative, they hinted at the new concerns for realism. Both Thomas Doughty and Alvan Fisher are best known for their woodland interiors and country landscapes, but their less common seascapes embody the turn of the School toward the seacoast. This turn had a definite influence on the next generation of Hudson River artists, especially Kensett and Church whose romantic spirits were at home not only on the coast but in distant, uncharted seas as well.

Doughty was somewhat older than Cole but has always been considered a less influential member of the School. While his painting often equalled Cole's in technical skill, it was often lacking in imagination. For Doughty and Fisher who were both born in the early 1790s "the simple contemplation of nature becomes motive enough for an illustration,"[19] and in this is their present significance. Making use of the expressive possibilities of his brushwork, Doughty was able to achieve a visual animation in his pastoral scenes. All too frequently, however, the uniformity of his manner resulted in monotony. For this reason his *Desert Rock Lighthouse* is unusually fresh (figure 40). Like Cole who was also visiting Mount Desert Island at about this time, Doughty rendered his personal impressions of an environment that was very different from the Catskills. The scene is visually correct, but also exhibits a feeling for light and moving air that equals much of his contemporary Thomas Birch's best work (see chapter seven). With his varied brushwork Doughty convincingly captures the drama of scudding clouds, silvery light, and dashing waves on the rugged Maine shore.

Alvan Fisher was also primarily a landscape painter, but his harbor scene (figure 41) has a liveliness not commonly seen in the rest of his

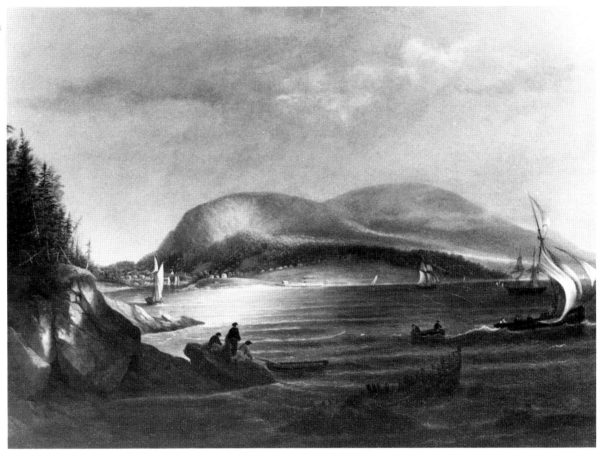

41 **ALVAN FISHER**. *Camden Harbor*. c. 1850s.
Oil on canvas, 27 × 36″. William A. Farnsworth
Library and Art Museum, Rockland, Maine.
Gift of Mr. and Mrs. Philip Hofer

work. Interest in this lesser known figure has been steadily rising in the light of instructive exhibits and fresh scholarly attention. Whereas Doughty taught himself to paint, being strongly moved by a love of nature, Fisher received major stimulation from a trip to Europe in the mid-1820s. However, his most typical transcriptions of nature were generally as factual as Doughty's. The undated *Camden Harbor* is cast in familiar dark greens with a diffusion of light in the background over the Camden Hills and smaller accents of light on foreground details. Fisher has exaggerated the scale of the hills and the actual perspective of the topography, but the resulting emphasis on the curving shapes of the hills has a pleasing effect. This *Camden Harbor* has a special relevance to the very similar versions of the town and harbor by Fitz Hugh Lane who followed Doughty and Fisher to Maine a few years later (see chapter ten). Lane pursued even further the effects of optical luminosity in his interpretation of Camden and the coast Down East. By midcentury the problems of painting light and atmosphere had taken on new dimensions with a younger group of painters.

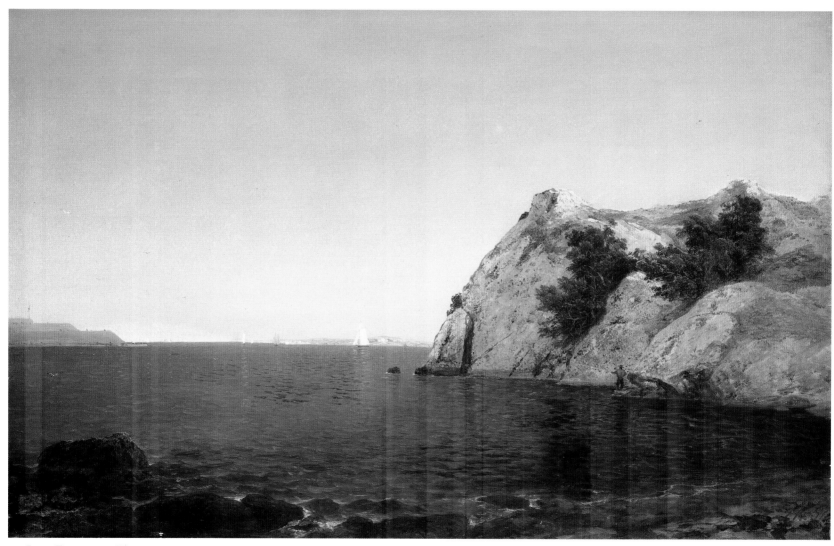

42 JOHN FREDERICK KENSETT. *Beacon Rock, Newport Harbor.* 1857.
Oil on canvas, 22½ × 36″. National Gallery of Art, Washington, D.C.
Gift of Frederick Sturges, Jr.

The Hudson River School: Second Generation

IF the coast brought forth only a handful of paintings from Doughty, Fisher, and the earlier members of the Hudson River School, it drew the major attention of the next generation. The careers of John Frederick Kensett, Fitz Hugh Lane, Martin Johnson Heade, William Bradford, William Stanley Haseltine, and William Trost Richards are all prominently associated with the shore and the open sea. More directly influenced by the Hudson River School style were Thomas Worthington Whittredge, Albert Bierstadt, and Frederic Edwin Church, all of whom contributed their individual statements to marine painting. For figures like Heade, Bradford, Bierstadt, and Church the romance of the New England shore led to the pursuit of exotic travel in remote seas and continents.

Kensett painted both river scenes and the seacoast in New England. Throughout his American work there is an appealing simplicity. His most familiar compositions were organized around the juxtaposition of large areas of dark and light. Always in control of light and color, he could render large spaces and quiet panoramas that suggested something of the vastness in nature that he sensed. His most common choice of format was the vertical division of the canvas into approximate halves, with massive trees or rocks filling one side and an open view of the water on the other. This bold contrast of values and the fine sense of drawing in his work doubtless derived from the engraving that Kensett practiced when he went abroad to paint with Durand and Casilear in the 1840s. After substantial travel that took him to London, Paris, and Rome, Kensett returned to the United States in 1848, painting and living in New York until his death a little over two decades later. *Shrewsbury River, New Jersey* of 1859 is in the usual layout (figure 43). A feeling of solitude and peace informs the work, largely through the artist's economy of design, refined draftsmanship, and subtle nuances of light and shadow in the reflections on the surface of the water. Shrewsbury was a popular vacation spot near the New Jersey coast, and Kensett has successfully managed to capture the quality of expanse that one senses at the shore as well as the aura of calm and leisure.[1] The small boats in the middle and far distance bespeak a feeling of human isolation and smallness that recalls Cole's work (see figures 38

43 JOHN FREDERICK KENSETT. *Shrewsbury River, New Jersey.* 1859. Oil on canvas, 18 × 30″. The New-York Historical Society

and 39). The strongly contrasting lights and darks and almost eerie stillness also anticipate the coastal paintings of Martin Johnson Heade (see chapter eleven).

Kensett's experience in Europe had given him a full familiarity with the theories of the sublime, picturesque, and beautiful, especially as exemplified in the works of Claude, Poussin, and Salvatore Rosa. Kensett's own early work in both Europe and in the White Mountains of New England demonstrated his grasp and application of these principles. But increasingly through the 1860s and seventies he turned to recording his direct observations of nature rather than reworking prescribed formulas for composing a painting. Like the painters of an earlier generation, Kensett also left the city and its taint of civilization for the pristine tranquility of lonely woodlands and coastal stretches.[2]

Among the subjects of Kensett's brush were beaches and promontories from Long Island to Newport (figures 42 and 44). His coastal scenes of Newport are composed like the river views, but with a crispness and clarity unparalleled in his other work. With sharp

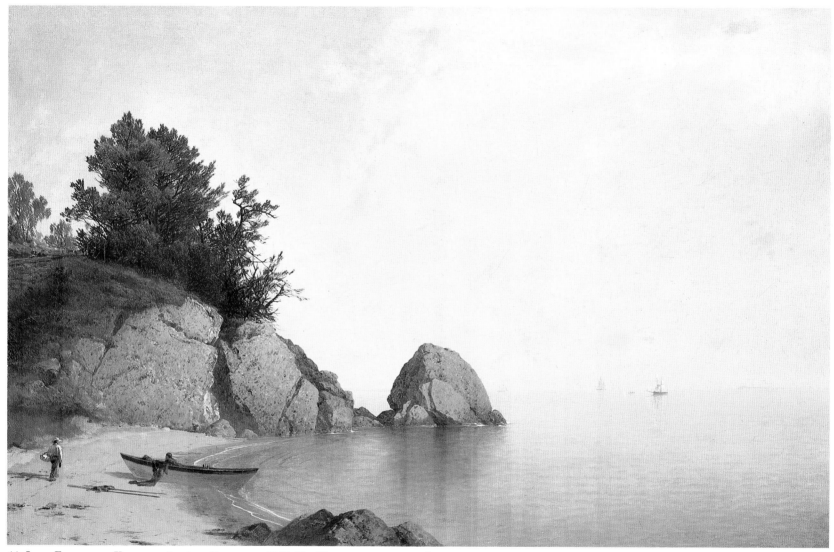

44 JOHN FREDERICK KENSETT. *Beach at Newport.* c. 1869–72. Oil on canvas, 22 × 34″.
National Gallery of Art, Washington, D.C. Gift of Frederick Sturges, Jr.

outlines, thinly applied paint, and subtle changes of color he achieves an expansive space flooded with light. Using a similar economy of composition and judicious placement of forms Fitz Hugh Lane would imbue his view of *Brace's Rock* with this stillness and purity of light (figure 117). Largely by means of curving and diagonal lines Kensett moves the eye back along the crests of waves or the edge of a beach

to an almost imperceptible shore or distant horizon. There is a romantic confrontation with nature in the open. Human figures seldom appear in Kensett's paintings, and usually only to reinforce man's insignificance before nature's lonely permanence.

His best work illustrates a high degree of expressive economy and an uncluttered poignance. There is a decided modernity in his simple, large areas of form and color. In these paintings, Kensett employed his favored composition of a large rock mass to one side balanced by an almost empty expanse of sky and water on the other. These broad slabs and the breaking waves lead the eye into the middleground where a closer look sometimes exposes small figures on the rocks, and ultimately into the distance where a sailboat sails down the lee of the shore.

These coastal views near Newport exemplify Kensett's later style, in which his sense of design became increasingly abstract. He would rely only on the basic elements of shore, sea, and sky, arranging them with a new spareness and simplicity. He also caught with growing power the transparency and luminosity of light that would reappear in the work of W. S. Haseltine, Francis A. Silva, and A. T. Bricher (figures 137–141). Kensett's vision of natural beauty and power would be further amplified by Winslow Homer at the end of the century.

The marine side of the Hudson River School had other voices in the younger members of the group. Most were, like Cole, Doughty, and the older exponents, primarily known for landscapes. The little wash *Study of Three Boats* by Worthington Whittredge has, therefore, an unusual charm and immediacy (figure 45). It is a careful piece of drawing with a telling use of wash, and the design itself gains positive interest from disposition of the small hulls in the upper right of the page. Not only does Whittredge's 192-page handwritten autobiography survive, but so also do six of his sketchbooks, all of which are now in the Archives of American Art in Washington, D.C. These sketches vary: some note what colors were to be used in a subsequent painting; some record the configurations of a particular place; others are studies of details for larger compositions.[3] *Three Boats* makes a remarkable contrast with the artist's more encompassing views of the New England coast and forest interiors or of the Colorado plains.

45 THOMAS WORTHINGTON WHITTREDGE. *Study of Three Boats.* 1856. Pencil and gray wash, 11¹¹⁄₁₆ × 16¹⁵⁄₁₆″. Museum of Fine Arts, Boston. M. and M. Karolik Collection of American Watercolors and Drawings

Born in Ohio in 1820, Whittredge soon took up painting, and at midcentury spent a number of years abroad, including study at Düsseldorf. Shortly after returning he saw Cole's and Durand's Hudson River paintings at the New-York Historical Society and was as moved as most of his generation were by the beauties of American scenery. Thereafter he painted chiefly in the Catskills or New England, except for two trips west. The coast and the sea were favored subjects of Whittredge's. In his sketches and paintings he noted his private meditations of appealing places along the shore. Several paintings of the Massachusetts shore may well be of Cape Ann, for Whittredge noted in his autobiography how attracted he was to the towns along its coast.[4] *A Home by the Sea-Side* of 1872 is a view further south overlooking the shore and ocean near Newport, Rhode Island (figure 46). Whittredge combines his spacious view of sea and sky with an intimate description of farmhouses in the foreground. A warm bright

46 THOMAS WORTHINGTON WHITTREDGE. *A Home by the Sea-Side*. 1872.
Oil on canvas, 14½ × 25½″. The Los Angeles County Museum of Art.
William Randolph Hearst Collection.

light pervades the scene, accenting details while also creating an expansive space in the distance.

Another Rhode Island view by Whittredge is *Second Beach, Newport* (figure 47). The scene focuses on the rocky promontory called "Paradise Rock" or "Bishop's Seat." Whittredge made a preparatory drawing (now in the Archives of American Art, Washington, D.C.) that included the moon just above the rock; he replaced this in the painting with bright daytime clouds.[5] It makes an interesting comparison with Kensett's paintings in the area (see figures 42 and 44). Both men made careful small-scale studies for their paintings; both exploited the low horizon, simple forms, and large, empty spaces. But Whittredge's brushwork is looser, the paint is laid on more thickly, and instead of the clear sky Kensett preferred, he fills it with layers of clouds. Whittredge also shows us a scene that does not quite have the barrenness of Kensett's late canvases. There are more figures here, and they are enjoying themselves in a variety of activities along the edge of the water. Some are seated with children, others are wading or swimming, while at the far end of the beach a horse and buggy promenades into view.

The debt that the later artists owed Cole is exemplified by the work of Frederic Edwin Church, a figure who is the more important for his interest in exotic travel. With Church and Albert Bierstadt the Hudson River School left its native birthplace for grander places and grander style. The appearance in 1852 of the travel narrative of the German naturalist Alexander von Humboldt stirred Church's imagination, and in the next two decades the artist explored and painted the landscapes of North and South America, the Arctic, and the Near East. Working on enormous canvases, Church sought to display in thorough detail the panoramas that he had seen. In the last few years a renaissance of attention to nineteenth-century American art has helped to restore Church to the place of importance that he held in his lifetime.[6]

We now have a clearer understanding of how the painted picture served an important purpose in national life during the years of Manifest Destiny. Prosperity and national self-confidence demanded heroic and optimistic art, in which Americans could see embodied their notion of the continent's fresh expanse and power. Church provided the style and iconology for this point of view, one that sought to replace an Old with a New World way of looking. This was the essential difference between him and Thomas Cole, who at the urging of Daniel Wadsworth had accepted Church as a pupil in 1844 and who would be the first direct influence on his work. Cole still belonged to an older European tradition, and Church felt it necessary to answer the needs of America in the present and future.

Apparently Church succeeded, for when *Niagara* (Corcoran Gallery of Art) was hung in 1857 in New York, hordes came to view it. The President of the United States was the first of more than eleven hundred individuals to sign a subscription list for an engraving of the painting. A few months later the work went to London where it won over Ruskin, and during the next couple of years triumphantly toured the major cities of the United States, until it had become this country's best known landscape painting. Why? In effect, Niagara had become an archetype of the American continent, a place known and visited by everyone. The grandeur of Church's interpretation seemed singularly able to incorporate the prevailing mystique. Vanderlyn,

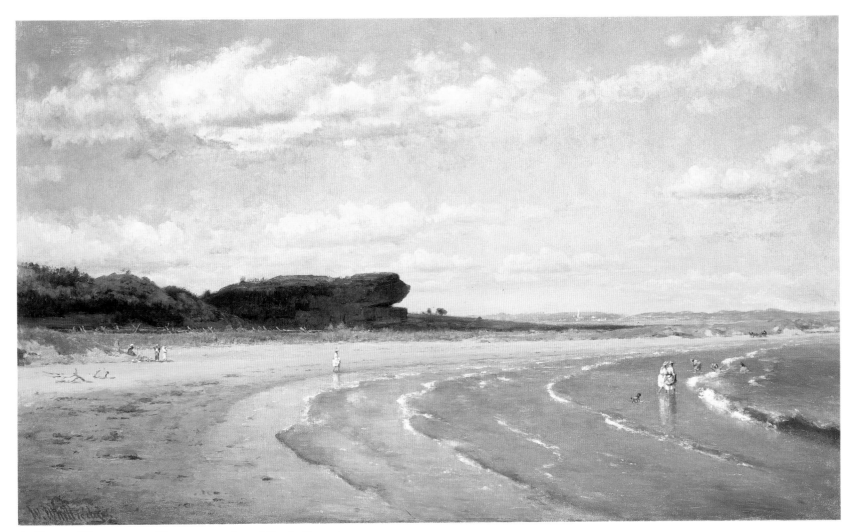

47 THOMAS WORTHINGTON WHITTREDGE. *Second Beach, Newport.*
c. 1870s–1880s. Oil on canvas, 30½ × 50¼″. Walker Art Center, Minneapolis.
Gift of the T. B. Walker Foundation

Trumbull, Cole, Kensett, Fisher, and Morse had all preceded Church in painting Niagara. But these earlier versions had remained essentially classical landscapes, formulaic compositions, whose limits were contained and based on secondhand knowledge. Church, by contrast, went to the scene and made extensive sketches. The result was a synthesis of them all, one in which the water expands and

48 FREDERIC EDWIN CHURCH. *Grand Manan Island, Bay of Fundy*. 1852.
Oil on canvas, 21³⁄₁₆ × 31⁵⁄₁₆″. Wadsworth Atheneum, Hartford, Connecticut.
Gallery Fund

pulses across the enormous canvas. Church was among the first to exploit a more horizontal format for his painting, to suggest a greater lateral expanse, a more panoramic breadth. Bierstadt, Kensett, and a few others were to employ similar dimensions soon after, but it was Church who gave the panorama new meaning in the context of his subject.[7]

The spectator stands in the foreground of *Niagara*, forced to enter a new and breathtaking space. The artist gained ready approval because he had filled the foreground with rushing water: here was fresh, objective observation.[8] With a billowing cloud half seen at the distant horizon, Church implies the curvature of the earth. In a manner close to Turner's, his brushwork coincides with the very movements of water and shapes of rock throughout every area of the canvas. This conception and technique captured the uniqueness of America for Americans. Church would employ this approach throughout the rest of his career, applying a similar scale and drama

to his paintings of northern New England and of Arctic icebergs.

In 1853, stimulated by von Humboldt's theories of natural history, Church made his first trip to South America. Under the further influence of Ruskin, he ventured back in 1857 to concentrate his energy in exploring the mountains of Ecuador. Meanwhile, he had made several summer trips in the early fifties to paint along the Maine coast (figures 48 and 50–52). Just as Cole and other younger artists had discovered, here was a rugged and raw coast which was in its own way an embodiment of the continent's powerful grandeur. Church's early masterpieces will show at once the debt to his master Cole while also expressing the new visionary heroism of a younger point of view. In *Grand Manan Island, Bay of Fundy*, 1852 (figure 46), a solitary figure walks across the beach, oars on his shoulder, as a resplendent sunset calms the evening waters, bathes the cliffs with a cleansing light, and floods the sky in streaks like an aurora borealis. Just over a decade later, in 1863, he painted *Sunrise off the Maine Coast*, also known as *Storm off Mount Desert* (figure 50). He probably based this on a painting by Andreas Achenbach, such as his *Sunset off a Stormy Coast of Sicily*, 1853, in the Metropolitan Museum. Not unlike Cole's painting of the cliffs at *Frenchman Bay* (figure 39), Church's work shows the violent waves pounding against the unyielding rocks, while the sun rises in the center, breaking through the mist and signaling the start of a new era. But this painting is without the figure of man: rather, it is the epitome of the American wilderness in its primeval state. As such, it stands halfway between Joshua Shaw's *Deluge* and Winslow Homer's *Incoming Tide* (figures 28 and 148).

Church's paintings of the Arctic icebergs, begun on his first trip to the north in 1859 and continued as late as 1891, represented in a marine subject Church's awe of these romantic hinterlands. Stimulated by Elisha Kent Kane's expeditions of a few years earlier and the subsequent publication of *Arctic Explorations* in 1857, Church set off for the Labrador coast with the Reverend Louis L. Noble, Thomas Cole's biographer, who described this venture in *After Icebergs with a Painter*. One of his most important paintings resulting from the trip is *The Icebergs (The North)*, dated 1861 (figure 53). Tinted with cool

yellows and pale greens, and showing the remnants of a ship's mast in the foreground, it creates the effect of an eerie northern wasteland, while possessing just the dramatic power that the artist sought.

The same combination of scientific realism and grandeur of scale informs *The Iceberg* (figure 49). Unlike the sweeping views of South America that were enveloped in Turneresque effects of atmosphere, this shows a harder, sharper recording. The iceberg fills the whole middleground of the picture, silhouetting the small vessel intrepidly sailing close by. With a deceptive variety of brushwork Church has painted the structure of the iceberg, the surface of the water, the wind-filled sails, and the northern sky with a convincing realism. It is at once geologically correct and artistically powerful. To Church the icebergs were symbols of the north, as Niagara, Cotopaxi, and Jerusalem were in their ways embodiments of time and history.[9] In such subjects he found both an expression of a continental geology and a sense of cosmic meaning. Polar expeditions had earlier stimulated James Fenimore Cooper; the same stark confrontation with nature would appear later in the paintings of William Bradford (see chapter eleven).

Albert Bierstadt is closely associated with Church because they both carried the Hudson River style to distant landscapes. In the seventies they were archrivals, each trying to outdo the other for public attention with enormous canvases that sought to capture a generation's attitudes toward the wilderness. Both experienced tremendous popularity through the 1860s and seventies, but thereafter sank gradually into almost total neglect until the twentieth century. If crowds lined up six deep with their Bibles and binoculars to study Church's *Jerusalem* in 1871, they had also strung a banner across Broadway in 1866 proclaiming the exhibition of Bierstadt's *Storm in the Rocky Mountains*.[10]

Although Bierstadt was born in 1830 in Solingen, Germany, near Düsseldorf, he came, at the age of two, to live in New Bedford, Massachusetts. Little over a decade later Albert Ryder was born in a house across the street from the Bierstadts (see chapter thirteen). Other painters were at work in New Bedford during Bierstadt's youth, notably William A. Wall, Albert Van Beest, and William Bradford

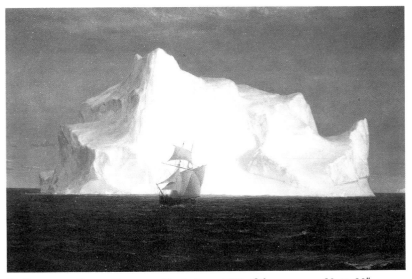

49 FREDERIC EDWIN CHURCH. *The Iceberg*. 1891. Oil on canvas, 20 × 30″. Museum of Art, Carnegie Institute, Pittsburgh. Howard N. Eavenson Memorial Fund, for Howard N. Eavenson Americana Collection

(see chapter eleven), and Bradford later became a close friend of Bierstadt's in New York. Bierstadt began drawing around New Bedford, receiving his first commissions from local ship captains and builders. By 1850 he had a sufficient reputation to exhibit in Boston, where his works hung alongside those by Kensett, Alvan Fisher, and Fitz Hugh Lane.[11] Soon, however, the lure of German discipline took hold, especially as exemplified by the Düsseldorf School, and paintings by Andreas Achenbach and others were to influence not only Church, Whittredge, and Bierstadt, but a whole generation of American painters. Bierstadt left for Düsseldorf in 1854 to remain for three years, in company with both Whittredge and Sanford Gifford. They traveled through Italy, joining a host of American painters, sculptors, and writers who in the nineteenth century felt compelled to make the pilgrimage.

When he returned, he made several extended sketching expeditions in the West, from which came spectacularly popular paintings. His usual approach was to reproduce the scale and melodrama of the

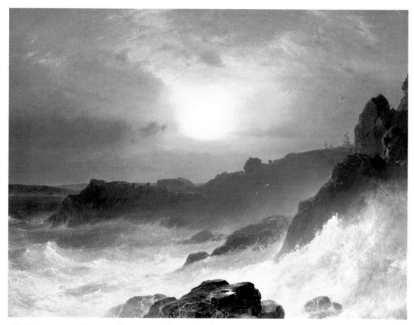

50 FREDERIC EDWIN CHURCH. *Sunrise off the Maine Coast (Storm off Mount Desert).* 1863. Oil on canvas, 36⅛ × 48″. Wadsworth Atheneum, Hartford, Connecticut. Bequest of Mrs. Clara Hinton Gould

Western plains or mountains on canvases proportionately large. But exaggerated feelings sometimes overpowered visual reality, and in his later works particularly hot colors and grandiose compositions replaced the more temperate early works. Two unusual exceptions are *The Burning Ship* of 1869 and *Wreck of the "Ancon" in Loring Bay, Alaska* of about 1889 (figures 54 and 55). The earlier is an extraordinary marine amidst the artist's far better known landscapes, and for that alone deserves attention. It is painted with fiery reds, oranges, and yellows, such as Bierstadt might have used for describing some of the Western sunsets that he had seen with the explorer Fitz Hugh Ludlow on their trip of 1863. Because the eye gravitates immediately to the two explosive areas of light, the fire and the moon, one only gradually sees in turn the subtle nuances of color throughout murky depths of the rest of the painting. Finally, details like the ghostly vessels on the horizon begin to emerge from the

gloom. Here is an apocalyptic and theatrical vision, appropriate to the trauma of the Civil War years, painted on a modest scale by Bierstadt with great technical virtuosity.

Wreck of the "Ancon" was the result of a shipwreck on an Alaskan trip in 1889. Bierstadt had been living in native huts and sketching constantly, as he had on previous trips. He wrote his wife that he felt he had made a "narrow escape" from the wrecked steamship; strongly impressed, he was able to produce an entirely fresh rendering of the event in his painting. The fluid brushwork and the sense of palpable atmosphere remind of his best and most suggestive oil sketches while having the completeness of a thought-out painting. Cool in color, simple in format, and intimate in scale, the painting contains the best of Bierstadt's observation as well as his ability to render the romance of place and event. Its style reflects the precision learned at Düsseldorf, but there is a straightforward, unlabored quality not always seen in its time.

Although a late example, *Wreck of the "Ancon"* makes a fitting close

51 FREDERIC EDWIN CHURCH. *Beacon off Mount Desert Island, Maine.* 1851. Oil on canvas, 31 × 46″. Private collection

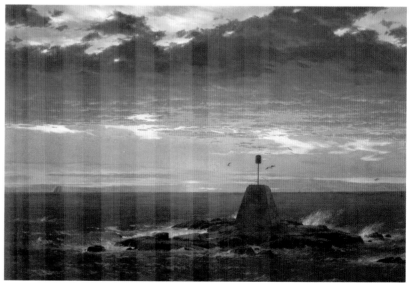

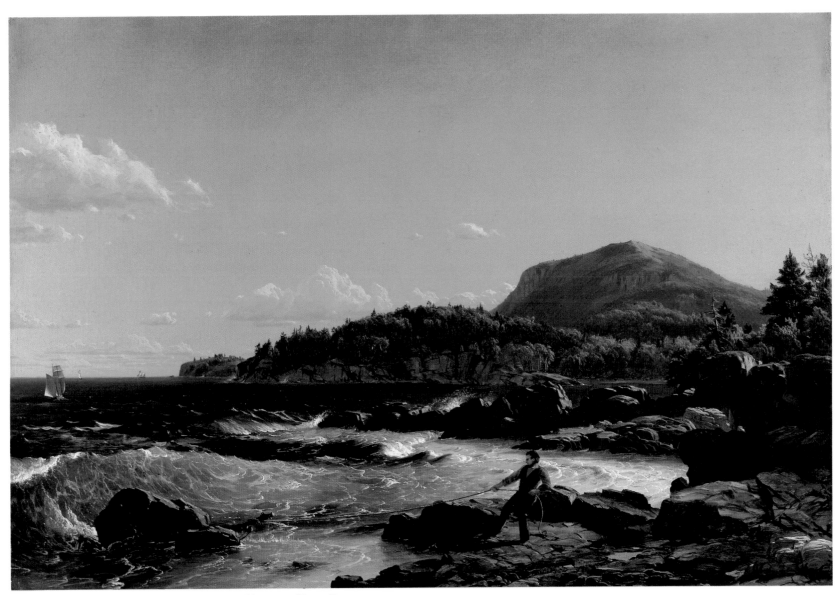

52 FREDERIC EDWIN CHURCH. *View of Newport Mountain, Mount Desert.*
Oil on canvas, 21¼ × 31¼″. Private collection

Overleaf:
53 FREDERIC EDWIN CHURCH. *The Icebergs (The North).* 1861.
Oil on canvas, 112⅜ × 64½″. Dallas Museum of Art. Anonymous Gift

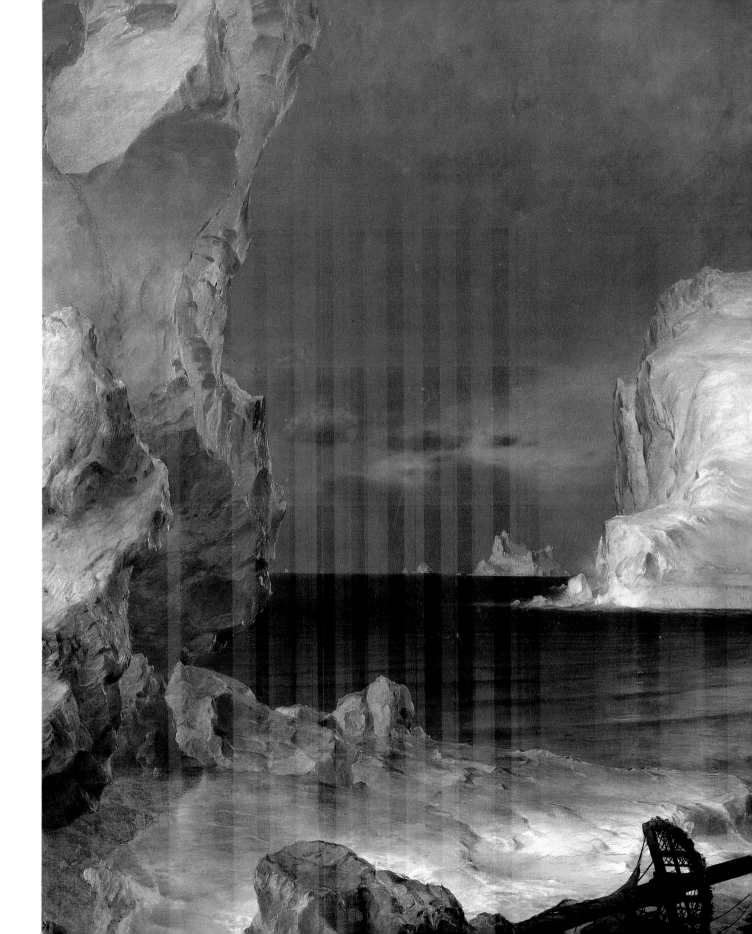

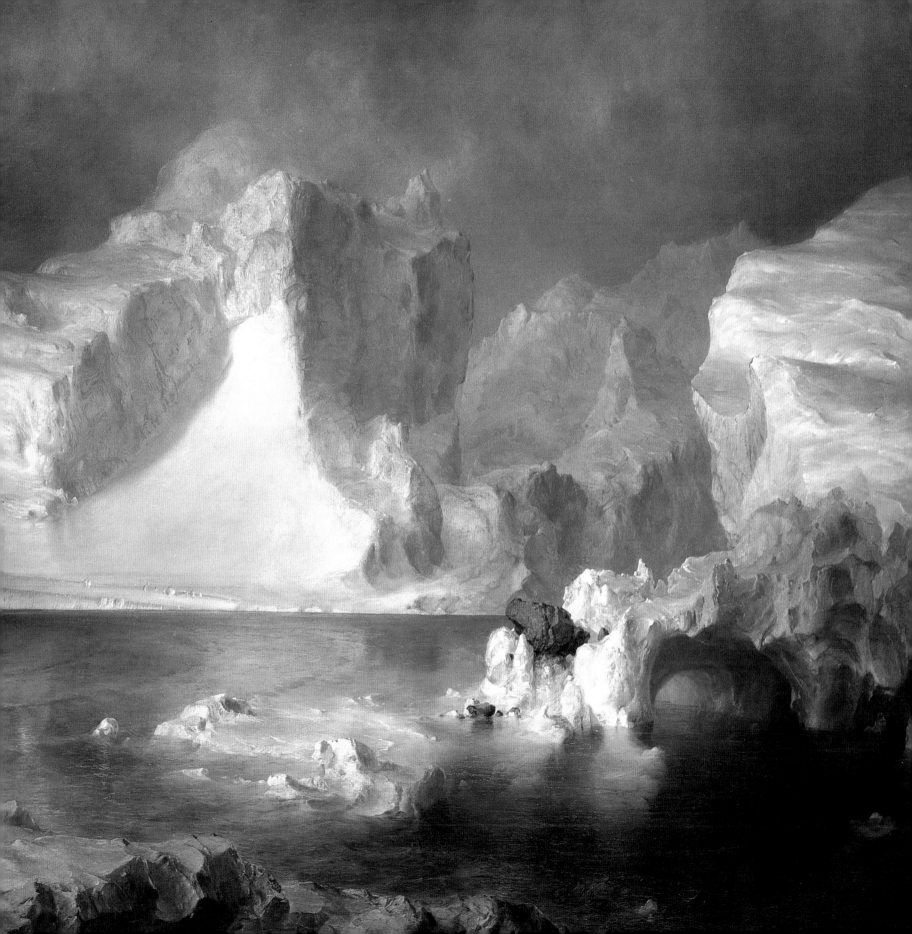

54 ALBERT BIERSTADT. *The Burning Ship.* 1869. Oil on canvas, 30¼ × 50″.
Shelburne Museum, Vermont

to this side of the Hudson River School. Spiritually it belongs with the high water mark of Hudson River School painting before midcentury. It summarizes the small but significant contribution that this group of painters made to American marine painting. For any

consideration of the Hudson River School and its Rocky Mountain counterpart helps to clarify the state of taste and mind in America at midcentury. What is less readily seen is the almost parallel rise of a wholly independent group of seascape painters in this same period.

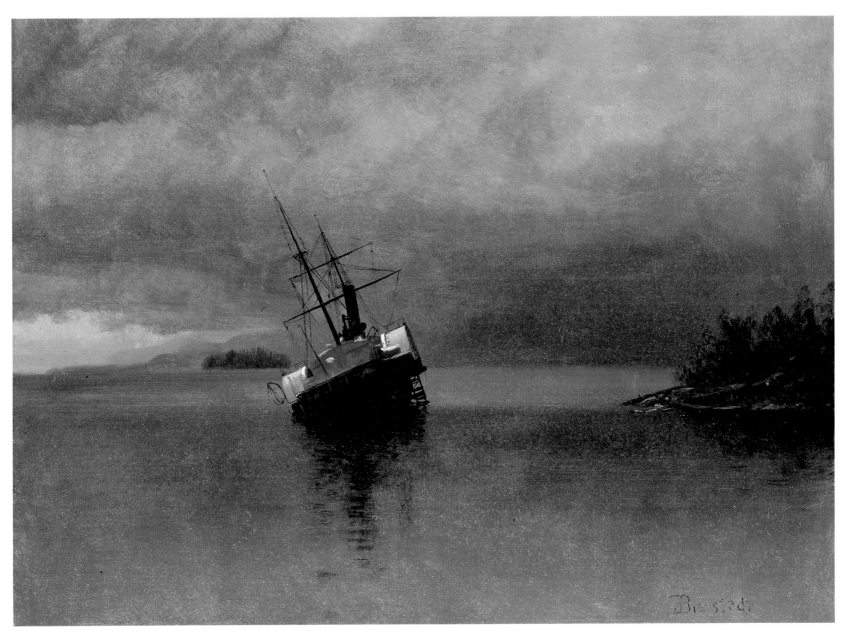

55 ALBERT BIERSTADT. *Wreck of the "Ancon" in Loring Bay, Alaska.* 1889.
Oil on paper, mounted on panel, 14 × 19¾". Museum of Fine Arts, Boston.
Gift of Mrs. Maxim Karolik for the Karolik Collection of American Paintings

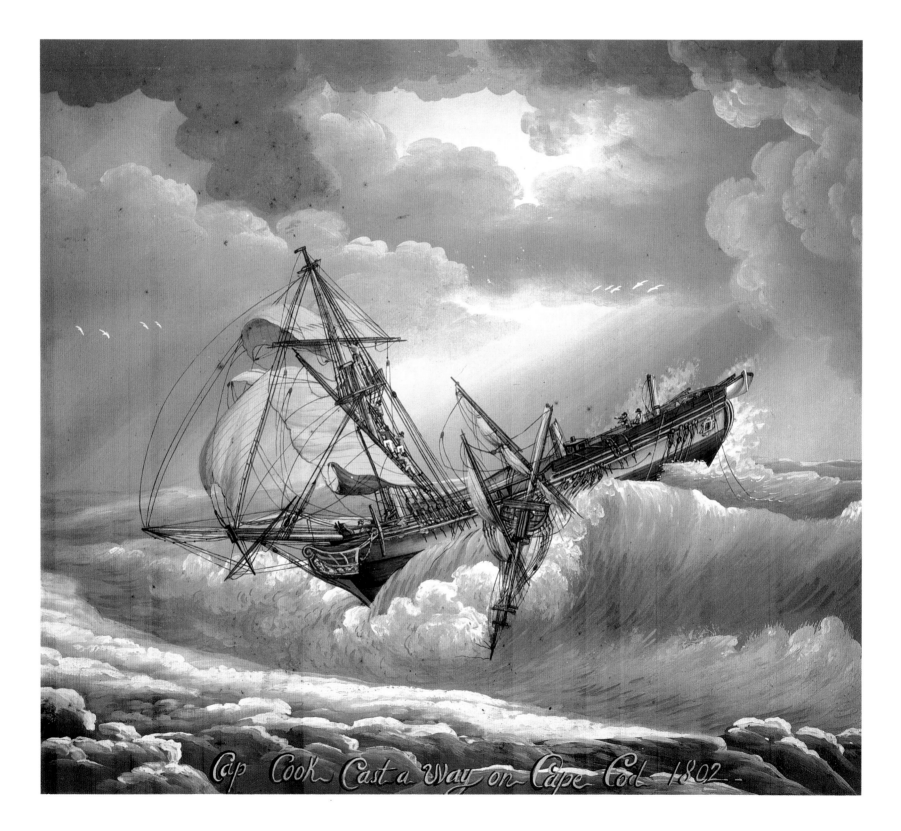

Cap Cook Cast a Way on Cape Cod 1802

The Inheritance of French Romantic Painting

Dᴜʀɪɴɢ the same years that the Hudson River School was developing new modes of landscape painting, emerging also were what may be called America's first pure seascape painters. Up to this point discussion has centered on artists who only infrequently painted marines or on isolated paintings that were significant contributions of an artist or movement. With the turn of the nineteenth century the United States offered new promise to citizens and foreigners alike. Originating with painters coming to this country from abroad a native school of seascape painting soon developed. We may for the first time consider closely the careers of artists catalogued as marine painters primarily. In fact, the extensiveness of marine painting and literature in the first half of the nineteenth century is surprising. Naval battles and foreign trade are but a partial explanation of the fact that "before 1850 the American frontier was primarily a maritime one, that the sea rather than the continental wilderness was the principal focus of the yearnings and imaginings of the American dream."[1]

In the seventeenth century power of the sea belonged largely to the Dutch; in the eighteenth it passed to the English; and in the nineteenth to the Americans. The great periods of marine painting in each country correspond. But not only did Dutch realism flow into American painting. Other streams of influence came from English topographical and French romantic painting. These three cultures, which need not always be separated, provide the major background for the rise of marine art in the United States. The first phases develop with the arrival of foreign-born artists whose careers mature here. Representing the immigration of Mediterranean painting is Michele Felice Cornè. The English-born Thomas Birch exemplifies the introduction of the Dutch tradition. Two other painters, James E. Buttersworth and Robert Salmon, turn their English styles into an American expression. Building on these respective traditions, native-born painters subsequently developed an independent American marine art.[2]

There are few marine specialists in the Italian or French schools with direct influence on American painting, but many of the romantic landscapists, like Salvatore Rosa, Francesco Guardi, Claude Lorrain, and Joseph Vernet, did an important number of marines.[3] Their luminous harbor views and dramatic shipwrecks often directly affected American artists. The special contribution of the French Mediterranean artists was ship portraiture, which first became popular in Europe and in this country during the last quarter of the eighteenth century. The painting of ship portraits remained fashionable well through the nineteenth century until photography almost eliminated it, along with figure painting, in the last quarter of the century.[4] The earliest known portrait of a New England ship is thought to be the anonymous 1748 painting of the *"Bethel"* of Boston belonging to the Peabody Museum.[5] Thereafter, the demand for such paintings steadily increased here and abroad.

The extraordinary Roux family of Marseilles perhaps best illustrates the type. Since they were active only in France and primarily in the Mediterranean, one may question their inclusion here. It is true that Antoine Roux, Sr., and his three sons were kept active executing commissions from French and English naval officers, but it was not long before the American sea captains who sailed the area began to place their orders. Consequently, a large number of American vessels were the subjects of Roux paintings. More importantly, a great many were naturally brought back to the United States by their owners, to the extent that today, while the largest collection of Roux paintings is in the Marine Museum of the Louvre, the second largest is in the Peabody Museum in Salem. Along with this substantial number are also fourteen sketchbooks by Antoine Roux at the Peabody Museum.[6] For these connections the Roux family deserves selective attention.

The most important member of the painting family was Antoine Roux, Sr., who was born in 1765 and was active in the early decades of the nineteenth century. His three sons, Antoine, Jr., Frédéric, and François, were born around the turn of the century and were active in its middle decades. Of the many painters at work in Mediterranean ports, the most famous were in Marseilles, and there the Roux were among the leading practitioners.[7] An example by Antoine Roux, Sr.,

56 Mɪᴄʜᴇʟᴇ Fᴇʟɪᴄᴇ Cᴏʀɴè. *Cap. Cook Cast A Way on Cape Cod.* 1802. Gouache on paper, 13½ × 15½". The Peabody Museum of Salem, Massachusetts

57 ANTOINE ROUX. *The Letter of Marque Grand Turk, of 14 Guns Wm Austin Comder Saluting Marseilles.* 1815. Watercolor on paper, 17½ × 24¼". The Peabody Museum of Salem, Massachusetts

style of Joseph Vernet, the eighteenth-century Romantic seascapist (see chapter seven).[8] Roux's sons Frédéric and François had the continuing assistance and instruction of Vernet's son Horace, in whose studio Géricault also received early training. But generally, by comparison to the work of the senior Roux that of his sons seems to lack in precision of line, imaginativeness of composition, and nuances of light and shade.[9] Of the three sons François gained the widest popularity. Frédéric Roux's work presents different virtues and faults. He surpassed his brother in clear, effective draftsmanship and in suggesting convincingly the quality of water. Sometimes Frédéric Roux was capable of grouping ships together in an articulate composition, but his general failing was in establishing a believable relation between water and ship. Nonetheless, they carried on a tradition of dexterity and facility in the watercolor medium. The whole family was familiar with the sea and life in a major port. Their art was accurate, thorough, and sincere. At times the passion that they felt for the

will demonstrate what their achievement in ship portraiture was. To the conventional portrait type Roux has given an interesting variation in his *The Letter of Marque "Grand Turk"* (figure 57). The brig "Grand Turk" was built in Wiscasset, Maine, in 1812, and this watercolor was done three years later. It shows the vessel on the quarter, a point of view not frequently essayed by painters; with her cannon she salutes the city of Marseilles seen beyond her bow. Although the scale of the vessel is too tall for the context, Roux has given the basic portrait a visual interest in the turned axis of the vessel and a psychological interest in the action described. His style is ordinarily characterized by a silvery tone and a clear understanding of the structure of ships. Unlike his sons he was generally able to create wide variety within the ship portrait "type." Rather than the bland broadside view, he could in many instances organize a composition that would be interesting beyond mere recording.

Although Roux was self-taught, he was consciously aware of the

58 ANTOINE PITTALUGA. *"Cleopatra's Barge" of Salem.* Early nineteenth century. Watercolor on paper, 15½ × 20½". The Peabody Museum of Salem, Massachusetts

individuality of ships made their paintings far more than mere documents.

That their manner of portraying ships was widely admired in this period is clear from the watercolor by A. Pittaluga of the *"Cleopatra's Barge" of Salem* (figure 58). Less sophisticated than most of the work of the Roux, it employs their format, emphasis on careful drawing, and accuracy of recording. Because Salem prospered in shipbuilding and trading at this moment, local merchants were enthusiastic commissioners of ship-portraits by the Roux. Salem directly became the obvious repository for their paintings in this country.

Another artist whom this port more completely adopted was Michele Felice Cornè, an artist of a surprising range of techniques and styles.[10] Born on the island of Elba around 1762, he was forced into refuge from the Napoleonic Wars in 1799, at which time the prominent merchant Elias Haskett Derby brought him to Salem on the *Mount Vernon*.[11] Cornè was soon engaged in copying portraits such as those of Governors Endicott and Leverett, and in painting local personalities such as Joseph Peabody. Generally, they were hesitant works, but showed his sensitivity to character and were good practice. At the same time his interest was aroused by painting the portraits of Salem ships, including many in the Derby fleet. Typical of the many fine watercolors dating from the early 1800s is one version that he did of the *Ship "John" of Salem* (figure 59). Close in style and format to similar portraits by the Roux family, it possesses a firmer and more telling draftsmanship than most of the work by the Marseilles painters. He manages convincingly to fill the sails with light and air through crisp modeling of detail and an ability to model solid form.

Through articulate brushwork and an expressive choice of colors Cornè was able to obtain various dramatic effects. Comparison of *Cap Cook Cast A Way on Cape Cod* (figure 56) with the *Ship "John"* vividly illustrates the point. Both exploit contrasts of values, but by manipulating the dark and light hues, each conveys the appropriate conditions of storm and sunlight. Dark brooding colors, combined with heavy application of paint, effectively transmit the romantic violence of the storm in *Cap Cook Cast A Way*. It remains a tight, vigorous drawing of the particular vessel, but Cornè adds interest with

59 MICHELE FELICE CORNÈ. *Ship "John" of Salem*. 1802. Oil on panel, 17½ × 21". Collection Nina Fletcher Little

the narrative element and the creation of a forceful setting. The *Ship "John"* is also above all a portrait, but not only of the details of rigging or structure; it makes use of the brightly lit clouds, calm sailing waters, and clear air to lend a feeling of pride and vigor to the ship herself.

Another early picture has had great local interest, namely the *Crowninshield Ship "America III" on the Grand Banks* (figure 60). More crude in the representation of the water than in the more facile later works, this nevertheless arranges a large number of ships in an accurate visual relationship to each other. Details are not always satisfactory, but the capacity for suggesting space and light gives animation to this and to later works of greater complexity.

One such example followed logically from his interest in ships and from the stimulation aroused by events of the War of 1812. Of the

60 MICHELE FELICE CORNÈ. *Crowninshield Ship "America III" on the Grand Banks.* 1800s. Oil on canvas, 31½ × 47¾". The Peabody Museum of Salem, Massachusetts

61 J. R. SMITH (after Michele Felice Cornè). *Close Engagement.* 1812. Engraving, 10¼ × 13¾". Museum of Fine Arts, Boston. M. and M. Karolik Collection

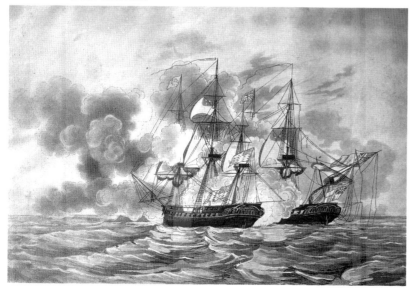

several naval engagements that he painted at this time, the first and one of the largest was *Close Engagement* (figure 61). J. R. Smith of Boston engraved the aquatint from Cornè's painting, itself executed "under Directions from Commodore Hull & Capt. Morris."[12] Its popularity derived from the same reasons that brought success to similar accounts by Thomas Birch: both men could record correctly and narrate dramatically (see chapter seven).[13] In the years intervening between this and the early *Ship "John"* Cornè has developed a mature fluid style, by which he can be selective in detail, successful in describing water, and clear in showing the action between the two ships. Some two dozen Cornè paintings of the War of 1812 were engraved as illustrations for *The Naval Monument* published by Abel Bowen in Boston in 1816. Several were engraved by Bowen himself, and many recapture with great fidelity the quality of the originals. Using close parallel lines these prints convey through their own medium much of the sensitivity to light, water surface, and cloud effects to be found in the watercolors.

Besides ship portraits and naval actions Cornè also turned to larger projects, one of which was a commission in 1805 to decorate the new quarters of the Salem East India Marine Society. This wall decoration includes a variation on the ship portrait type that he had been previously doing as well as the fanciful introduction of a gesturing muse and two hardy putti (figure 65). The view is of Salem Neck; the lettering is a later addition of 1825 when the Society again moved to new quarters called the East India Marine Hall.[14]

The Derby family of Salem was responsible for introducing Cornè to Salem's leading architect, designer, and wood carver, Samuel McIntire. It was logical that the work of these two men, preeminent in their professions, would appear together in many of Salem's finest houses. Cornè was also soon at work in Boston, where the city directories listed him at 61 Middle Street between 1810 and 1818. In 1822 he settled in Newport, where adequate patronage kept him comfortably occupied for the last two decades of his life. Around 1812 to 1815 he was commissioned to decorate the Sullivan Dorr House in Providence, in which one finds a new dimension to his subject matter and technique. There he painted a highly imaginative

coast with towering cliffs, a dim view of a walled city in the distance, and all manner of strange figures on the foreground rocks, pulling a boat ashore further back, and on the cliff an endless defile of small figures. Presumably this mysterious scene comes out of Cornè's youthful memories of the Italian coast and the painting tradition of Rosa and Vernet. Though it may well be derived from French engravings, the view has a simplicity and a sweep that characterized Cornè at his best. He painted directly on the plaster in a modification of the fresco technique. Evidently Cornè drew on strips of white paper similar to wallpaper; the major lines he then ran over with a handmade wheel with short spokes on it that made the small pricks in the wall underneath. A faithful Bolognese assistant, Billy Bottome, would then fill in the design with charcoal or chalk lines, and Cornè completed the painting from this.[15]

Cornè turned his hand to other types of decoration, such as fireboards and overmantels. *Cape Town, South Africa*, done expressly for the fireplace in the new room of the East India Marine Society, is

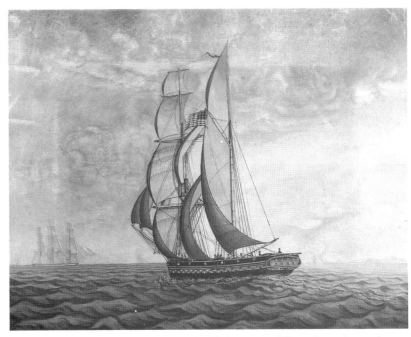

63 GEORGE ROPES. *"Cleopatra's Barge" of Salem*. 1818. Watercolor and gouache on paper, 17½ × 22½". The Peabody Museum of Salem, Massachusetts

62 MICHELE FELICE CORNÈ. *Cape Town, South Africa*. 1804. Oil on panel, 35 × 52¾". The Peabody Museum of Salem, Massachusetts

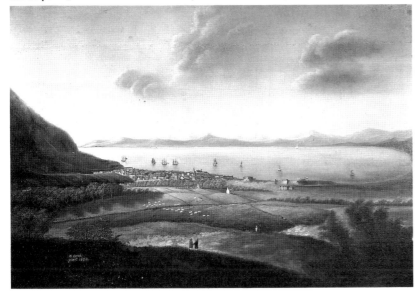

among the most attractive examples (figure 62). Its clear cool coloring and panoramic recession show a very different side of the artist from the close-up ship portraits that he was painting at the time. A similar blending of imaginative design with topographical observation is apparent in the equally versatile overmantel *Harbor View* from an unidentified Salem house (figure 64). Though not proven to be by Cornè, Nina Fletcher Little with justifiable authority attributes it to him.[16] Comparison with the rest of his work of this type offers reasonable stylistic evidence for this assumption. The spatial layout of this romantic view, the careful draftsmanship, and particularly the coloring are all reminiscent of Cornè's manner. Indicative, too, is the astute scale of all the elements in the landscape, the sure modeling of the buildings, and the ability to infuse the whole with clear, glowing light.

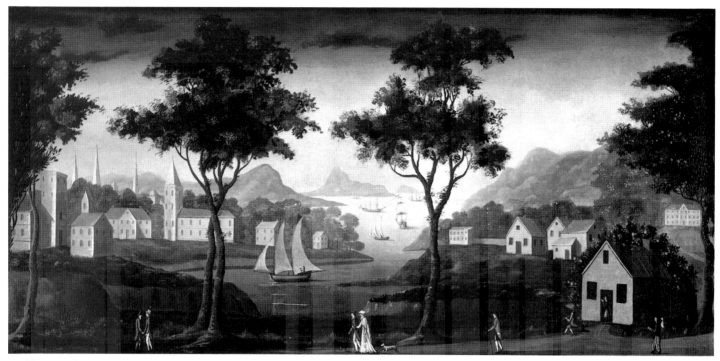

64 MICHELE FELICE CORNÈ (attributed). *Harbor View.* c. 1800.
Oil on panel, 27 × 65½". Essex Institute, Salem, Massachusetts

Cornè had a few pupils, among them George Ropes, Hannah Crowninshield, Samuel Bartol, and Anstis Stone, of whom Ropes was the best known. His more primitive style bears brief examination as a direct product of Cornè's instruction and for its own bright charm. Three of his oils are in the Essex Institute, several more are at the Peabody Museum, and an equal number are scattered in private collections. Ropes was born the deaf and dumb son of a ship captain, and when his father died in 1807, he had to support the rest of the family. Beginning his study under Cornè at the age of thirteen, he developed a personal style that was primitive but appealing in character. Two of his best-known panels are large views of Salem, one showing the common "Training Day" and the other a panorama of *Crowninshield's Wharf* (figure 66). A watercolor of *"Cleopatra's Barge"*

of Salem (figure 63) captures the remarkable vitality that this man could suggest in spite of his handicap in learning to paint. It has the bright details and the flat blues of Cornè's own ship scenes; Ropes works more with the expressive capacity of the flat patterns. The clear drawing and strong lighting show close affinity with Cornè portraits like the *Ship "John."* The efforts of Ropes testify to Cornè's popular influence at a moment when Salem was at her highwater mark of prosperity. She was fortunate in having such competent admirers to document her ships and her maritime activity. Cornè came at an auspicious point in the chronology of American marine painting, for he was representative of the first wave of seascapists who, while they brought with them the manners of Europe, looked forward to creating a uniquely American style.

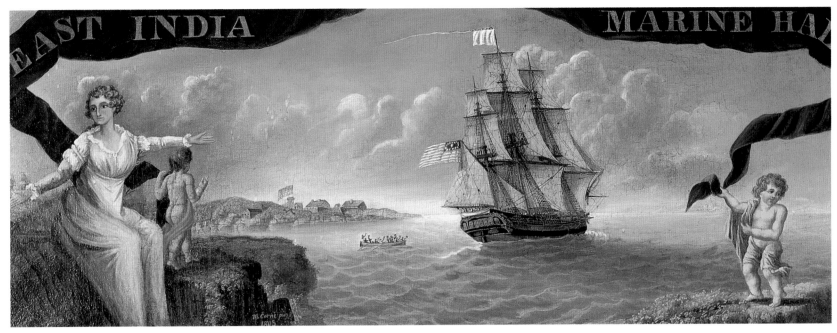

65 MICHELE FELICE CORNÈ. *Salem Harbor.* 1803. Oil on canvas, 15½ × 41¾″.
The Peabody Museum of Salem, Massachusetts

66 GEORGE ROPES. *Crowninshield's Wharf.* 1806. Oil on canvas, 32½ × 95″.
The Peabody Museum of Salem, Massachusetts

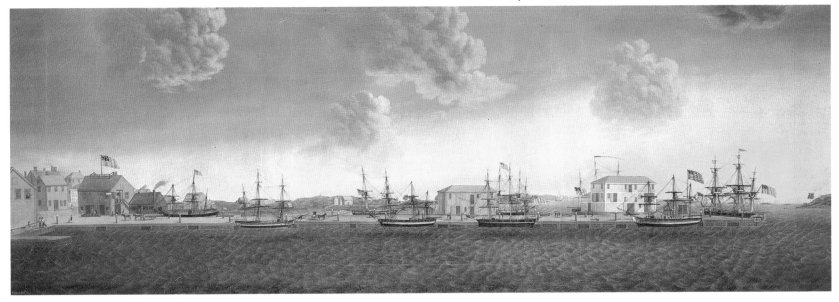

The Dutch Marine Tradition

THE first full development of a school of marine painting occurred in Holland during the seventeenth century. Notable among the exponents who depicted the open sea as well as scenes of rivers and canals were Jan Porcellis, Jan Van Goyen, Salomon Van Ruisdael, Simon de Vlieger, Jan Van de Capelle, and Willem Van de Velde, the younger. The last was influential along with his father in establishing an English school of marine painting following the war between England and Holland in 1665. The two Van de Veldes painted the naval battles of this war and other events from English maritime history during the period when they were working in England at the end of the seventeenth century. Their style considerably influenced subsequent English painting, especially as it was carried on in the work of Peter Monamy, Robert Dodd, Nicholas Pocock, Thomas Luny, and George Morland. It was this tradition that set the stage for the later achievements of Constable, Turner, and Bonington, who brought high originality to the English marine school in its culminating period. This tradition also provided the background in which younger, lesser-known figures would begin their styles of painting and which they would take across the Atlantic to a new setting. Among them were Robert Salmon, Thomas and James Buttersworth, and Thomas Birch. Salmon and the Buttersworths were more strictly influenced by the major English marine artists then at work, whereas Birch consciously reflects in his style the broader characteristics of the older Dutch and French traditions. Not only the types of subjects he painted, but many of his compositional devices also recall paintings by the Ruisdaels and the Van de Veldes. He was also inspired by Joseph Vernet's paintings, which were popularized by engravings after his work (figure 70).

Though not native-born, Birch was only fifteen when he left England with his father for the United States in 1794, and his artistic development may be truthfully called American. Like Cornè, Birch was brought to this country as a result of the Napoleonic Wars. His father, William Russel Birch, was an enamel painter and engraver of definite competence; the elder Birch's autobiography is helpful in recounting some of the details of their trip and early years in Philadelphia. Their arrival is representative of an important wave of immigrating foreign artists at the turn of the century. The importation of lithographic techniques was only one significant consequence. The role of graphic training continued to be influential in the stylistic development of artists' careers. Certainly what Thomas Birch learned from assisting his father to engrave views around Philadelphia contributed strongly to his later technical abilities.[1]

Within a decade of his arrival the younger Birch set himself up independently from his father as a portraitist, but working with his father had instilled in him a lasting interest in landscape. Philadelphia lost much of its political and economic importance with the removal of the national government to Washington. But if it suffered a decline in those areas, it was experiencing a bright moment of literary and artistic creativity.[2] Increasing public attention focused on art activities with the first full-scale art exhibits. Birch was soon elected to the Pennsylvania Academy of Fine Arts, which with the Society of Artists of the United States was among the fostering sponsors of public exhibitions.[3]

Birch's style drew on the Dutch tradition through his father's collection of art, which included works by Van Goyen and Ruisdael. In addition, William Birch had made several copies himself after paintings by Ruisdael. Another influence was the English artist William Pyne, whose studies of figures Birch used in some of his larger compositions.[4] But the style and the subject matter that Birch favored were American. Unlike Salmon who occasionally painted remembered views of English castles and crumbling gothic ruins, or Cornè who painted imagined views of the Italian landscape, Birch was almost always locally topographical.

Although he is best known as a marine painter—and nearly two thirds of his work are marines—he also did full landscapes and frequently included landscape in harbor or river views. Interestingly, Birch was not a sailor, and had little direct experience with boats.[5] Yet he made sufficient firsthand observations to convey accurately not only the structure of ships but their plastic beauty as well. During the course of a prolific career Birch worked equally well on canvases of various sizes. His best work is consistently characterized by clear coloring and a clean palette that served well his desire to transmit the

freshness of light or air and the fluidity of water. For these abilities and with the cooperation of exhibits by the academies Birch soon held the distinction of being the first ship painter in this country to gain enthusiastic public acceptance.[6]

Birch's painting underwent few stylistic changes as his career developed. His early work, begun under the tutelage of his father, has a tight linear quality, one properly appropriate to the depiction of the *Delaware River Front, Philadelphia* (figure 67). Contained within the strong perspective lines, the view crisply gives the feeling of a wharf crowded with sailing ships. Although a watercolor, it evinces the young artist's clean draftsmanship gained from working in the graphic arts. It bears a strong resemblance to some of W. J. Bennett's aquatinted city views, most notably his *South Street from Maiden Lane, New York* of the early 1830s. Both artists sought to capture the lively activity of America's busy city ports. Birch's suggestion of pervading illumination and the highlighting of details further shows an understanding of contrasts of value. Perhaps a bit stiff, the recording of details is precise and the rendering of space credible. The attention to everyday life and local geography will frequently reappear in Birch's work.

Birch continued his documentation of the Philadelphia environs throughout his life. The *Fairmount Waterworks* of 1821 presents his mature style: the brushwork is looser, the composition less obviously manipulated than the earlier city views (figure 68).[7] Aside from the inherent historical interest the work offers a pastoral version of the bustling river activities. Much of the artist's concern also goes toward the bright luminous sky which takes up half of the painting.

Another light-filled work is the more contrived *The Landing of William Penn* (figure 69), thought to be a late work from the last years before the artist's death in 1851. Birch's early awareness of historical places or events associated with Philadelphia is here carried to its imaginative culmination. The scene shows Penn stepping ashore at New Castle on the Delaware River from the ship *Welcome* on 27 October 1682. Leaving a slain deer on the ground, an Indian steps forward to greet Penn. More clearly an allegorical, or at least narrative, scene, it is a less cluttered design than the early works,

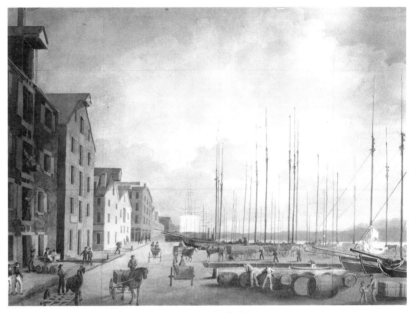

67 THOMAS BIRCH. *Delaware River Front, Philadelphia.* 1820s.
Pencil and watercolor on paper, 10⅛ × 13⅞″. Museum of Fine Arts, Boston.
M. and M. Karolik Collection

68 THOMAS BIRCH. *Fairmont Waterworks.* 1821. Oil on canvas, 20¼ × 30¼″.
Pennsylvania Academy of the Fine Arts, Philadelphia. Charles Graff Estate Bequest

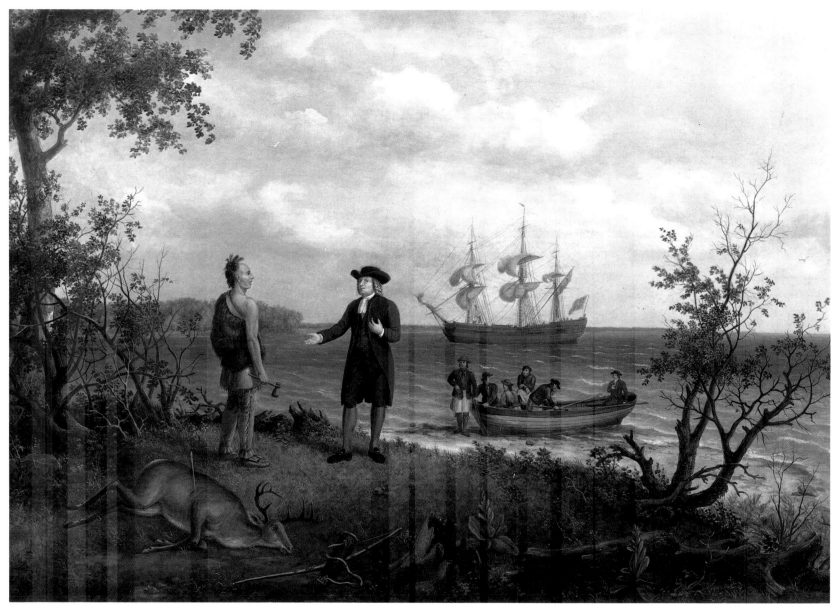

69 THOMAS BIRCH. *The Landing of William Penn.* c. 1849. Oil on canvas, 34½ × 48¼".
Museum of Fine Arts, Boston. Gift of Mrs. Maxim Karolik for the Karolik Collection
of American Paintings

with easy transitions among the major elements or figures. It blends a close observation of details, as in the rendering of foliage, animal, figures, and ship, with historical overtones that must have had obvious appeal for contemporary taste. Its organization is primarily in planes parallel to the picture surface, with the major components silhouetted across the horizontal levels, a method that Birch often employed in his mature work.

For one interested in the port of Philadelphia and the maritime activities in the area, the naval actions of the War of 1812 provided a natural source of inspiration. Gaining wide popularity for his paintings, Birch executed many versions of the same incident. He would vary slightly the number or relation of ships, the point of view, or different moments in the event. Several paintings are known of the *"Constitution" and the "Guerrière,"* the *"United States" and the "Macedonian,"* the *"Wasp" and the "Frolic,"* the *"Constitution" and the "Java,"* and the *"Hornet" and the "Peacock."* Paintings are known of another ten different engagements. Perhaps he found himself most at home in depicting only two vessels in direct action with each other, for this permitted him to concentrate the maximum visual and narrative impact in a single incident. But he also composed pictures around more complex groupings, such as those of *Perry's Victory on Lake Erie* (figure 72) and the *Battle of Lake Champlain.* These dramatic seascapes are the fullest expression of the Dutch marine tradition in Birch's work.

Drawing on Dutch marine painting, Birch's rendering of the *Naval Engagement Between the Frigates "United States" and the "Macedonian"* (figure 71) employs a low horizon, pyramidal structuring of the ships, strips of light and shadow horizontally across the surface of the water, and sensitive attention to rendering effects of atmosphere. These are aspects found commonly in the marines of Van de Capelle and Ruisdael. Paintings by these Dutch masters and engravings after their work were in other American collections besides that of Birch's father, and were upon occasion seen in public exhibitions. In addition, Birch used techniques similar to those used by Dutch painters. He fully employs glazes and impasto for dramatic effectiveness, as here in the treatment of sky and water.

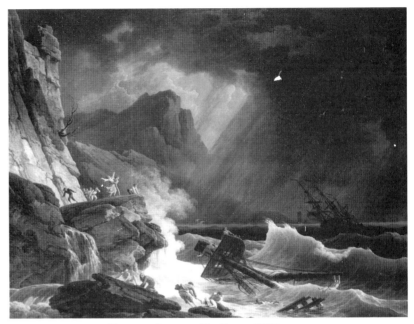

70 CLAUDE JOSEPH VERNET. *Seascape: The Storm.* 1787.
Oil on canvas, 45 × 59⅝". Wadsworth Atheneum, Hartford, Connecticut.
Ella Gallup Sumner and Mary Catlin Sumner Collection

The concerns for historical meaning and visual accuracy continue in other representations of naval engagements. His clarity of execution indicates great concern for accuracy. Birch's working method ordinarily involved the drawing of preliminary sketches both of important details and of the general composition. The initial brushwork was normally thin and rapid, but as he worked toward the final design, he sometimes engraved lines in the paint with the pointed end of the brush, and added highlights with pure color in the last stages.[8] The result was always tighter and more controlled than the early sketches, but without any loss of immediacy or freshness. Birch's paintings make interesting comparisons with those by Michele Felice Cornè. Both men's work was engraved for popular consumption (figure 61). But Birch went beyond Cornè in attempting to render the actual movement of water and the quality of light and air that filled the scene.

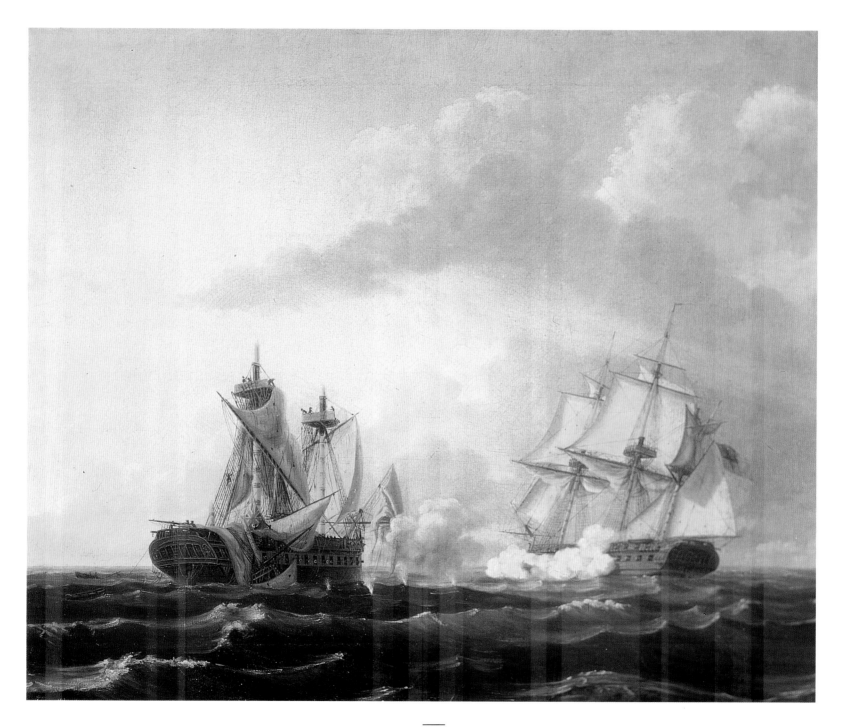

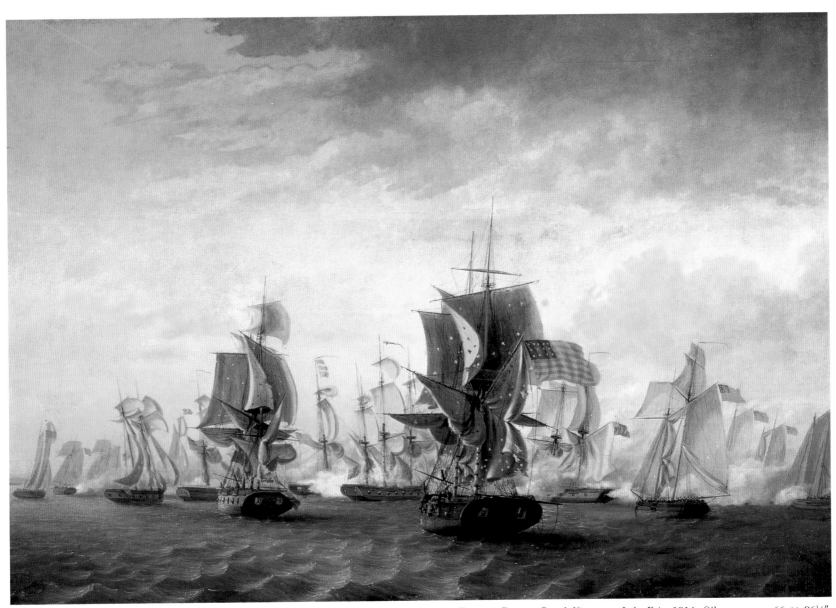

72 THOMAS BIRCH. *Perry's Victory on Lake Erie*. 1814. Oil on canvas, 66 × 96½".
Pennsylvania Academy of the Fine Arts, Philadelphia. Gift of Mrs. C. H. A. Esling

Opposite:
71 THOMAS BIRCH. *Naval Engagement Between the Frigates "United States"
and the "Macedonian," 1812*. 1813. Oil on canvas, 28 × 34¼".
Historical Society of Pennsylvania, Philadelphia

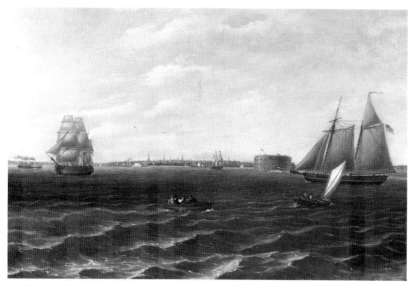

73 THOMAS BIRCH. *New York Harbor*. Early 1830s. Oil on canvas, 20¼ × 30¼".
Museum of Fine Arts, Boston. M. and M. Karolik Collection of American Paintings

74 THOMAS BIRCH. *Off the Maine Coast*. 1835. Oil on canvas, 39½ × 59½".
Fruitlands Museums, Harvard, Massachusetts

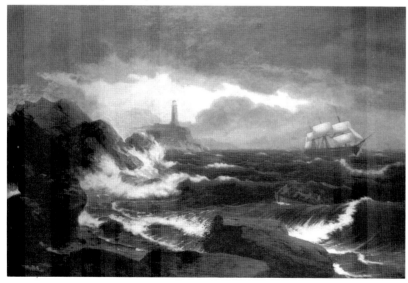

Less frequently Birch essayed a larger scale and more crowded composition, his *Perry's Victory on Lake Erie* being an example (figure 72). The painting went on exhibit in 1814 at the Pennsylvania Academy, to whom it still belongs. It successfully groups a large number of ships, although its impact derives more from its size— Birch's largest known painting—than from concentration on selected details. The debt to Dutch paintings of similar subjects is evident in the pyramidal massing. Altogether it shows the degree to which Birch derived from the Dutch school his own manner of reproducing an atmospheric setting. By seeking an American context his paintings reflected the current popular exultation in the early naval victories of the war. Symbolically, the American triumphs signaled the end of British maritime supremacy, and Birch's visually accurate recordings played up to the taste for patriotic storytelling. Besides his contribution to the emergence of an American sea fiction, James Fenimore Cooper also wrote a two-volume *History of the Navy of the United States of America*, in which he expressed these very sentiments of public excitement engendered by the country's naval triumphs.[9]

Most of Birch's paintings of the War of 1812 date from the years of the war itself through the 1820s. Thereafter he turned his attention more to local landscape, coastal or harbor scenes. It was in these later paintings that the influence of the French romantic seascapist Claude Joseph Vernet came to the fore. Some of Vernet's paintings were in American collections by this time, but more available were the engravings after his work then circulating in Philadelphia. Of these Birch made a close study, for several of his paintings are clearly reversed from the Vernet originals.[10] The paintings called *Shipwreck* and *Off the Maine Coast* are typical examples that derive from the Vernet format (figures 74 and 75). Birch did some that were much closer to Vernet, but these illustrate more clearly the differences in style. Vernet's usual composition viewed high rocky cliffs cutting off one side of the canvas on the diagonal (figure 70). A ship founders offshore and survivors struggle ashore amidst part of the wreckage. It is a formula that was seen earlier in Salvatore Rosa, and was to be one dear to the eighteenth-century Romantic painter. The ingredients are here, heightened by the turbulent sea crashing at the feet of the

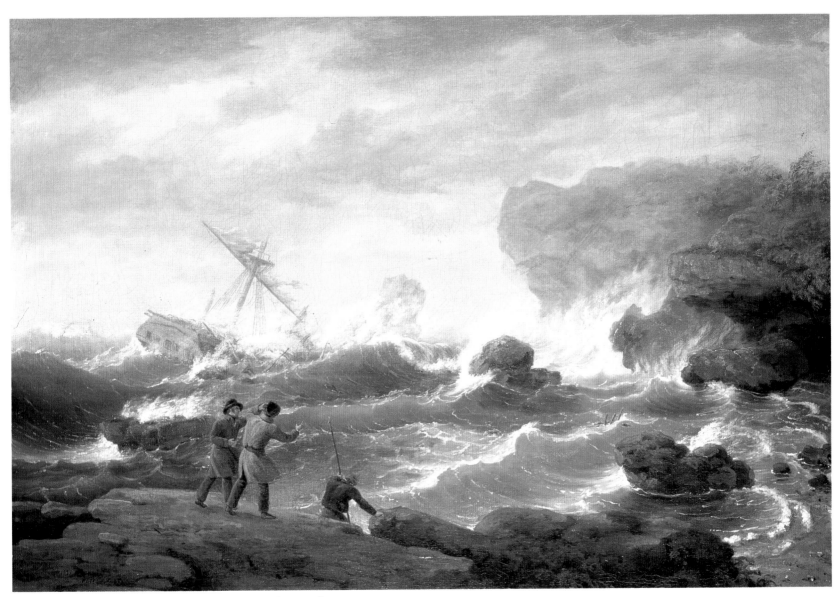

75 THOMAS BIRCH. *Shipwreck.* 1829. Oil on canvas, 27⅛ × 39″.
The Brooklyn Museum, New York

wildly gesturing figures. A dramatic light breaking through the storm clouds silhouettes their hapless plight. Vernet exploits the familiar elements of Romanticism—wild nature, tragedy of existence, infinite solitude, and terror.

Birch is nowhere nearly so exaggerated. He employs most of the components of the Vernet format, but the narrative is not so imaginative. The scenes are simpler; the coastlines, although unidentifiable, have the feeling of actually observed places. Birch focuses attention on fewer details and without Vernet's theatrics. Technically, he too uses contrasts of value and a heavy impasto to suggest the wildness of the storm, but his contrasts of light and dark are not so stark. Light delineates the crests of the waves; it models the breakers and the shapes of the clouds, but does not have the spotlight effect of the Vernet painting. Birch's achievement is in using these devices independently. If not a highly original artist, he did succeed in portraying American settings with visual accuracy and coherence.

Birch documented much of the mid-Atlantic coast. Although he worked around Philadelphia and the Delaware River area, he also painted New York harbor and the Massachusetts and Maine coasts. He painted with equal facility views from the shore, or in the harbor looking back at the coast, or on the open sea. His *New York Harbor* (figure 73) demonstrates the freer handling of paint and the simpler manner of composing that came to characterize his mature style. It has the open, airy quality that Kensett sought later, but also shows a mastery in understanding the fluid movement of waves and in reproducing the luminosity of light reflected on the surface of water. As an offshore view, it belongs to a group of similar views of Philadelphia done in the late 1820s and thirties. This is clearly organized into horizontal zones of shadow and light against which the various boats are silhouetted. The two center sailing vessels cut across the horizon, vertically relating sky and water, while the eye moves back into the distance by means of successful changes of scale. Birch is convincing in filling the sails with air, moving the vessels through the water, and showing the light as it flickers across the water. In the right distance is Castle William on Governor's Island. On the distant shore the eye can just make out the steeple of old Trinity Church and the lantern of the Merchants Exchange. Since both of these buildings were destroyed by the end of the thirties, the painting may date from the earlier part of the decade.[11] Birch shows a minimum of harbor activity, but manages to include several different kinds of vessels—a paddle steamer and merchantman at the left, a topsail schooner at the right, and a rowboat and sailboat in the foreground.

Thomas Thompson is worth introducing into the discussion at this point, for he was an almost exact contemporary of Birch's. Both men were born in England during the American Revolution; Birch died in 1851, Thompson a year later. From the 1830s to his death Thompson was a member and frequent exhibitor at the National Academy of Design. Although titles of his exhibited works suggest a man of extensive travels, his paintings were predominantly marines. Few are known today, but include views of New York, as well as the Hudson River and the New England coast.[12] His painting of New York harbor, entitled *Scene from the Battery with a Portrait of the "Franklin," 74 guns* (figure 76), shares much in common with Birch's painting of the same place. He views Castle William from a different angle and shows before it a panorama of bustling maritime traffic. Though there is a certain hardness in the drawing, the painting is filled with light, and its large size makes it an achievement that Birch seldom attempted. Together, the work of these two painters suggests that America's city ports were the subjects of active artistic interest.

Two small paintings of the open seas by Birch will complete this survey of his art. In *Minot's Ledge Rock Light* (figure 77) a sloop wallows dangerously in high seas, while a rowboat with passengers attempts to make its way to the questionable safety of the lighthouse. On this small scale and with few elements Birch is at his best. With thin painting in the sky he conveys the stormy atmosphere, while with tighter, heavier brushwork he describes as few painters could the waves cresting across the ledge. The work has the narrative drama and pictorial liveliness that demonstrate why Birch became popular.

Birch displays a similar ability in the open-sea portrait of *The Ship Ohio"* (figure 78). As his reputation and prosperity increased, Birch received commissions for ship portraits.[13] This work daringly

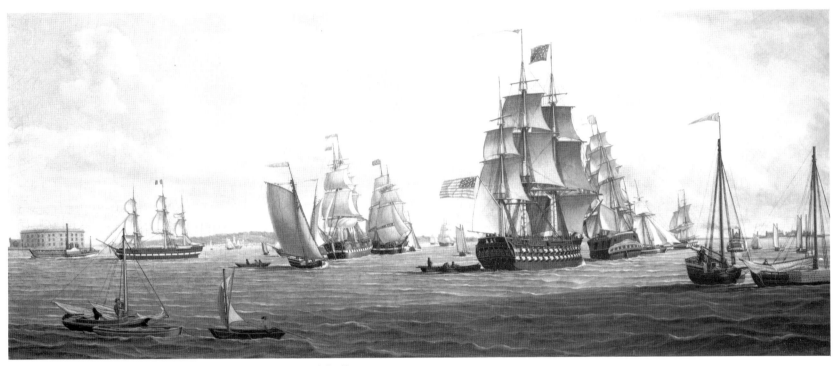

76 THOMAS THOMPSON. *Scene from the Battery with a Portrait of the Frigate "Franklin," 74 guns.* c. 1838. Oil on canvas, 26¾ × 63¾″. The Metropolitan Museum of Art, New York. The Edward W. C. Arnold Collection of New York Prints, Maps, and Pictures. Bequest of Edward W. C. Arnold

combines such a portrait with a dramatic seascape. It displays an economy of draftsmanship in the painting of the ship and a variety of brushwork in the expressive oil impasto bettered by none of Birch's contemporaries, except perhaps James Buttersworth or Robert Salmon. It makes an instructive comparison with Allston's *Rising of a Thunderstorm at Sea* (figure 29). In both paintings a vessel tosses on rough seas, but Allston intends more to show man insignificant before the breadth of nature. His vessels are symbolic and imaginative, whereas Birch's ship is a specifically American one, seen close at hand as if the observer were tossing nearby. The feeling of waves building and falling is immediate. Birch establishes a sense of visual

actuality. More, he created a new kind of ship portrait, one with heightened awareness of the setting. Such naturalistic representation, whether of ships or of harbors, brought him approval. Patrons bought his work, engravers copied his views, and younger local artists followed his style. John Neagle led a number of Birch's contemporaries in praising him as a marine painter.[14] But his foremost contribution was making marine painting American by treating local subject matter with a personal, independent style. His paintings are individually valuable as historical documents; his career provides an encompassing devotion to marine painting that was auspicious in its freshness.

77 THOMAS BIRCH. *Minot's Ledge Rock Light*. 1830s. Oil on canvas, 19¾ × 29⅞".
Historical Society of Pennsylvania, Philadelphia

78 THOMAS BIRCH. *The Ship "Ohio."* 1829. Oil on canvas. 20¼ × 30¼".
Shelburne Museum, Vermont

79 Thomas Buttersworth. *Escape of "H.M.S. Belvidera" from the U.S. Frigate*
"President." Early nineteenth century. Oil on canvas, 16 × 22".
The New-York Historical Society. Bequest of Irving S. Olds

English-American Artists

JOINING the French and Dutch influences on American marine painting was the English. Willem Van de Velde, the younger, is regarded as the founder of the English school of marine painting in the last quarter of the seventeenth century. In the century that followed, English seascape painters developed a local style based on the Dutch example. The high point came in the middle and late decades of the eighteenth century with the distinguished painting of, among others, Peter Monamy, Samuel Scott, Dominic Serres, Charles Brooking, and John Cleveley. These men in turn set the tone for the next generation active around the turn of the century, including Robert Dodd, Thomas Luny, and George Morland. Two lesser known figures of this latter group have special relevance to the development of American sea painting. Thomas Buttersworth painted in this tradition, and his work included views of American naval battles during the War of 1812. Whether he actually came to the United States is unknown, but his paintings gained popularity among American collectors through the circulation of aquatints after his work by the English engraver Joseph Jeakes. He may have been the grandfather of James E. Buttersworth, who did come to this country around 1850 and was active as a painter of clipper ships in the third quarter of the nineteenth century (see chapter twelve). Some connection is probable, since there is adequate evidence of stylistic similarities between the two.

The other artist, Robert Salmon, also learned a style of painting indebted to the great period of English marine painting. His early career began in Scotland and England around 1800, but after twenty-five years of painting there he came to Boston where he worked almost exclusively until 1842. He may be considered an American painter, since he did his best and most prolific work here. From England he brought a topographical style that came to have a marked influence on the younger native American artists then working in New England. By these various means Salmon and Buttersworth represented the transmission to America of the English manner.

Little is known about Thomas Buttersworth. Thieme-Becker notes that he exhibited at the Royal Academy in 1813 and at the British Institution in 1825. The few histories of English painting that mention

him give approximate working dates of 1797 to 1830.[1] As with James Buttersworth, attention to his career by historians is cursory; neither man's paintings are prominent in collections of English or American museums. Their work belongs largely in private hands, which makes biographical and stylistic discussion necessarily incomplete. Thomas Buttersworth is now regarded by the British as a minor figure of their marine school.[2] His style is derivative of that of their best marine painters. Of importance is his link with the American school. The style in which Thomas Buttersworth worked and which James Buttersworth brought to his American paintings had an obvious debt to the older English seascapists. They, in turn, derived much from the Dutch example that Van de Velde had set a century earlier, especially the use of a low horizon and concentration on effects of light and air.

Typical of Buttersworth's early painting are scenes of naval battles, which are often appealing for their narrative action. His palette, however, was basically gray in tonality, and he commonly painted

80 THOMAS BUTTERSWORTH. *"Royal George" Yacht Entering Leith Harbor on Visit to Scotland, August 16, 1822.* c. 1823. Oil on canvas, 37½ × 26″. Courtesy The Seaman's Bank for Savings, New York

water in muddy greens shading off to creamy whites. One reason why the younger Buttersworth became the better painter was his ability to paint with a wider range of colors. In his more dramatic paintings, the focusing of light on clouds and waves closely corresponds to the influential work of Dominic Serres and his contemporaries.

In his later work Buttersworth tended to paint less grand scenes, preferring instead to dramatize the engagement between a couple of ships or the striking grace of yachts under way. Continuing his interest in naval engagements, Buttersworth painted the *Escape of "H.M.S. Belvidera" from the U.S. Frigate "President"* (figure 79) as one of a pair. It belongs to a group of paintings that Buttersworth did of American naval battles during the War of 1812. This event took place 23 June 1812 and presumably the painting dates from shortly after. A mate to this depicts the *"President" and "Endymion"*; Joseph Jeakes published aquatints of both in London in 1815.[3] These prints subsequently brought much attention to the original oils, for by comparison, Jeakes's work was thin and dry, lacking in the feeling for light and space that Buttersworth convincingly captured in oil. It is a common format, one used by Corné, Birch, and others who chronicled these events (figure 61). Both the close observation of detail and the exploitation of contrasts of value squarely place the style within the Dutch-English tradition.

Buttersworth's later works forecast the work of James E. Buttersworth who triumphed in the painting of single clippers at sea (see chapter twelve). His warm, opaque coloring and confident draftsmanship were very likely influential in the emerging style of the younger artist. The smooth modeling of sails, waves, and clouds readily transmits the sturdy beauty of a sailing craft in her element (see figure 80). Working primarily in dark green, light tan, gray purple, and pale blue, Buttersworth at once attains variety and coherence. He controls light and shadow effectively to focus on the vessel and her movement through the water. Both this type of subject matter, showing sleek sailing vessels on open seas, and brushwork were to flourish in later American painting. To this Thomas Buttersworth is an obscured but critical step.

A more substantial step is that taken by Robert Salmon whose working dates of 1800 to 1843 are only slightly later than Buttersworth's. His style was similarly based on that of older English masters, but by coming to America in midcareer he was able to bring personally the older style to a new tradition of painting. Because he passed an important part of his career in Boston, his paintings were to be influential in forming the styles of Fitz Hugh Lane and other younger New England painters.[4]

Knowledge of the number and quality of Salmon's paintings has increased markedly in recent years. A surprising number of museums in the United States and England possess his paintings, although by far the largest number still remain in private hands. Salmon painted over a thousand pictures in his known career, and over four hundred of them in Boston.[5] Those that survive show us an artist of no small accomplishment.

Salmon's work has a freshness and an honesty that were sometimes lost by his contemporaries. While his manner was one of exacting representation, his marines never became a succession of dry topographical renderings, nor his ship portraits mere virtuoso exercises in architectural drafting. He was fully capable of sentiment in the best sense, of expressing his personal feelings about a place, and of capturing the particular character of what he saw before him. His work includes intimate paintings of romantic, unidentified shorelines as well as valuable historical recordings of how the harbors of Scotland, England, and Boston looked in the early decades of the nineteenth century. Whether Salmon was self-taught is unknown, but he proved himself to be a good craftsman. He was always sure of himself as a painter, knowing how to use his brush and his paints with an economy that was deceptively effective. He learned how to compose a scene so that what he transcribed possessed not only accuracy but an aesthetic sense as well.

His known career is divided almost equally into two periods, the first covering work from 1800 to 1828 in England and Scotland, and the second from 1828 to 1842 in the United States. His English work faithfully records the environs of Liverpool, the Scottish focuses on Greenock, while the American counterpart centers on Boston.

The facts of Salmon's biography come foremost from newspaper

81 ROBERT SALMON. *Ship "Aristides" off Liverpool*. c. 1806.
Oil on canvas, 22 × 31″. The Mariners' Museum, Newport News, Virginia

82 ROBERT SALMON. *The Ship "Favorite" Maneuvering off Greenock*. c. 1845. Oil on canvas, 30 × 50½″. National Gallery of Art, Washington, D.C. Paul Mellon Collection

notices, occasional posthumous reminiscences, and his own catalogue of paintings, known only through a copy now in the Boston Public Library.[6] Of his early life and career there is not a great deal of information, although several pertinent facts have come to light. The Bishop's Transcripts of the Parish of St. James in Whitehaven, county of Cumberland, England, record his baptism on 5 November 1775 as "Robert of Francis Salomon." Salmon had relatives living in both Maryport and Whitehaven, ports close to each other on the Cumberland coast. Whitehaven was the bigger town, in Salmon's youth the capital of coal-mining Cumberland. The striking topography of the

83 ROBERT SALMON. *Boston Harbor from Constitution Wharf (View of Charleston 1833)*. 1833. Oil on canvas, 26¾ × 40¾". United States Naval Academy Museum, Annapolis, Maryland

harbor and environs would elicit the first paintings we know of by the young Salmon.

His first paintings come from 1800, and as they are already mature works, suggest that he was by then at least an accomplished youth. The opening pages of the artist's catalogue indicate something of his whereabouts before he sailed for America. He begins by stating that

84 ROBERT SALMON. *Coastal View near Greenock.* 1826.
Oil on panel, 16½ × 25½″. Private collection

he "arrived in Liverpool 10 June 1806, and had twenty-six guineas. No. 1. The first picture I painted, The Battle of Trafalgar on speculation, sold for £8.8." There are, however, several paintings predating this catalogue, including the ones of Whitehaven. Why he did not list them is unexplained. It might be that he had not yet developed sufficient confidence in his youthful ability, and only after getting to Liverpool was he fully prepared to record and sell his paintings. Still, he was professional enough to exhibit in the Royal Academy. Moreover, in 1809 he was able to paint a ship portrait on commission for Sir John Warburton as a present to the prince regent.

Salmon worked in Liverpool for five years, painting on an average a little over twenty pictures a year. Going to Liverpool was a natural move for a youth brought up in an active seaport and whose family dealt with ships. Here he enthusiastically recorded the cityscape, and particularly the shipping activities on the Mersey. A number of fine, crisp ship portraits have survived from these years (figure 81).

After a while the lure of another active port and shipbuilding

center, that of Greenock on the west coast of Scotland, began to attract Salmon. Between 1811 and 1822 Salmon was chiefly in Scotland, and produced in this time over two hundred and fifty paintings that visually confirm the romantic picturesqueness of the area. The uncommon beauty of the Ayrshire and Argyllshire landscape and the extraordinary islands in the Clyde strongly impressed the painter's eye (Figures 82 and 84).

The artist was active both in his painting and in helping to stimulate public interest in the arts. In 1822 he left for Liverpool where he would record nearly eighty paintings for the next three years of work. The city to which he returned was busier than ever. The river was crowded, new docks were being completed, and steam packets were now part of the regular waterside scene. Maritime activity continued at a quickened pace, and Salmon did not fail to record it. He also journeyed out to the country to sketch the landscape.

Salmon was back in Greenock by late 1825, but this time not for long. He is not listed in the local directory at this time, which suggests he was on the move a good deal. Indeed, an examination of the places noted in his catalogue indicates that before his departure for Boston his travels in Scotland and England between 1800 and 1828 were extensive. His paintings based on experience from this period and those based later on sketches and a store of memories reveal that he painted or visited many parts of the coast of Great Britain. He found more subjects on the west coast of Scotland in and around the Firth of Clyde than anywhere else. He also knew the Liverpool area well, painted at least one subject on the Welsh coast and another in Bristol. The evidence of his travels along the eastern coast of Scotland and England and the south coast of England centers in four areas: the Firth of Forth, the mouth of the River Tyne in Northumberland and Durham, the Channel coast above Dover, and the south coast near Dorset and Cornwall.

Salmon's notes are insufficiently precise, unfortunately, in telling us exactly when he visited these spots. By the end of 1826 his notes only indicate that he was back in London and soon after in Southampton and North Shields. At this point the catalogue gives much fuller information about the subject and sale of individual

85 ROBERT SALMON. *View of Algiers*. 1828. Oil on canvas, 69 × 162½″.
The New Britain Museum of American Art, Connecticut

pictures. Almost all of the one hundred and eighteen paintings done between mid-1826 and mid-1828 were sold at auction a few years later in Boston.

Confidently, he prepared to take a sizable stock of his work across the Atlantic, planning to turn a few sales in another port which he hoped would be sympathetic to a marine painter. His thinking proved correct. Most of the oils brought about ten dollars apiece, giving him a modest but steady income after his arrival in the United States. In June of 1828 he boarded the packet ship *New York* of the Black Ball Line, which arrived a month later in New York. He left almost immediately for Boston, where he set to work eagerly on his painting.

One of the first paintings he did was a ship portrait of the *New York*, doubtless to record a memorable crossing. Soon he was involved in various activities around Boston: painting scenery for a theater backdrop; making sketches, paintings, and lithographs of local views; painting remembered English views; and grinding colors to keep himself in business. Several of the large panoramas that he did at this time of a naval engagement of Algiers (figure 85) were probably inspired by a series of panoramas of the same subjects on view in Glasgow and Liverpool during the periods that Salmon was in those cities. When his own version went on exhibition in Boston in 1830, it brought immediate and admiring critical approbation. The newspapers exhorted that "all persons of taste and curiosity will take an early opportunity to witness what is everyway worthy of attention."

86 ROBERT SALMON. *Wharves of Boston.* 1829. Oil on canvas, 40 × 68″.
The Bostonian Society, Old State House, Boston

If recognition and success came to Salmon early in Boston, neither diminished in the decade that followed. Reviews of his sales appeared regularly in the Boston papers, always admiring, occasional large exhibitions were held bringing wide popular attention, and some of Boston's most distinguished citizens became his patrons. During the thirties the prices for his paintings steadily rose; his volume also increased. He took a studio at the lower end of the Marine Railway Wharf. The Marine Railway was on Commercial Street near the foot of Hanover Street, and here he worked from 1831 to 1840. His 1834 address on Washington Street was a brief exception. The maritime

activity that he witnessed along the wharves and in the harbor of Boston must have excited him as much as anything he had seen in Liverpool (figures 83 and 86). Already in 1828 he began to think of exchanging paintings to acquire a boat. In 1831 he actually sold some paintings to this end. Whatever the type of boat he actually bought, he could now sail about the harbor, the better to record Boston's crescendo of shipping activity. In July 1840 the artist's list of paintings comes to an end, but not without noting that in March 1840 he took only four hours to paint what he thought was "the best picture I ever painted." Critics concurred: "As a Marine Painter, Mr. Salmon has never been excelled by any artist in this country."

If the catalogue is accurate in accounting for Salmon's movements, he rarely painted farther from Boston than Nahant to the north and Milton and Squantum to the south. As well as depicting thoroughly the shoreline of the inner harbor and Boston's wharves, he also explored in his boat many of the islands of the outer harbor, painting as far out as Rainsford Island and Deer Island. In 1840, at the age of sixty-five, he was still actively painting and exhibiting. But in this year his doctor forbade him to continue doing small paintings, presumably because his eyesight was failing. After this there is little further record of his activities, and it was long thought that his death soon followed. However, the Artist's Fund Society of Philadelphia exhibited one of his paintings in 1841 and gave his address as Boston. In June 1842 an auction of his paintings was held in Boston, and the advertisement noted that this would be the last such sale of his works, "Mr. Salmon having returned to Europe."[7] Several paintings have turned up indicating that he continued to paint, if infrequently, through 1842 and into 1843. Two of them in the Corcoran Gallery of Art, painted in 1837 and 1841 respectively, were retouched and redated 1842 and 1843. Still two others in private collections are actually dated 1843. One is titled *Coast of Scotland*, which suggests that this is where the aging artist returned.

Salmon must have died shortly after. In 1844 the Catalogue of Paintings of the Third Exhibition of the Boston Artists' Association included four paintings by him loaned by C. Sprague. Salmon appeared in the list of artists represented, but with an asterisk

87 ROBERT SALMON. *Dismal Swamp Canal.* 1830. Oil on wood panel, 10½ × 15″. Private collection

following his name. The footnote against the asterisk read "Deceased."[8] A confirming note came in 1851 when the *Boston Evening Transcript* referred to Fitz Hugh Lane as the best marine painter in Boston "since Salmon's death."

The sources of Salmon's style of painting lie ingrained in the English and Scottish schools as they had developed through the seventeenth and eighteenth centuries. The tradition of the Van de Veldes was one obvious influence; another was Canaletto. When this Italian visited London in the late 1740s, he infused into British painting a new attention to topographical detail and the brilliant clarity of his own Venetian manner. His familiar precision of observation and drawing had a decisive influence on the paintings of Samuel Scott. Scott was born in the first decade of the eighteenth century, and he began his career painting marines, which soon brought him the recognition of "The English Van de Velde."[9] As a youth of twenty-two he collaborated on views in the East Indies with

88 ROBERT SALMON. *Chelsea Creek, Massachusetts*.
1832. Oil on panel, 15⅝ × 23⅜″.
The Peabody Museum of Salem, Massachusetts

the landscapist George Lambert; Canaletto's appearance in 1746 strongly turned him to painting views of London after the Italian's style. His views of London and the Thames were usually less panoramic than those by Canaletto, but he shared the same concern for clear light and crisp drawing. Salmon must have been very aware of the legacy left him by Canaletto, Scott, and the English marine painters of this period, for his own views of Liverpool and, later, of Boston were in the same topographical style (figures 81 and 86). Scott also painted storms at sea and events from English maritime history, such as battles in the Channel, more in the Dutch manner; these may well have provided the prototype for similar paintings that Salmon did occasionally (figure 91).

Among his own contemporaries who would play an influential role in the development of his personal style were J. C. Ibbetson, George

Morland, John Thompson of Duddingston and J. M. W. Turner, the latter born the same year as Salmon. In fact, Salmon was to make copies after works by all of these men; he notes doing several in Turner's style. If he occasionally experimented with different manners of painting, he also painted a wider variety of subjects than many have thought. He painted some nine portraits during his career, most of them imaginary. Not surprisingly, among his marine subjects a large category was ship portraits, and he was adept at all types in a variety of settings.

Salmon's earliest known paintings from the first decade of the nineteenth century are mature and confident in handling, although they sometimes suffer from stiff, obvious compositions. The central placement of the *Ship "Aristides" off Liverpool* of c. 1806 (figure 81) will give way to more varied and sophisticated designs in later

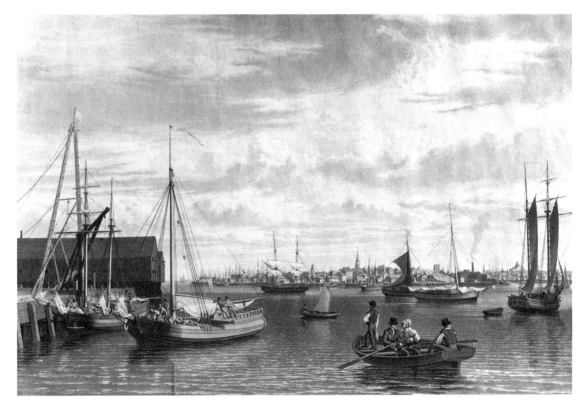

89 WILLIAM BENNETT. *Boston from the Ship House,
West End of the Navy Yard.* 1833.
Etching and engraving, 24¼ × 27¼″.
Museum of Fine Arts, Boston.
Gift of Club of Odd Volumes

decades (compare with figures 85 and 86). The *Ship "Aristides"* is a typical early work. The drawing and modeling of forms are crisp, the lighting and color strong. With a point of view that is low and close to the vessel, Salmon achieves an effect of directness. A firm sense of outline and a selective focusing of detail contribute to a high degree of coherence. The artist's understanding of naval architecture and of weather conditions is evident; he creates a fine feeling for movement among these juxtaposed hulls, as the eye moves across space into depth. Notable, too, is the fluid brushwork, which here lends a special freshness to the result. Through these short, liquid accents he successfully manages to convey the actual sensations of wind and sunlight. The same sharpness of contrast carries over into his work done a few years later in Greenock. Shipbuilding in Greenock was

markedly on the rise during this period, and Salmon eagerly sought to capture the intense activity.

Some paintings reveal how personal and intimate an interpretation Salmon could render of sites that were especially familiar and appealing to him. *Coastal View near Greenock* (figure 84), done in 1826, devotes a new narrative importance to human figures, while carefully integrating them into the total scale of the landscape. This was one of a group of similar paintings that Salmon did at this time; all included the same heavy slabs of rocks and the volcanic islands common in the landscape of the Firth of Clyde near the island of Arran. For each he used a similar format, one that is characteristic of his manner of composing: a curving beach with rocks and figures in the foreground, a large beached hull to one side in the middleground,

other vessels at anchor in the background, and an island in the center distance. While these views may not be of a single location, the closeness of approach and scaling indicates how much of interest Salmon could find in a chosen theme. With these paintings he has turned from a repertory largely of ship portraits to views of interesting stretches of local topography. Different, too, from the earlier examples are the controlled use of creamy glazes, the precise detailing and the heightened differentiation of textures and masses. Emerging is a new interest in the depiction of elusive conditions of weather or times of day, such as hazy or overcast skies. He also found fresh challenge in the treatment of still water and the reflections on its surface.

After he arrived in the United States and settled himself in Boston, Salmon painted during the decade of the 1830s a comprehensive portrait of Boston. Aside from the shore and harbor views, he also recorded a number of street scenes, including several fires. The romantic emerged in him chronically in scenes with smugglers on the lookout or in ghostly night escapades, in calm sunrises or sunsets, and in intimate moonlight views which increased in his last years. Too frequent to be counted are the most typical of all, ships in squalls, shipwrecks, ships aground, unknown inlets, islands, beaches, headlands, lighthouses, fishermen at work; occasionally a "fancy" storm or place, or a panorama sketch on a small scale, but usually just the comprehensive "shore, boat, and figures" which he loved doing most and for which he is best known.

The works done during Salmon's first year in Boston are among his finest. A major canvas from this time, the *View of Algiers* (figure 85), was one of a series of six monumental canvases. Most of them were close to fifteen feet long. One was intended as a scene for a theater backdrop, two others were views of Boston (figure 86), and three were devoted to the naval events of a battle of Algiers in 1816. The illustrated canvas shows various vessels in calm waters before the city of Algiers which rises on the hillside in the background. The companion canvas now in Boston's Museum of Fine Arts is the *British Fleet Forming a Line off Algiers*, while a still lost panorama was supposedly semitransparent and depicted a night battle with the Algerian fleet on fire.

Salmon did not confine himself to remembered or imagined European views, but found almost endless subject matter right at hand along the wharves and in the harbor of Boston. Two of his large views of Boston harbor done in 1829 (figures 83 and 86) are not only attractive in their own right, but gain additional interest for their effect on the work of younger artists. Both are works large in scale, concept, and execution. Among his finest in quality and execution, they possess a sharpness of light and clarity of form seldom surpassed anywhere else in his work. Coming but a year after his arrival in Boston, these paintings must have won him immediate respect. The Boston wharves were, in these years, undergoing expansion in order to accommodate the increased volume and tempo of shipping activity. During Josiah Quincy's tenure as mayor (1823 to 1828) the two-story granite market building designed by Alexander Parris went up on land filled in near Long Wharf. Salmon has made a point of showing it at the far right of his painting *Wharves of Boston* (figure 86), for it was in the spacious rotunda above that he was shortly to receive the first large exhibition of his paintings.

The artistic significance of Salmon's paintings lies in their striking similarity to works by Fitz Hugh Lane and by Albert Van Beest and William Bradford done over two decades later (figures 106 and 123; see chapters ten and eleven). The younger artists have adapted Salmon's compositional motifs, such as the placement of a large vessel or group to the right, a smaller one to the left, and figures in a dory near the foreground. Further characteristics in common are the concern with lighting, the manner of painting ripples on the water, the knowing delineation of ship details, the restraint of color application, and the subtle modulation of atmospheric tones. The Lane and Bradford-Van Beest views open out on a more distant view of the shoreline than Salmon ordinarily chose, but the same panoramic disposition of ships on the surface, the low horizon, and the expressive cloud formations carry over. Indeed, Salmon's work in Boston was to have marked effect on local marine painting during the several decades after his departure.

Once settled in Boston, Salmon probably saw the work of other contemporary painters; some he specifically makes note of in his

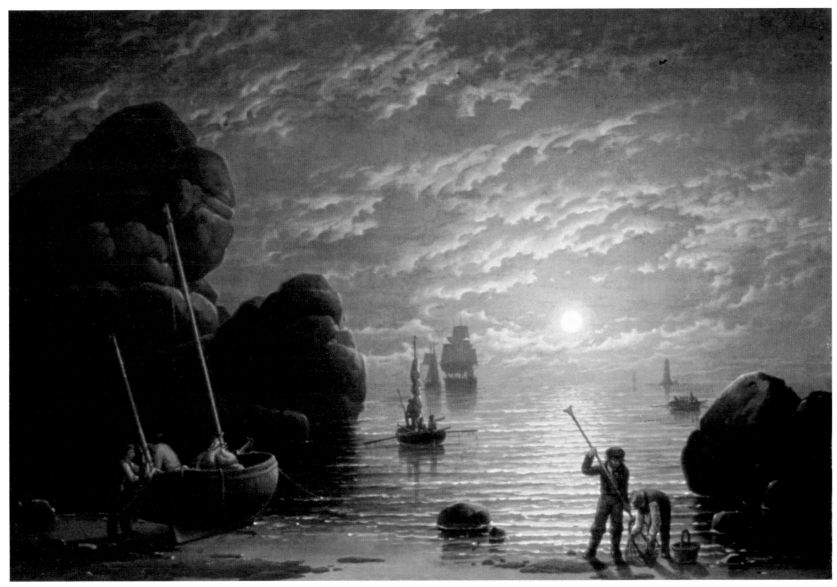

90 ROBERT SALMON. *Moonlight Coastal Scene.* 1836. Oil on panel, $16\frac{5}{8} \times 24\frac{1}{4}''$.
The St. Louis Art Museum, Missouri

catalogue. One whom he does not mention but whom he may well have met and even influenced through common interests was Charles Hubbard. Hubbard was an artist who painted primarily in Chelsea, an area where Salmon also worked (see figure 88). In 1832 Henry H. W. Sigourney of Chelsea asked Salmon to paint a view of the ferry landing and shoreline at this point. Sigourney and Hubbard were among several prominent directors of the Winnisimmet Company, or more familiarly, the Chelsea ferry company. Sigourney's house sits prominently on the slope rising up from the water in the background.

Although Hubbard was known best as a portrait painter, he was also active in city and state affairs.[10] He must have painted his view of the Chelsea ferry landing at about the same time as Salmon, though from a slightly different angle. The interests of these men probably crossed in other ways. Among Hubbard's lithographs was one dedicated to Sigourney; a second was *The National Lancers*, which Fitz Hugh Lane had put on stone in 1837 for Thomas Moore's firm (see chapter ten). Lane was certainly acquainted with both Hubbard and Salmon, and a meeting between these last two was more than likely through one or more of their common associations.

The work of William James Bennett also offers several points of comparison with Salmon. Bennett had exhibited in London galleries between 1808 and 1825, and had sailed for New York only two years before Salmon. Although he remained there for most of his career, he made several sketching excursions to large American cities during the 1830s. Like Salmon he had developed a preference for city and harbor views that came out of the English tradition established by Canaletto and Samuel Scott. Known for his large aquatints, Bennett also drew on the legacy of Dutch marine painting for his low horizons and expansive lighting effects. Significant here is a trip that he took to Boston in 1830, which resulted three years later in two of his best-known and most admirable prints, *Boston from City Point near Sea Street* and *Boston from the Ship House, West End of the Navy Yard* (figures 37 and 89). Of the second view Bennett also made a watercolor in 1832 (Stokes Collection, New York Public Library).

It is hard to believe that a marine painter as active as Salmon was along the Boston harbor front did not make Bennett's acquaintance on one of these occasions. Their manners of composing harbor views are very similar. One scale-giving device especially favored by Bennett was that of a few figures rowing a dory in the foreground. Whether Salmon picked this up from him is unknown, but it is a rare component of paintings in his English period, and he seems to take it up in Boston shortly after arriving. The device is one that his successors would similarly employ (figures 108 and 123).

Once developed, Salmon's technique of painting seems to have remained consistent throughout most of these subjects. He normally began with careful pencil sketches, often using a ruler for proportioning distances or a quadrant system for establishing scale. After the general outlines of the landscape and major components were clear, he might add shading with crosshatching or a few brushstrokes of oil to indicate textures and volumes. Frequently he worked directly on a stiff pasteboard, although many of the smaller paintings are on panel, and the larger are on canvas. He seems equally adept on a scale of a few inches as on one of several feet. His brushwork ranges from the tight and crisp to the loose and expressive; besides oil he also used tempera.

Throughout his remaining years in Boston, Salmon constantly extended his range of subjects and moods of interpretation. Increasing flexibility of design and variety of brushwork appear. He continued through the thirties to paint remembered English scenes alongside views of places visited firsthand near Boston. With thin glazes and fluid brushwork he managed to capture perfectly the quality of hazy atmosphere suffusing the view from the promontory at Cornwall. Four years later, in 1836, he began a series of romantic moonlight scenes, usually populated with fishermen going about their business. An especially successful version is the *Moonlight Coastal Scene* (figure 90), which blends a feeling of spaciousness with intimacy. In so doing, it looks both back to Allston's *Moonlit Landscape* and forward to Lane's *Fishing Party* (figures 33 and 112).

In the late *Storm at Sea* (1840) still one more aspect of Salmon appears (figure 91). The powerful, dramatic light and stormy sea contrast with his other methods of painting sky and waves. He has here employed a heavier impasto and a more stark design that parallel

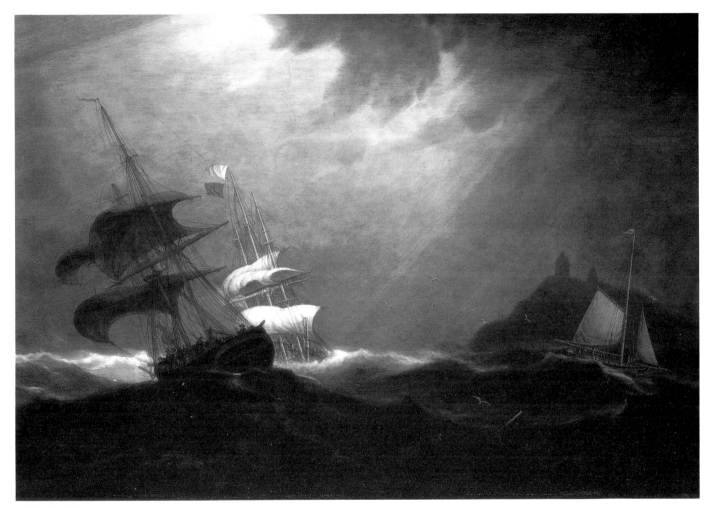

91 ROBERT SALMON. *Storm at Sea*. 1840.
Oil on canvas, 16½ × 24½″. Museum of Fine Arts, Boston.
M. and M. Karolik Collection

the contemporary marines of Thomas Birch (figure 78). Like Birch he too recalls Allston's monumental seascapes (figures 29 and 34). And he anticipates similar paintings of the next decade by James E. Buttersworth (see chapter twelve, figure 143). Only in Salmon's last years of painting does his former sureness begin to weaken, and the now familiar style begin to deteriorate. At his best he left a picture that appropriately and honestly reflected the vigorous optimism of his time.

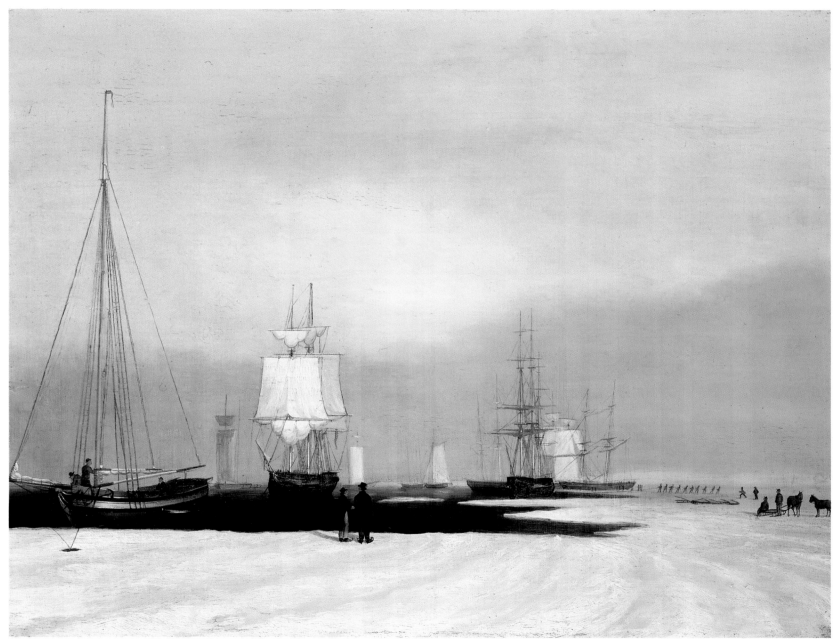

92 JOHN SAMUEL BLUNT. *Boston Harbor.* 1830s. Oil on panel, 20¼ × 28″.
Museum of Fine Arts, Boston. Gift of Mrs. Maxim Karolik for the Karolik Collection
of American Paintings

Independents

AMERICAN painting came into its own during the first half of the nineteenth century. If this was so partly because of the stimulation that it drew from European art, it was equally due to the imaginative native painters whose careers developed independently of formal schools or groups or types of painting. In their hands American painting steadily nurtured its stream of Romanticism, which, in contrast to many of the wild and monumental conceptions of European counterparts, was expressed as a visionary lyricism. Terror seemed muted with a bemused quality, and even the brooding mystery of Albert Ryder's painting was a culmination of this strain that retained a pervading personal intimacy (see chapter thirteen). Another development around midcentury was the rise in popularity of scenes from everyday life. Both John Quidor and William Sidney Mount gave new focus to American customs and storytelling.

John Quidor has proven uniquely difficult to categorize. Oliver Larkin saw him as "less the genrist than the illustrator of other men's fancies."[1] Virgil Barker claimed: "It is importantly true that Quidor was not an illustrator."[2] He viewed him with Chambers as a brand of primitive painter, whose primary mode of expression was nonvisual. Quidor, he felt, worked through the expressive potential of the brush and conceptual patterns. Quidor may also be considered as a belated member of the Hudson River School with whose countryside he was equally familiar. Yet his painting was less documentary than that of Cole, Durand, or Doughty. Quidor's landscapes were more subjective, his subjects frequently narrative and fantastic. In this respect he anticipated the same strains to appear in Ryder. But for all these associations Quidor remains a delightfully isolated figure.

The known works by Quidor reveal a painter of lively imagination and good humor. In his own time his painting met with evident displeasure and perhaps rejection. Because of the exhibition politics at the National Academy during Quidor's early years as an artist, he was refused exhibition by the Academy for nine years.[3] William Dunlap, the contemporary painter and historian, scarcely discussed his artistic talents; his notation consists of itemizing Quidor's shop work, that he made parade banners, decorated fire engines and fire buckets. He did admit that Quidor possessed certain cleverness, but

concluded that his painting had no unusual merit.[4] From all accounts the public was indifferent to him, and from the time of his death in 1881 until the 1950s, this vivid figure dropped from public and critical sight.

Quidor was born in Tappan, New York, in 1801. His family moved to New York City around 1811 where sometime during the next decade Quidor began working in the studio of the portrait painter John Wesley Jarvis. Another painter at work there during the same time was Quidor's future competitor, Henry Inman, and one may only conjecture if the later ill-feeling had seeds in this early association. Comparing the styles of Jarvis and Quidor gives rise to the question of whether the older artist taught the younger very much, although the New York City Directory for 1827 did list Quidor for the first time as a portrait painter. No portraits definitely by him are extant; many paintings whose titles are recorded are still lost, and only a few dozen

93 JOHN QUIDOR. *Embarkation from Communipaw.* 1861.
Oil on canvas, 27 × 34¼″. The Detroit Institute of Arts, Michigan

works have been found. These fall into two chronological groups which curiously date from either end of an evidently undocumented period.[5]

He took subjects from the New Testament, *Don Quixote*, and stories by Cooper and Irving. Although the painter apparently never knew him, it was Irving who provided the richest source of subject matter for Quidor's pictorial embellishments. Embellishments they were, too, which may help to explain why Quidor is best called a narrator but not an illustrator. Because he spoke through pictorial means primarily, his best pictures took on a life independent of their literary origins. He employed an animated brushwork, vivid accents of light and dark, and twisted forms which writhe expressively, as may be seen in the *Embarkation from Communipaw* of 1861 (figure 93). Though it has a Hudson River setting and takes its immediate source from "Diedrich Knickerbocker's" *A History of New York* by Washington Irving, it is more imagined than visual or literary. The evocative empty spaces, strangely illuminated forms and gestures, and wiry silhouettes suggest an affinity with the equally individualistic Pieter Brueghel's work.[6] The colors are primarily hazy tans and reds and dull greens. The blurring of the background is typical of the artist's later style of thin glazes and partially distinct forms.[7] Much of the power of expression comes through the bulging shapes of the boat and the weird melee of figures. Quidor uses strong contrasts of value and contorted patterns of shape that transform the visual world into one of fantasy. Ryder's moonwashed, sea-tossed boats would evoke a similar spiritual and subjective ambience at the end of the nineteenth century.

Information is sparse about much of Quidor's life. He was presumably in New York until 1836 when his name no longer appeared in its directories. Three years earlier his only known work to be exhibited in Boston, *Leatherstocking Meets the Law*, was shown at the Athenæum.[8] Quidor had two pupils around 1830, Charles Loring Eliot and his friend Thomas Bangs Thorpe; other than this, Quidor's influence is self-contained. His paintings were almost exclusively American in subject matter, and he produced a style of flair and individuality to suit his interpretation. This note of originality and self-sufficiency brought to his version of American Romantic painting

a unique intensity. Some of this intensity weakened in his later pictures. While the earlier sense of gusto dissipated, a poetic intimacy lingered to the end.

A figure even more isolated and less known is John Samuel Blunt (1798–1835). His career is as unusual in its interest as in its brevity.[9] Of his few dozen known works, ten are marines of varying types, and for a painter who died at thirty-seven they show remarkable diversity.[10] His work showed steady improvement as he matured, and had he lived, he might well have become a major figure of marine and landscape painting in New England. Born just before the turn of the century in Portsmouth, New Hampshire, Blunt was listed in that city's directory for 1821 as an "Ornamental and Portrait Painter." Among his early work, besides tentative landscapes and marines, he is thought to have done miniatures, military standards, and ship ornaments. Excepting the landscape and marine paintings now recorded, no examples of the other types remain.

Married in 1821, he was able, four years later, to announce in the local papers the opening of a school of instruction, in which he proposed to teach "oil painting on canvas and glass, water colors and with crayons. Painting in its various branches attended to as usual."[11] Perhaps seeking a wider audience and better connections, he moved to Boston in 1831; he had already exhibited once at the Athenæum in 1829 and again the year he moved. He took a studio at 62 Cornhill and with his wife moved into a house on Castle Street. In 1835 he was selling his family's property in Portsmouth and negotiating the possible acquisition of land in Texas when he died on board the ship *Ohio* in passage from New Orleans to Boston. Perhaps this ship was the one that Birch had painted six years earlier (figure 78).

Dutch painting may have been one source for Blunt's artistic style, but he appears to have been self-taught, and a review of his paintings hints primarily of an imaginative self-reliance. That his father and men in his father's family were ship captains inevitably put sailing in his blood. In this light there is solid reason to believe that at the age of sixteen or so he was painting canvases like the *Launching of the U.S. Ship "Washington" in Portsmouth, October 1, 1814* (figure 94). Though having some of the flatness and crudeness of primitive

94 JOHN SAMUEL BLUNT. *Launching of the U.S. Ship "Washington"*
at Portsmouth, October 1, 1814. c. 1815. Oil on canvas, 47¾ × 57".
Collection Nina Fletcher Little

95 JOHN SAMUEL BLUNT. *Picnic on Long Island Sound.* c. 1823.
Oil on panel, 15 × 18¾". Private collection

painting, the painting has the characteristics that Blunt was to possess and develop in the remaining two decades of his life. The predominant colors are cool blues and greens, and dull orange-tans, but from these he could derive a crystalline light that suffuses the whole. His thin application of glazes contributes to the translucence of these muted tonalities; their appropriateness is particularly noticeable in the wispy streaks of clouds and in the reflections of light and shadow on the surface of the water. This range of color and application of paint he would retain throughout his career.

Blunt would retain the economy of detail that is also apparent here. While the perspective is deficient and the surfaces generally flat, the drawing has a contrasting firmness which makes his rendering of the ships probably the most successful element in the work. This ability

stood him well in the depiction of vessels in other settings. The ceremony launching the *Washington* was a big occasion befitting the esteem in which the vessel was held at the time.[12] To her right in the painting is the frigate *Congress* built in 1799 also at Portsmouth.

Two paintings from the first documented years of his career directly demonstrate his somewhat diverse handling of marine themes. *Picnic on Long Island Sound* is closest to a possible Dutch prototype with the luminous, atmospheric light, quiet coastal activity along the low shoreline, and details like the windmill on the far bank (figure 95). The diagonal organization of space and the broad juxtaposition of dark foreground plane on the left with bright recession of space on the right complete the simple but effective visual drama. There is no evidence Blunt went to Long Island, and one is more inclined to

96 JOHN SAMUEL BLUNT. *Imaginary Scene.* 1824. Oil on panel, 15½ × 22½″.
Shelburne Museum, Vermont

foreground, and an ability to exploit color and light fully for the expression of mood. It is a more intimate, less ambitious view than the *Imaginary Scene.* With warm, dark colors in the foreground and glowing sunset tones in the distance he directs attention to the vessel peacefully drifting in the cove, her sails hanging limply in the still air. This may well be the painting exhibited at the Boston Athenæum in 1829 as *View of Winnipiseogee Lake.*[13] This would fit with Blunt's seemingly increased interest in actual views. It is one of the last paintings dating from his New Hampshire years, and it sets the tone for the views he would essay of Boston harbor after the family had moved.

A late painting, the unusual winter view of *Boston Harbor,* illustrates Blunt's tendency to reduce a panoramic view to an intimate scale (figure 92). His canvases never were large: they average around sixteen-by-twenty inches. He enhances the viewer's sense of distance from the scene often by leaving much of the foreground or

97 JOHN SAMUEL BLUNT (attributed). *Topsail Schooner in Sheltered Waters.* c. 1810.
Oil on panel, 16 × 22″. Private collection

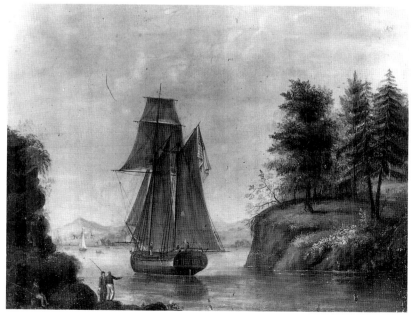

consider this a partly imaginary scene. *Imaginary Scene* is in fact the title of a painting done by Blunt only a year later (figure 96). It is a strange combination of elements: a scraggly tree to the left, a narrow isthmus with cylindrical clifflike rock on the point directly in front, at the top of the spiraling road a miniature city fortress, to the right the profile of a cluttered harbor façade, in the distance an idle ship, and across the middleground casual fishermen and strollers. The brushwork has an opaque, oil character, although the green, blue, and tan tonalities are similar to those in the *Launching of the "Washington."*

The painting appears to be an experimental search by the artist for a personal mode of expression, perhaps one he found in a later painting, *Topsail Schooner in Sheltered Waters* (figure 97). With this picture Blunt turned more specifically to identifiable locales. It dates from his last years in which he achieved a coherent sense of scale that had been lacking previously. Notable, too, is the competent handling of the human figure to create scale and give interest to the

middleground relatively empty. Nor is there ever extraneous detail. Here he articulates the small figures so they lend interest, but do not detract from the general vista. The disposition of forms is compact and economical. Few artists have tried to meet the challenge of scenes of ice or snow. Birch succeeded in some paintings of sleigh rides and skating; Bierstadt also tried a handful; George Durrie of course became a recognized master at farm scenes in winter; and William Bradford produced masterful scenes in the Arctic. One other marine painter, Fitz Hugh Lane, tested his skills in this way in his *Ships in Ice off Ten Pound Island, Gloucester* (figure 111). Fortuitously, Lane's and Blunt's versions of these New England harbors in the dead of winter are together in the Karolik Collection at Boston's Museum of Fine Arts. The difficulty in transcribing the elusive blues, grays, and reflected colors in white is obvious. Blunt's success is partially due to his familiar simplicity of design. The recession of the diagonal edge of ice and the corresponding diminution in scale of the vessels lends a physical space to the enveloping visual atmosphere. Compare this to the early attributed *Launching of the "Washington"* or to the early dated *Imaginary Scene* (figures 94 and 96). The figures in both are out of scale; in one they are antlike, in the other jerky and overemphasized. How finely Blunt integrates them into the *Boston Harbor*. Yet the foreground is empty, a strip running parallel to the bottom of the frame. The spectator is not immediately involved: he is not pulled in, but permitted to look on with detachment. Gray shadows, green water, brown reflections, pink clouds, and patches of blue sky: throughout there is a surprising range of warm and cool tones all kept within control. The painting is documentary of winter activities and captivating to the sensibilities. As a statement of mood it is direct but subtle. Accurate recording and careful organization are not easily combined. Blunt did so here and the result was a happy and aesthetically interesting one. It is to be regretted that his death followed eight months later.

Like that of Blunt's, the career of William Sidney Mount was a self-sufficient and original one. His contribution to the American tradition of marine painting is not major, but does invite examination. He is of course known first as a painter of everyday life, although he began as a history painter and portraitist, and throughout his life devoted attention to pure landscape and some seascape as well. Study of old masters seldom interfered with his individuality; he was never attached to a group. By honest observation he elevated his subject matter while stressing its native character. He said that he wanted to paint for the many, not the few. What he painted had a democratic flavor that would be solidly carried on by George Caleb Bingham, Eastman Johnson, and Winslow Homer. Mount was really the first to paint scenes of daily pastimes and to profit from his profession.[14] Recognition came in the mid-1830s with wide popular acceptance and steady exhibition of his paintings at the National Academy.[15] The favor was deserved on grounds of careful craftsmanship and the diverse abilities to transcribe the pastoral moods of nature and the comical side of ordinary life. His high technical competence enhanced his capacity for seeing intensely and often satirically.

He was born in 1807 in the place he would make famous forty years later on paper and canvas: Setauket, Long Island.[16] When his father died in 1814, the family moved to the nearby farm of his mother's father at Stony Brook. Here he grew up and would return to spend most of his life. In 1824 he became apprenticed to his brother Henry, a sign and ornament painter in New York. Two years later he entered the art school of the recently founded National Academy of Design, where he participated in the traditional instruction of copying antique casts, presumably studying accomplished paintings and receiving advice from the Academy's president, Samuel F. B. Morse.[17] Dissatisfied with the limited possibilities of a career like his brother's, Mount soon turned to historical painting under the stimulation of works by Benjamin West and John Trumbull. Dating from this time was his *Christ Raising the Daughter of Jairus*, stylistically notable for its flat patterns and incongruous four-poster bed. Around 1830 he increasingly relied on the conventional success of portraiture, and in 1831 he was elected an associate of the National Academy, and the year after, a member.

The decade of the thirties was the transition from early tentative exploration of subject matter and style through a steady development to the launching of his mature career of the next decade. Why did

98 WILLIAM SIDNEY MOUNT. *Crane Neck Point*. November 10, 1850.
Pencil on paper, 5½ × 4⅜". The Museums at Stony Brook, New York.
Bequest of Mr. Ward Melville

attachment to his native countryside may have further prodded artistic interests in new directions. The Age of Jackson provided unique opportunity for pictorial expression of the life it championed.

Mount doubtless saw advantage in seizing the opportunity. His painting became important not merely for subject matter, an above average ability to tell a story on canvas with telling wit, but also for a manner of drawing that combined care with spontaneity. Through this combination he infused a work with solid pictorial structure as well as a sense of outdoor light. The perfect embodiment of this came at the high point in his career with *Eel Spearing at Setauket* of 1845 (figure 99)—the successful culmination of his avowed concern with local everyday life and his less discussed sensitivity to the observed visual world.

This later interest is nowhere better evident than in the seldom seen pencil sketches by Mount done between 1833 and 1867.[19] Here is an immediacy of touch that the eye can easily overlook in the finished paintings. The pencil strokes are ordinarily short and light, but there is a solidity in what they describe. A study called *Crane Neck Point* (figure 98) shows how satisfactorily Mount could draw a boat under sail. With a softness of handling and sureness of direction, his lines create solid form on paper. Only a few marks suggest the needed reflections to convince the eye of the whole surface of water, while the white of the paper asserts the sunlight that fills the cloudless air. Few other American artists could draw as well as they painted, or produce drawings as intimately revealing of their approaches to painting.

Mount occasionally added imagined elements to his work: one painting dated 1852 of Long Island Sound has nonexistent large mountains looming up in the distance beyond the shore; another drawing includes a tulip tree canoe manned by two figures wearing hats with one or two feathers arching from them. They paddle an unidentified river landscape that may be entirely fanciful. But these

this period also see his strong leaning toward anecdotal painting? He is known to have admired seventeenth-century Dutch genre painting, and been urged by Allston to study Jan Steen.[18] His previous disenchantment with other types of painting and an abiding

Opposite:
99 WILLIAM SIDNEY MOUNT. *Eel Spearing at Setauket*. 1845.
Oil on canvas, 29 × 36". New York State Historical Association, Cooperstown

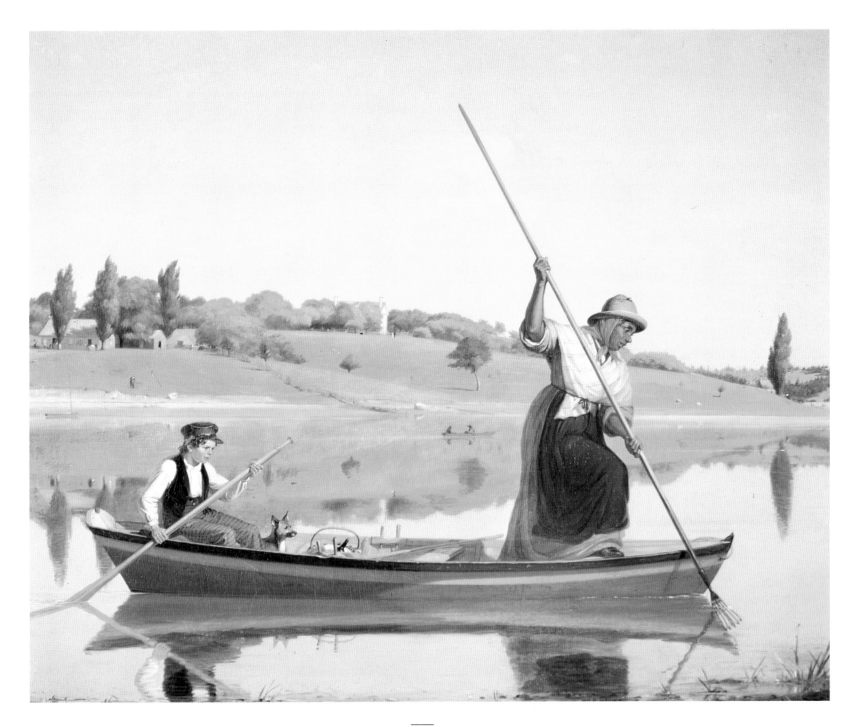

were singular occasions in his work, and more characteristic were the oil paintings or "palette sketches" done, rather oddly, on paper for his own pleasure and experimentation.[20] A typical example, titled *By the Shore* (figure 100), retains the loose, fresh quality of a sketch, while having the more extensive interest of a filled-out composition. The oil on paper permits the expression of high banks of clouds and strong reflections on the glassy water with an almost watery brushstroke. This liquid touch serves the more precise delineation of the small house to the left and the foreground plants as well as the broader textures of the landscape.

Mount's most famous work, justifiably so, is *Eel Spearing at Setauket* (figure 99). He achieves a poise and balance in the deft triangular structure made by boat, paddle, and spear that recall Copley's *Watson and the Shark* (figure 25). However radically different in the mood of the subject from Copley, Mount shares the same directness of observation. The pictorial recording of a local activity is historically valuable; even the figures are identified, and their descendants lived in the area for several generations after.[21] But the aesthetic value resides deeper in the fineness of drawing, the evocative warm gold tonalities, the masterful depiction of sunlight and water, and the deceiving simplicity of the design.[22] It was the culmination of a career in which he regularly experimented with painting outdoors and with techniques of color application. As a result his colors were occasionally off, sometimes too cold and flat, sometimes too hot and metallic.[23] But in *Eel Spearing at Setauket* he gave form to the realization that color was as much a property of an individual detail as it was the reflector of all the other surrounding tones. Color must respond to the conditions of light and atmosphere. Mount saw this and the embodiment that he sought to capture in pigment had a truth to visual fact difficult to transcribe.

As the present illustrations demonstrate, Mount tended to work from the spontaneous pencil sketch to the "palette sketch" on paper and then to the finished canvas. The sense of unifying structure in his compositions derives partly from careful drawing. Thereafter he would lay out the basic shapes of light and dark, finally moving to the addition of color. As his health began to fail in the 1860s, so did his work. He became increasingly interested in spiritualism; a peculiar letter from "Rembrandt" that he wrote himself was a means of explaining his philosophy of painting. It also reflected his long interest in the Dutch masters.[24] At his best Mount had refreshing forthrightness. His work had a way of making contemporary life seem timeless.

Mount's work is usually linked with that of George Caleb Bingham. They both captured the gesture and character of the human figure, and both developed a narrative genre style. But the Long Islander who declined to go to Europe achieved a spontaneous and immediate touch where his Midwest counterpart suffered a contrived and harsh style by succumbing to Düsseldorf. Mount is also associated with his fellow Long Islander Walt Whitman by proximity of subject matter and approach. The sounds of the poet join in praise for his native island, that "fish-shape Paumanok where I was born."[25] His was a new poetic voice and the form of his poetry freely expressed the natural rhythms of American speech, names, and its expansive enthusiasm. The crucial quality in common was accuracy of observation.

O to have been brought up on bays, lagoons, creeks, or along the coast,
To continue and be employ'd there all my life,
The briny and damp smell, the shore, the salt weeds exposed at low water,
The work of fishermen, the work of the eelfisher and clam-fisher.[26]

At the same time this was a new poetic form, and Mount was not so new in his form of art. His technique of painting and manner of composing was closer to artists who preceded rather than followed him. Whitman, by contrast, was closer to the new vision of Thomas Eakins than to the older, Jacksonian vision of Mount. Still, the fact that Mount's work involves questions of seeing the outdoor world places him in a critical period of transition. He looks back to Hudson River painting without literary trappings; he embodies the rising democratic spirit of the age; and he anticipates the revolutionary modes of vision emerging in the second half of the century. His intensity of looking and the quiet force of his painting had parallel flowering in Fitz Hugh Lane, a New England artist whose full devotion was to the sea and ships.

100 **WILLIAM SIDNEY MOUNT.** *By the Shore.* c. 1850. Oil on paper, 10 × 14″.
The Museums at Stony Brook, New York. Bequest of Mr. Ward Melville

101 Fitz Hugh Lane. *View of Gloucester Harbor.* 1848. Oil on canvas, mounted on panel, 27 × 41″. Virginia Museum, Richmond. The Williams Fund

The Establishing of a Style

Fitz Hugh Lane was our first native marine painter of real stature.[1] Copley and Allston were painters of other subjects foremost; Cornè, Birch, and Salmon were born abroad; Blunt and Mount offer only parts of their careers for consideration. Not only was Lane a seascapist above all: he was the first to use stilled time as a means of expressing mood. Before him artists largely painted scenes of storm, turbulence, battle, or wreck. His awareness of conditions of weather and effects of light evoked a considerable number of paintings depicting unique times of day. At their best his marines surpass those by any contemporary, and it turns out that they had a widespread influence on a number of minor followers. His achievement is of a remarkably high caliber.

Lane was a highly popular artist in his own lifetime, and several times received one-man exhibitions in New England. Yet, shortly after his death in 1865 his work fell into popular and critical disfavor, due largely to what John Baur has described as a uniformity of critical taste for a long while toward American painting of the first half of the nineteenth century.[2] It was a taste that also submerged Quidor, Church, Bierstadt, and Heade. Only in recent decades has their work once again come to wide and admiring attention. The reevaluation of the Gloucester artist's serene and light-filled paintings has been astonishing in its pace. A generation ago only a handful knew and appreciated Lane's work. Now his best marines are among the most valued American paintings of this period.

Lane's ancestors were among Gloucester's first settlers in 1623; both family ties and enchantment with the sea were to hold him to Cape Ann for almost his entire life. Born in 1804, he was partially crippled in his legs as a child. Early in his youth, he turned to pencil sketching along the Cape Ann shore, a coast unusually marked by alternating curved beaches and large, dark boulders. Encouraged by local printmakers he sought and secured an apprenticeship at Pendleton's lithography firm in Boston, at that time one of the most important shops in the country. During the decade of the 1830s his artistic interests grew under the only formal training he was to have. He also profited from association with other young aspiring artists. In his *Sixty Years' Memories of Art and Artists* the painter Benjamin Champney recorded that at one point he and Lane and a number of others had studios in Tremont Temple, not far from Pendleton's shop.[3] While still at Pendleton's, Lane probably met Robert Salmon. The latter was to provide a major external source of inspiration for the young Gloucester painter (figure 86). Further stimulation doubtless came from the exhibitions of European, and particularly Dutch, painting held regularly at the Athenæum.

Lane's work is remarkable for variety of both medium and subject matter. Aside from his house in Gloucester,[4] of which he was the architect, and nearly two hundred oil paintings now known, he was also the author of close to fifty different lithographic series, some one hundred pencil drawings, and half a dozen watercolors. His ship portraits, harbor and shoreline views are best known, but he also painted two naval engagements from the War of 1812, several lovely landscapes, a few portraits, a still life, a huge sign painting, parade decorations, and an oil executed from a vision in a dream. His

102 Fitz Hugh Lane. *View of Norwich from the West Side of the River.* 1839. Lithograph, 11¾ × 16½". Boston Athenæum, Massachusetts

lithographs include commercial trade cards and music sheet covers, a book frontispiece and book illustrations, not to mention the extensive topographic depiction of many New England coastal ports. Generally, his pencil sketches and watercolors served as preliminary studies for later oils. In them he noted special details or objects that he wanted to include or he sketched out the essential contours of a coastline. Occasionally he executed a free oil sketch as another step toward a final composition, to be completed upon his return to the Gloucester studio.

Unlike most of his contemporaries, Lane drew and published his own prints. Because his lithographic training and production played a significant role in his style of painting, his graphic achievement needs preliminary examination.[5] During his years apprenticed to Pendleton, Lane did small sketches of the harbor and environs of Boston which were incorporated into the covers of music sheets. Later, on his own, he began to develop a personal style in fullsized lithographs. Three of his prints—two very rare—will give some idea of his progress in this medium. Only a few copies are known of his 1839 *View of Norwich from the West Side of the River* (figure 102). Lane recorded on it that he had sketched the scene from nature and had had it printed by Sarony and Major in New York. This suggests that even at this early date in his career he was moving up and down the New England coast in search of objects to draw and paint. Not a large print, it combines the details of a charming village harborside with a feeling for sparkling color and light. Lane's abiding concern with local topography here is characteristic of early nineteenth-century printmaking, and his *View of Norwich* is not very different from Bennett's better known city scenes (figures 37 and 89) of a few years earlier.

With the 1846 *View of Gloucester (from Rocky Neck)* a lowered horizon and a greater tonal harmony result in a new coherence (figure 103). As became an increasing practice with him, Lane based the print on an oil painting, in this case a large bright canvas done in 1844 (figure 104). A more selective choice of detail and a greater openness in the composition now contribute to that purity of mood and atmosphere which will characterize all his nature work. The

figures are more in scale with the setting, and the view embraces a more lateral panorama. Lane's clear and telling draftsmanship and his control over contrasts of tone in graphics were to contribute, in turn, to his later painting in oil.

Almost a decade later, Lane did his view of *Castine from Hospital Island* (figure 105), a large and beautiful lithograph. From several cruises down the Maine coast he accumulated many sketches of places along the coast on which he could later base paintings or lithographs. More typical of his later work is the choice of an offshore point of view. The composition is even less filled than in the earlier views, though it is still carefully ordered. Using only the single mast of the little sailboat in the foreground Lane leads the eye deftly from this area across the water to the distant shore. With evident delight he leaves more than half of the composition to the bright, thin cloud formations above the town. From the early *View of Norwich* he has moved steadily toward this spacious and serene expanse. It is a mature statement of the artist's lithographic abilities, and parallels the

103 FITZ HUGH LANE. *View of Gloucester (from Rocky Neck)*. 1846. Lithograph, 21½ × 35½". Courtesy Kenneth M. Newman, The Old Print Shop, New York

poetic style of painting that he was mastering at the same time.

Lane recognized that lithography held noteworthy characteristics of its own. In this medium, as in painting, he did not merely keep abreast of contemporary European and American efforts, but self-reliantly explored new possibilities. Consequently, his rendering of blacks and white, his lines, crosshatchings, and tonal gradations and relationships produced in his best work sensations of light and atmosphere quite different from those deriving from oil. Effects of chiaroscuro, space, and air took on a sparkling richness that came only from his feeling for the stone and what could be done with it. His marine lithographs were unique in kind and quality. No other lithographer specialized in marine views, and even the works of artists in portraits or landscapes seldom matched his. Few could combine his ability to exploit his material and to compose a large picture on stone. For his time it was no small merit to have solved distinctively the different problems of graphics and oils.

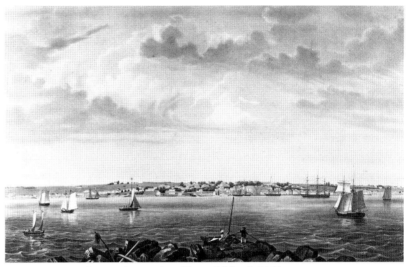

105 FITZ HUGH LANE. *Castine from Hospital Island.* 1855. Lithograph, 19¾ × 32¾″. The Mariners Museum, Newport News, Virginia

104 FITZ HUGH LANE. *View of Gloucester Harbor from Rocky Neck.* 1844. Oil on canvas, 29½ × 41½″. Cape Ann Historical Association, Massachusetts

Lane's style of painting possessed from the beginning a command of drawing and of ordering values of light and dark. One source was plainly his work in lithography; another was equally clearly his perceptive study of Robert Salmon's work (see chapter eight). Lane painted *The Yacht "Northern Light" in Boston Harbor* (figure 108) after a sketch by Salmon in 1845. Lane's painting has the concentrated visual activity typical of Salmon; in this respect it is unlike the rest of Lane's marines which tend to be expansive and quiet. Here, perhaps bound by Salmon's sketch, Lane confines his vision to the foreground, much like the older artist's painting of the *Wharves of Boston* (figure 86). One can barely see the horizon and is by no means invited to gaze off toward the open ocean or upward into the sky. This visual wandering, encouraged but always carefully directed by Lane, gives to his purest and best works a serenity and spaciousness that are his special signature. Lane frames the yacht by the partially seen ships at each side and by the dark strip of water along the bottom of the picture. The several ships are viewed from different angles, posed statically about the *Northern Light* which is the only craft to be seen from the side and with the heightened character of moving across the

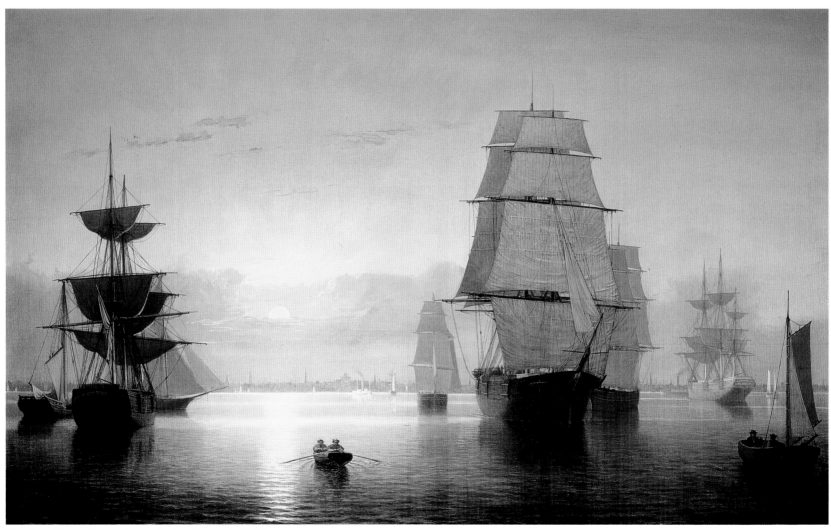

106 FITZ HUGH LANE. *Boston Harbor, Sunset.* 1850–55.
Oil on canvas, 24 × 39¼″. Collection Jo Ann and Julian Ganz, Jr.

center of the canvas. Yet Lane has characteristically frozen everything in place; in further contrast to Salmon's usually opaque pigments he relies on a thinner and more varied stroke.

The sense of space that Lane personally felt and had expressed in his early lithographs emerged clearly in his first paintings of Gloucester. *View of Gloucester Harbor* in 1848 showed his style had moved slightly away from that which he had derived from Salmon a few years earlier (figure 101). Perhaps a search for a more individual

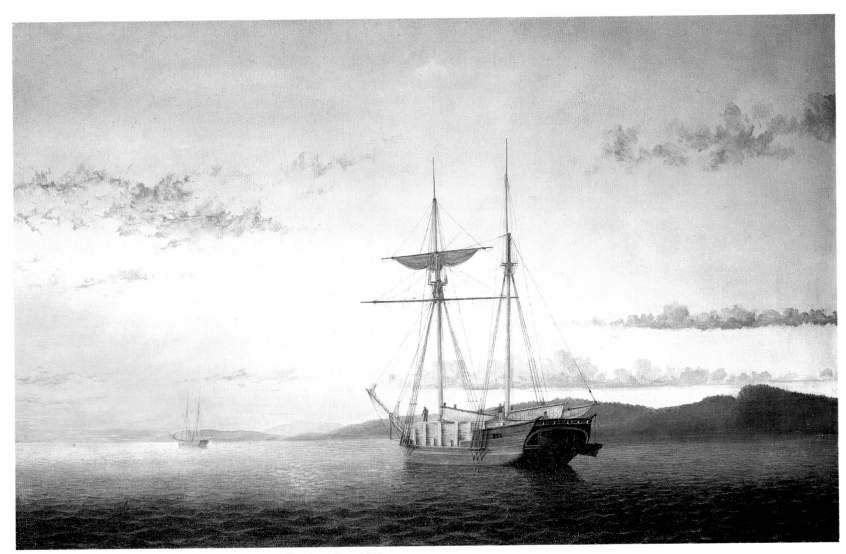

107 FITZ HUGH LANE. *Lumber Schooners at Evening on Penobscot Bay.* 1860.
Oil on canvas, 24⅝ × 38⅛″. National Gallery of Art, Washington, D.C.
Andrew W. Mellon Fund and Gift of Mr. and Mrs. Francis W. Hatch, Sr.

manner led him to this change in style and composition. There is a tightness of detail and an emphasis on narrative elements that parallel his work in lithography. He takes delight in describing the activities of several fishermen in the foreground. Throughout the painting he has worked in bright, cool colors to convey effectively the pervading luminosity in the view.

By the end of the 1840s Lane had come to maturity and he had achieved a vigorous personal style. He understood naval architecture

108 Fitz Hugh Lane. *The Yacht "Northern Light" in Boston Harbor.* 1845. Oil on canvas, 18¾ × 26″. Shelburne Museum, Vermont

and knew how to paint ships with confidence and clarity. He had also mastered the difficult talent of depicting water convincingly. Besides the more topographical views of Gloucester's inner harbor, he also turned to painting ships in rough seas. In such works he laid the paint on thickly, preferring to depict the heavy chop and the dark storm clouds. Through the selective application of impasto he could suggest the very turbulence of the scene itself. Clearly he responded to the subtleties of atmospheric and light conditions, but his full awareness of time's stillness was yet to come. Perhaps sensing this, and also in search of new subject matter, he planned what were to become annual summer cruises down the Maine coast with his close friend Joseph L. Stevens, Jr.[6]

His friendship with Stevens was to be instrumental in opening a new phase in Lane's artistic life. Stevens, Sr., was a doctor in Castine, although the family had long been in Gloucester. Lane and Stevens, Jr., probably first went to Maine to stay at the Stevens homestead in 1848. The first trip that is documented by dated

drawings took place in 1850, the last in 1855. From these few years come many of Lane's finest paintings down east, although he continued to paint Maine scenes for another decade. The impact of those visits would affect all his work until his death in 1865. He was immediately fascinated with the rugged, irregular coast and possessed by the special character of its light and air. Of particular interest to him were the unmistakable contours of Owl's Head, the Camden hills, Blue Hill, and Somes Sound and Bear Island at Mount Desert.

A new purity enters his work at this time. Eager to capture the transitional hours of the day, such as sunrise and sunset, Lane began to apply his paint in thinner glazes, using, in general, lighter colors. He composed now with greater assurance, no longer feeling the necessity to fill his canvas with objects. The effect was of stillness and lucidity. A bold spaciousness and economy emerges. Compare the earlier view of Gloucester (figure 101) with the painting of *Owl's Head, Penobscot Bay, Maine,* of 1862 (figure 109). In the later work Lane eliminates the narrative foreground elements. The eye follows the glance and the pole of the standing figure across to the distant shore. The artist takes a vantage point more detached from his subject. He does not press into the shore, but stands off in order to capture the total feeling and mood of a much broader landscape. In these late paintings of his last ten years the air is quiet. The elusive glow of pink tinges the horizon or catches the edge of a cloud. A canvas might now be only half filled with shore and boats or figures, leaving the rest to a crystalline sky. Similar gradations of the most subtle colors and glazes are apparent in his serenely evocative *Lumber Schooners at Evening on Penobscot Bay* (figure 107). Lane's control of color raises such works high above mere topography and places them among the best American paintings of the nineteenth century.

These summer visits to Maine demonstrably changed Lane's style. First evident in his work along the coast down east, this new manner soon characterized all his work in Gloucester and Boston as well (figures 106 and 117). His employment of reds, oranges, and pinks for sunset and twilight scenes may also have affected other painters coming to Mount Desert at this time, most notably Frederic Church. One of Lane's first sunset scenes done in Maine, *Twilight on the*

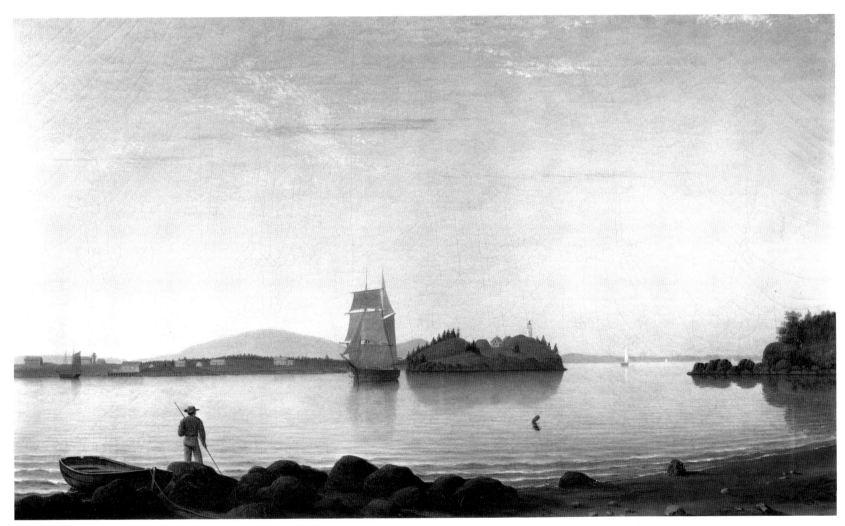

109 Fitz Hugh Lane. *Owl's Head, Penobscot Bay, Maine.* 1862.
Oil on canvas, 16 × 26″. Museum of Fine Arts, Boston.
Bequest of Martha C. Karolik for the Karolik Collection of American Paintings

Kennebec, was exhibited at the American Art Union in 1849.[7] Both M. J. Heade and Church were submitting pictures at this time, and there is good stylistic evidence to indicate that they were soon affected by Lane's romantic wilderness paintings. The next year Church made his first trip to the Maine coast (figure 48), and like Lane he returned in the summers of the next few years. Their trips of 1850 and 1855 in particular dovetailed in the late summer, and from the closeness of style in their work at this time, some association between them is highly likely.

In addition to traveling to Maine, Lane also made trips during the

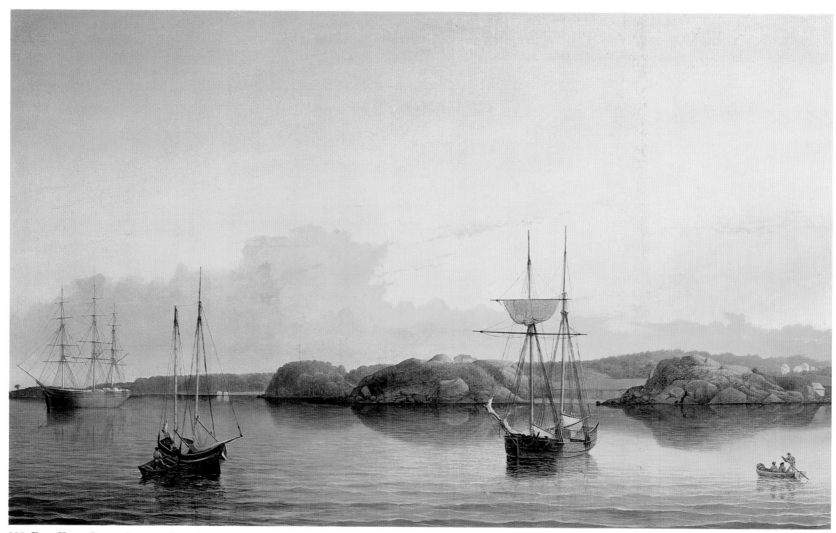

110 Fitz Hugh Lane. *Stage Rocks and Western Shore of Gloucester Outer Harbor.*
1857. Oil on canvas, 23 × 38″. Private collection

fifties to New York, Baltimore, San Juan, Puerto Rico, and possibly New Brunswick and Nova Scotia. But personal problems beset him as well: difficulties arose with his estranged brother-in-law; disappointment came over the loss of his lithographs in a major fire along Gloucester's waterfront; and he was troubled by a recurring

illness which was to take his life in 1865. Still, the paintings of his last ten years are among his best. He continued a steady production of paintings in his clear, luminous style, ever gaining in control, economy, and expressiveness.

Both intimacy and variety inform this culminating period of Lane's

career. A painting of deceptive scale—it is actually rather small—is the remarkable *Ships in Ice off Ten Pound Island, Gloucester* (figure 111). The subject must have provided a distinctive challenge for Lane; he painted a winter scene only once. Like Blunt's version of *Boston Harbor* (figure 92), this is filled with a subtle range of color. Within the various blues, grays, and browns there is a suffusing luminosity of real and reflected light. It was Lane's habit to construct his marines on simple but disguised geometric designs. Occasionally, he devised oblique triangles or flattened Z-shaped designs; in *Ships in Ice* it is a flattened X along whose arms the vessels are situated. Even the sails of the two central vessels fall along these two crossing diagonals in a complex play of their own. Such planning permits an effective means of animating the composition, leading the eye into a convincing space, and maintaining all components in a coherent whole. By means of slight asymmetry Lane alleviated possible rigidity; he always carefully balanced his ordering of nature with the recording of what he saw. It was this delicate equilibrium that raised his work above the topography of his contemporaries.

In the last two years of his life Lane turned to painting a few moonlight marines, perhaps as an expression of the solitude of his own old age. *Fishing Party* (figure 112) has a deep glow and richness that Lane may first have seen in Allston's *Moonlit Landscape* (figure 33). The earlier artist's romantic paintings were certainly on view in Boston during Lane's apprentice years, and Allston's reputation doubtless drew attention to his work long after his death. Allston's discovery of color contrasts and of glazing, which he had learned from the Venetians, had a clear reanimation in the hands of the Gloucester artist. The figures and boats silhouetted against the ghostly patterns of the sky are also reminiscent of Salmon's moonlight pictures (figure 90). The pervading warm yellow of the moon, clouds, and reflection hold attention to the center. Lane's unifying color harmonies will reappear in the work of the culminating romanticist of the century, Albert Ryder.

Lane was a well-known figure in Gloucester and Boston, and his paintings came to have a marked influence on a number of minor local artists. Because he worked alongside of John W. A. Scott in

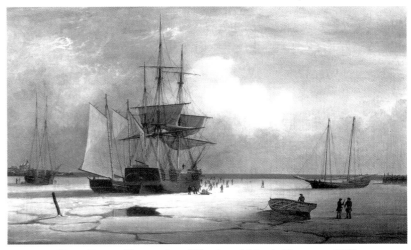

111 Fitz Hugh Lane. *Ships in Ice off Ten Pound Island, Gloucester.* 1850s. Oil on canvas, 12 × 19¾". Museum of Fine Arts, Boston. M. and M. Karolik Collection

their Boston apprentice days, Lane must have regularly exchanged ideas about painting with his associate. Together, they ran their own lithographic firm in the mid-1840s. After Lane had returned to Gloucester in 1848, Scott stayed on in Boston working at both landscape and marine painting. But Scott's ability to draw never matched Lane's. Scott independently approached some of Lane's abilities in his later landscapes, but his style always maintained a debt to the years of their association.

It is unknown whether William Allen Wall derived part of his style from Lane, but it seems likely. Wall was but three years older than the Gloucester painter; he began a career as apprentice to a watchmaker, but soon gave it up for painting. Serious study led him to become Thomas Sully's pupil in Philadelphia and from there to a European trip to copy in the galleries. Returning to his native New Bedford in 1834, Wall settled down to painting views in the local environs, some from nature and some with historical subjects such as the landing of the Pilgrims. He became adept in oil and watercolor; the *View in New Bedford, Massachusetts* (figure 113) is characteristic of his mature style.[8] Its color is much brighter than Lane's but its

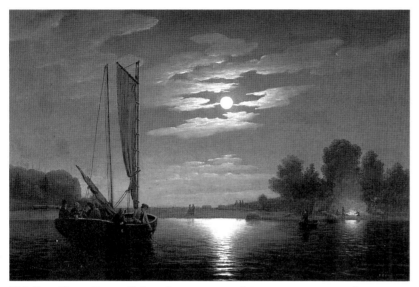

112 FITZ HUGH LANE. *Fishing Party.* c. 1863. Oil on canvas, 20 × 30″. Museum of Fine Arts, Boston. Gift of the Estate of Henry Lee Shadduck

have turned up. *View of Gloucester Harbor and Dolliver's Neck* (figure 114), bears the inscription on the reverse: "Painted by M. B. Mellen after F. H. Lane, 1870." In style it is somewhat drier than Lane's manner; the pigments seem harder and more opaque than her teacher's, but she has mastered his feeling for outdoor sunlight and the careful drawing of every detail. Its bright, airy spaciousness approaches many of Lane's weaker efforts, and one wonders how many of them now attributed to his hand may in fact be his pupil's. The difficulty does not arise often, but since he did not regularly sign his best works and since both copies and forgeries have appeared, judgment is not readily resolved.

D. Jerome Elwell was another earnest admirer. He was a generation younger, and after the beginning of a promising career studying Gloucester's then most famous artist, he left for Europe on a romantic tour that put him in contact briefly with Whistler in Venice. When one of Lane's paintings of Gloucester burned in the city hall after his death, Elwell made an exact reproduction which now hangs in the

similarity in drawing and layout to the Gloucester artist's work is clear (figures 101 and 102). The manner of placing figures in the foreground, the divided interest between landscape and marine elements, and the attention to details like foliage, rocks, and rigging recall parallel concerns of Lane. How far Wall had developed toward this style when Lane was in New Bedford to do a lithograph in 1845 is unclear. Lane had some contact with another New Bedford artist, William Bradford, and it is still difficult to say whether the association occurred locally or in Boston. It is certain that Lane knew the New Bedford–Fairhaven area and probable that his distinctive style affected painters with similar interests.

In Gloucester his influence appeared in several paintings by local pupils or admirers.[9] Among them were Mary B. Mellen, Kilby and D. Jerome Elwell. Mellen was the wife of a local preacher and a friend of the artist's. Known to have been his pupil, she was also a beneficiary of his will. Only a few signed examples of her work in Lane's style

113 WILLIAM ALLEN WALL. *View of New Bedford, Massachusetts.* 1850s. Watercolor on paper, 11¼ × 18⅛″. Museum of Fine Arts, Boston. M. and M. Karolik Collection

114 **Mary B. Mellen.** *View of Gloucester Harbor and Dolliver's Neck.* 1870. Oil on canvas, 22¾ × 38″. Collection Mrs. Philip S. Weld

Sawyer Free Library. On two known occasions Lane signed and dated paintings, both of which Elwell added in his hand that he had "touched upon, March 13, 1891." Elwell was a fair marine painter in his own right, even if at times melodramatic on top of what he learned from Lane. His colors were sometimes dull and even harsh in places, tending to exaggerated details in pink or orange, whereas Lane, even in his sketches, exercised a subtle restraint in his handling of color. Elwell had the capacity for convincing draftsmanship and for establishing a coherent spatial recession. But a dry, vacuumlike quality often overtook his work.

A relative, Kilby Elwell, likewise painted in Lane's style. Even less is known of his life or career, but he became adept at pleasing watercolors. This Elwell used the paper and thin washes to lend sensations of light and air to his scenes; his feeling for space, solid objects, and different textures showed an indirect debt to Lane.

One other artist painted extensively in the style that Lane used for stormy scenes. Clement Drew was active exclusively as a marine painter between 1838 and 1886. Although his subjects ranged from Maine and the Grand Banks to Cape Horn and San Francisco harbor, his largest group of early marines are views along Boston's south shore. In the 1860s, seventies, and eighties he painted more along the coast of Cape Ann near Gloucester. Drew could not have helped meeting Lane in Gloucester during the early sixties, or at least seeing his oils locally on view then or in later visits. While Drew's paintings never achieved the power or subtlety of mood in Lane's work, they do show a perceptive grasp of the Gloucester artist's technique. While not a conscious pupil in the manner of Mellen or the Elwells, Drew represents the lesser-known painter of a slightly younger generation than Lane's who nevertheless painted in the shadow of the older artist.[10] Reevaluation of nineteenth-century painting has gradually clarified Lane's place in the history of American art. One of the intriguing aspects of his career is his effect on younger painters. Both for their influence and for their inherent beauty, his paintings deservedly rank high in American art of the nineteenth century.

The Style Established

THERE is no documented association between Martin Johnson Heade and Lane, although most historians invariably link the two together. There is good reason; in certain instances the similarity is so close that it seems impossible for Heade not to have seen Lane's work and absorbed the older artist's style into his own. *Stranded Boat* is a variation on Heade's familiar format, and its closeness to Lane's *Brace's Rock, Eastern Point, Gloucester* is almost magical (figures 115 and 117). Aside from the immediate parallels of composition, draftsmanship, coloring and light, application of paint, and mood, both are dated 1863. Heade traveled compulsively and extensively; one of his few settled moments was a brief period of work in the Studio Building in Boston during 1861. He also went in both directions to paint the coast of Maine and Rhode Island. The most likely point of contact probably came in the early 1860s when the two artists were frequently painting along the marshy coasts of Cape Ann, Massachusetts. Heade, who was normally given to placing primary attention on the middleground and background of his painting, by

115 MARTIN JOHNSON HEADE. *Stranded Boat*. 1863. Oil on canvas, 22¾ × 36½″. Museum of Fine Arts, Boston. Gift of Maxim Karolik for the Karolik Collection of American Painting

contrast stresses the foreground hull in *Stranded Boat*. Examination of Lane's work in the same year reveals that his style did not go unchanged by association with Heade. The Gloucester artist undertook for the first time in his career a pure landscape, *View of Riverdale* (Cape Ann Historical Association, Gloucester), which he painted largely in the cool blues and greens that typified Heade's palette. Moreover, Lane astutely juxtaposed the shapely silhouettes of trees and a haycart against the landscape in a manner very similar to Heade's paintings of haystacks in the salt marshes. In still another painting of that area, *Ipswich Bay* (Museum of Fine Arts, Boston), Lane uncharacteristically left the foreground expanse relatively empty, choosing to emphasize the sun-tinted clouds and the stretch of open water off the coast. The resemblance of such a painting to the pictures that Heade was doing in the Newburyport and Ipswich marshes a few miles away is striking.

Heade's interest in marine subjects was less constant than Lane's. Born in 1819, he was early encouraged in a love of art by his father and some youthful instruction from Thomas Hicks.[1] A lifetime of travel began for Heade before he was twenty, with a trip to Italy, France, and England. In 1843 he set up a studio in New York, but was shortly at work in Brooklyn and in Trenton, New Jersey. His early work consisted of landscapes in the Hudson River manner—dense woodland interiors with filtering sunlight, carefully detailed foliage, and Claudian vignettes in a hazy distance.

In the years immediately following he appeared as far afield as St. Louis and Chicago. During the fifties and sixties he restlessly painted in Philadelphia, Providence, and Newburyport, besides Boston and Maine. His meeting with the Reverend J. C. Fletcher, whose interests ranged to natural history, led in 1863 to a trip to South America. Heade's aim in going was to paint in their native surroundings the hummingbirds that he had studied since childhood; he hoped subsequently to publish a book with chromolithographed illustrations after his oils. He stayed until 1865 in Brazil long enough to dedicate the projected work to Emperor Don Pedro II. Though he was unable to find a publisher in London for his prints, he did sell the paintings. His later years found him traveling again in South and Latin America,

116 MARTIN JOHNSON HEADE. *Twilight on Newbury Marsh*. Late 1860s. Charcoal and white chalk on paper, 13½ × 29″. Collection Jo Ann and Julian Ganz, Jr.

doubtless under the stimulation of his close friend, Frederic Church. Heade often left his belongings at Olana while he set off on long trips, and during the seventies and eighties regularly used Church's New York studio. Thus a series of circumstances and shared interests very likely brought together Heade, Lane, and Church at a significant point in the history of American art. For his part, Heade continued to travel actively to various places in the United States. Finally, in the 1880s, with his friend Church retired to Olana, he married and settled down in Florida for the rest of his long life.[2]

If his life was constantly changing and full of excitement, he instilled in his landscapes a feeling of solitude. Even less seldom than in Lane do figures appear. His canvases were unusually narrow horizontal formats; he was most at ease with canvases averaging twelve-by-twenty-four inches, but often achieved an intimate poignance in a panel only a few inches long. His less successful paintings tended to be the larger canvases several feet in length: little virtue was gained in the bigger scale, only a dissolution of design and an aggravating color scheme frequently pitched to garish extremes. He commonly divided them horizontally in half like Kensett, with whom he shared some of the same interests.[3] At their most intense Heade's paintings could be harsh and disunified; at their best they bespoke a poetic mystery.

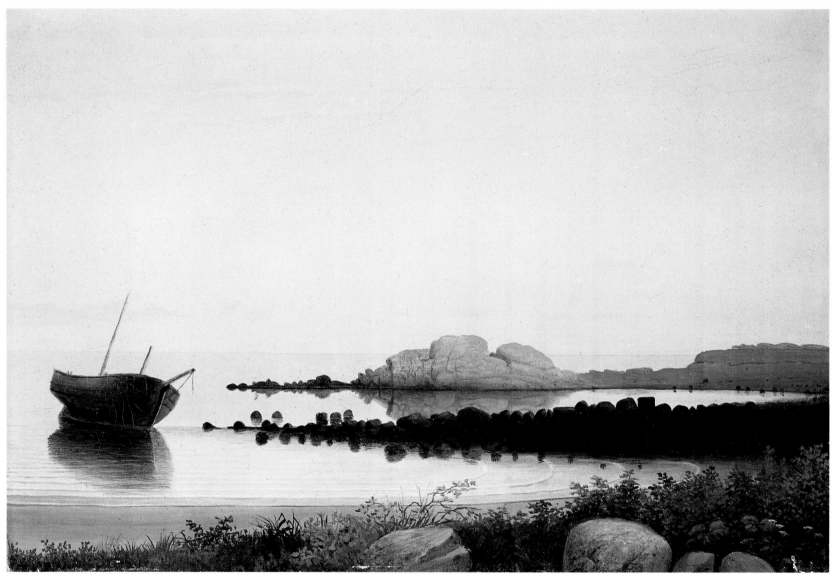

117 Fitz Hugh Lane. *Brace's Rock, Eastern Point, Gloucester.* c. 1864.
Oil on canvas, 10 × 15″. Private collection

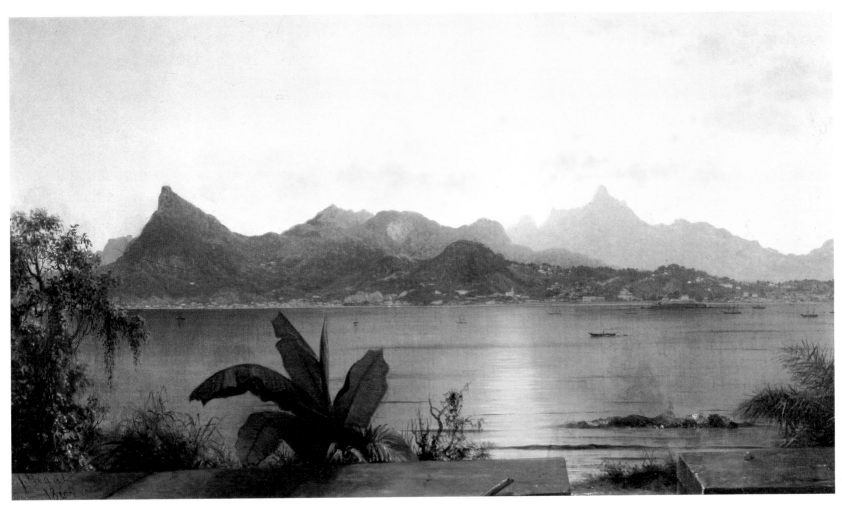

118 MARTIN JOHNSON HEADE. *Sunset Harbor at Rio.* 1864.
Oil on canvas. 20⅛ × 35″. Pennsylvania Academy of the Fine Arts, Philadelphia.
Henry C. Gibson Fund

The charcoal and chalk drawing of *Twilight on Newbury Marsh* (figure 116), one of an extensive series done near Newburyport, is especially fine. The scene is situated in the marshes between the high land of Newbury, Massachusetts, and Plum Island, whose northern tip is just visible at the right of the drawing. Directly ahead on the horizon is the light marking the entrance to the Merrimack River.

Several drawings of the subject in watercolor and charcoal precede this one, each capturing a somewhat earlier moment in the day. Together, they nicely illustrate Heade's approach to his subjects. The first is a small watercolor done in the morning, since the shadows fall opposite to the direction here. Two charcoal drawings of almost the same size as this subtly rearrange the components of the scene in an

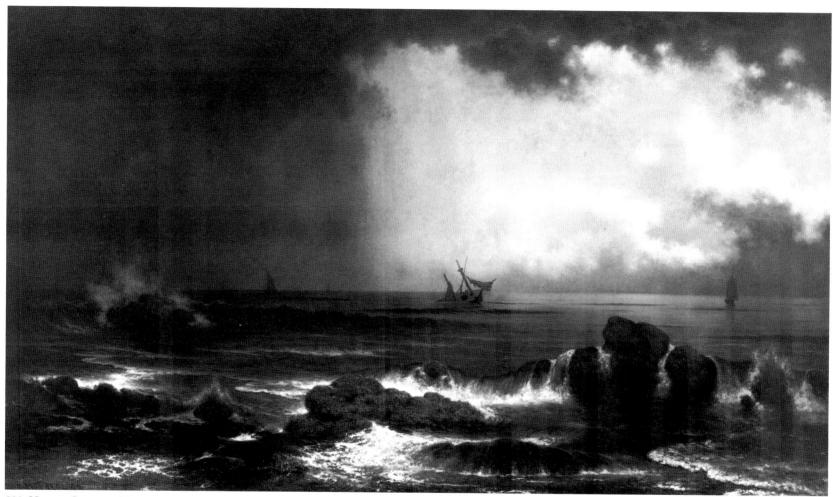

119 MARTIN JOHNSON HEADE. *Coastal Scene with Sinking Ship.* 1863.
Oil on canvas, 40¼ × 70¼". Shelburne Museum, Vermont

increasingly abstract design. In this late version dusk is on the verge of night as a line of ducks gracefully arches to earth and the lighthouse blinks on. Several of the haystacks seen in the earlier drawings are now gone in favor of a simpler, more expressive design. Even their earlier, rather vertical shapes have now become more rounded as part of the rhythmic play of silhouettes. The lines of the marsh edge, the slanting sail, and the birds all converge at the near center of the composition. The principal elements are laid out in the dark charcoal, followed by highlights in white and colored chalks. The eerie half lights and the isolated forms add to the silence that surrounds the small sailboat as she makes her way among the salt haystacks in the marsh fields. The size is small, the scene intimate, but due to a telling design and control of tones, a hypnotizing spaciousness results.

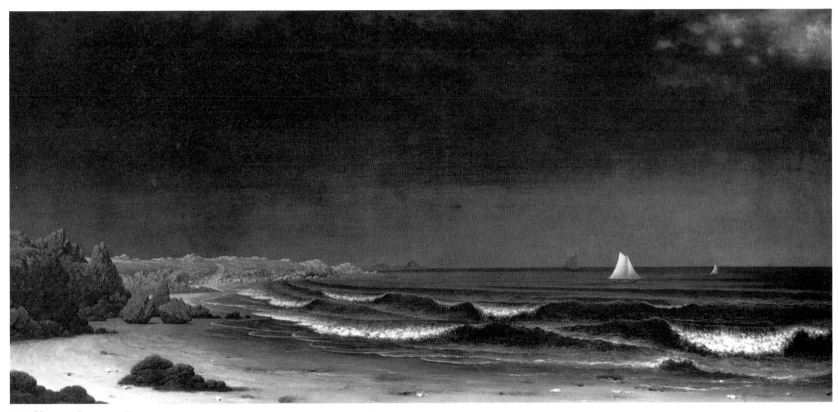

120 MARTIN JOHNSON HEADE. *Approaching Storm: Beach near Newport*. 1860s.
Oil on canvas, 28 × 58½″. Museum of Fine Arts, Boston. M. and M. Karolik
Collection. Gift of Maxim Karolik

Ordinarily Heade's canvases came from the same mold: a
foreground marked by a pool or pile of rocks, a middleground
sparsely filled with haystacks or sailboats, and the sky striated with
orange- or pink-edged clouds. This often static quality of his
landscapes carried over partly to his painting of hummingbirds.
Although in fact close-up still lifes, they invariably posed the birds
against a contrived grouping of orchids or roses. The precision of
observation and execution gave a photographic realism to the
rendering; this sharpness of outline and values of light and dark
reappears throughout his work.

Heade made few changes in his approach or technique during the
1860s. It seems that once he felt he had attained a satisfactory style
for a subject or view, he tended to make alterations only in details.
Within their special limits, both the Brazilian bird and flower series
and the coastal landscapes explored seemingly endless variations on a
theme (figure 118).

One of the best seascapes that Heade did is in a distinctive manner
of painting for him. In *Coastal Scene with Sinking Ship*, 1863 (figure
119), he commands attention for his attempt at the heavier brushwork
to convey the breaking waves and stormy panorama. It recalls similar
paintings by Doughty, Birch, and Lane. As a study of atmosphere and
effects of light, it is almost unmatched, especially coming out of a

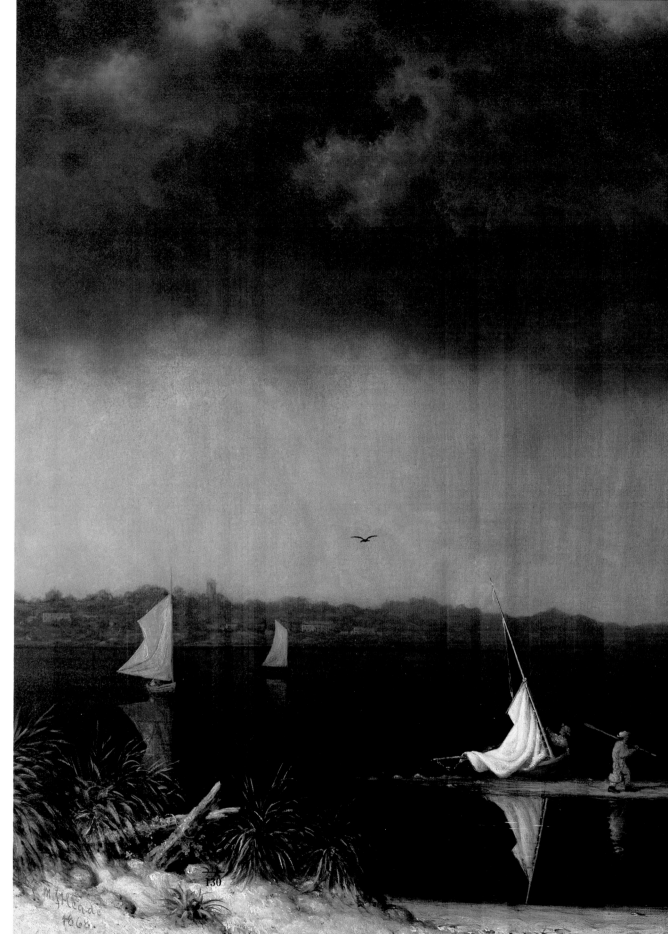

121 MARTIN JOHNSON HEADE.
Thunderstorm over Narragansett Bay.
1868. Oil on canvas, 32⅛ × 54½″.
Amon Carter Museum, Fort Worth, Texas

130

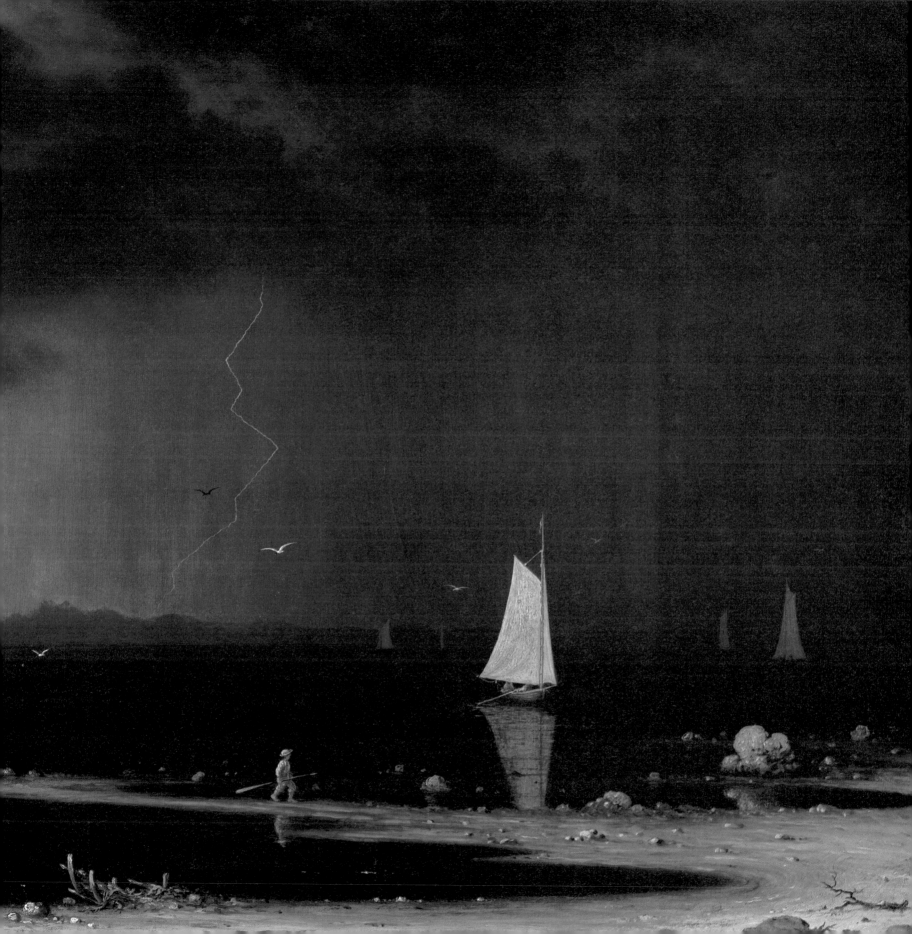

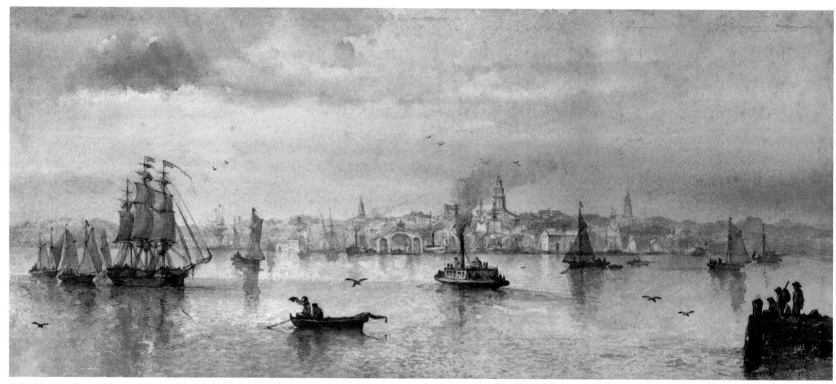

122 ALBERT VAN BEEST. *New Bedford from Fairhaven.* c. 1848. Pen, brown and
gray watercolor on paper, 12½ × 28½″. Museum of Fine Arts, Boston.
M. and M. Karolik Collection

period of anguishing intensity in the nation's civil strife.

Two other striking examples by Heade stand out: the familiar
Approaching Storm: Beach near Newport (figure 120) and the closely
related *Thunderstorm over Narragansett Bay* (figure 121). Both possess
an eerie power in their clarity of vision. The former is essentially a
dramatically darkened version of Heade's lighter landscape pastorals,
while the latter has an unusually forceful composition. Even though
the coming storm bears heavy rains, the air seems to have been
pumped out of the view. Starkly black water reflects the carefully
placed whiteness of transfixed figures and sailboats alike. Every detail
is surrealistically clear, but Heade places them economically to lead
the eye across the scene. The sense of electric tension finds

appropriate expression in the single streak of lightning that holds
clouds and water together in the design. Similarly, the three sailboats
nearest the viewer serve as transitions across critical parts of the
black mirror, in which their reflections seem unable to move. Church
had warned Heade of failure if he did not establish himself in New
York, yet much of commendable variety in his work derives from his
desire to travel. Heade's best work is sufficiently exciting and
compelling to overshadow the repetitiousness elsewhere.

Two other artists born within three years of Heade also have an
interesting relation to Lane. Both Albert Van Beest and William
Bradford probably knew Robert Salmon's work and doubtless Lane's as
well. Their jointly executed oil of *Boston Harbor* is an unusually

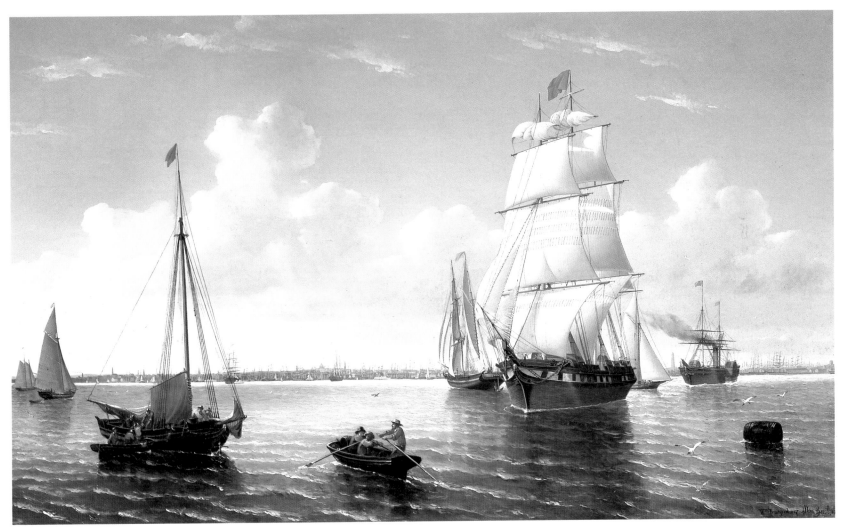

123 ALBERT VAN BEEST and WILLIAM BRADFORD. *Boston Harbor.* 1857.
Oil on canvas, 31½ × 51½″. Private collection

successful collaboration for its size and subject matter (figure 123). Its debt to similar paintings by Salmon and Lane seems apparent. Each of the two New Bedford painters developed his own individual style based on the tradition of English topographical painting which Salmon had brought to this country and to which Lane had given direction.

Van Beest, for example, chose to explore the expression of light and air through watercolor, whereas Bradford carried on the strain of realism and detailed draftsmanship.

Van Beest had been born in Holland in 1820 and had grown up on the Amsterdam wharves. After sailing and painting for three summers

124 FITZ HUGH LANE. *View of Boston Harbor.* 1854. Oil on canvas, 23¼ × 39¼″.
White House Historical Association, Washington, D.C.

in the 1840s with the Royal Dutch Fleet, he is reported to have left Holland for America in 1845. The first notice of him appears in connection with Bradford ten years later. Thoreau recorded in his journal a call he made at Bradford's studio in Fairhaven:

Visited the studio in Fairhaven of a young marine painter, built over the water, the dashing and gurgling of it coming up through a grating in the floor.

He was out, but we found there painting Van Best [*sic*], a well-known Dutch painter of marine pieces whom he has attracted to him. He talked and looked particularly Dutchman-like.[4]

Robert Swain Gifford was another pupil of Van Beest's at this time, and one may well imagine the lively exchange of ideas among these painters. Van Beest's interests naturally turned to painting local

scenes and whaling pictures, four of which were chromolithographed by Prang and Mayer in New Bedford. Contemporary accounts picture him as eccentric in dress and habit. His method of sketching or painting was rapid and impetuous.[5] In the Whaling Museum in New Bedford are spontaneous studies of cloud formations, revealing of his technique. When held in check this vitality worked to great advantage in his painting, as for instance in his watercolor of *New Bedford from Fairhaven* (figure 122). In the disposition of ships across the water, choice of viewpoint, and handling of color and brushstroke to transcribe optical effects of sunlight or atmosphere, it bears very close resemblance to Lane's 1854 view of *Boston Harbor* (figure 124) in the White House. Since Van Beest must have been in Boston with Bradford to paint their large canvas, and since the result bears such close affinity to Lane's style, there is strong reason to believe that some sort of exchange took place among them. Before his death in 1860 Van Beest also took a studio intermittently in New York.

Van Beest's strength was in applying the freshness of watercolor to breezy and more confined views along the coast. With accuracy he might transcribe lazy cows idling on a grassy point overlooking a lighthouse and a fleet of sailboats beyond. His watercolors display a fine sensitivity to sunlight and air. The pervading luminosity and the spacious recession of his work look back to qualities in Dutch marine painting of its great period, but also anticipate in the free use of watercolor as an independently expressive medium the contribution of Winslow Homer (see chapter thirteen).

Bradford's brushwork in watercolor and oil was not so loose or suggestive as Van Beest's. He was more realist than impressionist in his approach, although he shared with his associate a penchant for the close-in view of a subject. His *Study of the Fairhaven Waterfront* (figure 125) exhibits a similar accuracy in depicting sailing vessels. It is easy to see how their artistic leaning drew them together, and why Bradford too could find sympathy in both Salmon's and Lane's painting. Bradford was but three years younger than Van Beest, and had tried various occupations by the time he began to paint ship portraits for twenty-five dollars in the mid-1850s. His only training was from the Dutchman, although his early oil style also suggests an awareness of Lane.

125 WILLIAM BRADFORD. *Study of the Fairhaven Waterfront.* 1850s or 1860s. Pencil and watercolor on paper, 17⅛ × 27⅝″. Museum of Fine Arts, Boston. M. and M. Karolik Collection

126 WILLIAM BRADFORD. *"Bark J. D. Thompson."* 1855. Oil on canvas, 20¼ × 30¼″. Old Dartmouth Historical Society and Whaling Museum, New Bedford, Massachusetts

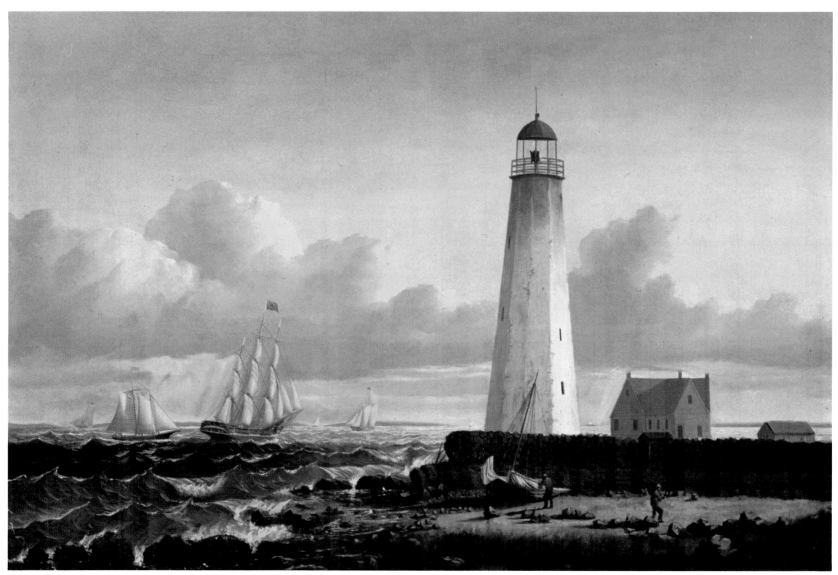

127 WILLIAM BRADFORD. *Clark's Point Light, New Bedford*. 1854.
Oil on canvas, 23 × 36″. Old Dartmouth Historical Society and Whaling Museum,
New Bedford, Massachusetts

Born and brought up in Fairhaven, Bradford admitted an early desire to paint. Like his father, a storekeeper before him, the young Bradford briefly opened a wholesale clothing establishment in New Bedford in 1852. But, as he later related, "I spent too much time in painting to succeed."[6] With the subsequent association with Van Beest and increasing sales, success soon came to him as an artist.

A typical ship portrait is that of the *Bark "J. D. Thompson"* (figure 126) from 1855. Bradford is equal to Lane and Salmon in his feeling for the fluidity of water, luminosity of light, and precision of drawing. He also executed shore views with competence, as in the 1854 painting of *Clark's Point Light, New Bedford* (figure 127). Aside from the special marks of the local topography which Bradford has included, the handling of details like the small figures in the right foreground, the breaking of the green waves on the shore, the various vessels sailing off the lee, and the bright, billowing clouds is all out of Lane's handbook. Bradford's own pictorial organization is clear and strong; large areas of light and dark work together with simple effectiveness. He learned to paint early and well both moving water and sails filled with air.

129 FITZ HUGH LANE. *New York Yacht Club Regatta.* c. 1856. Oil on canvas, 28 × 48″. Shelburne Museum, Vermont

128 WILLIAM BRADFORD. *New York Yacht Club Regatta.* 1856. Oil on canvas. 38 × 66″. Collection Edgartown Yacht Club, Martha's Vineyard, Massachusetts

Lane's and Bradford's paintings of the *New York Yacht Club Regatta* are almost identical reverses of each other (figures 128 and 129). The setting for the regatta was off New Bedford, 8 August 1856. There are fewer identifying features in Lane's work. Bradford has shown a clearer knowledge of local landmarks, and one can only speculate on the relation of the two views. Both portray the sloop *Julia* in similar scale at the center but reversed; the same schooner with sheer-streaked hull is seen to the left in each case. The treatment of the water is slightly different, and Bradford has added the excursion steamer *National Eagle* entering left and Clark's Point Lighthouse at the extreme right.[7] Van Beest joined in the collaboration in the preliminary stages. He made sketches of the *Eagle* which are now in the New Bedford Whaling Museum. More importantly, he and Bradford both signed a full-scale preliminary watercolor drawing (figure 130). In the light of their accustomed practice, Bradford probably drew the water and sailing vessels, Van Beest the sky and the figures. The wash drawing is a unique document in associating Lane with the two New Bedford artists.

After Van Beest's death Bradford went on in the 1860s to sail for

130 ALBERT VAN BEEST and WILLIAM BRADFORD. *New York Yacht Club Regatta.* 1856. Pencil and watercolor on paper, 21 × 36½″. Old Dartmouth Historical Society and Whaling Museum, New Bedford, Massachusetts

Labrador, where he could paint and photograph icebergs. With one exception he made trips to the north every summer between 1861 and 1869. Extensive accounts have survived of two excursions in particular: a log kept on the cruise of 1865 and a large, elegant book published shortly after the 1869 journey.[8] Along with the written observations about the Labrador and Greenland coasts, the types and nature of icebergs, and the activities of Eskimo and polar bears, Bradford supervised the taking of hundreds of photographs, many of which he later used as ideas for his paintings.

An immensely successful career followed in the wake of this pursuit of the exotic, so similar to Church's. Bradford got extensive backing for later trips, and was subsequently rewarded with publication of his accounts in England and with the sale in 1875 of a painting to Queen Victoria.[9] As if to match this scale of success, his style became somewhat grandiose. Many good paintings did come from his brush after 1870 (figure 132), but these trips also prompted an overproduction of pictures and, in some cases, a lessening of quality. The crisp linework of his style in the 1860s gradually

loosened and became more painterly in his work through the seventies and eighties. During these later decades he also traveled extensively in the western United States, painting the Yosemite and Mariposa valleys in California and the mountains of the Sierra Nevada, much like his fellow New Bedford artist, Albert Bierstadt. Further popularity came to Bradford in the 1880s from occasional lectures about his visits to the polar regions, illustrated with a lantern projection of transparencies based on photographs taken by him collaboratively with colleagues.[10] His reputation as a photographer and as a painter has endured as a distinctive one in nineteenth-century American art.

James Hamilton is another artist who deserves mention here. He was born in 1819, making him the same age as Heade. Like Church he studied the work of Turner and was associated with the Arctic explorer Elisha Kent Kane. In his inveterate traveling abroad he paralleled Bradford's career. Along with them Hamilton experienced first wide success and then oblivion. During the last few years he has joined many of these contemporaries in gaining wider appreciation.[11]

Hamilton is an important artist of the period in his own right, largely for the extraordinary imaginativeness that he brought to American marine painting. He was capable of painting both identifiable coastal scenes and highly inventive visions, like his well-known *Last Days of Pompeii* (Brooklyn Museum). Born in Ireland and later brought to the United States by his parents, he was self-taught, although soon able to offer lessons in drawing to others. For close to thirty years he worked out of Philadelphia, where he probably knew the many paintings of Thomas Birch in local collections. From 1840 through the next three decades he exhibited regularly at major galleries there and in New York and Boston. In the mid-fifties he traveled extensively in England and studied the work of Turner, which occasioned giving him the name of the "American Turner" upon his return. To Kane's *Arctic Explorations* of 1857 Hamilton contributed engravings after the author's own firsthand sketches. Their romantic drama places them alongside Church's and Bradford's arctic dramas.

The last twenty years of his life were spent largely in illustrating books, and in painting along the mid-Atlantic states, both on the

coast and inland. He once took naval history as a subject, and also produced some wild imaginative scenes. A visit to the New England coast in 1869 seems likely from evidence in the exhibition lists of his paintings. Three years before his death he auctioned over one hundred of his paintings in Philadelphia to support a trip around the world. This characteristically romantic vision was cut short by his death in San Francisco.[12]

Hamilton's varied work included scenes of cresting waves on empty stretches of beaches, much as William Trost Richards would take up (see figure 135). He also undertook several Civil War paintings (figure 147). The great number of his marines were ships at sea, some like the ghostly *Fishermen off Gloucester* (figure 131), others like the melodramatic *The Capture of the "Serapis" by John Paul Jones* (figure 133). The former has particular interest since it at some point had added to it a signature reading "F. H. Lane." Comparison with typical works by Lane will yield little similarity. By contrast, the liquid handling of paint in sketchy, suggestive brushstrokes and the romantic handling of light on the water bear unmistakable resemblance to Hamilton's style. Lane's handling of paint was much tighter than this; his sense of color, even in sunset scenes, was more muted.

The pyrotechnics evident in *The Capture of the "Serapis"* are derived from Hamilton's awareness of Turner's fiery paintings of the 1840s. The organization of the composition into two halves joined by a central axis of incandescent light has its specific source in the Englishman's work.[13] Hamilton's combination of history and imagination was distinctive in American art at this time. Its romantic power of expression anticipates Bierstadt's handling of a similar scene by some twenty years (figure 54). But Hamilton's loose accents of light and his hot silvery colors became his special style, one appreciated by two of his pupils and later marine painters in their own right, Thomas and Edward Moran (figure 134).

Mention of the Morans carries the style embodied in Lane and Heade in the 1860s up to the last decades of the nineteenth century. Two figures who close out this period in American art are William Stanley Haseltine and Alfred Thompson Bricher. Their misty and light-flooded canvases are an appropriate conclusion to the

131 JAMES HAMILTON. *Fishermen off Gloucester.* 1850s. Oil on canvas, 22 × 36″. Shelburne Museum, Vermont

romantic optimism that characterized much of the period.

Haseltine was born in 1835 in Philadelphia, the city of Birch and Hamilton. Like Hamilton he spent a good deal of time in Europe. His years in Düsseldorf between 1854 and 1856 brought him into close association with Bierstadt and Whittredge. The three painters journeyed up the Rhine and into Switzerland during the summer of 1856. Out of this experience in Europe came a style of clarity and precision that would come to characterize much of Haseltine's work thereafter.[14] He learned well the romantic formulas of the celebrated Andreas Achenbach, and steeped himself in the traditions of European painting. As a consequence, his paintings done in Rome breathe with the spirit of Poussin, Claude, and Corot. The year 1858 found him glad to be back in Philadelphia, where his pictures began to sell for modest but steady prices. That fall he moved to the Tenth Street Studio, soon to be frequented by Bierstadt, Church, Heade, and others. When his wife died in 1864, Haseltine turned to traveling up and down the New England coast. From the 1860s came some of his strongest and most poignant pictures.

Rocks at Nahant, Massachusetts (figure 138) is a large and fine

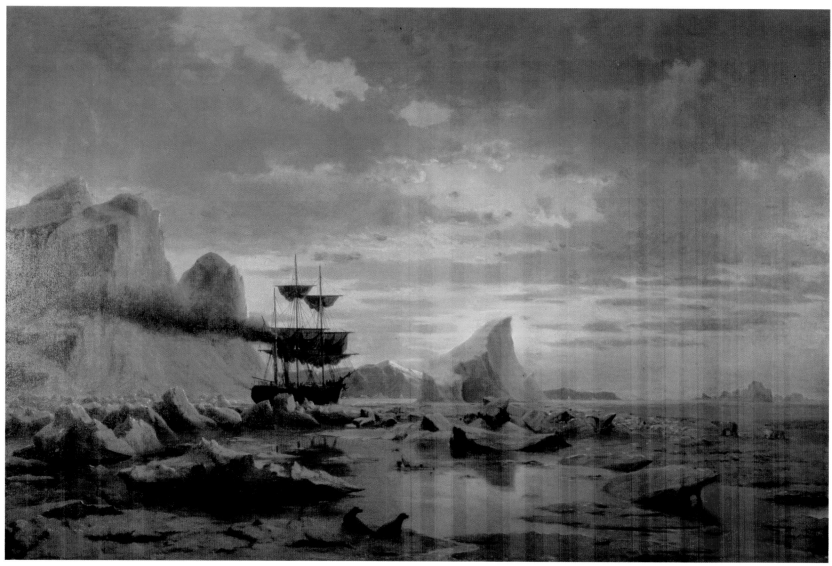

132 WILLIAM BRADFORD. *Ice Dwellers Watching the Invaders.* c. 1870.
Oil on canvas, 23 × 36″. Old Dartmouth Historical Society and Whaling Museum,
New Bedford, Massachusetts

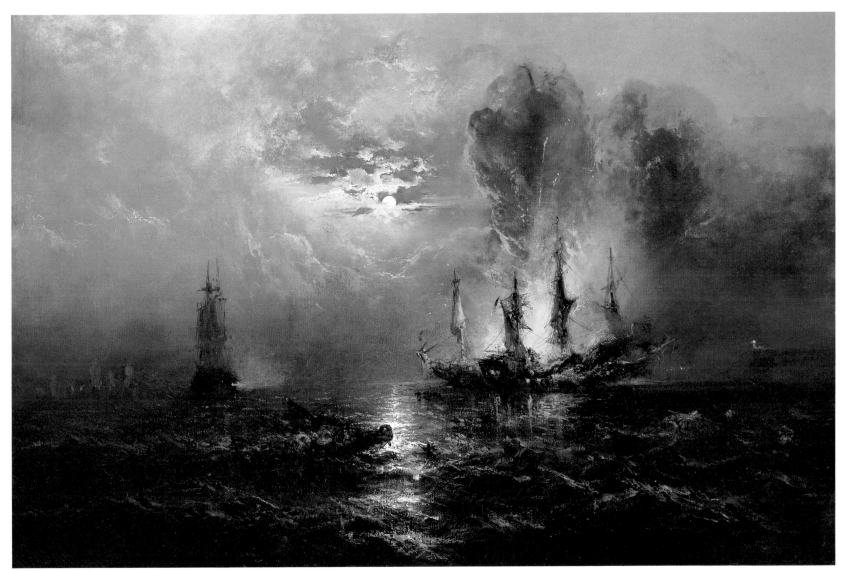

133 JAMES HAMILTON. *The Capture of the "Serapis" by John Paul Jones.* 1854.
Oil on canvas, 58 × 87¼″. Yale University Art Gallery, New Haven, Connecticut.
The Mabel Brady Garvan Collection

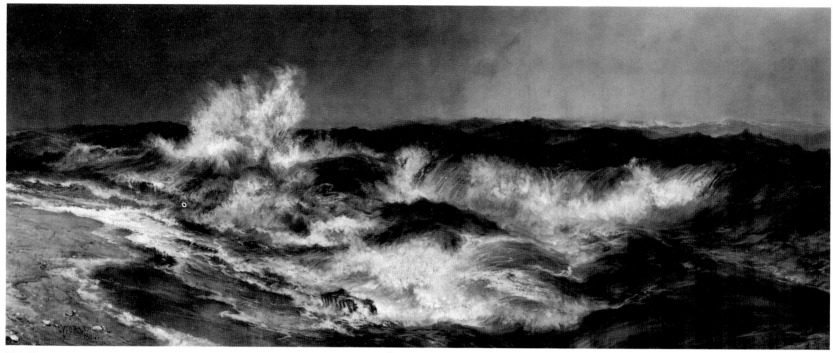

134 THOMAS MORAN. *The Much Resounding Sea*. 1884. Oil on canvas, 25 × 62".
National Gallery of Art, Washington, D.C. Gift of the Avalon Foundation

example from this period. To the left the stark promontories of rock slabs rise up from the water's edge, while the right side of the painting consists of a brilliant, almost cloudless sky and the sweep across the water to a small sailboat on the horizon. It is not unlike the format of Kensett's paintings (figures 42 and 44), possessing a similar crispness of light and air. Haseltine makes greater use than Kensett of the jagged silhouettes of rock forms against the sky, the equally strong contrasts of sunlight and shadow, and the bright lines striating the rocks just above the water. This very accuracy of observation, while grudgingly admired, came in for certain criticism in the newspaper reviews of his exhibitions: "What we miss is tenderness of color and delicate rendering; Haseltine should give due attention to the subtle and exquisite parts of nature."[15] Such a point of view was largely conditioned by the expectations aroused in late eighteenth-century

painting. Haseltine's hardness and strength of painting looked rather to the new nineteenth-century taste for realism. The painter who would soon give greatest expression to this impulse was Haseltine's contemporary Winslow Homer.

Alfred Thomas Bricher was but two years younger than Haseltine, and the two painters became acquainted in midcareer. Though he was born in Portsmouth, New Hampshire, Bricher grew up in Newburyport, Massachusetts, where he may well have had the opportunity to see paintings of local scenes by Lane and Heade. It is conceivable too, that he may have met the artists themselves. In any case he soon took up painting, and set off to sketch at Mount Desert, Maine, in 1858, the same year as Lane's first trip there. In the years that followed he sketched in northern New England and New York. By 1868 he had moved from Boston to New York, where he

increasingly took up watercolor painting. His summer trips continued to the coast near Boston and to the islands off Maine, where he painted with others who followed in Lane's footsteps (figure 140).[16] At Nahant, Massachusetts, he painted subjects close to those chosen by his friend Haseltine; at Grand Manan Island he painted in the footsteps of Frederic Church.

135 WILLIAM TROST RICHARDS. *At Atlantic City.* 1877.
Oil on canvas, 24¼ × 20¼". Collection Jo Ann and Julian Ganz, Jr.

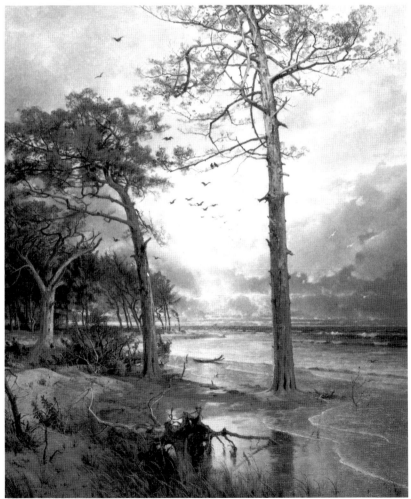

136 WILLIAM STANLEY HASELTINE. *Marina Piccola, Capri.* 1856. Oil on paper, mounted on canvas, 12 × 18½". National Gallery of Art, Washington, D.C. Gift of Mrs. Roger H. Plowden

One dazzling canvas done near Newport, Rhode Island, is that of *Indian Rock, Narragansett Pier* (figure 137) dating from the summer of 1871. Stressing the firm horizontals that Kensett and Haseltine also favored, Bricher creates a scene of abiding calm and luminous atmosphere. Especially nice is the sense of sunlit haze bathing the upper half of the canvas. Using the ripples of water in the foreground, Bricher astutely leads the eye to the massive promontory. There a bright accent of sunlight focuses attention on the figures gazing at the sailboats and the sea. His colors are predominantly pale blues and greens with touches of bright yellow, all harmoniously blended to render convincingly the sensations of summer. If critics could not agree about Haseltine's work, few found argument with one observer of a Bricher scene: "He makes the water sparkle like diamonds in a silver setting."[17]

When Heade, Church, Haseltine, and Bricher all died during the first decade of the twentieth century, more than a generation of artists

137 Alfred Thompson Bricher. *Indian Rock, Narragansett Pier.* 1871.
Oil on canvas, 27 × 50⅛″. Collection Jo Ann and Julian Ganz, Jr.

138 WILLIAM STANLEY HASELTINE. *Rocks at Nahant, Massachusetts*. 1864.
Oil on canvas, 22⅛ × 40⅛″. The Brooklyn Museum, New York

140 SANFORD ROBINSON GIFFORD. *The Artist Sketching at Mount Desert, Maine*.
1864–65. Oil on canvas, 11 × 19″. Collection Jo Ann and Julian Ganz, Jr.

141 FRANCIS A. SILVA. *Schooner Passing Castle Island, Boston Harbor*. 1874.
Oil on panel, 22 × 38″. The Bostonian Society, Old State House, Boston

139 ALFRED THOMPSON BRICHER. *Sunny Day, Grand Manan*. Date unknown.
Oil on canvas, 15 × 33″. Private collection

had passed away, and more than a century had ended. A period of painting devoted fundamentally to the picturing of light and air had come to a close. These men represented the final expression of that cult of nature which had first stirred Thomas Cole and William Cullen Bryant in the early decades of the century. Now, nature and men's attitudes toward her were undergoing a great transformation. Meanwhile, American marine painting had arrived at and sustained one of its best moments.

CHAPTER TWELVE

Wind, Sail, and Steam

ORDINARILY, the two Buttersworths are considered together. James E. Buttersworth may possibly be the grandson of Thomas, but no one is sure (see chapter eight). James was also born in England, in 1817 on the Isle of Wight. The exact date of his arrival in America is still tentative, although on the basis of pictures, probably close to 1845.[1] At one point he took a studio in Hoboken, New Jersey, and in the 1850s he did some work for Nathaniel Currier, which resulted in many of the best Currier and Ives lithographs of clipper ships. Buttersworth's first exhibited works in this country were set either on the Thames or on the Mersey from sketches or recollections of native views. The style of painting that he brought with him was in the same tradition in which Thomas Buttersworth and Salmon had worked. Paintings by James E. from his English period and from his first years in America show definite affinity to the earlier Buttersworth (figures 80 and 145).

The two Buttersworths shared not only common interests in the same type of ships, but also preferred the same pale green-gray tonalities for painting water. Their points of view further join in confining their pictures to a few vessels well placed in open but moderate seas, and engaging in coherently related actions. The regularized treatment of the choppy waves and dramatic formations of clouds in James Buttersworth's paintings especially recall parallel effects in the older artist's work.

According to exhibition lists of the American Art Union, Buttersworth turned during the fifties to painting the environs of New York harbor and coastal views along the mid-Atlantic states. But this was the material of every marine painter, and perhaps in search of a personal specialty Buttersworth took up painting the clippers. They were an obvious choice for several reasons. Popular and exciting for their extraordinary abilities to carry cargo faster than any previous vessel of their size, the clippers raced from Boston and New York to San Francisco and back in repeatedly record times. Who could fail to be captivated? But their matchless grace and beauty of design enhanced their functional capacities. Like the Brooklyn Bridge conceived in these same years, they fulfilled Horatio Greenough's ideal that an art form should be a promise of its function. The giant among shipbuilders, Donald McKay, was himself a rare mixture of artist and scientist.[2] What he produced was a combination of beauty and action, of art and personality, that Alexis de Tocqueville had noticed in the 1840s as being peculiarly American.

Samuel Eliot Morison called the clipper ship "the greatest revolution in naval architecture since the days of Hawkins and Drake."[3] Her special contribution to trade was speed, although paradoxically she was soon to disappear as swiftly as she had appeared. During her reign new activity came to the ports and shipyards of the East. Commerce reached an unprecedented peak. Prosperity and adventure filled harbors like Boston's. No wonder that artists like Lane wanted to paint them on the spot. For the painter the clippers offered a new challenge: how to translate effectively their graceful, complicated shapes? Buttersworth was among the best in answering the test with a meticulous draftsmanship and a sensitive use of color for modeling.

Buttersworth's portrait of the *Clipper Ship "Great Republic"* became widely known through the large folio lithograph by Currier and Ives after the original oil now in the Peabody Museum, Salem (figure 144). Her building by McKay aroused wide interest; she was the largest clipper ever built, and like the launching of the *Washington* which Blunt had observed in Portsmouth harbor nearly forty years earlier, the occasion was festive. Boston had a special holiday the day that the *Great Republic* went down the ways in October 1853.[4] When she burned to the water the day after Christmas, she became a legend. Although rebuilt directly after, she was reduced in tonnage and size. Buttersworth's record of the original has therefore added nostalgia to the documentation. His understanding of rigging and the setting of sails under way was unrivaled, and he matched his understanding with careful drawing. His general approach was similar to Bradford's, one popular at midcentury. Neither of them shared the crystalline rendering of minute detail and strong contrasts of value in the fashion of Salmon. Nor did Buttersworth ever attempt the spacious designs of Lane. But he became an equal master at drawing sailing vessels.

His ships in storms made particularly dramatic paintings, as for example the *Clipper Ship "Eagle" in a Storm* (figure 143). Proudly the

142 JAMES E. BUTTERSWORTH. *Westward-Ho.* c. 1853.
Oil on canvas, 29½ × 34½″. Private collection

graceful but strong vessel cuts through the turbulent seas. In a manner typical for Buttersworth he has played off the stark contrasts of darks and lights in water and sky. While the waves and the clouds have a striking visual impact of their own, they carefully lead the eye to focus on the clipper herself. The artist is one of the few who could—as Birch occasionally did (figure 77)—go beyond ship portraiture to portray a scene of larger environment and mood. Buttersworth was preeminent in creating the popular image of the clipper as the sovereign of the seas. Her feats of time and endurance were part of a tradition that went back to Allston's *Rising of a Thunderstorm at Sea* (figure 29). To nineteenth-century eyes and to many since, the clipper was the fastest and most beautiful sailing vessel ever built. Although she was to be surpassed in speed by steam vessels, her beauty was never to be matched.

The approaching end of the age of the sail was to have wide impact

both on the maritime economy of the country and on the course of marine painting. The age of steam meant the coming of a new technology which would also see full-scale development of photography. The importance of these advances was to be felt throughout the remainder of the nineteenth century and into the twentieth. Buttersworth met the decline of clipper ships by shifting his artistic interest to yacht racing in the years following the Civil War. The America's Cup competition that began in 1851 soon provided a natural source for his keen eye and ready brush.

One of the largest groups of yacht portraits by Buttersworth is now in the New York Yacht Club; many others belong to private collectors. One such is *The Yacht Orion* (figure 145). It was a prototype that he painted for the rest of his life. Buttersworth utilized pale greens and blues with creamy grays and yellows to transcribe the transitory effects of light and air. He captured convincingly the sense of water under bright sunlight and clouds. Always present, too, in these paintings is his full knowledge of naval architecture.

He nevertheless suffered in his later career from the same impulse

143 JAMES E. BUTTERSWORTH. *Clipper Ship "Eagle" in a Storm.* c. 1855.
Oil on canvas, 37½ × 26″. Courtesy The Seamen's Bank for Savings, New York

144 JAMES E. BUTTERSWORTH. *Clipper Ship "Great Republic."* 1853.
Oil on canvas, 17⅜ × 23⅜". The Peabody Museum of Salem, Massachusetts

145 JAMES E. BUTTERSWORTH. *The Yacht Orion.* Mid-nineteenth century.
Oil on canvas, 12 × 18″. Private collection

that Heade did: to paint a type over and over again. Yet individual paintings are striking in their freshness and individuality, if unordinary as compositions. Buttersworth felt deeply enough about the vessels that he painted and the conditions that animated them, but he seldom could interpret nature, give her new order or insight on canvas, as could, say, Copley or Allston or Homer. Among a host of contemporaries he was one of the last and best of a long roll of American ship and yacht portraitists. Such painting is a valuable expression of the ambitions, industry, and competitive pleasures in nineteenth-century America.

An equally indicative expression was a new type of painting devoted to steamships. Robert Fulton has come to symbolize in American history the momentous arrival of the steamboat. Of the known painters specializing in the depiction of these vessels James Bard is probably foremost. His active career from 1826 to 1890 parallels closely that of James Buttersworth. Exponent of a more primitive style of paintings, he perhaps belongs more in the company of Thomas Chambers (see chapter two). Yet his subject matter projects him beyond the world of Hudson River landscapes, the War of 1812, and even portraits of clipper ships. Steam meant inevitably a critical turning point in American history, and Bard's steamship portraiture reflected an unknowing devotion to a new age.

Bard was highly esteemed in his own time.[5] He is still considered the best in his field. In his early work, mainly of the 1830s and forties, he had the collaboration of his twin brother John. After 1849 he was on his own.[6] Addresses usually added beneath his signature indicate that he worked largely in lower Manhattan near the docks.[7] Although he often took great care in measuring the vessels which he painted, he also, unfortunately, overlooked consistency of scale and perspective. He favored predominantly the river view of a steamboat seen from the port side (figure 146).[8] And like Blunt in his early work, Bard peopled his paintings with figures curiously dressed or out of proportion. His images have certain characteristics of primitive painting: flat patterning, naive scaling and spatial relationships, and bright, arbitrary coloring. But Bard was more sophisticated than most primitive painters, a fact embodied in his actual measurements of

ships and in his effort to record correctly what he saw. He is not nearly so primitive in manner as some anonymous painters of figures, boats, or landscapes. Nor could one judge his style as primitive as that in wall decorations by Rufus Porter's generation. His is a more semiprimitive style approaching that of J. H. Wright and Thomas Chambers (see chapter two). Bard achieves some sense of space by parallel horizontal planes and meticulous observation of visual fact. His style belongs at the edge of the independent area of primitive painting, while, innocent as he was, what he chose to paint was transforming American painting and life.

If the Civil War all too severely changed American life, it had a curiously negative effect on American painting. Although Homer's early illustrations include Civil War subjects, his subsequent choices of subject would indicate that almost any variety of activity from everyday life would have satisfied him.

James Hamilton's painting of the *Naval Engagement Between the "Monitor" and the "Merrimac"* (figure 147), an exceptional Civil War image, is an expression of midcentury Romanticism. Hamilton chooses a spacious scene in which he stresses primarily the few forms of the gunboat and other sunken or moving vessels. It has the heightened drama of action typical of his other historical or imaginary scenes (figures 131 and 133). As a depiction of a contemporary event of lively interest, it is the descendant of those War of 1812 paintings by Birch, Cornè, and Thomas Buttersworth (figures 61 and 79). But in contrast to them Hamilton found relatively little material in the Civil War for his painting.

In fact, marine painting generally was interrupted more than landscape painting by the Civil War, because, unlike the War of 1812, it was fought by armies more than navies. Where ships were used, and to the most effective ends, they were steamboats. This was the first war in which vessels driven by steam were placed in combat. Though critical to the future conduct of battle, these vessels somehow never stimulated artists in the way that they had been in the age of sail. Few marines of great prominence emerge from these years: it was not a war for marine painters to record. By contrast, the fires of conflict appeared to have found more intense metaphoric expression in

the explosive storms and sunsets of Heade and Church.

Fred M. Cozzens was one artist who produced work of merit and interest at this time. Both his portfolio of Civil War chromolithographs and his later yachting paintings have enjoyed continued popularity. Along with Buttersworth he recorded faithfully in his watercolors and chromolithographs the great days of sailing in the nineteenth century.

Another artist who painted marines extensively during the Civil War was Conrad Wise Chapman, son of a history painter contemporary with Trumbull.[9] Some thirty-one paintings by the younger Chapman of views around Charleston harbor in the Civil War years are presently in the Confederate Museum at Richmond. His work possesses some variety within the scope of his subject matter, but one's attention habitually returns to the ever-present steamboat.

Good marine painting did not desist because of the Civil War: it continued throughout much of the nineteenth century. New figures were emerging, and the strains that had been running through earlier decades were soon to culminate in the appearance of three major figures, Winslow Homer, Thomas Eakins, and Albert Ryder. They

would at once summarize earlier streams of expression and contribute a new and powerful art of their own. In the meantime, the Civil War had gravely slowed shipping and commerce; thereafter the country would look increasingly westward to the continent. The middle decades were a critical turning point in many respects, for giving rise to movements of reform and to bright figures in American letters. In short, a new age was issuing from the old.

The upheaval of the Civil War marked not only the passing of the age of sail, but also the closing of the New England "Renaissance." During much of the nation's life to date this special segment of the country had put its stamp on the whole. American marine painting largely began and had its flowering here. In time American art would have broader and more important aims, but its later achievement had a preparation that many have overlooked. During the two centuries that separated the painting of Boston harbor as a setting for the portrait of *Major Thomas Savage* (figure 2) and the painting of Gloucester harbor as a setting for young boys sailing in *Breezing Up*, (figure 150) the American spirit in marine painting became a reality.

146 JAMES BARD. *Steamer St. Lawrence.* 1850.
Oil on canvas, 28⅞ × 48″. National Gallery of Art, Washington, D.C.
Gift of Edgar William and Bernice Chrysler Garbisch

Overleaf:
147 JAMES HAMILTON. *Naval Engagement Between the "Monitor" and the "Merrimac."* 1874–1875. Oil on canvas, 20 × 40″.
Historical Society of Pennsylvania, Philadelphia

The Great Age

JUST as *Moby Dick* is praised as a literary masterpiece and as an accurate historical document, so the paintings of Winslow Homer combine factual recording of nature with personal interpretation of high artistic power. As Melville represented the culmination of nineteenth-century sea fiction, so Homer plays a similar role for painting of the sea. Equally forgotten are Cooper's influence on Melville and Frederic Rondel's on Homer. Homer's career continues the devoted observation of nature by preceding American artists like Cole and Mount and Lane, although his vision and creative originality were greater than theirs. We consequently know his best work not to be figure pieces or landscapes or seascapes especially, but arresting individual paintings like *Snapping the Whip, The Life Line, The Fox Hunt.* Not merely a painter of the Catskills, Long Island, or Gloucester, he saw a view as more than a locale: as something that gained new and lasting meaning through the reordering of artistic creativity. He is a painter of visual fact, but in a larger sense than being a recorder only of Long Branch, of Tynemouth, of the Adirondacks and Canada, of Nassau, Bermuda, and Florida, or of Prout's Neck. Places provided him with certain stimulations, such that his methods of color or composition and his technique of watercolor had foremost significance.

His life belongs to a period now receiving a new kind of biographical writing. Up to the end of the nineteenth century biographies were commonly written by close friends or admirers of the subject; the twentieth century has seen the rise of more careful and more critical writing. Partially because of its proximity the second half of the nineteenth century was a natural area of popular attention. Public appreciation for major figures like Homer, Ryder, and Eakins has therefore exceeded that for most other periods. The critical work on this period is of undeniable value, and can only be enhanced by further consideration of preceding American art.

Homer's paintings seem to have a specially American character, in the tradition of William Sidney Mount and Eastman Johnson. This quality appears in his love of the outdoors and of boyhood, in his isolation of the individual against a broad natural panorama, and in his feeling for factual details, objects, and specific places. His bright palette and spontaneous touch often express a sense of vigor and freshness. This is sometimes overlooked by those who have tried too stringently to tie Homer's development to French Impressionism.[1] Although Homer shared with his European contemporaries artistic interest in recording the out-of-doors, he viewed nature more as a physical presence than as a purely optical phenomenon to be caught in paint through scientific experimentation. The illustrative, genre tradition remains through most of his work.

A. T. E. Gardner has argued that "Homer's trip to Paris was the most important event in his entire career as an artist."[2] Certainly there are similarities between Homer's painting of the 1860s, before his trip to Paris in 1866–1867, and the early Monet and Boudin; as there are between some of his late works and those of Manet. But these parallels arise more from speculation than documentation. It is clear that the influence of the Japanese print, which was making its popular debut in Paris at the time of Homer's visit, was strong. The Japanese print was useful in organizing decorative compositions, especially in the positioning and integration of figures with the total structure or format.[3] Homer was probably thus prodded into bolder viewpoints and a greater selectivity of elements; increasingly in his mature work cut-off or single figures appear, as do close-up views, near-geometric patterning, expressive linear designs, and flat color areas. Some of these characteristics also appear in Manet's work of this period, but the evidence is still arguable that Homer's art underwent a crisis as a result of contemporary French painting.

What seems likely is that Homer's early training in Bufford's lithography shop between 1854 and 1857 attuned his eye to the effective possibilities of black and white design. His ability to draw, to compose contrasts of value, and to master the subtle range of tones in engraving perhaps most prepared him to respond to the impact of Japanese prints. Both a print like *The Sharpshooter* of 1862 and a painting like *The Morning Bell* of 1866 already demonstrate a forceful sense of two-dimensional design. Homer's sense for juxtaposing areas of light and dark and for clear pictorial structure seems to have developed early. Assuredly the European trip of 1866 confirmed, even catalyzed, the artist's already maturing sympathies.

Throughout the Civil War, Homer did a large number of engravings and drawings of scenes around army camps, similar in their directness to Mathew Brady's photographs. During the late sixties and early seventies he turned more to portraying young boys on farms or young ladies in relaxed, genteel pursuits. Much of this work in the decade after the Civil War displays a fine crispness of line and silhouette.

Homer's concern with effects of light and air outdoors in a carefully constructed composition continued to his last works. During the summers of 1873 and 1880 he painted the environs of Gloucester; his major development between these years was in watercolor. Here and in the Adirondacks he pursued the challenge of putting down the instantaneous effects of light and the elusive translucence of water. For him the new medium demanded a boldness of execution and an economy that in turn permitted a frankness and intimacy of statement. *Children Playing Under a Gloucester Wharf* (figure 149) was painted in the summer of 1880 when the artist was forty-four. It represents one of the happy moments in his life when he enjoyed being with and portraying people. As the next two years would show, this was a summary style for Homer. After his trip to Tynemouth, England, his manner of painting watercolors gained new power of expression, and he correspondingly turned more to unpopulated raw nature for subjects.

Homer's ability to handle flat design, derived both from his various graphic works and the influence of Japanese prints in Paris, is apparent here in the beams and piers of the wharf which frame the scene. This device combined with the low viewpoint catches the playfulness of the subject with a spontaneous intimacy. For the most part the palette is subdued, although Homer tellingly maneuvers through all the gradations from dark to light values to distinguish between important and minor details. Color is low-keyed but lively throughout: the wharf is painted in a brown that results from overlaid blues and reds, and the clothing on the children is in brown-yellow and gray-pink, all to suggest this shadowy area beneath the dock. By contrast, Homer allows the white of the paper to show through the background sails, suggesting the bright sunlight on the water beyond.

148 WINSLOW HOMER. *Incoming Tide: Scarboro, Maine.* 1883. Watercolor, 15 × 21½″. National Gallery of Art, Washington, D.C. Gift of Ruth K. Henschel in memory of her husband, Charles B. Henschel

Complete understanding of the uses of his range of color is further evident in the holding of the brightest colors to the center, from which lower-keyed gradations radiate outward. This convincingly captures the effect of the sun filtering through onto the hat and backs of the little figures next to the dory, but serves the added functions of pulling the composition together and focusing attention into depth. Homer re-creates the sunlight and reflections of the surface of the water through differing intensities of blue applied by changing lengths or widths of his strokes. He has begun with an underlying pencil sketch to establish the essential network or structure of the picture, over which he has laid horizontals and verticals of varying sizes. His overlapping washes of color reveal a full comprehension of the demands of watercolor for selectivity and boldness. A painter can easily go too far in filling in too much, but Homer's sense for major and minor accents and for expressiveness in dry or fluid brushstrokes

149 WINSLOW HOMER. *Children Playing under a Gloucester Wharf.* 1880.
Watercolor on paper, 8 × 13¼″. Museum of Fine Arts, Boston.
The Hayden Collection

makes this work technically polished. Subtle, too, is the compositional balance between animate and inanimate. The three center sailboats are aligned over the three children clinging to the dory, while the fourth child at the left is connected by the curving gunwale of the dory to the boat at the upper right. In this simple, unobtrusive arc the artist carries our view from foreground to background while also pulling together the major components of the design. Such intuitive integration of space and surface in painting

contributes to raising Homer's work from charming genre to an art of lasting aesthetic merit.

Homer's Gloucester watercolors were generally small, intimate, and descriptive. In some cases they served as preliminary studies for a subsequent oil; in this manner a watercolor study entitled *Sailing the Catboat* of probably 1873 provided the source for the familiar oil *Breezing Up* (*A Fair Wind*) three years later (figure 150). Both watercolor and oil have a bright coloring and a lively brushstroke. In the study a lighthouse is seen on a distant point to the right, which Homer has replaced in the oil with the fullsailed schooner sailing on a parallel with the catboat. While there is an obvious interest in capturing the brilliance of light and the splash of the waves, Homer seeks to stress the activity of these boys out for adventure. To this end the addition of the schooner enhances the sense of their movement diagonally toward the horizon. The cut-off sail also leads the eye in swiftly from the corner and creates a feeling of instantaneous visual action.

Most scholars believe that Homer's later English trip was the critical one.[4] How striking a change occurred in Homer's style because of the English trip is evident in a comparison of *Breezing Up* (figure 150) with the watercolor *Fisher Folk in a Dory (Tynemouth)* of 1881 (figure 151). During two years spent mainly in the fishing village of Cullercoats near Tynemouth, Homer concentrated extensively on watercolor as a full expression in itself. The drama of the North Sea at this isolated English port became a significant catalyst in his development of a bold, monumental style. The new freedom and powerful economy that he attained carried over into all his subsequent painting. It is possible that Homer was influenced by the English watercolorists and, more provocatively, by the Elgin marbles.[5] Whatever the stimulation, Homer embraced a new approach to both his watercolor technique and the depiction of figures in a composition.

Where in *Breezing Up* there is a robust innocence and boyish excitement, there is in *Fisher Folk* almost no action. The earlier bright palette and energetic brushwork have yielded to subdued colors and soft, translucent strokes. Most of the faces are turned away. The figures are no longer framed by architecture or landscape, as they were in *Children Playing Under a Gloucester Wharf*, but stand out isolated against nature and detached from the viewer. The format is similar to *Breezing Up*, but the viewpoint is slightly lower; we no longer look into the cockpit and visually join the boys in their sail. Even the unstepped mast of the fishing boat in *Fisher Folk* remains critically within the edge of the paper at the left. Just as the color is more restrained, so too are the flickering contrasts of light and shadow and the active silhouettes of the boys. Here the forms of fishermen are more at one with the boat and their task of survival. In all of Homer's figures painted at Cullercoats there is a new monumentality in their stark juxtaposition against the local cliffs and breakwaters. This new mood of man's heroic struggle against nature is a major turn in Homer's work, much more so than the crystallization of former ideas that seem to have taken place in the earlier trip. The English interlude signaled changes in technique, composing, and attitudes toward his subject matter. One may trace the genesis of important later paintings like *The Fog Warning* (1885) and *The Gulf Stream* (1899) back to the format of *Breezing Up*. In those paintings a single boat diagonally heads for the left horizon while in the right distance is the single sailboat or rising waterspout, replacing the lighthouse or sailboat in the previous paintings. Yet the tone of these post-Cullercoats paintings is altogether different from *Breezing Up*. Forsaking the portrayal of everyday life and outdoor activities, Homer struck the deeper themes of man and the forces of nature. By confronting them now with fresh personal ability he gave them compelling meaning. Confidently he reached the great years of his career with variety and force.

Within a year of his return from England, Homer settled in Prout's Neck, Maine. He took a house, which still stands, facing the sea and the brunt of northeast storms. Heavy striated cliffs fall down to the water from beneath the house. This was the appropriate place for his present frame of mind and artistic interest. In the late 1880s figures appeared less and less in his views as he turned to painting the drama of nature herself. The sloping rocks of Prout's Neck and the wild breakers occupied his central attention in all seasons of the year and in both watercolor and oil, as *Incoming Tide: Scarboro, Maine* and *Winter Coast* demonstrate (figures 148 and 152). Here he could work out basic artistic problems of structure in solid forms as well as

150 **WINSLOW HOMER.** *Breezing Up (A Fair Wind).* 1876.
Oil on canvas, 24⅛ × 38⅛″. National Gallery of Art, Washington, D.C.
Gift of the W. L. and May T. Mellon Foundation

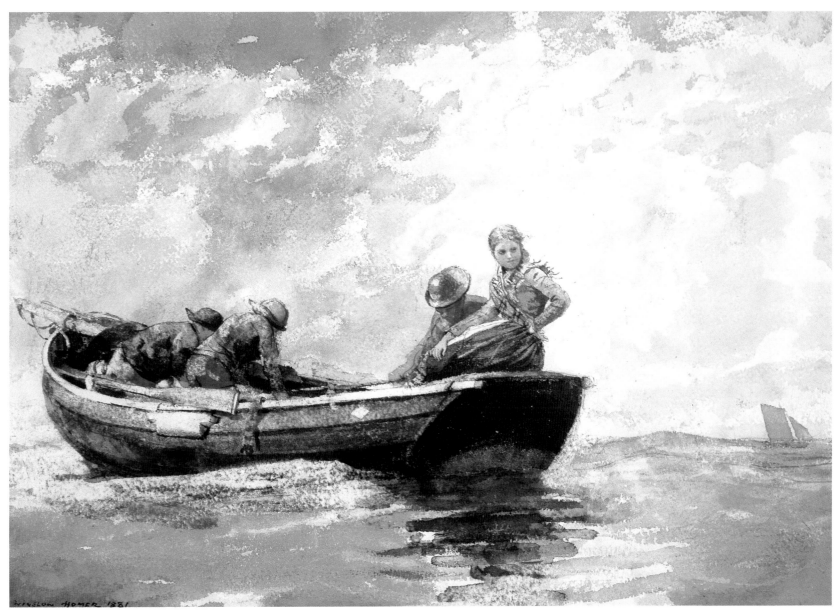

151 WINSLOW HOMER. *Fisher Folk in a Dory (Tynemouth).* 1881.
Watercolor over graphite on white wove paper, 14 × 19″.
Harvard University Art Museums, Cambridge, Massachusetts. Anonymous Gift

the elusive fluidity of water and sunlight. By using oil in *Winter Coast* he could build up the heavy quality of the sloping piles of rock and the towering spectacle of the surf beyond, so that the dark figure is almost lost in the middleground. By contrast, watercolor permitted more experimentation with catching the spontaneous designs the breakers made as they fell on the underlying rocks, each glinting in the light. At the same time Homer caught other moods in paintings of this type, among them *The West Wind* and *A Summer Night*, but all possessed a common romantic drama. He worked with large, simple designs to express the expansive power of nature. These later works by Homer again suggest a parallel with Melville, who sought to give form to the forces of nature in his characters. About Melville F. O. Matthiesen wrote, though he could equally have been writing of Homer, that he:

developed his basic contrasts between land and sea, and between calm and storm, both for their own dramatic force, and as his most powerful means of projecting man's inner struggle.[6]

This search to convey man's struggle with nature and his own inner conflicts motivated much of Homer's work in the decade following the North Sea experience. The power evident in his work was largely missing in that of his imitators and followers. The empty ocean and coastal expanses by Frederick Waugh and Paul Dougherty lack in cogency of design or expressive meaning when put alongside Homer's Maine paintings.

Ever looking for new subject matter, Homer pursued his skills in oil and watercolor to the last years of his life. Although he maintained his artistic strength up to the time of a cerebral hemorrhage two years before his death in 1910, painting important oils after 1900 like *On a Lee Shore*, *Kissing the Moon*, and *Right and Left*, he seemed to have achieved greater fluidity of expression in watercolor. Technically, his most significant contribution to American art is the development of full expressive power in the medium of watercolor. Like the English watercolorists Turner, Constable, and Bonington, he painted actual outdoor conditions with a fresh eye. As engraving was symptomatic of the Renaissance style and etching of the Baroque, watercolor emerged as a suitable expression of modern interests in the nineteenth century.

Once settled in Prout's Neck, Homer soon sought periodic visits to Nassau, Cuba, and Florida, and later to the Adirondacks and Canada. While maintaining his ability to compose pictures of strength, he rediscovered the vividness of bright colors temporarily subdued in England and Prout's Neck. Under the hot sun of southern climates his style gained new warmth. In the cool air of northern woods it took on fresh sparkle. Single figures, animals, birds, or fish occasionally appeared now, but usually silhouetted against open landscape or translucent water. The late watercolor *Leaping Trout* of 1889 (figure 153) and oil painting, *Right and Left* of 1909 (figure 154), combine his lifelong concern with expressive designs and facility for rendering the glistening colors of clear water. They often have unusual close-in points of view, and cut-off space to either side and in depth. For example, the ducks in *Right and Left* seem almost frozen into the two-dimensional pattern. The sense of scale in the painting is partially disturbing, yet Homer describes movement and stillness with deceiving simplicity. His fishing pictures frequently exhibit a similar use of curving shapes to convey an instantaneous moment in the course of action. There is no sentiment in these paintings: only the sensations of vigorous motion objectively recorded. Homer's was a masculine, even primitive world, from whose often lonely power man could draw his strength. Yet always tempering the wild forces of nature's face was a meditative quality that strikes the soul. "Yes, as every one knows, meditation and water are wedded for ever."[7]

The scientific bent in Thomas Eakins was as evident in his approach to art as much as it was absent in either Homer or Ryder. Eakins's lifelong interest in photography is well known.[8] The human figure in motion intrigued him, and he made its natural beauty central to his painting. When the renowned photographer Eadweard Muybridge made his experiments of taking sequential pictures of galloping horses, Eakins followed up his natural curiosity by corresponding with Muybridge. The impact of photographic composing and instantaneity appears in much of Eakins's painting of the seventies and eighties. The integral concern with outdoor light appeared also in much of his early work of sailing or sculling activities on the Schuylkill and Delaware. After 1885 Eakins turned

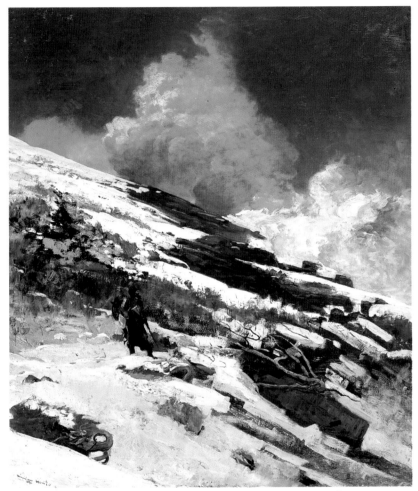

152 WINSLOW HOMER. *Winter Coast*. 1890. Oil on canvas, 36 × 31″.
Philadelphia Museum of Art. John G. Johnson Collection

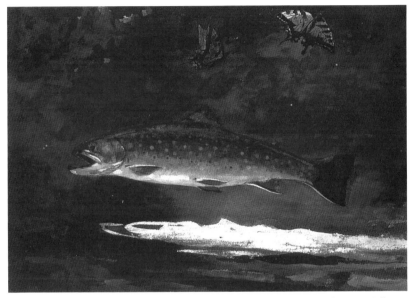

153 WINSLOW HOMER. *Leaping Trout*. 1889. Watercolor on paper, 13¼ × 19¼″.
Museum of Fine Arts, Boston. William Wilkins Warren Fund

154 WINSLOW HOMER. *Right and Left*. 1909. Oil on canvas. 28¼ × 48⅜″.
National Gallery of Art, Washington, D.C. Gift of the Avalon Foundation

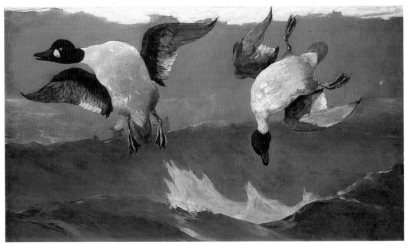

increasingly to portraiture, producing the most penetrating American
portraits since Copley, and arguably the greatest in American art.

While Eakins's taste for mathematics and science reflected a new
post-Civil War mentality, his training also drew on traditional
influences of the past. He combined study of academic drawing with

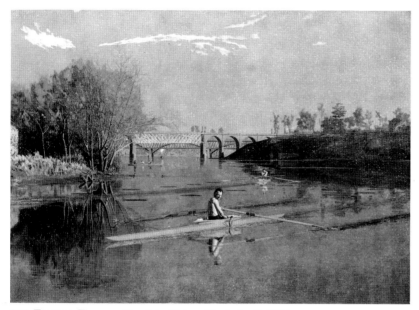

155 THOMAS EAKINS. *Max Schmitt in a Single Scull.* 1871.
Oil on canvas, 32¼ × 46¼". The Metropolitan Museum of Art, New York.
Alfred N. Punnett Fund and Gift of George D. Pratt

anatomy. On both counts he found in Paris sympathetic instruction from Gérome, a painter in the manner of Ingres. Later, in 1869, he discovered the warm tonalities of Spanish painting, especially Velásquez. His own portraits over a decade later would reflect not only a penchant for the standing format, but the rich contrasts of lights and darks, and the expressive power of faces and hands. After his return to America he taught painting at the Pennsylvania Academy of Fine Arts until the precepts of his art led to dismissal in 1887. The important paintings of *Walt Whitman* in the same year and of *The Agnew Clinic* in 1889 signified the focus of his later artistic attention.

Eakins's marine subjects fall almost completely within the years of his early maturity. His interests in the functioning of anatomy, the properties of photography, and the application of mathematics to the construction of a picture conjoined in his well-known series of scullers and boaters around Philadelphia. Of these among the more

familiar are *The Biglin Brothers Racing* and *Max Schmitt in a Single Scull* (figures 155 and 157). Rendering every detail of figures, objects, and landscape, Eakins comes close to the optical precision of photography. He chooses a day of broad clarity, filled with light and atmosphere. He makes articulate use of reflections and the linear shapes of shells and oars to construct a complicated pictorial network. During the seventies he often worked out careful grids and perspective lines to delineate the dimensions of space in his pictures. Within this space the subtle selection of critical details and placement of components in telling relation to each other gave coherent depth to his views. As a result, the rowing paintings have a deceptive organization around a wide variety of angles and curves integrated both as a design on the surface and also locked together in space. Their tight drawing and clear coloring enhance the sense of photographic stillness.

The characteristic devices of a photograph are apparent in other sculling scenes of the seventies. Eakins would cut off the stern of the shell at the edge of his canvas or some reflection of the lower edges of the painting, much as a single frame of film might. In employing such a framed view to define space and the relation of figures to it, Eakins parallels similar efforts by his French contemporary Edgar Degas in his series of ballet dancers. Eakins never uses Degas's extreme juxtapositions of near and far-off space, or severely cut-off and telescoped views, but both men share a consciousness of photography's contribution to art. *Sailing* (figure 156) consists of a deceiving but selective arrangement of horizontals, verticals, and flat diagonals. By distinct contrast to Ryder and even more than Homer, Eakins here stresses the creation of an illusion of space. The astute placement of the plane of the sail allows the lines of its edges to establish the receding perspective. As the eye follows the gentle arc of the peak of the sail and the diagonal of the sprit, it moves by implication back to a point on the horizon just to the left of the small sailboat in the background. This calculation of lines and planes in a play of their own lends visual interest and optical accuracy to the view.

Eakins displayed similar sureness in the displacement of forms in *Sailboats Racing on the Delaware* of 1874 (figure 159). The relation of

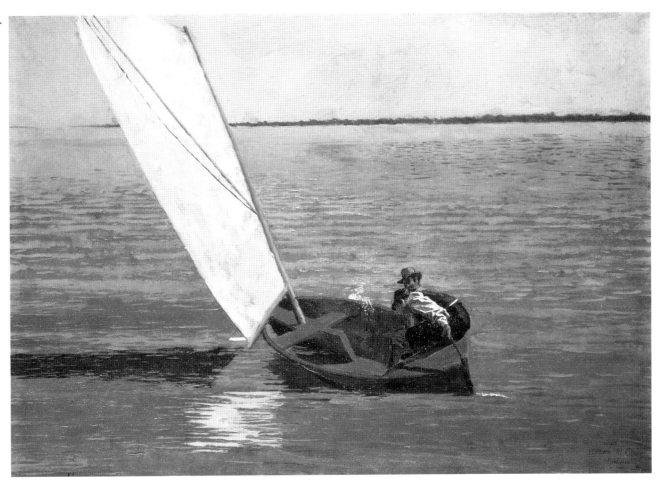

156 THOMAS EAKINS. *Sailing.* 1874.
Oil on canvas, 32 × 46⅝".
Philadelphia Museum of Art.
The Alex Simpson, Jr., Collection

sails to the direction of the wind and to the surface of the water has a unifying mathematic harmony. Fairfield Porter has described the process succinctly: "The painting became a projection of the figure on a vertical plane, like an architect's elevation."[9] The formula worked with equal success for several varieties of these river scenes, among them single scullers, others in pairs and fours, as well as larger groups of yachts anchored or racing. It was a type of painting that clarified the artist's preponderant curiosity about the uses of scientific techniques in his art. Eakins parallels not merely the rising

importance of photography, but also the development of the telescope and microscope. His concern with optics was therefore a natural one of the age. Yet it was still rooted in the older Hudson River efforts to document nature, without the transcendental qualities of the earlier Emersonian vision. Just as true photography was the outcome of preceding developments of daguerreotype, camera obscura, and silver plate, so the recording of nature by Eakins and Whitman was a culmination of former efforts to picture the outdoors with increasing objectivity as the century proceeded.

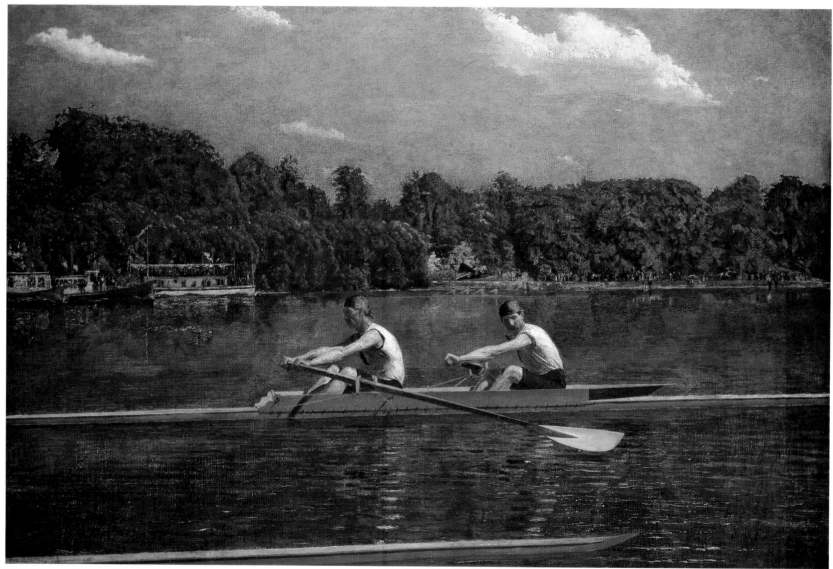

157 THOMAS EAKINS. *The Biglin Brothers Racing.* c. 1873.
Oil on canvas, 24⅛ × 36⅛″. National Gallery of Art, Washington, D.C.
Gift of Mr. and Mrs. Cornelius Vanderbilt Whitney

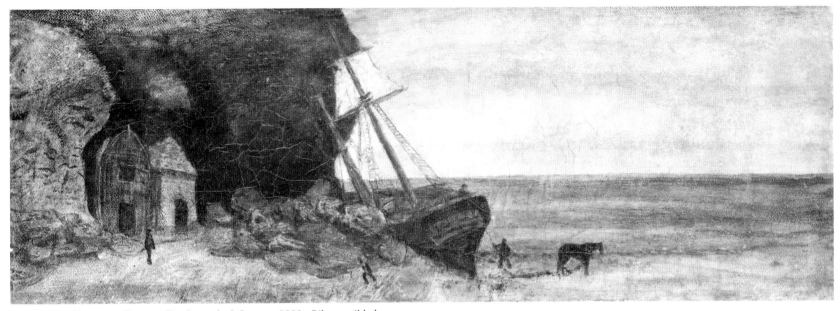

158 ALBERT PINKHAM RYDER. *The Smugglers' Cove.* c. 1900. Oil on guilded
leather, 10⅛ × 27¾". The Metropolitan Museum of Art, New York. Rogers Fund

The strain of objective recording endured from the earliest
likenesses of Colonial portraiture. The tradition was fed by both
Dutch and English realism in painting, but it became American in its
own unique passion for nature. Bred of the image of a new world, the
richness, wonder, and opportunity of the land itself, this American
passion could not help but shape our arts. By the second half of the
nineteenth century industrial technology was producing precision
instruments that would have wide scientific and artistic effects.
Science and the arts were allied in the American spirit as early as
Benjamin Franklin and Thomas Jefferson; figures like Samuel F. B.
Morse, William Rimmer, and John James Audubon continued the
mold in the nineteenth century. Eakins' alliance with photography
becomes a high point in this tradition.

If Eakins's single sculls glided on water keenly observed by the
outer eye, Albert Ryder's lonely boats sailed on a sea of the inner
eye. Pensiveness imbued Ryder's paintings with a unique quality, for
he chose to let forms convey imaginative sentiment. His poetic
reveries stirred pictures far from Homer's objectivity. Like the families
of many painters of the sea before him, Ryder's own family was active
in shipping and trading. He was born just before midcentury in New
Bedford, where, earlier, Bierstadt and Bradford had grown up. The
inward-turning mind of Ryder found landscapes within rather than
without: remembered and imagined. This personal self-sufficiency
often allies him with Emily Dickinson, whose written poetry had the
same originality and introspection. Ryder's poetry was purely
pictorial; even though he drew themes from romantic poets and
biblical stories, his were visionary interpretations. Unlike Homer and
other painters in the American realist tradition, Ryder hardly ever
painted from nature, relying rather on the evocative power of his
feelings and associations. For his lonely course of painting he

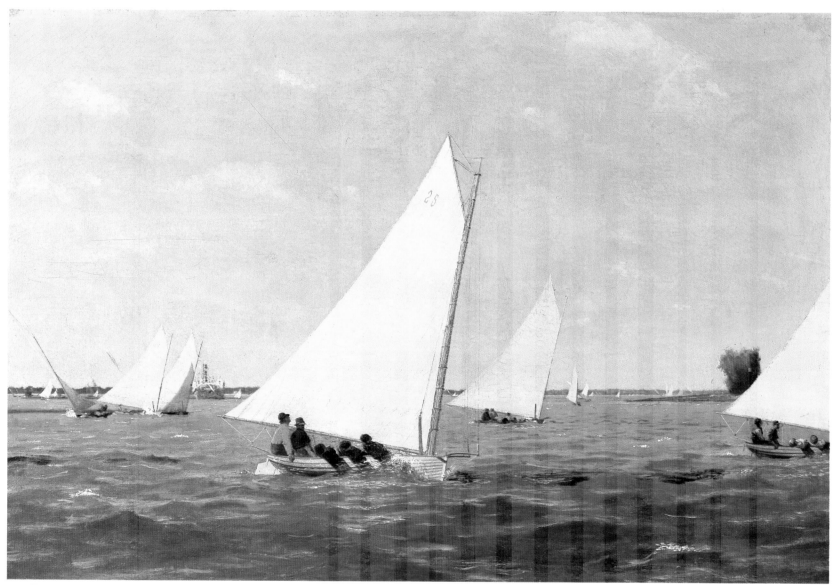

159 THOMAS EAKINS. *Sailboats Racing on the Delaware.* 1874.
Oil on canvas, 24⅛ × 36⅛″. Philadelphia Museum of Art.
Given by Mrs. Thomas Eakins and Miss Mary Adeline Williams

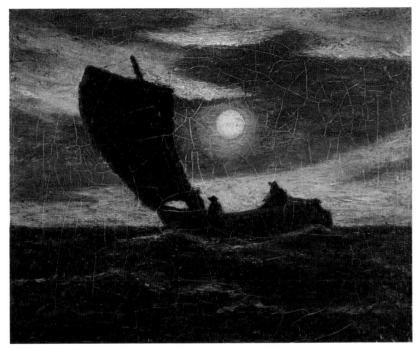

160 ALBERT PINKHAM RYDER. *Toilers of the Sea.* c. 1900.
Oil on canvas, 10 × 12″. Addison Gallery of American Art,
Phillips Academy, Andover, Massachusetts. Gift of Miss L. P. Bliss

Right, above:
161 ALBERT PINKHAM RYDER. *The Flying Dutchman.* c. 1887. Oil on canvas, 14¼
× 17¼″. National Museum of American Art, Smithsonian Institution, Washington,
D.C. Gift of John Gellatly
Right:
162 ALBERT PINKHAM RYDER. *Moonlit Cove.* 1880–90. Oil on canvas, 14⅛ ×
17⅛″. The Phillips Collection, Washington, D.C.

received relatively little fame in his own lifetime. His detachment
from outdoor naturalism and literary illustration deflected favor from
his work to that of more conventional contemporaries, many now
unknown.[10]

As a youth Ryder began painting landscapes and farm scenes
synthesized from the countryside around New Bedford. He bathed
these pastoral idylls in the golden light of transitional hours, setting
the key for his later moonlight marines. The choice of quiet scenes

and half-lit moments of the day is reminiscent of an earlier romantic, Fitz Hugh Lane. But Ryder's was a self-made imagery; even the shapes of trees, houses, and cattle assumed evocative capacities in these early paintings, to many of which he gave lyrical titles like *Summer's Fruitful Pasture*. Through a heavy plastic brushwork he created sensual textures and simple impressionistic shapes that would give a generalized sense of the universal and infinite. His colors for the most part consisted of creamy pinks, hazy yellow, lemon, orange, amber, brown, and black-greens. Due to a regrettable lack of technical understanding of pigments many of Ryder's paintings have suffered irreparable discoloration.

His most famous paintings were a series in which many bore the title of *Toilers of the Sea*, and they are especially strong in evocative colors and patterns (figure 160). They reflect the mind of a man who would travel to Europe not for what he could see abroad but for the experience of the sea on the boat across. Much more than Homer he composed in masses. He used line not for its own sake but as part of rhythmic contours. Rich, opaque colors, large curving shapes, and carefully placed areas of dark and light were the ingredients of his formula; through them he embodied his other-worldly visions.

> On this wondrous sea
> Sailing silently,
> Ho! Pilot, ho!
> Knowest thou the shore
> Where no breakers roar—
> Where the storm is o'er?
>
> In the peaceful west
> Many the sails at rest—
> The anchors fast—
> Thither I pilot thee,—
> Land Ho! Eternity!
> Ashore at last![11]

Emily Dickinson captures Ryder's mood of reverie on the infinite, on that sea wed to meditation. Her assonant rhythms built around "r" and "s" sounds correspond to Ryder's rounded shapes and symbolic generalizing of the scene. Though his pictures were small, as her poems were short, they described an eternal space. For Ryder the single boat tossing on a universal sea bore man's own lonely voyage. This romantic quality of mystery belongs to the same vein struck half a century earlier by Washington Allston, who also used the suggestiveness of pigment and color in the half-remembered world of his *Moonlit Landscape* (figure 33).

Occasionally Ryder painted interesting variations on his theme, as in *The Smugglers' Cove* and *Moonlit Cove* (figures 158 and 162). In the latter, large round flat forms fill the canvas. Like a cup the beached dory fills the saucer of the cove, while a yellow cloud reinforces the profile of the cliff. Though a moonlit scene, these generalized shapes glow with a light that could easily be daylight. But Ryder seeks to convey the sensations of an inner mood, not an outer observation. The *Smugglers' Cove* has a secretive mystery, too, uniquely enhanced by the long narrow format and the application of paint on gilded leather. Again an infinite sea occupies almost half the canvas. The vessel seems to cling to the shore and the huts to the interior of the cave. The powerful emptiness of some areas and the dark masses in others serve well the artist's haunting dreams.

Pushed to its extreme, Ryder's painting, as he saw it, reduced nature to three essential areas of sky, foliage, and earth.[12] In *Constance* he simplified the components of his marine to their utmost (figure 163). A somewhat more realistic nocturne than other moonlight marines, *Constance* comes from Chaucer, one of several literary sources from which Ryder drew. However partially illustrative, there is no Chaucerian narrative: only the brooding peace of an infinite seascape. Although Ryder confines the subject to the lower third of the canvas, he lends equal visual interest through rich coloring and heavy scumbling to the upper portion, also horizontally divided into wide bands of clouds. Loneliness balances tranquility.

Two major literary marines were more ambitious, *The Flying Dutchman* and *Jonah* (figures 161 and 164). Except for the vision of God at the top of the canvas, the scene of *Jonah* is filled with the writhing forms of churning waves. In the center the dark shape of the whale fuses into the trough of the sea, while Jonah is almost

immersed in the foam of pigment below. Ryder interprets the spiritual turmoil of the event through the expressiveness rather than actuality of forms. *The Flying Dutchman* presents the ghostly legend with a similar unreality. This mystical apparition charges the paint with a fusion of warm colors and almost amorphous forms. Some of this distortion appeared to a milder degree in John Quidor's fanciful Hudson River voyages. However Ryder was less concerned with time and place, and the world of mind and memory that he painted was a rich personal effusion. Through his singularly original art Ryder gave the physical world symbolic meaning. In this he gave fresh expression to the continuing undercurrent of American Romantic painting and literature. He was little possessed by the macabre and grotesque that often haunted the dark tales of Poe or the sense of evil that Hawthorne felt or the note of heroic tragedy that overcame the paintings of Allston and West. But he continued their poignant melancholy and sense of nature's immanence, just as did his literary

164 **ALBERT PINKHAM RYDER**. *Jonah*. c. 1885. Oil on canvas, mounted on fiberboard, 27¼ × 34⅜″. National Museum of American Art, Smithsonian Institution, Washington, D.C. Gift of John Gellatly

163 **ALBERT PINKHAM RYDER**. *Constance*. 1896. Oil on canvas, 28¼ × 36″. Museum of Fine Arts, Boston. Abraham Shuman Fund

contemporaries Melville and Emily Dickinson. Ryder was one of the most modern artists of his time, and for it little appreciated until the twentieth century. The effect on a spiritual descendant like Marsden Hartley is natural. While of a tradition, he remade it.

In differing ways Homer, Ryder, and Eakins carry the major currents of American painting into the twentieth century. The implication of photography ultimately meant that artists would have to turn to other areas and subject matter, including nonrepresentational painting, to create an original expression. Homer, Eakins, and Ryder lived their last years in a world quite changed from their youth. Symbolic of the decade in which all three died was the New York Armory Show of 1913 which officially introduced the twentieth century into American art.

165 GEORGE BELLOWS. *The Gulls, Monhegan.* c. 1913. Oil on panel, 11 × 15⁵⁄₁₆″.
Addison Gallery of American Art, Phillips Academy, Andover, Massachusetts.
Gift of Anonymous Donor

Toward New Directions

I<small>T IS A</small> revealing fact that in the 1913 Armory Show Albert Ryder was represented by six works, while Homer and Eakins were virtually overlooked. Of the three, Ryder seemed at the time the most modern to the early twentieth century, because he alone painted subjects of increasing interest to the modern tastes—the world of the mind and imagination. His romantic visions were intensely personal and subjective. His handling of paint and color was stressed and explored for its own properties. Painting was not dependent on describing what the eye saw, but was devoted to expressing what the soul felt. Reality in the twentieth-century view was no longer what nature said it to be but what the artist said it to be. As everyone knows, one course for such thinking would ultimately be abstraction.

The work of Homer, Eakins, and Ryder in the closing years of the nineteenth century represents the principal concerns of American painting at the time. Contemporaries took up one or another variation on their manners of painting or approach to nature. While this generation summarized much of what had occupied American artists throughout the century, it also anticipated much of what was to develop in the new century. William Morris Hunt deserves inclusion here for his particular brand of Impressionism that parallels in some ways the interests of Homer and Eakins in painting light and air.

Much of Hunt's life was spent in travel or study abroad; he was in frequent contact with other artists and familiar with current art developments in France; and he expressed himself articulately about art in lecture, conversation, and letter. His proper New England family was able soon to send him to Europe. Study in Rome and in the fashionable academy of Düsseldorf during the 1850s was followed by work under Couture in Paris. Under the spell of Millet and the Barbizon School, Hunt returned to Boston in 1855, and proceeded to Newport, where during the late fifties John LaFarge came to join him. Here Hunt worked largely with landscape, although when the Civil War forced a move back to Boston, he turned increasingly to portraiture. His much-celebrated portraits and many charcoal sketches reveal Hunt's continuing interest in light and dark and in textures. A strong feeling for the living quality of people and things led to further landscape painting. In 1872 a fire in Hunt's Boston

166 W<small>ILLIAM</small> M<small>ORRIS</small> H<small>UNT</small>. *Gloucester Harbor.* 1877. Oil on canvas, 21 × 34¼″. Museum of Fine Arts, Boston. Gift of H. N. Slater, Esther S. Kerrigan and Mrs. Ray S. Murphy, in memory of Mabel H. Slater

studio destroyed most of his work. This became a turning point after which he began to travel into the country to paint Newbury and Magnolia, Massachusetts. A trip to Florida followed in 1874, and by 1877, two years before the end of his life, Hunt found himself spending the summer in Kettle Cove on Cape Ann. His palette had been lightening all the while; his brushwork was looser and more evocative.

Of the painting depicting *Gloucester Harbor* (figure 166) that dates from this summer, Hunt admitted that he had painted it in one afternoon, but by working from nature, felt that for once he had captured a sense of outdoor light. Painted primarily in a light key with yellows, whites, and intense blues, the picture gains a further sense of light and air from the rough, sketchy brushstrokes. The horizon line divides almost equally the areas of sky and water. The brightest colors in the center serve to focus attention, while the two arms of the shoreline curve around to the foreground where the dark

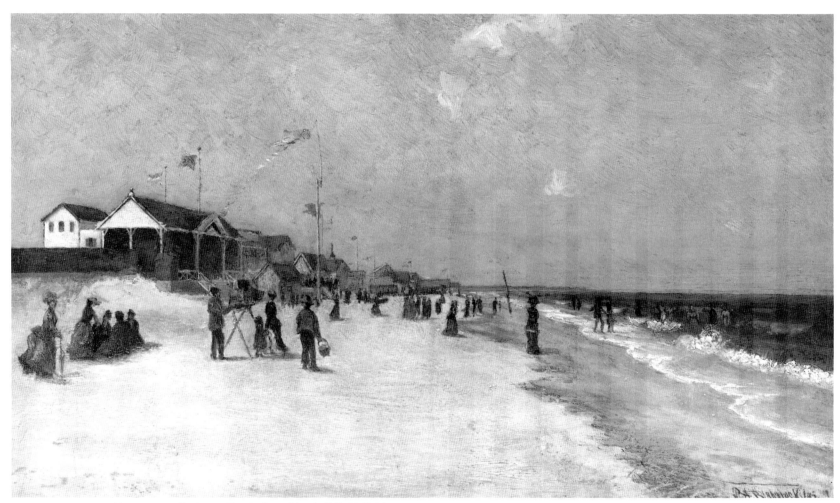

167 RALPH ALBERT BLAKELOCK. *Rockaway Beach, Long Island, N.Y.* 1869–70.
Oil on panel, 11¾ × 20″. Museum of Fine Arts, Boston.
M. and M. Karolik Collection

wharf and barge seem to embrace one's view into depth. Broad churning strokes define the windcarried clouds in the sky, while shorter, more narrow touches of paint capture the water's reflections and translucence. This is not the tight, rarified realism of Lane's topographical approach, but a soft and sensitive treatment of an outdoor scene in the manner of Millet and the Barbizon School. The selection of elements is simple; the dark foreground objects invite the eye to pass over them or through the central opening and move by graded degrees of color and light into the distance. Through control of brushwork and palette Hunt has successfully recreated the bright, almost tangible atmosphere as it clarifies or dissolves the physical setting.

The year after this painting came the commission to decorate the Capitol at Albany, New York, with large allegorical murals. *Gloucester Harbor* was the summary of a special type of subject and manner of painting for Hunt before turning to the culminating panels of his last years. In this single work was embodied his whole feeling for nature, his adeptness at translating some of the initial discoveries of French Impressionism into an American idiom, and his attuned sympathy for a particular locale.

Hunt's contemporary Ralph Blakelock was, like Ryder, a tormented and isolated soul. These two further shared the dubious distinction of being among the most widely forged of nineteenth-century American painters. Blakelock passed the last decades of his life confined in a hospital, which the unscrupulous took as the opening opportunity to market paintings under his name at will. At his best Blakelock is known for moody and haunting moonlight paintings, sometimes with Indian encampments, usually just with a field, a few trees, and a small pond to catch the reflections of light. His prevailing tonalities were deep greens and browns, highlighted with golden yellows. He experimented freely with his mixtures of paint and solvents, often repainting or glazing partially dried surfaces. As a consequence many of his paintings have irreparably darkened or cracked. Those that have survived in relatively good condition have a luminous depth and glow to them unequaled by any of his contemporaries.

One atypical painting of Blakelock's permits mention of him in the present context. His painting of *Rockaway Beach, Long Island, N.Y.* (figure 167) has a brightness and a breadth that one seldom sees in his work. Taking a subject more likely for Homer or Hunt, Blakelock shows a leisurely group at the beach on a sunny day. The fluttering flags and foamy breakers suggest a carnival atmosphere, such as that which will characterize the work of Maurice Prendergast (figure 175). Although having none of the somber introspection of his familiar moonlit landscapes, the painting exhibits the personal brushwork of Blakelock in the impasto used for the water and the free scumbling of paint in the clouds.

A blend of the subjective expressiveness of Ryder and Blakelock with the objective recording of Eakins and Homer appears in the work

168 GEORGE INNESS. *Coast of Cornwall.* 1887. Oil on canvas, 32 × 42".
Art Institute of Chicago. Charles H. and Mary F. S. Worcester Collection

of George Inness. Inness's early work was largely in the Hudson River School manner and based on compositions by seventeenth- and eighteenth-century masters. In the 1850s he made trips to both France and Italy, where his style began to change more in the direction of that exemplified by the Barbizon School. During the 1860s he came in contact with Swedenborgianism, which gave his work a new theoretical and mystical turn, and in the 1870s with Impressionism, which stimulated fresh interest in expressive brushwork and color. By the mid-eighties Inness had developed a highly personal manner and his work from here on out was to have a special character of its own. In his later work he conscientiously explored his formulated theories of composition and design, carefully integrating the various areas and forms in his paintings.[1]

Typical of this last period is the *Coast of Cornwall* (figure 168), done in 1887. Figural and landscape elements complement each

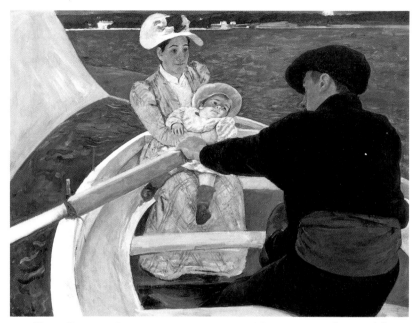

169 MARY CASSATT. *The Boating Party.* 1893–94. Oil on canvas, 35½ × 46⅛″. National Gallery of Art, Washington, D.C. Chester Dale Collection

Museum, New York), owes more than its title to the interpretation of that subject by Ryder. Among more recent and abstract paintings the work of Arthur Dove, Mark Tobey, and Mark Rothko stands as a final expression of Ryder's subjectivity. In their paintings hovering areas of color express entirely personal moods and emotions. Sometimes the artist suggests a subject, as in Dove's *Fog Horns* (Colorado Springs Fine Arts Center) or, more generally, as in Rothko's and Tobey's panels that are reminiscent of areas of land, sea, or sky.

While the great figures of Homer, Eakins, and Ryder were creating an expression that was especially American, many of their contemporaries felt it necessary to pursue their careers in Europe. Among the better known were John Singer Sargent, Mary Cassatt, and J. A. M. Whistler. Their marine paintings are intimately bound up with the more cosmopolitan developments occurring in European art,

170 JOHN SLOAN. *Clouds and Sunlight, Gloucester.* 1915. Oil on canvas, 24 × 30″. Bowdoin College Museum of Art, Brunswick, Maine. Bequest of George Otis Hamlin

other; the whole painting is unified through the rich textured brushwork and glowing colors. Linear and silhouetted forms play off one against another, each softened or accented by the dense atmosphere. A storm is stirring up the clouds and water, while fishermen are making for shore to bring in their boats through the surf. At the left the water boils around the looming cliff, itself accented by the white form of the gull.[2]

The Romantic tradition in painting, which culminated in the nineteenth century with Ryder, had another exponent in Elihu Vedder. His more surrealistic pictures like *The Lair of the Sea Serpent* (Museum of Fine Arts, Boston) add still another dimension to paintings of the imagination done in this period. In the opening years of the twentieth century, perhaps the painters most notable as spiritual descendants of Ryder were Arthur B. Davies and Louis Eilshemius. The latter's painting of *The Flying Dutchman*, 1908 (Whitney

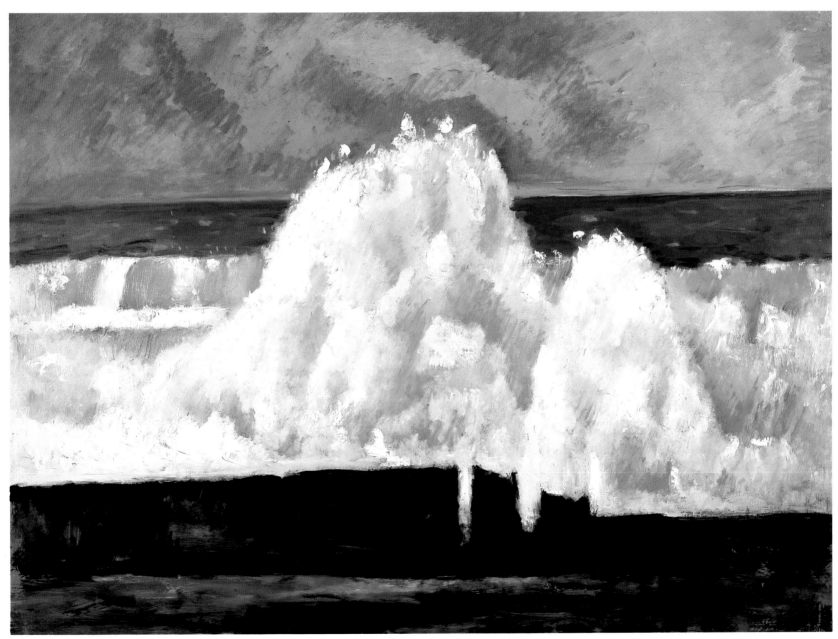

171 MARSDEN HARTLEY. *The Wave*. 1940. Oil on fiber board, 30¼ × 40⅞".
Worcester Art Museum, Massachusetts

such as the concerns with surface design, color harmonies, and expressive brushwork associated with aspects of Impressionism (figure 169). Not until the period of the Ash Can School and the Armory Show after the turn of the century would American artists again attempt to assert the importance and interest in native subject matter.

Two of the leading figures in this generation were George Bellows and John Sloan. Both men had experience as graphic artists, and therefore were familiar with the possibilities of expression in black and white. Their subsequent work has a strength of form and a feeling for contrasts that doubtless derives from work in newspaper illustration and lithography. The painting by Bellows of *The Gulls, Monhegan* (figure 165) in particular has a boldness of form and richness of texture that once more remind of Ryder's work. With broad liquid strokes of paint Bellows captures the powerful shapes of the Maine island in a manner also recalling Homer's late paintings. But here there is no confrontation between the forces of nature. Rather a strong light bathes the scene and creates a feeling of spacious clarity. Working swiftly, Bellows varies his brushwork to distinguish among the different components of his picture, notably the house, foreground rocks, distant hillside, water, and clouds. With even quicker accents he adds the final notes of the seagulls circling in the center of the view.

Sloan's painting of *Clouds and Sunlight, Gloucester* (figure 170) makes an instructive comparison with views of that area by earlier artists, for example, Lane, Homer, and Hunt (figures 101, 149, and 166). It is a setting to which other younger painters would also come, in particular Childe Hassam and Maurice Prendergast (figures 172 and 175).[3] Strong contrasts of light and dark inform Sloan's painting. With a brushwork almost as heavy as Bellows's he builds up the massive rock forms of Cape Ann in the foreground as well as the lowering clouds in the distance.

In Marsden Hartley's paintings we see the powerful inheritance of Ryder's style and temperament. Hartley very much admired the older painter, and his haunting portrait of Ryder is as telling as the older man's own painting of himself. Lonely and romantic, Hartley sought serenity and tranquility in the large rock formations of the mountains and the coast. This twentieth-century visionary found power and meaning in the raw elements of nature. He painted the churning surf, the great glacial boulders, the shells and dead birds washed up on beaches with an aggressive style of strong outlines, heavy impasto, bright, intense colors, and big, simplified shapes. Human figures seldom enter his work, and when they do, they are similarly abstracted into mobile patterns.

The photographer Alfred Stieglitz was an early champion of Hartley's; aided in his trips to Europe during 1912 and again in the late twenties, the artist developed a style that successively passed through all of the schools of painting current in the first decades of the century. The need for roots in America brought Hartley to Franconia, New Hampshire, where he spent the summer of 1930. Exhausted from work in the wilds of nature, he went to Brooklyn in the fall to be troubled further with bronchitis. Early the following spring of 1931, notice came of the award of a Guggenheim fellowship, and Hartley made plans to travel in the Southwest and Mexico later in the year. Meanwhile he went to Gloucester to pass a quiet summer of work and relaxation. After Mexico and another visit to Germany, personal disillusionment once more gripped him, and he returned to Dogtown during the critical summer of 1934. This was followed by trips to Bermuda and Nova Scotia, and yet a third time to Dogtown in 1936. These three visits to Cape Ann produced a series of paintings that are strong in power and expressiveness, and suggest in each case that he found fresh creative stimulation among the ancient remains. These special rocks left by glaciers provided a permanence of natural force; Dogtown was a symbol, if subconscious, of the past, of roots in the present, and of a continuing imperturbability. This place seemed to crystallize the fermentations of Hartley's wanderings, to the degree that the year after his third visit he began painting in Maine and produced the first version of his *Fishermen's Last Supper*, a landmark in his career.

In the paintings of Dogtown, as in much of Hartley's later work, lies his acknowledged debt to the landscapes of Cézanne, the marines of Ryder, and the murals of Orozco, Rivera, and Siqueiros. Using the basic volumes of cylinder, cone, cube, and pyramid to give a

172 CHILDE HASSAM. *Inner Harbor, Gloucester*. 1918. Lithograph, 7¾ × 11⅝".
Museum of Fine Arts, Boston. Gift of Miss Kathleen Rothe

monumental character to his forms, Hartley treated landscape almost as enlarged still life. Strong value contrasts of bright colors and broad planes with clear outlines helped to create a massive oversimplification that is deceiving. But with simplification came a new basic style that would reappear in the paintings of Popocatepetl in Mexico, Mont Sainte Victoire in France, the Alpine peaks in

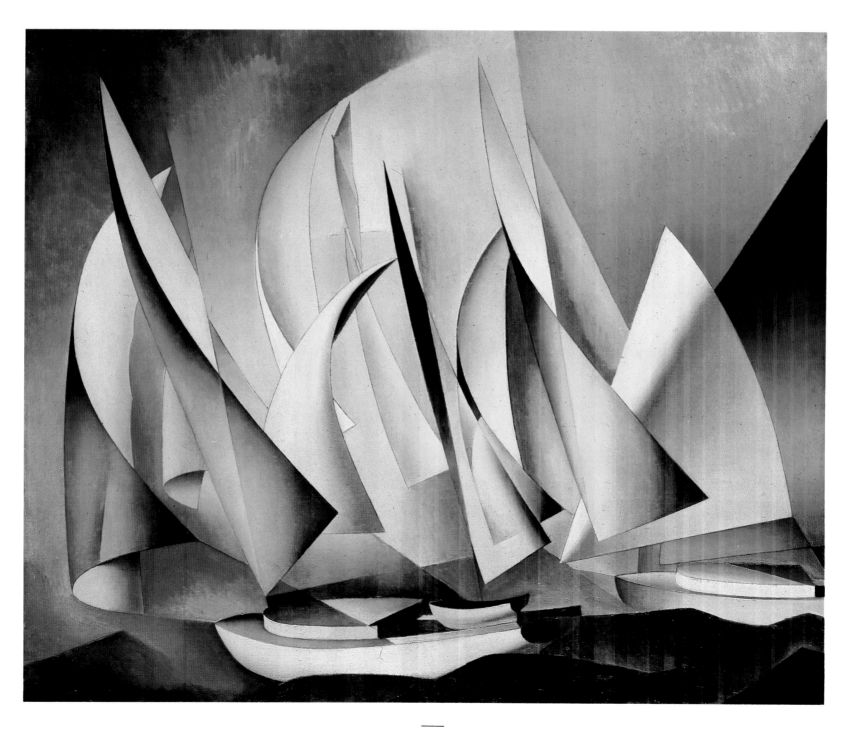

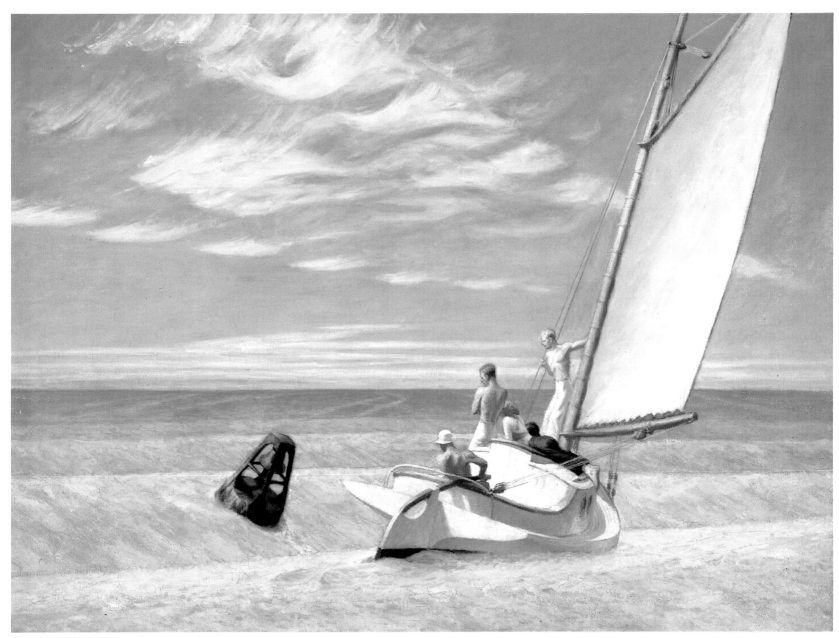

173 Charles Sheeler. *Pertaining to Yachts and Yachting.* 1922.
Oil on canvas, 20 × 24″. Philadelphia Museum of Art.
Bequest of Margaretta S. Hinchman

174 Edward Hopper. *Ground Swell.* 1939. Oil on canvas, 36½ × 50¼″.
Corcoran Gallery of Art, Washington, D.C. Museum Purchase, William A. Clark Fund

Germany, and, ultimately, Mt. Katahdin in Maine. The down east vistas of his last years retain the mature poetry generated by Dogtown during the thirties. One such late painting is *The Wave* of 1940 (figure 171). After the manner of Ryder, Hartley has reduced the scene to a few broad areas of color. With thick strokes of paint he has immobilized the form, making the crashing wave as substantial and monumental as a mountain. The work has the brutal force of Homer's late paintings, but not the effervescence. Hartley is in search of permanence, not movement. Even water must be stilled.

The fact that Hartley's early work was so markedly affected by current trends in European art underscores the impact that movements like Fauvism and Cubism were having on American painting after the Armory Show. Stuart Davis, Lyonel Feininger, and Charles Sheeler each developed a style of fragmented forms that was derived from Cubism. Sheeler's *Pertaining to Yachts and Yachting* (figure 173) has the architectural structuring, arbitrary lighting, and multiple points of view of Cubist painting. In Europe in 1909 Sheeler soon became aware of the work of Picasso and Braque. Gradually he adapted the Cubist vocabulary to his own personal style, one with few incidentals or details. Employing the sharp focus of photography, he painted uniform, cleanly modeled surfaces. He responded with many of his contemporaries to the shapes and vistas of a machine age. Here he has caught the precision and dynamics of wind and sail in interaction with each other. To that extent the curving planes of the sails in several places become one with the planes of light, air, and sky. One of the challenges facing artists of this generation was to integrate representation and abstraction. In this task Sheeler has here achieved a distinctive success.

Another painter who often came close to abstraction in the purity and simplicity of his careful designs was Edward Hopper. His light-filled paintings and the geometry of his compositions recall river and sailing scenes of Eakins. Like Sheeler he was devoted to painting the modern American city and the machine forms that made it function. But he could also turn to the stark quiet of a lighthouse on a point, the empty dunes, an abandoned house, or the open sea. *Ground Swell* (figure 174) has the brilliant light and clearly defined forms typical of

Hopper's painting. The crew in the sailboat concentrate on the bellbuoy as the boat is about to turn the mark. With rhythmic lines Hopper catches the hypnotic sensations of deep water. The crisp lines of the boat and buoy play off against the almost empty zones of sea and sky. As in his more familiar cityscapes Hopper has used a solid horizontal base for his composition with the vertical and diagonal forms rising in cadenced relation above. Bright, opaque colors, predominantly blues and yellows, enhance the feeling of hot sunlight and unlimited space that surrounds the personal drama of the foreground. Hopper's depiction of everyday subjects and modern life have since been rightly linked with the subjects taken up by American Pop artists in the 1960s. To many his clearly defined shapes and flat colors also seem to have been recently revived by the hard-edge abstractionists.

Hopper turned his energies for a while to printmaking, which calls to mind the fact that several artists contemporary to him made a major contribution to the revival of the graphic arts in America during the first decades of the twentieth century. His acquaintance as a young man with the painters of the Ash Can School exposed him to their aims and style. Printmaking enhanced their contribution to American art as it soon did Hopper's. Bellows, for example, could create in his lithographs sensuous textures that are unique in the medium. Another figure who achieved remarkably fresh results in both etching and lithography was Childe Hassam.

Hassam is of course best recalled as an American Impressionist, whose style was derivative of the French movement. When he was not quite twenty, he spent five years in France, where he fell under Monet's influence. Impressionism had become increasingly popular with a group of American painters at the end of the nineteenth century, and Hassam securely fashioned himself a high reputation as an American exponent. He did not take up lithography until late in life. Ironically, his prints failed financially in the face of wide popularity. His lithographs have interest on several counts: as examples of his work, as studies made directly out-of-doors in the French manner, and as contributions to the revival of the medium as an independent artistic expression.

Traces of Monet are perhaps evident in Hassam's sketchy handling of the *Inner Harbor, Gloucester* (figure 172), in which the forms come close to dissolving under the brilliance of the light and pressure of the air. Yet he maintains a taut network of linear outline and a clear suggestion of planes and volumes that are certainly personal. An admitted admiration for Whistler appears in the delicate equilibrium between the softness and precision of the drawing. Throughout this work there is a high degree of boldness and originality that were the unique result of an inventive experimentation not possible to Hassam in oils. In the exploitation of the given medium they are probably more successful even than the etchings, their stylistic partners of the same period.

In Gloucester, Hassam drew various aspects of the city and shoreline, from street and harbor scenes to close-up views of figures on beaches or far-off views with no figures such as the present example. Still, for all the distance in technique and time, Hassam remains close in spirit to Lane (figure 105). The offshore viewpoint, the high horizon as it allows open areas of water and sky, the sense of light and air defining the special contours or facets of the landscape are common to both. Hassam's own originality is clear in the confident expanse of white that constitutes the lower two thirds of the sheet. Just a few lines to suggest the fleeting reflections across the water's surface, and the rush into depth over this sunlit glass is both figuratively and literally captured. Notable here also is the evocative variety under the restraint of economy that characterizes Hassam's draftsmanship; with the slightest change in direction or pressure these small strokes tellingly render the soft foliage, hard rooftops, white walls, sloping hillsides, and even the casting of shadows by the sunlight. The artist's manner of understatement should not be allowed to keep the viewer from enjoying the aesthetic pleasure in exploring the gamut of effects from precision to richness. This is the particular challenge of working on stone, and Hassam's solutions are among the most felicitous in the medium.

Just as Hassam had given new life to the lithographic medium, Maurice Prendergast and John Marin brought the American watercolor tradition to a new maturity. Prendergast also enjoyed painting around Gloucester and the environs of Cape Ann. His paintings of places in a bright, personal mood continue the spirit of his great predecessor in watercolor, Winslow Homer. But there is a marked stylistic change in the direction of decorativeness for its own sake, and Prendergast may be one of the first Americans to anticipate developments in modern art toward emphasizing, even exploiting, the processes of creation for expressive purposes. His painting illustrates well the transition from the nineteenth-century's penchant for realism to our own for imagination and subjectivity. In his work we are directly made more conscious of brushwork and color meant to be pleasing while independent of what they represent. Where his predecessor painted the physical reality, Prendergast uses his paint to give us a mood or a feeling in the scene. This process toward increased abstraction of design, stroke, and color is gradual but marked. In the background certainly lay an awareness of the recent contribution of European art. Prendergast made a number of trips abroad, and early acquired a sympathy for the work of the Impressionists and the Nabis, Cézanne, Toulouse-Lautrec, and for Japanese prints. But like Homer, Prendergast was not concerned with problems in optics, seeking rather to convey generally holiday emotions through lyrical color harmonies, subjectively arrived at, sensuously stated.

During the first decade of the 1900s, Prendergast painted in New York and in Boston and its North Shore. He had developed a personal style that culminated in these years with the familiar group of Central Park views. Decorative brilliance and subtlety accompanied continued confidence, but the need for further stimulation persuaded him to make two highly productive trips abroad, to France in 1909–1910 and to Italy in 1911–1912. Prendergast struck a new balance between spontaneity and clarity in the now famous views of Parisian boulevards and Venetian waterways. The former revealed his sensitive control of light and color in outdoor scenes of people; the latter his ability to render effects of atmosphere and water. He also experimented in a variety of media—watercolor, oil, pastel, and monotype—and in new subject matter, portraits and still lifes, all of which he mastered with a new freedom of handling.

Returning to New England in 1912, Prendergast frequently painted

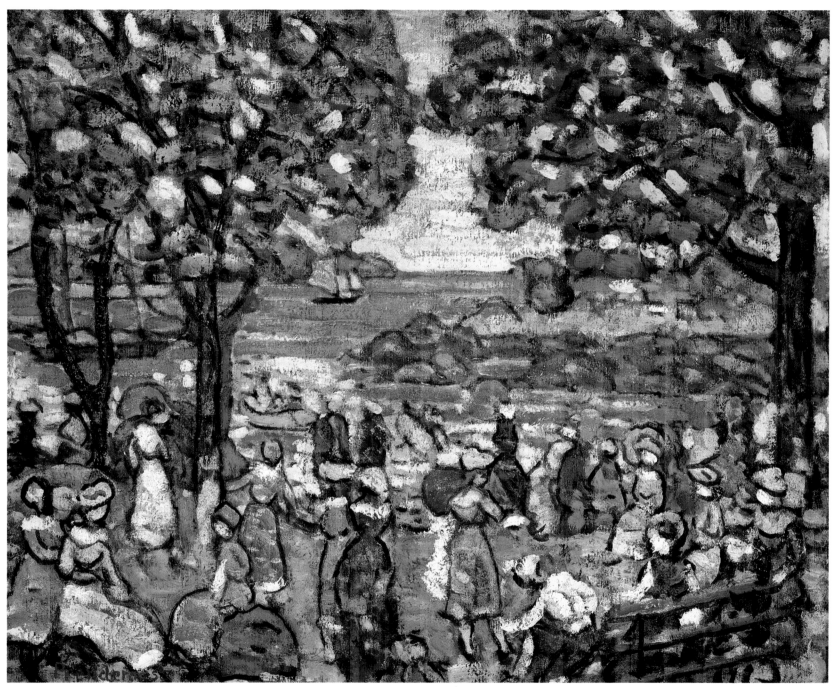

175 MAURICE BRAZIL PRENDERGAST. *Salem Cove*. 1916. Oil on canvas, 24⅛ × 30⅛″. National Gallery of Art, Washington, D.C. Collection of Mr. and Mrs. Paul Mellon

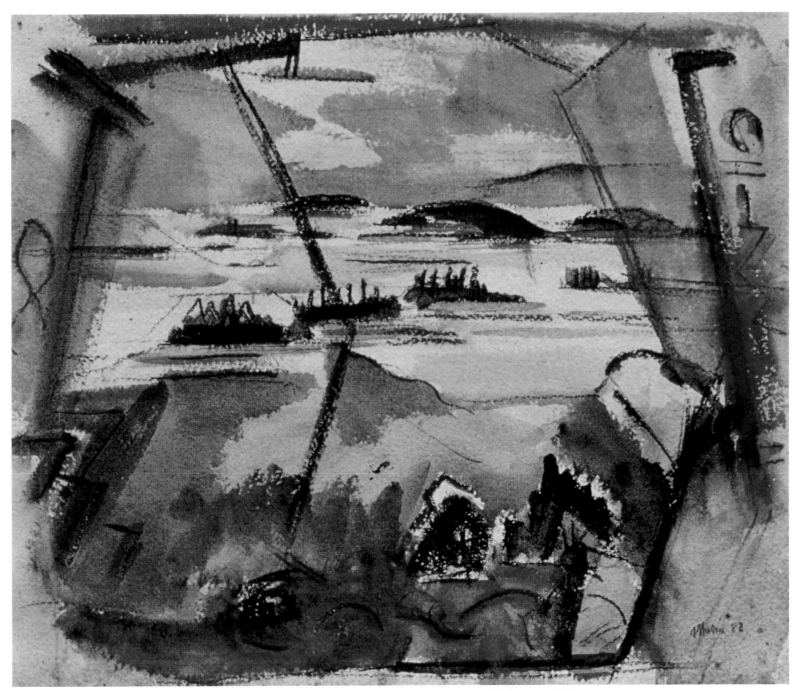

176 JOHN MARIN. *Maine Islands*. 1922. Watercolor on paper, 16⅞ × 19¾". The Phillips Collection, Washington, D.C.

near Gloucester and Salem (figure 175). Both his oils and watercolors of this time have a freshness and happiness that make them perhaps the most memorable of their type, equal in competence to the oils of Paris, Venice, and New York. The artist himself must have subconsciously seen this, for he returned to paint two more groups of watercolors of Gloucester in 1915 and 1919–1920. What Prendergast portrayed was not merely people enjoying themselves, relaxing, or playing, although this is where he began, but the actual sensations of holidays and festivals. It was as if he meant his bright paints to express the very quality of exhilaration itself. Yet as illustration his work never lost its meaning, and the decorative design, flat as it seemed, was never without clear organization.

His work speaks with economy and eloquence. Most important is the sure sense of spatial planes, beginning with the foreground that serves as a stage, followed into depth by a band of water, the offshore islands, another line of water marking the horizon, and the sky. Cleverly, the horizon does not coincide with the center of the picture, lending an added visual tension in the important central area. Yet the scene is markedly divided across the center by the shoreline of the islands and the lower edges of the trees' foliage. Such internal balance laterally gains further tightness by the framing verticals of the tree trunks. No less successful than the organization is the draftsmanship. With a keen eye for the telling gesticulation or stance, Prendergast integrates individuals and groups of figures with each other and with the surroundings. The distracting or unnecessary detail yields to a bold statement of essentials, out of which the total mosaic coalesces. Similarly, Prendergast uses a restraint in his brushwork that is appropriate to the different textures or details to be conveyed. He will change from short, narrow strokes for the rippled water surface, or thin, longer lines outlining islands, and shorelines, to a broader brushwork for foreground and tree foliage. Often he will introduce a variety of strokes even between two trees or between the sunlit and shaded areas of grass. Frequently, longer bands of paint will depict the fair weather clouds above. Bright colors, red or orange, are used only for human figures, adding to the decorative pattern throughout. John Marin is also one of the major figures adapting Post-

Impressionism into an American idiom. He similarly makes maximum use of spontaneous brushwork and the white of the paper in his watercolor of the *Maine Islands*, 1922 (figure 176). He too spent several years in the early 1900s in Europe, familiarizing himself with the work of Cézanne and the Cubists. After his return to the United States he customarily spent his winters in Taos, New Mexico, and his summers in Maine. Peculiar to his style was the vignette technique and the suggestion of atmosphere by means of loose washes of paint. He produced a large number of etchings and oils, but the watercolors at their best have a surpassing freshness and sparkle. Some observers have speculated that Marin's ambidextrousness lies beneath the quality of dynamic balance in his art. His paintings consist largely of lines and forces in conflict, both with each other and with the framing edge. Yet generally, they possess a center of gravity, a compositional core around which the components are disposed.

Both fragmentation and equilibrium are evident in *Maine Islands*. A frequent tension in much of Marin's work existed in his attempted reconciliation of representative and abstract forms. He resolved these opposing forces in his best paintings, and this watercolor is among the most successful. Aside from the compositional problem, it also demonstrates a masterly use of watercolor. The swift strokes, bright colors, and contrasting white ground combine to capture the unmistakable characteristics of the clear Maine air and sunlight.

Marin's views of Maine come almost a full century after American artists first began voyaging Down East to paint the wild rugged coast. The features that attracted Cole, Doughty, and Fisher have retained to this day their appeal for artist and layman alike. One of the most accomplished and admired artists today, Andrew Wyeth, has spent much time in Maine. Among the most memorable images that he has created is *Northern Point* (figure 178) done at Teel's Island, Maine, in 1950. That summer, the painter wrote, he

climbed onto the roof of the two hundred year old Teel house to see the stretch of sea and islands beyond. The weathered decay of the black shingles in contrast to the smokey blue day and the amber light in the lightning rod excited me, so I painted *Northern Point* in the studio after making many pencil and water color studies on the spot.[4]

The experience brought back childhood memories of roof-climbing and the accompanying excitement of height. The title derives from the fact that the peak of the roof faced north. The horizon line is high and runs through the center of the globes, thus tying together the horizontal and vertical axes of the picture. Diagonally leading the eye into the distance is the pitch of the roof, which further serves to draw attention to the rocky shore and cove beyond. Details are sharper at the center, emphasizing the incredible sharpness of the lightning rod. A greater expanse of the right side of the composition, included in the preliminary drawing, is gone in the final painting to make a more emphatic vertical design.

A key word in Wyeth's description of the scene is contrast. The intensity of effect which the work achieves comes as a consequence of the contrasts made between man-made and natural, light and dark, liquid and solid, round and angular, smooth and rough, close-up and distant, serenity and inherent violence. It is a very American painting with its love of the physical and its celebration of the out-of-doors. The method of drawing and the precision of accuracy place Wyeth directly in the tradition of Homer, to whom he is naturally compared. Wyeth's admitted admiration for Fitz Hugh Lane and Thomas Eakins is understandable. He has kept alive in a hostile century the tranquility and the contemplativeness of an earlier time. Facing the open sea from the coast as so many painters before him have done, Wyeth recalls the passion, the pensiveness, or the lyricism that others have often felt when standing at the edge of the unknown.

That love of standing at the shore's edge has continued through the late twentieth century, even where the unknown has been explored and more fully revealed. Many of the artistic concerns of earlier generations have undergone transformations and recapitulations both by major established figures and younger artists. The play between representation and abstraction which developed in the first quarter of the century has remained a strong factor in recent years, as some artists have pursued variations in the realist tradition while others have turned to more formal and intellectual issues of picture-making.

Among those inheriting the legacy of Homer and Bellows are such realist painters as Fairfield Porter and Jack Helliker, who continued to

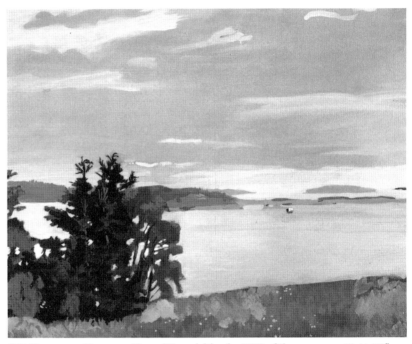

177 FAIRFIELD PORTER. *View of Barred Islands.* 1970. Oil on canvas, 40 × 50″. Herbert W. Plimpton Foundation on extended loan to the Rose Art Museum, Brandeis University, Waltham, Massachusetts

celebrate on canvas an affection for life and light on the Maine coast. With his creamy pigments and saturated colors Porter captures the liberating pleasures of the fresh physical world, especially as experienced on the New England coast in the summer months (figure 177). In turn, like Marin before him, Helliker responds to the flickering light and vibrant contrasts of rocks, trees, and water with compositions of linear and planar rhythms (figure 181).

Although we tend to assume that the evolving phases of abstract art in the twentieth century unfolded on a quite separate parallel course, we have also found that much non-representational painting is highly charged with meaning and feeling. Even without illustrating reality, these paintings often allude by title or design to recognizable motifs, including landscape and seascape. For example, though we know of

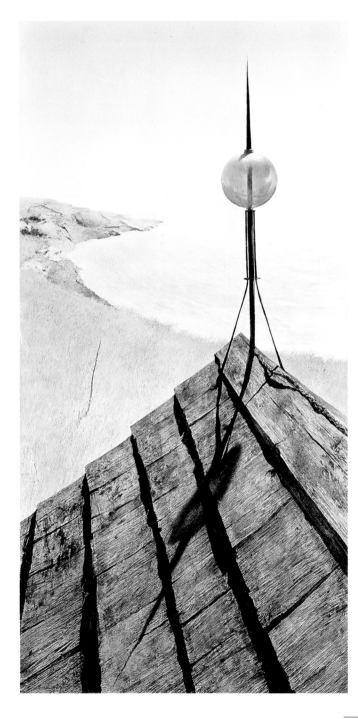

Jackson Pollock's primary commitment to projecting personal gesture to his canvas surfaces, and to achieving an original interrelationship between his painted figuration and the surrounding space, frequently his work of the later 1940s dealt with suggestions of mythic figures and environments. *Full Fathom Five* of 1947 (figure 182) is such a work, with its sense of a vast and mysterious underwater world. Obviously not referring to any seen landscape, it nonetheless evokes an imagined expanse of the deep. In the same way we can consider the purely abstract surfaces of Mark Rothko's color paintings as spacious zones of earth or sea and sky, to be sure, more mental than depicted landscapes.

The concern for a painting as a record of personal gesture, but also with some allusion to place, carried into the work of younger Abstract Expressionists. For example, Richard Diebenkorn, having painted on both coasts and traveled back and forth across the country, has in recent years settled in southern California, where he has produced an extensive series of large canvases with the title of *Ocean Park* (figure 183). Their inspiration comes from an area of Santa Monica, as we can sense from the warm colors and expansive planes and lines suggesting ocean, sky, and piers. In a similar vein, the work of Helen Frankenthaler has also developed ideas generated by the first generation of Abstract Expressionists. Above all, she is known for being among the first to explore new means of paint handling, including the pouring of acrylic pigments on to unprimed canvases so that her colors both sit on their surfaces as well as seep into the material. The first key example of this process was *Mountains and Sea* (figure 184), where the new technique perfectly suited the effect of floating forms and airy gestures of color, which in turn, by its title, becomes a pictorial conjuring of a coastal landscape in the mind's eye. Yet another painter in this period concerned with evocative patterns of broad color was Milton Avery, who like Diebenkorn,

178 ANDREW WYETH. *Northern Point*. 1950. Egg tempera on gesso panel, 36 × 18³⁄₁₆″. Wadsworth Atheneum, Hartford, Connecticut. Ella Gallup Sumner and Mary Catlin Sumner Collection

looked in part to Matisse for inspiration. Painting on the Massachusetts coast throughout the 1950s and sixties, he produced a number of highly simplified compositions in which beach and sky and occasional figures existed in harmonious rhythms of bright, often thinly washed tones (figure 185).

But the withdrawal from direct observation and representation of nature, along with the pursuit of abstraction's possibilities, were not the only developments of the period. During the 1960s and since, the bold forms of Pop Art and other forms of realism revived attention to representation in new ways. Some, as always, drew on everyday experience and observation, like Alex Katz (figure 179); others like the Pop artists looked to the visual world of advertising, popular culture and media, parodying the ubiquitous presence of movies, television, magazine illustrations, and billboard signage. Their images were often mural-sized and imitated the look of commercial printing, as in Andy Warhol's use of silkscreening or Roy Lichtenstein's dot patterns of newsprint and the television screen (figure 180). Pushing even further at the boundaries of subject and process, still other artists began in the sixties to turn the actual landscape itself into art, not merely frame it on canvas. They literally exercised their gestures of fabrication on the real geography, as Robert Smithson did in building his *Spiral Jetty* of 1970 out of blocks of stone into the Great Salt Lake, or Christo who wrapped with acres of fabric parts of the coastlines of Newport, Rhode Island, Australia, and the bay of Miami in the 1970s and eighties. These so-called earthworks called attention to nature as both a source of art and as art itself.

Perhaps understandably, however, the impulses toward realism have most constantly satisfied the American artist's fascination with the subject of the sea, for by definition the infinite manifestations of its character have called above all for ways to depict and interpret this edge of nature. Appropriately, then, we return to one of the country's preeminent realists of the later twentieth century, Andrew Wyeth, for a final image. Painted in the summer of 1986, *Squall* (figure 186) depicts those strong elements of nature familiar on the coast: the sense of rising winds and sharp light, a view of the open sea and its always mysterious horizon, and the traces of man's presence in the

179 ALEX KATZ. *Canoe*. 1974. Oil on canvas, 72 × 144″. Atlantic Richfield Corporate Art Collection

180 ROY LICHTENSTEIN. *Gullscape*. 1964. Oil and magna on canvas, 68 × 80″ Private collection

181 JACK HELLICKER. *Rocks and Trees, Maine.* 1961.
Oil on canvas, 50 × 40″. Whitney Museum of American Art, New York.
Gift of the Ford Foundation Purchase Program

Right:
182 JACKSON POLLOCK. *Full Fathom Five.* 1947. Oil on canvas with nails, tacks,
buttons, keys, coins, cigarettes, matches, etc., 50⅞ × 30⅛″.
The Museum of Modern Art, New York. Gift of Peggy Guggenheim

hanging gear and island pathway. Typical for Wyeth are its play of windowframe and door as junctures between indoor and outdoor space, at the same time holding all together in an austere abstracted design.

No matter whether nature's forces appear to be aggressive or benign, artists have continued to feel them directly in this special landscape where boundary and juncture seem so compelling. First, the seashore and the coast constitute one form of dividing line, where continent and ocean both come together and expand outward. The horizon viewed from the shore is a second line, dividing sea and sky, each areas of contrasting density, each buoying floating images respectively of sailboats and clouds, together sustaining vessels of leisure, commerce, and thought. We no less than the artist have continued to find this space ever pleasing to the eye and elevating to the spirit.

American marine painting is in major part a story of the nineteenth century. Its important exponents are within its embrace, although its sources go back much earlier and its tradition reaches forward toward the present. The role of marine subjects took many guises after its first appearance in the backgrounds of portraits. The ingenuity of choice and the depth of interpretation mirrored the intentions of each phase in American art. The originality of Homer, Ryder, and Eakins shows how difficult an inclusive definition of marine painting becomes by the end of the nineteenth century. As in the origins of the genre, marine subjects once more became part of larger ends. Homer is not strictly a marine painter, as Salmon or Lane or Kensett or Buttersworth might be so categorized; he is an artist who painted many great marines, and part of his contribution was carrying forward the marine tradition in American painting. With the twentieth century art began to break ever more conclusively with traditionally defined subject matter. The history of art teaches that most types of painting serve the special ideals of each period. American marine painting is an illuminating expression of the country's character. With the sea as its special province this painting is an eloquent manifestation of the changing dream of America.

183 RICHARD DIEBENKORN. *Ocean Park #40.* 1971.
Oil on cotton duck, 93 × 81″.
Collection Mrs. S. I. Newhouse, Jr.

10/26/52

184 HELEN FRANKENTHALER. *Mountains and Sea.* 1952. Oil on canvas, 86¾ × 117¼″.
Collection the artist, on loan to the National Gallery of Art, Washington, D.C.

185 MILTON AVERY. *Green Sea*. 1954. Oil on canvas, 42 × 60″.
The Metropolitan Museum of Art, New York. Arthur Hoppock Hearn Fund

186 ANDREW WYETH. *Squall*. 1986. Tempera, 17¾ × 28½″.
Private collection

CHAPTER ONE
The Contribution of Portrait Painting

1. Cf. Perry Miller, ed., *The American Puritans, Their Prose and Poetry*, 60.

2. *Ibid.*, 240.

3. Vernon L. Parrington, *Main Currents of American Thought*, I, "The Colonial Mind," 18.

4. Cf. Samuel Eliot Morison, *The Maritime History of Massachusetts*, II.

5. Louisa Dresser, ed. *XVIIth Century Painting in New England*, 17–18.

6. *Ibid.*, 12.

7. *Ibid.*, 120–132.

8. *Ibid.*, 20, 24, 26, 27. See also Louisa Dresser, "Portraits in Boston, 1630–1720," 11–13.

9. Waldron Phoenix Belknap, Jr., *American Colonial Painting*, 276.

10. *Ibid.*

11. Belknap is unsure of the sitter's name and of the attribution to Duyckinck, but this obviously does not detract from the relationship of the painting to the print. Cf. *Ibid.*, 282.

12. *Ibid.*, 323–329. Cf. also E. P. Richardson, *A Short History of American Painting*, 28–29.

13. Documentation in Lawrence Park, *Joseph Badger*, 24–25.

14. Henry Wilder Foote, *Robert Feke, Colonial Portrait Painter*, vii, 108. For information on portrait of Waldo, see 198–199.

15. Notably Oskar Hagen and James Thomas Flexner, who are taken to task by Foote in *John Smibert, Painter*, 116–120; and by Belknap in *American Colonial Painting*, 3–28.

16. Namely his *Isaac Royal and Family* (c. 1748) owned by Harvard, and Smibert's *Bermuda Group* (1729) at Yale.

17. Documentation in Foote, *Smibert*, 97, 114.

18. *Proceedings* of the Massachusetts Historical Society, XLIX, 31. See also Belknap, *American Colonial Painting*, 277; and Foote, *Smibert*, 88–89.

19. Foote, *Smibert*, 88.

20. Alan Burroughs, *John Greenwood in America*, 19. Documentation of the painting, 63.

21. *Ibid.*, 31, 34.

22. A replica is owned by Mrs. Lendall Pitts, Norfolk, Virginia, but it is unknown which is the original. See Park, *Badger*, 9–10; and Belknap, *American Colonial Painting*, 290.

23. There is a third, more grand version commissioned by Harvard in 1772; Boylston is seen full length against classical columns, seated on a floral rug, and wearing red morocco slippers. See Alan Burroughs, ed., *Harvard Portraits*, 23–24 (Cambridge, MA., 1936); Barbara Neville Parker and Anne Bolling Wheeler, *John Singleton Copley*, 43–45; and Jules D. Prown, *John Singleton Copley*, I, 54–55.

24. It is dated c. 1768 by Parker and Wheeler from a bill in the Massachusetts Historical Society. See their *Copley*, 21–22; and Prown's, 60–61.

25. Parrington, *American Thought*, I, 197.

CHAPTER TWO
The Folk Art Tradition

1. James Thomas Flexner tried to argue otherwise. See his review of Mary Black and Jean Lipman's *American Folk Painting* in the *New York Times Book Review*, 30 April 1967, 7, 33.

2. Cf. Jean Lipman, *American Primitive Painting*, 3; and James Thomas Flexner, *That Wilder Image*, 257. See also Mary Black and Jean Lipman, *American Folk Painting*.

3. Lipman, *American Primitive Painting*, 8–9.

4. Jean Lipman, "Rufus Porter, Yankee Wall Painter," 135. The entire October 1950 issue of *Art in America* is devoted to Porter in the most complete account available. It contains a full biography, summary chronology, genealogical data, evaluation and checklist of his work, and extensive illustrations.

5. *Ibid.*, 145.

6. Nina Fletcher Little, *American Decorative Wall Painting*, 121. In 1965 Professor Robert McGrath of Dartmouth College discovered frescoes by Porter in Topsham, Vermont, thus enlarging the territory where the artist was known to have painted.

7. Quoted in Little, *Ibid.*, 123. Originally from one of seven articles by Porter, "Landscape Paintings on Walls of Rooms," *Scientific American*, I (26 March 1846). In this series he discussed the muralist's approach to his art.

8. Lipman, "Rufus Porter," 156.

9. Little, *Wall Painting*, 127, 132, and Lipman, "Rufus Porter," 164.

10. I am indebted to Professor McGrath for providing me with information and photographs of the Topsham frescoes. See his "Rediscovery: Rufus Porter," 78–79.

11. *That Wilder Image*, 277.

12. Virgil Barker places the figure near two dozen, *American Painting*, 496; Nina Fletcher Little leans toward the larger number, "T. Chambers, Man or Myth?," 194.

13. Little, "Man or Myth?," passim.

14. Nina Fletcher Little, "Earliest Signed Picture by T. Chambers," 285.

15. Oliver W. Larkin, *Art and Life in America*, 227.

16. Barker, *American Painting*, 496.

CHAPTER THREE
The Contribution of History Painting

1. Vernon L. Parrington, *Main Currents in American Thought*, I, "The Colonial Mind," 271–282, passim.

2. Oliver W. Larkin, *Art and Life in America*, 63.

3. E. P. Richardson, *A Short History of Painting in America*, 77. See also Jules D. Prown, *John Singleton Copley*, 267–274.

4. See Prown, *Copley*, 273.

5. E. P. Richardson, *Washington Allston*, 5, 70.

6. Albert TenEyck Gardner and Stuart P. Feld, *American Paintings: A Catalogue of the Collection of the Metropolitan Museum of Art*, I, 130–133.

7. *Ibid.*, 132.

8. Richardson, *Allston*, 66.

9. Quoted in *M. and M. Karolik Collection of American Paintings 1815 to 1865*, 478.

10. *Ibid.*

11. *Antiques*, LXXXIV (November 1963), 574.

12. Richardson, *Washington Allston*, Crowell ed. (New York, 1967).

13. *Ibid.*, 65.

CHAPTER FOUR
The Hudson River School: First Generation

1. Cf. Richard Hofstadter, *Anti-Intellectualism in American Life* (New York, 1963), 158–160; and Arthur M. Schlesinger, Jr., *The Age of Jackson*, 339.

2. Vernon L. Parrington, *Main Currents in American Thought*, II, "The Romantic Revolution," 185.

3. F. O. Matthiessen, *American Renaissance*, 18. Cf. also Van Wyck Brooks, *The Flowering of New England*, 25, 168.

4. Schlesinger, *Jackson*, 43.

5. Parrington, *American Thought*, II, 374.

6. Perry Miller, ed., *The American Transcendentalists*, ix; and Parrington, *American Thought*, II, 312.

7. Samuel Eliot Morison, *The Maritime History of Massachusetts*, 140, and Chapters 13 and 14, passim; also, Parrington, *American Thought*, II, 287; and Schlesinger, *Jackson*, 144, 310.

8. E. P. Richardson, *American Romantic Painting*, 35.

9. "Autobiography," Worthington Whittredge, 54.

10. Perry Miller, *Nature's Nation*, 152–153, 197–199, 204–205.

11. Barbara N. Deutsch, *Cole and Durand: Criticism and Patronage, a Study of American Taste in Landscape, 1825–1865*, passim.

12. Matthiessen, *American Renaissance*, 162.

13. Ralph Waldo Emerson, *Poetry and Imagination*, Introduction. Published in 1870, but compiled from his *Journal* of 1837. Quoted in Miller, *American Transcendentalists*, 200.

14. Louis Legrand Noble, *The Life and Works of Thomas Cole*, 210.

15. *Ibid.*, 210–227.

16. *Ibid.*, 270.

17. Thomas Philbrick, *James Fenimore Cooper and the Development of American Sea Fiction*, 22, 42.

18. *Ibid.*, 234–235.

19. E. P. Richardson, *A Short History of American Painting*, 93.

CHAPTER FIVE
The Hudson River School: Second Generation

1. Joan C. Siegfried, "The Art of John Frederick Kensett," *John Frederick Kensett: A Retrospective Exhibition*, 8, 18.

2. *Ibid.*, 3, 8.

3. Sadayoshi Omoto, "The Sketchbooks of Worthington Whittredge," 331.

4. Worthington Whittredge, "Autobiography," 5, 68. Quoted in *M. and M. Karolik Collection of American Paintings 1815 to 1865*, 518.

5. Omoto, "Sketchbooks," 334.

6. David C. Huntington, *The Landscapes of Frederic Edwin Church: Vision of an American Era*; and Huntington, *Frederic Edwin Church*.

7. *Ibid.* See also my review of Huntington's book in the *Massachusetts Review*, VIII (Winter 1967), 208–212.

8. Virgil Barker, *American Painting*, 587.

9. Huntington, *Landscapes of F. E. Church*, 83–87.

10. *Ibid.*, 99; and R. S. Trump, "Life and Works of Albert Bierstadt," I.

11. Trump, "Bierstadt," 24–25.

CHAPTER SIX
The Inheritance of French Romantic Painting

1. Thomas Philbrick, *James Fenimore Cooper and the Development of American Sea Fiction*, vii.

2. One of the best summaries of the history of Western marine painting is to be found in the catalogue *Five Centuries of Marine Painting*.

3. *Ibid.*, 21.

4. Cf. Jean Meissonier, "Ship Painters of the Mediterranean," 304.

5. *Five Centuries*, 24.

6. Louise Karr, "The Roux Family," 120. See also *Antoine Roux Sketch Books*.

7. Meissonier, "Ship Painters," 304.

8. Karr, "Roux Family," 119.

9. *Ibid.*, 121.

10. Continued dispute over the accent (or not) of what type on Corné's name was resolved by the late M. V. Brewington, former director of the Kendall Whaling Museum in Sharon, Massachusetts. He wrote: "The best clue to the pronunciation of his name is on a bill submitted to the East India Marine Society which was docketed by the treasurer as 'Mr. Corney's bill'" (From personal correspondence.) Cf. also Virgil Barker, *American Painting*, 289–290.

11. Details in *M. and M. Karolik Collection of American Water Colors & Drawings 1800–1875*, I, 119; and Nina Fletcher Little, *American Decorative Wall Painting*, 42–44.

12. From title engraved beneath the print.

13. Cf. Charles D. Childs, "Marine Painting: Flood Tide," 52–55, passim.

14. Little, *Wall Painting*, 42.

15. Katharine McCook Knox, "A Note on Michele Felice Corné," 450–451. Cf. also Mabel M. Swan and Louise Karr, "Early Marine Painters of Salem," 63–65.

16. Little, *Wall Painting*, 44.

CHAPTER SEVEN
The Dutch Marine Tradition

1. One study of Thomas Birch's career and place in American art is Doris Jean Creer's master's thesis at the University of Delaware, June 1958: "Thomas Birch: A Study of the Condition of Painting and the Artist's Position in Federal America." She discusses Birch's artistic relation to his father and to his contemporaries; the varieties of his work, techniques of painting, and working methods. She concludes with an extensive checklist and appendices of biographical data, outlines of the brother's career, the art collection of the father, letters, and a full bibliography. See also William H. Gerdts, *Thomas Birch, 1779–1851, Paintings and Drawings*; and Gerdts, "Thomas Birch: America's First Marine Artist."

2. Vernon L. Parrington, *Main Currents in American Thought*, II, "The Romantic Revolution," 178–180.

3. Creer, "Thomas Birch," 12.

4. *Ibid.*, 18.

5. *Ibid.*, 22.

6. Charles D. Childs, "Marine Painting: Flood Tide," 53.

7. *M. and M. Karolik Collection of American Paintings 1815 to 1865*, 122.

8. Creer, "Thomas Birch," 28–30, passim. See also Gerdts, *Thomas Birch*, for reproductions of several drawings.

9. James Fenimore Cooper, *The History of the Navy of the United States of America*. Cf. reference in *Karolik Collection*, III.

10. Creer, "Thomas Birch," 24; and Gerdts, *Thomas Birch*, 13.

11. *Karolik Collection*, 114.

12. Albert TenEyck Gardner and Stuart P. Feld, *American Paintings: A Catalogue of the Collection of the Metropolitan Museum of Art*, I, 128.

13. Creer, "Thomas Birch," 25.

14. *Ibid.*, 42.

CHAPTER EIGHT

English-American Artists

1. See listing in Helen Comstock, "Marine Paintings by Two Buttersworths," 99.

2. *Ibid.*, 100.

3. *Ibid.*, 99.

4. Throughout what follows I have drawn freely on my *Robert Salmon, Painter of Ship and Shore*. See also my "A New Look at Robert Salmon"; and my *Robert Salmon: The First Major Exhibition*.

5. Charles D. Childs, "Robert Salmon: A Boston Painter of Ships and Views." See also Childs, "Marine Painting: Flood Tide."

6. The most important sources are the reminiscences of Henry Hitchings, a friend of the artist's: see *Proceedings* of the Bostonian Society at the Annual Meeting, 37–38; quoted in part in Childs, "Robert Salmon," 96–97. And "Catalogue of Robert Salmon's Pictures 1828 to 1840, from His Own Notes, Now in the Possession of Miss Darracott, 1881."

7. *Boston Daily Advertiser*, 7 June 1842.

8. I am grateful to Leeds A. Wheeler, Wellesley Hills, Massachusetts, for providing this information.

9. *Painting in England 1700–1850: Collection of Mr. and Mrs. Paul Mellon* (Virginia Museum of Fine Arts, Richmond, 1963), 226.

10. Leeds Wheeler has graciously provided much of the information about Hubbard.

CHAPTER NINE

Independents

1. Oliver W. Larkin, *Art and Life in America*, 216.

2. Virgil Barker, *American Painting*, 499.

3. *Ibid.*, 496.

4. William Dunlap, *History of the Rise and Progress of the Arts of Design*, III, 87.

5. Barker, *American Painting*, 499. See also John I. H. Baur, *John Quidor* (Munson-Williams-Proctor Institute), 61, 66.

6. Larkin, *Art and Life*, 216.

7. John I. H. Baur, *John Quidor* (Brooklyn Museum), 17; also Baur, *Quidor* (Munson-Williams-Proctor Institute), 64.

8. *M. and M. Karolik Collection of American Paintings 1815 to 1865*, 456.

9. Nina Fletcher Little, "J. S. Blunt: New England Landscape Painter," 172–174.

10. *Antiques* LXXXIV (November 1963), 575; LXXXV (March 1964), 327; and LXXXVI (July 1964), 63.

11. *Karolik Collection 1815 to 1865*, 124.

12. Cf. Nina Fletcher Little, "Indigenous Painting in New Hampshire," 63.

13. Little, "J. S. Blunt," 173.

14. Herman Warner Williams and Bartlett Cowdrey, *William Sidney Mount*, I.

15. *Ibid.*, 5.

16. *Ibid.*

17. *Ibid.*, 2.

18. *Ibid.*, 4.

19. Two dozen of the best drawings have been reproduced in Robert Cushman Murphy's *Fish-Shape Paumanok, Nature and Man on Long Island*.

20. Williams and Cowdrey, *Mount*, 12.

21. Tom Strong and Rachel Holland Dart. *Ibid.*

22. Cf. F. O. Matthiessen, *American Renaissance*, 598.

23. Williams and Cowdrey, *Mount*, II.

24. Letter from "Rembrandt to his friend Wm. Mount." Quoted in Williams and Cowdrey, *Ibid.*, 8–9.

25. Walt Whitman, "Starting from Paumanok," *Leaves of Grass*, 12.

26. *Ibid.*, "A Song of Joys," 142.

CHAPTER TEN

The Establishing of a Style

1. See my *Fitz Hugh Lane, 1804–1865, American Marine Painter* and *Fitz Hugh Lane: The First Major Exhibition*.

2. *M. and M. Karolik Collection of American Paintings 1815 to 1865* (Cambridge, 1949). Introduction, "Trends in American Painting 1815 to 1865," by John I. H. Baur, *xv–xvi*.

3. Benjamin Champney, *Sixty Years' Memories of Art and Artists*, 10, 99.

4. A full account of its building and an analysis of its style is given in Alfred Mansfield Brooks, "The Fitz Hugh Lane House in Gloucester."

5. See my "The Lithographs of Fitz Hugh Lane."

6. Frederic A. Sharf, "Fitz Hugh Lane: Visits to the Maine Coast, 1848–1855." See also my "Fitz Hugh Lane's Paintings Down East."

7. I am grateful to T. E. Stebbins for calling my attention to the exhibition records of these painters. See his *Luminous Landscape: The American Study of Light, 1860–1875*, 10; and my *F. H. Lane: The First Major Exhibition*.

8. Biographical facts in *M. and M. Karolik Collection of American Water Colors and Drawings 1800–1875*, I, 297–298.

9. Cf. Frederic A. Sharf, "Fitz Hugh Lane Reconsidered."

10. For further discussion of differences between original oils by Lane and imitations by followers see my "As Under a Bell Jar: A Study of Quality in Fitz Hugh Lane."

CHAPTER ELEVEN

The Style Established

1. Robert G. McIntyre, *Martin Johnson Heade*.

2. Biographical summaries in *M. and M. Karolik Collection of American Paintings 1815 to 1865*, 301–302; and in *M. and M. Karolik Collection of American Water Colors and Drawings*, I, 181–183.

3. James Thomas Flexner, *That Wilder Image*, 277.

4. H. D. Thoreau, *Writings*, VII, 481–482.

5. Biographical facts outlined in *Karolik Collection of Drawings*, 290.

6. Leonard B. Ellis, *History of New Bedford*, 99. I am grateful for further information on Bradford from Professor Chauncey C. Loomis of Dartmouth.

7. Information about local ships and topography kindly supplied by Philip Purrington, the Whaling Museum, New Bedford, Massachusetts.

8. Arnold B. Chace, "A Trip to Labrador," 1865, and William Bradford, *The Arctic Regions*, 1873.

9. See *The Coast and The Sea: A Survey of American Marine Painting*, 10–11.

10. "The Paintings of Mr. William Bradford, of New York," 7–8.

11. Arlene Jacobowitz, *James Hamilton, 1819–1878, American Marine Painter*.

12. Biographical information from *Karolik Collection of Drawings*, I, 172–174; John I. H. Baur, "A Romantic Impressionist: James Hamilton"; and Jacobowitz, *Hamilton*.

13. Lawrence Gowing, *Turner: Imagination and Reality*, 27.

14. Helen Haseltine Plowden, *William Stanley Haseltine, Sea and Landscape Painter (1835–1900)*, Chapters III and IV.

15. Unidentified source; quoted in Plowden, *Haseltine*, 83.

16. Biographical information from John Duncan Preston, "Alfred Thompson Bricher, 1837–1908."

17. *Ibid.*, 149.

CHAPTER TWELVE

Wind, Sail, and Steam

1. Helen Comstock, "Marine Paintings by Two Buttersworths," 100.

2. Samuel Eliot Morison, *The Maritime History of Massachusetts*, 342.

3. *Ibid.*, 327.

4. Comstock, "Two Buttersworths," 102.

5. Cf. obituary quoted in Jean Lipman and Alice Winchester, eds., *Primitive Painting in America, 1750–1950*, 121–124.

6. *Ibid.*, 126.

7. Information about the *Rip Van Winkle* and her history in *M. and M. Karolik Collection of American Paintings 1815 to 1865*, 70–72.

8. Cf. general characteristics of a Bard Painting in Lipman and Winchester, *Primitive Painting*, 128.

9. Virgil Barker, *American Painting*, 553.

CHAPTER THIRTEEN

The Great Age

1. Albert TenEyck Gardner, *Winslow Homer*.

2. Albert TenEyck Gardner, *Winslow Homer: A Retrospective Exhibition*, 28.

3. *Ibid.*, 46, 58.

4. Lloyd Goodrich, *Winslow Homer* (Braziller ed.); and Philip C. Beam, *Winslow Homer at Prout's Neck* (Boston, 1966).

5. I am grateful to the late Robert Goldwater of the Museum of Primitive Art, New York, for first raising this possibility.

6. F. O. Matthiessen, *American Renaissance*, 287.

7. Herman Melville, *Moby Dick, or, The Whale*, 3.

8. Fairfield Porter, *Thomas Eakins*, 113.

9. *Ibid.*, 20.

10. Biographic summary in Lloyd Goodrich, *Albert P. Ryder*, 11–32.

11. Robert N. Linscott, ed., *Selected Poems and Letters of Emily Dickinson*, 29.

12. Goodrich, *Ryder*, 13.

CHAPTER FOURTEEN

Toward New Directions

1. Nicolai Cikovski, Jr., *The Paintings of George Inness (1844–1894)*, 3–5.

2. LeRoy Ireland, *The Works of George Inness*, 310–311.

3. See also my "Interpretations of Place: Views of Gloucester, Massachusetts, by American Artists."

4. Wadsworth Atheneum *Bulletin*, 2nd series (May–September 1951), 2. See also E. P. Richardson, *Andrew Wyeth*, 34–35.

General works are listed first and in two sections, on American marine painting and on related literary and historical works. They are followed by individual chapter bibliographies.

GENERAL

An Album of American Battle Art: 1755–1918. Library of Congress, Washington, D.C., 1947.

Barker, Virgil. *American Painting, History and Interpretation.* New York, 1950.

Baur, John I. H. *American Painting in the Nineteenth Century: Main Trends and Movements.* New York, 1953.

————. "Early Studies in Light and Air by American Landscape Painters," *Bulletin* of the Brooklyn Museum, IX (Winter 1948), 1–9.

————. "The U.S. Faces the Sea," *Art News,* XLVII (November 1948), 21–23, 54–55.

————. "Unknown American Painters of the 19th Century," *College Art Journal,* VI (Summer 1947), 277–282.

Born, Wolfgang. *American Landscape Painting.* New Haven, Conn., 1948.

Brewington, M.V. and Dorothy. *Marine Paintings and Drawings in the Peabody Museum* (catalogue). Salem, Mass., 1968.

————. *Kendall Whaling Museum, Paintings* (catalogue). Sharon, Mass., 1965.

————. *Kendall Whaling Museum, Prints* (catalogue). Sharon, Mass., 1969.

Carey, John Thomas. "The American Lithograph from Its Inception to 1865, with Biographical Consideration of Twenty Lithographers and a Check List of Their Works." Unpublished doctoral dissertation, Ohio State University, 1954.

Catalogue of a Special Exhibition of the Irving S. Olds Collection of American Naval Prints and Paintings. Peabody Museum, Salem, Mass., 1959.

Catalogue of Paintings. United States Naval Academy Museum, Annapolis, Md., 1954.

A Catalogue of the Charles H. Taylor Collection of Ship Portraits. Peabody Museum, Salem, Mass., 1949.

Champney, Benjamin. *Sixty Years' Memories of Art and Artists.* Woburn, Mass., 1900.

Chatterton, E. Keble. *Old Sea Paintings: The Story of Maritime Art As Depicted by the Great Masters.* London and New York, 1928.

————. *Old Ship Prints.* London and New York, 1927.

Childs, Charles D. "Marine Painting: Flood Tide," *Antiques,* LXVI (July 1954), 52–55.

————. "Thar She Blows: Some Notes on American Whaling Pictures," *Antiques,* XL (July 1941), 20–23.

The Coast and the Sea: A Survey of American Marine Painting (catalogue). The Brooklyn Museum, Brooklyn, New York, 19 November 1948–16 January 1949.

Downes, William Howe. "American Painters of the Sea," *American Magazine of Art,* XXIII (November 1931), 360–374.

Dunlap, William. *History of the Rise and Progress of the Arts of Design.* 3 vols. Boston, 1918.

Finch, Christopher. *American Watercolors.* New York, 1986.

Five Centuries of Marine Painting (catalogue). Detroit Institute of Arts, 6 March–5 April 1942.

Flexner, James Thomas. *That Wilder Image: The Painting of America's Native School from Thomas Cole to Winslow Homer.* Boston, 1962.

Gardner, Albert TenEyck. *History of Water Color Painting in America.* New York, 1966.

————, and Stuart P. Feld. *American Paintings: A Catalogue of the Collection of the Metropolitan Museum of Art,* I. New York, 1965.

Green, Samuel. *American Art.* New York, 1966.

Groce, George C., and David H. Wallace. *The New-York Historical Society's Dictionary of Artists in America, 1564–1860.* New Haven, 1957.

Harris, Neil. *The Artist in American Society: The Formative Years 1790–1860.* New York, 1966.

Hart, Charles H. *Historical, Descriptive and Critical Catalogue of the Works of American Artists in the Collection of Herbert L. Pratt.* New York, 1917.

Isham, Samuel. *The History of American Painting.* New York, 1936.

Larkin, Oliver W. *Art and Life in America.* New York, 1949.

Lochheim, Aline B. "Forgotten Men of American Art," *New York Times Magazine,* CI (30 September 1951), 20–23.

M. and M. Karolik Collection of American Paintings 1815 to 1865. Introduction by John I. H. Baur. Cambridge, Mass., 1949. (Published for the Museum of Fine Arts, Boston.)

M. and M. Karolik Collection of American Water Colors and Drawings 1800–1875. 2 vols. Boston, 1962.

McLanathan, Richard B. K. *American Marine Painting.* Boston, 1955. (Museum of Fine Arts Picture Book No. 7.)

Mellon, Gertrud A., and Elizabeth F. Wilder, eds. *Maine and Its Role in American Art, 1740–1963.* New York, 1963. (Published under the auspices of Colby College, Waterville, Me.)

Morgan, Charles S. *New England Coasting Schooners.* Pictorial Supplement V, *The American Neptune,* Salem, Mass., 1963.

Nineteenth Century American Paintings, 1815–1865, from the Collection of Maxim Karolik: A Loan Exhibition to Mid-Western Museums. Minneapolis Institute of Arts, 2 April–31 May 1953.

Nineteenth Century American Paintings, 1815–1865, from the Private Collection of Maxim Karolik. Circulated by the Smithsonian Institution, 1954–1955–1956. Foreword by Otto Whitman, Jr.

Novak, Barbara, and others. *The Thyssen-Bornemisza Collection, Nineteenth-Century American Painting.* New York, 1986.

Parker, Barbara N. "American Paintings 1815–1865 in the M. and M. Karolik Collection," *Antiques,* LX (October 1951), 292–296.

Peters, Harry T. *America on Stone.* New York, 1931.

Pisano, Ronald G. *Long Island Landscape Painting, 1820–1920.* Boston, 1985.

Reps, John W. *Views and Viewmakers of Urban America: Lithographs of Towns and Cities in the United States and Canada, Notes on the Artists and Publishers, and a Union Catalogue of their Work, 1825–1925.* Columbia, Mo., 1984.

Richardson, E. P. *American Romantic Painting.* New York, 1944.

————. *Painting in America.* New York, 1956.

————. *A Short History of American Painting.* Crowell ed. New York, 1963.

————. *The Way of Western Art.* Cambridge, 1939.

Scott, David W. *American Landscape: A Changing Frontier* (catalogue). National Collection of Fine Arts, Smithsonian Institution, Washington, D.C., 28 April–19 June 1966.

Soby, James Thrall, and Dorothy C. Miller. *Romantic Painting in America* (exhibition catalogue). Museum of Modern Art, New York, 1943.

Stebbins, Theodore E., Jr. *American Master Drawings and Watercolors: A History of Works on Paper from Colonial Times to the Present.* New York, 1976.

Stein, Roger B. *American Naval Prints, from the Beverley R. Robinson Collection, U.S. Naval Academy, Annapolis, Maryland* (catalogue). International Exhibitions Foundation, Washington, D.C., 1976–1977.

————. *Seascape and the American Imagination.* New York, 1975.

Tuckerman, Henry T. *Book of the Artists.* New York, 1867.

Two Hundred Years of Watercolor Painting in America: An Exhibition Commemorating the Centennial of the American Watercolor Society (catalogue). The Metropolitan Museum of Art, New York, 8 December 1966–29 January 1967.

Von Groschwitz, Gustave. *The Seashore, Paintings of the 19th and 20th Centuries* (catalogue). Museum of Art, Carnegie Institute, Pittsburgh, Pa., 22 October–5 December 1965.

Whaling Paintings. Pictorial Supplement IV, *The American Neptune*, Salem, Mass., 1962.

Wilmerding, John. *American Art.* London and New York, 1976.

————. *American Marine Painting* (catalogue). Virginia Museum of Fine Arts, Richmond, and The Mariners' Museum, Newport News, Va., 1976.

————. *By Land or Sea: A Loan Exhibition of 19th Century American Landscape and Marine Paintings* (catalogue). Beaumont-May Gallery, Hopkins Center, Dartmouth College, Hanover, N.H., October 1966.

————. "Interpretations of Place: Views of Gloucester, Massachusetts, by American Artists," Essex Institute *Historical Collections*, CIII (January 1967), 53–65.

————. "Under Chastened Light: The Landscape of Rhode Island," *The Eden of America, Rhode Island Landscapes, 1820–1920* (catalogue). Museum of Art, Rhode Island School of Design, Providence, 1986.

————. *The Waters of America: Nineteenth-Century American Paintings of Rivers, Lakes, and Waterfalls* (catalogue). The Historic New Orleans Collection and New Orleans Museum of Art, La., 1984.

————. and others. *The Genius of American Painting.* New York, 1973.

LITERARY AND HISTORICAL WORKS

Albion, Robert G. *Square Riggers on Schedule: The New York Sailing Packets to England, France, and the Cotton Ports.* Princeton, 1938.

Brooks, Van Wyck. *The Flowering of New England.* Dutton Everyman ed. New York, 1952.

Jarves, James Jackson. *The Art Idea.* Introduction by Benjamin Rowland, Jr. Cambridge, Mass., 1960.

Jones, Howard Mumford. *O Strange New World, American Culture: The Formative Years.* New York, 1964.

Kouwenhoven, John A. *Made in America.* New York, 1948.

Matthiessen, F. O. *American Renaissance, Art and Expression in the Age of Emerson and Whitman.* London, Toronto, and New York, 1941.

Miller, Perry. *Nature's Nation.* Cambridge, Mass., 1967.

Morison, Samuel Eliot. *The Maritime History of Massachusetts.* Sentry ed. Boston, 1961.

Parrington, Vernon L. *Main Currents of American Thought.* 2 vols. Harvest ed. New York, 1954.

Rowe, William Hutchinson. *The Maritime History of Maine, Three Centuries of Shipbuilding and Seafaring.* New York, 1948.

Swan, Mabel Munson. *The Athenaeum Gallery: 1827–1873; The Boston Athenaeum As an Early Patron of Art.* Boston, 1940.

Thompson, Ralph. *American Literary Annuals and Gift Books: 1825–1865.* New York, 1936.

CHAPTER ONE

The Contribution of Portrait Painting

Bayley, Frank W. *Five Colonial Artists of New England: Joseph Badger, Joseph Blackburn, John Singleton Copley, Robert Feke, John Smibert.* Boston, 1929.

Belknap, Waldron Phoenix, Jr. *American Colonial Painting.* Cambridge, Mass., 1959.

————. "The Identity of Robert Feke," *Art Bulletin*, XXIX (September 1947), 201–207.

Bolton, Charles Knowles. *The Founders, Portraits of Persons Born Abroad Who Came to the Colonies in North America Before 1701.* 3 vols. Boston, 1919–1926.

Bolton, Theodore, and Harry Lorin Buisse. "Robert Feke, First Painter to Colonial Aristocracy," *Antiquarian*, XV (October 1930), 32–37.

Burroughs, Alan. *John Greenwood in America, 1745–1752: A Monograph with Notes and a Check List.* Andover, Mass., 1943.

Craven, Wayne. *American Colonial Portraiture.* New York, 1986.

Dresser, Louisa. "Portraits in Boston, 1630–1720," *Journal of the Archives of American Art*, VI (July–October 1966), 1–34.

————, ed. *XVIIth Century Painting in New England: A Catalogue of an Exhibition Held at the Worcester Art Museum in Collaboration with the American Antiquarian Society*, July and August 1934. Worcester, Mass., 1935.

Elam, Charles H. *The Peale Family: Three Generations of American Artists* (catalogue). Detroit Institute of Arts, 1967.

Flexner, James Thomas. *American Painting: First Flowers of Our Wilderness.* Boston, 1947.

————. *America's Old Masters.* New York, 1939.

————. "Robert Feke, Active ca. 1741–ca. 1750," *Art Bulletin*, XXVIII (September 1946), 197–202.

Foote, Henry Wilder. *John Smibert, Painter, with a Descriptive Catalogue of Portraits, and Notes on the Work of Nathaniel Smibert.* Cambridge, Mass., 1950.

————. *Robert Feke, Colonial Portrait Painter.* Cambridge, Mass., 1930.

Goodrich, Laurence B. *Ralph Earl, Recorder for an Era.* New York, 1967.

Grosse, Edmund. *British Portrait Painters and Engravers of the Eighteenth Century, Kneller to Reynolds.* Paris, London, New York, and Berlin, 1906.

Hagen, Oskar. *The Birth of the American Tradition in Art.* New York, 1940.

Killanin, Lord Michael Morris. *Sir Godfrey Kneller and His Times, 1646–1723, Being a Review of English Portraiture of the Period.* London, 1948.

M. and M. Karolik Collection of Eighteenth-century American Arts. Cambridge, Mass., 1941. (Published for the Museum of Fine Arts, Boston.)

Massachusetts Bay Colony Tercentenary, Loan Exhibition of 100 Colonial Portraits. Museum of Fine Arts, Boston, 1930.

Miller, Perry, ed. *The American Puritans, Their Prose and Poetry.* Anchor ed. New York, 1956.

————. *Errand into the Wilderness.* Harper Torchbooks ed. New York, 1956.

Morgan, John Hill. *Early American Painters, Illustrated by Examples in the Collection of the New-York Historical Society.* New York, 1921.

The Notebook of John Smibert. Boston, 1969.

Park, Lawrence. *Joseph Badger.* Boston, 1918.

————. "Joseph Badger (1708–1765), and a Descriptive List of Some of His Work," *Proceedings* of the Massachusetts Historical Society, LI (December 1917), 158–201.

————. *Joseph Blackburn, a Colonial Portrait Painter, with a Descriptive List of His Works.* Worcester, Mass., 1923.

Parker, Barbara Neville. "The Identity of Robert Feke Reconsidered in the Light of W. Phoenix Belknap's Notes," *Art Bulletin*, XXXIII (September 1951), 192–194.

————, and Anne Bolling Wheeler. *John Singleton Copley, American Portraits in Oil, Pastel and Miniature, with Biographical Sketches.* Boston, 1938.

Plate, Robert. *Charles Willson Peale, Son of Liberty, Father of Art and Science.* New York, 1967.

Prown, Jules D. *John Singleton Copley.* 2 vols. Cambridge, Mass., 1966.

Richardson, E. P. *Gilbert Stuart, Portraitist of the Young Republic* (catalogue). National Gallery of Art, Washington, D.C., 1967.

Russell, Charles E. *English Mezzotint Portraits and Their States from the Invention of*

Mezzotinting Until the Early Part of the 19th Century. London and New York, 1926.

Sellers, Charles Coleman. *Portraits and Miniatures by Charles Willson Peale.* Philadelphia, 1952.

Wright, Louis B., George B. Tatum, John W. McCoubrey, and Robert C. Smith. *The Arts in America: The Colonial Period.* New York, 1966.

CHAPTER TWO

The Folk Art Tradition

Allen, E. B. *Early American Wall Painting.* New Haven, Conn., 1926.

Black, Mary, and Jean Lipman. *American Folk Painting.* New York, 1966.

Brewington, M. V. *Shipcarvers of North America.* Barre, Mass., 1962.

Lipman, Jean. *American Folk Art in Wood, Metal, and Stone.* New York, 1950.

———. *American Folk Painters of Three Centuries.* New York, 1980.

———. *American Primitive Painting.* London and New York, 1942.

———. *The Flowering of American Folk Art.* New York, 1974.

———. *Primitive Painters in America.* New York, 1950.

———. *Rediscovery: Jurgen Frederick Huge.* New York, 1973.

———. *Rufus Porter, Yankee Pioneer.* New York, 1968.

———. "Rufus Porter, Yankee Wall Painter," *Art in America,* XXXVIII (October 1950), 130–200.

Little, Nina Fletcher. *American Decorative Wall Painting.* Sturbridge, Mass., 1952.

———. "Earliest Signed Picture by T. Chambers," *Antiques,* LIII (April 1948), 285.

———. "Indigenous Painting in New Hampshire," *Antiques,* LXXXVI (July 1964), 62–65.

———. "More About T. Chambers," *Antiques,* LX (November 1951), 469.

———. "T. Chambers, Man or Myth?" *Antiques,* LIII (March 1948), 194–196.

101 Masterpieces of American Primitive Painting from the Collection of Edgar William and Bernice Chrysler Garbisch. Revised ed. New York, 1962.

McGrath, Robert L. "Rediscovery: Rufus Porter in Vermont," *Art in America,* LVI (January–February 1968), 78–79.

Porter, Rufus. "The Art of Painting," *Scientific American,* I (1845–1846), Nos. 10, 13, 19, 20–22, 26–30.

CHAPTER THREE

The Contribution of History Painting

Bayley, Frank W. *Life and Works of John Singleton Copley.* Boston, 1915.

Evans, Grose. *Benjamin West and the Taste of His Times.* Carbondale, Ill., 1959.

Flagg, Jared B. *The Life and Letters of Washington Allston.* New York, 1892.

Flexner, James Thomas. *American Painting: The Light of Distant Skies.* New York, 1954.

———. *John Singleton Copley.* Boston, 1948.

Galt, John. *The Life, Studies, and Works of Benjamin West, Esq., President of the Royal Academy of London, Composed from Materials Furnished by Himself.* London, 1820.

Gerdts, William H., and Theodore E. Stebbins, Jr. *"A Man of Genius": The Art of Washington Allston* (catalogue). Museum of Fine Arts, Boston, 1979.

The Paintings of Washington Allston (catalogue). Lowe Art Museum, Coral Gables, Fla., 1975.

Prown, Jules D. *John Singleton Copley.* 2 vols. Cambridge, Mass., 1966.

———. *John Singleton Copley, 1738–1815* (catalogue). National Gallery of Art, Smithsonian Institution, Washington, D.C., 1965–1966.

Richardson, E. P. "Allston and the Development of Romantic Color," *Art Quarterly,* VII (Winter 1944), 33–58.

———. *Washington Allston.* Chicago, 1948. New York, 1967.

Staley, Allen. *Benjamin West in Pennsylvania Collections* (catalogue). Philadelphia Museum of Art, Philadelphia, 1986.

———. and Helmut Von Erffa. *The Paintings of Benjamin West.* New Haven, 1986.

CHAPTER FOUR

The Hudson River School: First Generation

Bartlett, W. H. *American Scenery.* London, 1838.

Cantor, Jay E. *Drawn from Nature, Drawn from Life, Studies and Sketches by Frederic Church, Winslow Homer and Daniel Huntington, from the Collection of the Cooper-Hewitt Museum of Decorative Arts and Design, Smithsonian Institution* (catalogue). American Federation of Arts, New York, 1972.

Carr, Gerald Lawrence. *The Icebergs.* Dallas, 1980.

The Crayon: A Journal Devoted to the Graphic Arts and the Literature Related to Them. New York, 1855–1861 (monthly).

Cooper, James Fenimore. *The History of the Navy of the United States of America.* 2 vols. London, 1839.

Driscoll, John Paul, and John K. Howat. *John Frederick Kensett, An American Master.* New York, 1985.

Dwight, Edward H., and Richard J. Boyle. "Rediscovery: Thomas Cole's *Voyage of Life,*" *Art in America,* LV (May–June 1967), 60–63.

Emerson, Ralph Waldo. *The Complete Essays and Other Writings.* Edited by Brooks Atkinson. Modern Library ed. New York, 1950.

An Exhibition of Paintings by Thomas Cole N. A. from the Artist's Studio, Catskill, New York (catalogue). Kennedy Galleries, Inc., New York, 29 November–December 1964.

Goodyear, Frank H., Jr. *Thomas Doughty, 1793–1856, An American Pioneer in Landscape Painting* (catalogue). Pennsylvania Academy of the Fine Arts, Philadelphia, 1973.

Hendricks, Gordon. *Albert Bierstadt* (catalogue). Whitney Museum of American Art, New York, 1972.

———. *Albert Bierstadt, Painter of the American West.* New York, 1974.

Howat, John K. *The Hudson River and its Painters.* New York, 1972.

Major, A. Hyatt. "Aquatint Views of Our Infant Cities," *Antiques,* LXXXVIII (September 1965), 314–318.

Manthorne, Katherine. *Creation & Renewal: Views of Cotopaxi by Frederic Edwin Church.* Washington, D.C., 1985.

Merritt, Howard S. *Thomas Cole* (catalogue). Memorial Art Gallery of the University of Rochester, New York, 1969.

Miller, Perry, ed. *The American Transcendentalists.* Anchor ed. New York, 1957.

Noble, Louis Legrand. *The Life and Works of Thomas Cole.* Introduction by Elliot S. Vesell. Cambridge, Mass., 1964.

Philbrick, Thomas. *James Fenimore Cooper and the Development of American Sea Fiction.* Cambridge, Mass., 1961.

Schlesinger, Arthur M., Jr. *The Age of Jackson.* Boston, 1945.

Sears, Clara Endicott. *Highlights Among the Hudson River Artists.* Boston, 1947.

Stebbins, Theodore E., Jr. *Close Observation: Selected Oil Sketches by Frederic Edwin Church.* Washington, D.C., 1978.

Sweet, Frederick A. *The Hudson River School and the Early American Landscape Tradition* (exhibition catalogue). Art Institute of Chicago and Whitney Museum of American Art, 1945.

Thoreau, Henry David. *Writings.* Walden ed. 7 vols. Boston, 1906.

Whittredge, Worthington. "Autobiography." Edited by John I. H. Baur. Brooklyn Museum *Journal,* I (1942), 5–68.

Wilmerding, John. *Spring Bloom and Autumn Blaze: Topographies of the American Landscape and Character* (catalogue). Lowe Art Museum, University of Miami, Coral Gables, Fla., 1974.

CHAPTER FIVE

The Hudson River School: Second Generation

Bayley, W. P. "Mr. Church's Picture of 'The Icebergs,'" *Art Journal,* XV (1 September 1863), 187–188.

Ferber, Linda S. *The New Path: Ruskin and the American Pre-Raphaelites.* New York, 1985.

Hendricks, Gordon. "The First Three Western Journeys of Albert Bierstadt," *Art Bulletin,* XLVI (September 1964), 333–365.

Huntington, David C. *Frederic Edwin Church* (catalogue). National Collection of Fine Arts, Smithsonian Institution, Washington, D.C., February–June 1966.

———. *The Landscapes of Frederic Edwin Church: Vision of an American Era.* New York, 1966.

———. "Olana—'the Center of the World,'" *Antiques,* LXXXVIII (November 1965), 656–663.

John Frederick Kensett: A Retrospective Exhibition (catalogue). Hathorn Gallery, Skidmore College, Saratoga Springs, N.Y., 13 April–3 May 1967.

Kensett, John F. "Journal." 2 vols. Manuscript. Frick Art Reference Library, New York.

Lindquist-Cock, Elizabeth. *The Influence of Photography on American Landscape Painting, 1839–1880* (Ph.D. dissertation, New York University). Reprint, Garland Series, New York, 1977.

Ludlow, Fitz Hugh. *The Heart of the Continent: A Record of Travels Across the Plains and in Oregon with an Examination of the Mormon Principle.* Cambridge, Mass., 1870.

Noble, Louis Legrand. *After Icebergs with a Painter.* New York, 1861.

———. *The Heart of the Andes.* New York, 1859.

Novak, Barbara. *Nature and Culture: American Landscape and Painting, 1825–1875.* New York, 1980.

Omoto, Sadayoshi. "The Sketchbooks of Worthington Whittredge," *Art Journal,* XXIV (Summer 1965), 331–335.

Paintings by Frederic E. Church, N. A. (catalogue). The Metropolitan Museum of Art, New York, 28 May–15 October 1900.

Trump, R. S. "Life and Works of Albert Bierstadt." Unpublished doctoral dissertation, Ohio State University, 1963.

Whittredge, Worthington. "Autobiography." Edited by John I. H. Baur. Brooklyn Museum *Journal,* I (1942), 5–68.

CHAPTER SIX

The Inheritance of French Romantic Painting

Antoine Roux Sketchbooks. Pictorial Supplement II, *American Neptune,* Salem, Mass., 1960.

Bowen, Abel. *The Naval Monument.* Boston, 1816.

Brès, Louis. *Antoine Roux et ses fils.* Marseilles, 1883.

Copeland, Charles H. P. "To the Farthest Port of the Rich East," *American Heritage,* VI (February 1955), 10–19.

Johnson, Alfred. *Ships and Shipping.* Salem, Mass., 1925.

Karr, Louise. "The Roux Family," *Antiques,* XV (February 1929), 119–122.

Knox, Katharine McCook. "A Note on Michele Felice Cornè," *Antiques,* LVII (June 1950), 450–451.

Little, Nina Fletcher. *American Decorative Wall Painting.* Sturbridge, Mass., 1952.

Meissonier, Jean. "A Dynasty of Marine Painters: The Roux Family of Marseilles," *Antiques,* LXXXVI (November 1964), 583–587.

———. "Ship Painters of the Mediterranean," *Antiques,* LXXXIII (March 1963), 304–308.

Philbrick, Thomas. *James Fenimore Cooper and the Development of American Sea Fiction.* Cambridge, Mass., 1961.

Swan, Mabel M., and Louise Karr. "Early Marine Painters of Salem," *Antiques,* XXXVIII (August 1940), 63–65.

Wood, Ruth Kedzie. "Ship Portraits by the Roux Family," *International Studio,* LXXXIV (June 1926), 75–79.

CHAPTER SEVEN

The Dutch Marine Tradition

Barnes, James. *Naval Actions of the War of 1812.* New York, 1896.

Birch, William. *The City of Philadelphia in the State of Pennsylvania, North America.* Springland, England, 1800.

———. *The Country Seats of the United States of America.* Springland, England, 1808.

———. *Délices de la Grande Bretagne.* London, 1791.

———. "The Life of William Russel Birch, Enamel Painter, Written by Himself," 1829. Unpublished typescript. New York Public Library, New York.

Brewington, Marion V. *Notes on Thomas Birch.* Unpublished folder of miscellany. Peabody Museum, Salem, Mass.

Carson, Marion. "Thomas Birch," *Catalogue of the 150th Anniversary Exhibition of the Pennsylvania Academy of the Fine Arts* (Philadelphia, 1955), 32–36.

Comstock, Helen. "Naval Views by Thomas Birch," *Connoisseur,* CXXVI (December 1950), 202–203.

Cooper, James Fenimore. *The History of the Navy of the United States of America.* 2 vols. London, 1839.

Creer, Doris Jean. "Thomas Birch: A Study of the Condition of Painting and the Artist's Position in Federal America." Unpublished master's thesis, University of Delaware, June 1958.

Gerdts, William H. "Thomas Birch: America's First Marine Artist," *Antiques,* LXXXIX (April 1966), 528–534.

———. *Thomas Birch, 1779–1851, Paintings and Drawings* (catalogue). Philadelphia Maritime Museum, 16 March–May 1966.

Ingersoll-Smouse, Florence. *Joseph Vernet: Peintre de Marme 1715–1798*. 2 vols. Paris, 1926.

Lunny, Robert M. "The Great Sea War," *American Heritage*, VII (April 1956), 12–21.

Olds, Irving S. "Early American Naval Prints," *Art in America*, XLIII (December 1955), 22–29, 54–55.

Pleasants, J. Hall. "Four Late 18th Century Anglo-American Landscape Painters," American Antiquarian Society *Proceedings*, LII (1943), 187–324.

Snyder, Martin P. "William Birch: His Philadelphia Views," *Pennsylvania Magazine of History and Biography*, LXXIII (July 1949), 271–315.

Thomas, Abel C. "Obituary of Artist: Sketch of Thomas Birch," *Philadelphia Art Union Reporter*, I (January 1851), 22–23.

CHAPTER EIGHT

English-American Artists

Childs, Charles D. "Robert Salmon: A Boston Painter of Ships and Views," *Old-Time New England*, XXVIII (January 1938), 90–102.

Comstock, Helen. "Marine Paintings by Two Buttersworths," *Antiques*, LXXXV (January 1964), 99–103.

Hardie, Martin. *Water-colour Painting in Britain: The Eighteenth Century*. London, 1967.

Parker, Barbara N. "An Early View of Boston," *Old-Time New England*, XXXV (July 1944), I.

Salmon, Robert. "Catalogue of Robert Salmon's Pictures 1828 to 1840, from His Own Notes, Now in the Possession of Miss Darracott, 1881." Manuscript. Boston Public Library, Boston.

Wilmerding, John. "A New Look at Robert Salmon," *Antiques*, LXXXVII (January 1965), 89–93.

———. *Robert Salmon: The First Major Exhibition* (catalogue). DeCordova Museum, Lincoln, Mass., April–May 1967.

———. *Robert Salmon, Painter of Ship and Shore*. Boston, 1971.

———. "Robert Salmon's Boston Harbor from Castle Island," *Arts in Virginia*, XIV: 2 (Winter 1974), 14–27.

———. "Robert Salmon's Early Career," *Scottish Art Review*, XIII: 1 (1971), 20–24.

CHAPTER NINE

Independents

Baur, John I. H. *John Quidor* (catalogue). Brooklyn Museum, Brooklyn, N.Y., 1942.

———. *John Quidor* (catalogue). Munson-Williams-Proctor Institute, Utica, N.Y., November 1965–April 1966.

Drawings and Sketches by William Sidney Mount, 1807–1868, in the Collections of the Suffolk Museum and Carriage House at Stony Brook, Long Island, New York (catalogue). Stony Brook, 1974.

Flexner, James Thomas. "Painter to the People," *American Heritage*, XI (August 1960), 11–23, 91–92.

Frankenstein, Alfred. *Painter of Rural America, William Sidney Mount, 1807–1868* (catalogue). National Gallery of Art, Washington, D.C. 1969.

Little, Nina Fletcher. "Indigenous Painting in New Hampshire," *Antiques*, LXXXVI (July 1964), 62–65.

———. "J. S. Blunt, New England Landscape Painter," *Antiques*, LIV (September 1948), 172–174.

Murphy, Robert Cushman. *Fish-Shape Paumanok, Nature and Man on Long Island*. Memoirs of the American Philosophical Society, LVIII, Philadelphia, 1964.

Ruder, Celia. "John Quidor and Washington Irving, the Outcast and the Hero." Unpublished master's thesis, University of Wisconsin.

Sokol, David M. *John Quidor: Painter of American Legend* (catalogue). Wichita Art Museum, Wichita, Kansas, 1973.

Whitman, Walt. *Leaves of Grass*. Modern Library ed. New York, 1950.

Williams, Herman Warner, and Bartlett Cowdrey. *William Sidney Mount*. New York, 1945.

CHAPTER TEN

The Establishing of a Style

Andrus, Lisa F. *Measure and Design in American Painting, 1760–1860* (Ph.D. dissertation, Columbia University). Reprint, Garland Series, New York, 1977.

"Authors and Artists of Cape Ann," II. Unpaged notebook of newspaper and other clippings, plus miscellaneous information in the Cape Ann Scientific, Literary, and Historical Association.

Babson, John J. *History of Gloucester, Cape Ann, Including the Town of Rockport*. Gloucester, Mass., 1860.

———. *Notes and Additions to the History of Gloucester*: I, Gloucester, Mass., 1876; II, Salem, Mass., 1891 (bound in one volume).

Brooks, Alfred Mansfield. "The Burning of the Packet Ship *Boston*," Essex Institute *Historical Collections*, LXXIX (April 1943), 114–116.

———. "The Fitz Hugh Lane House in Gloucester," Essex Institute *Historical Collections*, LXXVIII (July 1942), 281–283.

———. "Fitz Lane's Drawings," Essex Institute *Historical Collections*, LXXXI (January 1945), 83–86.

McCormick, Gene E. "Fitz Hugh Lane, Gloucester Artist, 1804–1865." Unpublished master's thesis, Yale University, 1951.

———. "Fitz Hugh Lane, Gloucester Artist, 1804–1865," *Art Quarterly*, XV (Winter 1952), 291–306.

McLanathan, Richard B. K. *Fitz Hugh Lane*. Boston, 1956. (Museum of Fine Arts Picture Book No. 8.)

Memorial of the Celebration of the Two Hundred and Fiftieth Anniversary of the Incorporation of the Town of Gloucester, Mass., August, 1892. Boston, 1901.

Portfolio of the Old Print Shop, New York, I (April 1942), 9–13.

Pringle, James R. *History of the Town and City of Gloucester, Cape Ann, Massachusetts*. Gloucester, Mass., 1892.

Sharf, Frederic A. "Fitz Hugh Lane, His Life and His Art," *Antiques*, LXXVIII (November 1960), 452–455.

———. "Fitz Hugh Lane Reconsidered," Essex Institute *Historical Collections*, XCVI (January 1960), 73–83.

———. "Fitz Hugh Lane: Visits to the Maine Coast, 1848–1855," Essex Institute *Historical Collections*, XCVIII (April 1962), 111–120.

Stebbins, Theodore E., Jr. *Luminous Landscape: The American Study of Light, 1860–1875* (catalogue). Fogg Art Museum, Harvard University, Cambridge, Mass., 18 April–11 May 1966.

Tibbets, Frederick W. *The Story of Gloucester, Massachusetts*. (Address before the Convention of

the Massachusetts State Firemen's Association at City Hall, Gloucester, 21 September 1916.) Gloucester, 1917.

Wilmerding, John. *The Art of Fitz Hugh Lane* (catalogue). William A. Farnsworth Library and Art Museum, Rockland, Maine, 1974.

———. "As Under a Bell Jar: A Study of Quality in Fitz Hugh Lane," *Antiques*, LXXXII (October 1962), 406–409.

———. *Fitz Hugh Lane*. New York, 1971.

———. "Fitz Hugh Lane, 1804–1865, American Marine Painter," Essex Institute *Historical Collections*, XCIX (July 1963), 173–202, and XCIX (October 1963), 289–310.

———. *Fitz Hugh Lane, 1804–1865, American Marine Painter*. Salem, 1964.

———. *Fitz Hugh Lane: The First Major Exhibition* (catalogue). DeCordova Museum, Lincoln, Mass., and Colby College Art Museum, Waterville, Me., March–June 1966.

———. "Fitz Hugh Lane, Painter of Gloucester," *Journey Through New England*, III (1966), 72–74.

———. "Fitz Hugh Lane's Paintings Down East," *Down East*, XII (April 1966), 22–25, 43.

———. "The Lithographs of Fitz Hugh Lane," *Old-Time New England*, LIV (Fall 1963), 33–39.

———. *Paintings and Drawings by Fitz Hugh Lane at the Collection of the Cape Ann Historical Association* (catalogue). Gloucester, Mass., 1974.

———. "Rediscovery: Fitz Hugh Lane," *Art in America*, LIII (February 1965), 62–69.

———. *A Selection of Marine Paintings by Fitz Hugh Lane, 1804–1865*. Pictorial Supplement VII, *American Neptune*, Salem, Mass., 1965.

———. with others. *American Light: The Luminist Movement, 1850–1875*. Washington, D.C., 1980.

CHAPTER ELEVEN
The Style Established

Baur, John I. H. "American Luminism," *Perspectives USA*, IX (Autumn 1954), 90–98.

———. "Francis A. Silva: Beyond Luminism," *Antiques*, 118 (November 1980), 1019–1025.

———. "A Romantic Impressionist: James Hamilton," *Bulletin* of the Brooklyn Museum, XII (Spring 1951), 1–9.

Bradford, William. *The Arctic Regions, Illustrated with photographs taken in an Art. Expedition to Greenland, with descriptive narrative by the Artist*. London, 1873.

"Bradford's photographs of Greenland, arranged as illustrations of *Frost and Fire* [Edinburgh, 1863] by J. F. Campbell, June, 1871." Manuscript. National Library of Scotland, Edinburgh.

Brown, Jeffrey R. *Alfred Thompson Bricher, 1837–1908* (catalogue). Indianapolis Museum of Art, Indiana, 1973.

Chace, Arnold B. "A Trip to Labrador in the Summer of 1865." Manuscript. Private collection, Boston.

A City and Its Painters: A New Bedford Summer Festival Event (catalogue). Crapo Gallery, Swain School of Design; New Bedford Free Public Library; and Whaling Museum, New Bedford, Mass., July–August 1965.

Commemorative Exhibition: Paintings by Martin J. Heade and Fitz Hugh Lane from the Karolik Collections in the Museum of Fine Arts, Boston (catalogue). Introduction by John I. H. Baur. M. Knoedler and Co., May 1954.

Ellis, Leonard B. *History of New Bedford and Its Vicinity: 1602–1892*. Syracuse, N.Y., 1892.

Ferber, Linda. *William Trost Richards (1833–1905): American Landscape and Marine Painter*

(catalogue). Brooklyn Museum, New York, 1973.

Gerdts, William H. *American Luminism* (catalogue). Coe Kerr Gallery, New York, 1978.

Gowing, Lawrence. *Turner: Imagination and Reality* (catalogue), Museum of Modern Art, New York, 1966.

Jacobowitz, Arlene. *James Hamilton, 1819–1878, American Marine Painter* (catalogue). The Brooklyn Museum, Brooklyn, N.Y., 28 March–22 May 1966.

James Hamilton Sales Catalogue. James S. Earle and Sons, Philadelphia, 21 April–May 1875.

Kane, Elisha Kent. *Arctic Explorations*. 2 vols. Philadelphia, 1856.

McIntyre, Robert G. *Martin Johnson Heade*. New York, 1948.

McLanathan, Richard B. K. *Martin J. Heade*. Boston, 1955. (Museum of Fine Arts Picture Book No. 5.)

"The Paintings of Mr. William Bradford, of New York," *The Philadelphia Photographer*, XXI (1884), 7–8.

Plowden, Helen Haseltine. *William Stanley Haseltine, Sea and Landscape Painter (1835–1900)*. London, 1947.

Preston, John Duncan. "Alfred Thompson Bricher, 1837–1908," *Arts Quarterly*, XXV (Summer 1962), 149–157.

Stebbins, Theodore E., Jr. *The Life and Works of Martin Johnson Heade*. New Haven, Ct., 1975.

———. *Luminous Landscape: The American Study of Light, 1860–1875* (catalogue). Fogg Art Museum, Harvard University, Cambridge, Mass., 18 April–11 May 1966.

Thomas, Stephen. "The American Career of Albert Van Beest, Dutch Painter of the Sea," *Antiques*, XXXI (January 1937), 14–18.

Thoreau, Henry David. *Writings*. Walden ed. Boston, 1906.

Wilmerding, John. "Fire and Ice in American Art: Polarities from Luminism to Abstract Expressionism," *The Natural Paradise: Painting in America, 1800–1950* (New York, 1976), 38–57.

———, *William Bradford, 1823–1892, Artist of the Arctic: An Exhibition of his Paintings and Photographs* (catalogue). DeCordova Museum, Lincoln, Mass., 1969.

———, *William Stanley Haseltine (1835–1900), Drawings of a Painter* (catalogue). Davis & Langdale Co., New York, 1982.

CHAPTER TWELVE
Wind, Sail, and Steam

American Clipper Ships. Pictorial Supplement I, *American Neptune*, Salem, Mass., 1959.

Blockade Runners. Pictorial Supplement III, *American Neptune*, Salem, Mass., 1961.

Clark, A. H. *The Clipper Ship Era*. New York, 1910.

Comstock, Helen. "Marine Paintings by Two Buttersworths," *Antiques*, LXXXV (January 1964), 99–103.

The Francis Lee Higginson Collection of Steamships. Pictorial Supplement VI, *American Neptune*, Salem, Mass., 1964.

Lipman, Jean, and Alice Winchester, eds. *Primitive Painters in America, 1750–1950*. New York, 1950.

Schaefer, Rudolph J. *J. E. Buttersworth, 19th-Century Marine Painter*. Mystic, Ct., 1975.

Williams, Herman Warner. *The Civil War: The Artists' Record* (exhibition catalogue). Corcoran Gallery of Art, Washington, D.C., and Museum of Fine Arts, Boston, 1961.

CHAPTER THIRTEEN
The Great Age

Beam, Philip C. *Winslow Homer at Prout's Neck*, Boston, 1966.
———. *Winslow Homer at Prout's Neck* (catalogue). Bowdoin College Museum of Art, Brunswick, Me., 1966.
Cooper, Helen. *Winslow Homer Watercolors*. New Haven, Ct., 1986.
Cox, Kenyon. *Winslow Homer*. New York, 1914.
Dorra, Henri. "Ryder and Romantic Painting," *Art in America*, XLVIII (December 1960), 22–33.
Downes, William Howe. *The Life and Work of Winslow Homer*. Boston, 1911.
Gardner, Albert TenEyck. *The Paintings of Winslow Homer from the Cooper Union Museum* (catalogue). Ira Spanierman Gallery, New York, 29 November–20 December 1966.
———. *Winslow Homer*. New York, 1961.
———. *Winslow Homer: A Retrospective Exhibition* (catalogue). National Gallery of Art, Washington, D.C., and the Metropolitan Museum of Art, New York, 1958.
Goodrich, Lloyd. *Albert P. Ryder*. Braziller ed. New York, 1959.
———. "Homer and the Sea," *Arts in Virginia*, V (Fall 1964), 12–21.
———. *Thomas Eakins*. New York, 1933.
———. *Winslow Homer*. New York, 1944.
———. *Winslow Homer*. Braziller ed. New York, 1959.
Hannaway, Patti. *Winslow Homer in the Tropics*. Richmond, Va., 1973.
Hendricks, Gordon. *The Life and Work of Thomas Eakins*. New York, 1972.
———. *The Life and Work of Winslow Homer*. New York, 1979.
Hoopes, Donelson F. *Eakins Watercolors*. New York, 1971.
Linscott, Robert N., ed. *Selected Poems and Letters of Emily Dickinson*. Anchor ed. New York, 1959.
Melville, Herman. *Moby Dick, or, The Whale*. Modern Library ed. New York, 1930.
Porter, Fairfield. *Thomas Eakins*. Braziller ed. New York, 1959.
Schendler, Sylvan. *Eakins*. Boston, 1967.
Siegl, Theodor. *The Thomas Eakins Collection* (catalogue). Philadelphia Museum of Art, Philadelphia, 1978.
Wilmerding, John. *Winslow Homer*. New York, 1972.
———. *Winslow Homer Drawings* (catalogue). Cooper-Hewitt Museum, New York, 1972.
———. *Winslow Homer: The Charles Shipman Payson Collection* (catalogue). Coe Kerr Galleries, New York, 1981; and Portland Museum of Art, Portland, Maine, 1983.
———. "Winslow Homer's Dad's Coming," *Essays in Honor of Paul Mellon, Collector and Benefactor* (Washington, D.C., 1986), 389–401.
———. "Winslow Homer's Right and Left," *Studies in the History of Art*, 9 (National Gallery of Art, Washington, D.C., 1980), 59–85.

CHAPTER FOURTEEN
Toward New Directions

Adams, Adeline. *Childe Hassam*. New York, 1938.
Ashbery, John, and Kenworth Moffett. *Fairfield Porter*. Boston, 1982.
Boswell, Peyton, Jr. *George Bellows*. New York, 1942.
Breuning, Margaret. *Maurice Prendergast*. New York, 1931.

Brooks, Van Wyck. *John Sloan: A Painter's Life*. New York, 1955.
Brown, Milton W. *The Story of the Armory Show*. New York, 1963.
Christo. *Oceanfront* (catalogue). The Art Museum, Princeton University, Princeton, N.J., 1975.
Cikovsky, Nicolai, Jr. *George Inness*. New York, 1971.
———, and Michael Quick. *George Inness* (catalogue). Los Angeles County Museum of Art, Los Angeles, 1985.
———. *The Paintings of George Inness (1844–1894)* (catalogue). University Art Museum, University of Texas, 12 December 1965–30 January 1966.
Corn, Wanda M., and others. *The Art of Andrew Wyeth* (catalogue). Fine Arts Museums of San Francisco, 1973.
Cortissoz, Royal. *Catalogue of the Etchings and Dry-points of Childe Hassam*. New York, 1925.
Daingerfield, Elliott. *Fifty Paintings by George Inness*. New York, 1913.
———. *Ralph Albert Blakelock*. New York, 1914.
DuBois, Guy Pène. *Edward Hopper*. New York, 1931.
George Bellows, Paintings, Drawings and Prints (catalogue). Art Institute of Chicago, 31 January–10 March 1946.
Goodrich, Lloyd. *Edward Hopper*. London, 1949.
———. *Edward Hopper*. New York, 1978.
———. *John Sloan*. New York, 1952.
Griffith, Fuller. *The Lithographs of Childe Hassam* (catalogue). The Smithsonian Institution, Washington, D.C., 1962.
Handbooks of the Complete Set of Etchings and Drypoints of Childe Hassam. New York, 1933.
Haskell, Barbara. *Marsden Hartley* (catalogue). Whitney Museum of American Art, New York, 1980.
———. *Milton Avery* (catalogue). Whitney Museum of American Art, New York, 1982.
Helm, MacKinley. *John Marin*. Boston, 1948.
———. *John Marin Memorial Exhibition* (catalogue). Whitney Museum of American Art, New York, 1956.
Inness, George, Jr. *Life, Art, and Letters of George Inness*. New York, 1917.
Ireland, LeRoy. *The Works of George Inness*. Austin, Tex., 1965.
Knowlton, Helen Mary. *Art-Life of William Morris Hunt*. Boston, 1900.
Langdale, Cecily. *Monotypes of Maurice Prendergast in the Terra Museum of American Art* (catalogue). Chicago, 1984.
Levin, Gail. *Edward Hopper, The Art and the Artist*. New York, 1980.
———. *Hopper's Places*. New York, 1985.
McCausland, Elizabeth. *Marsden Hartley*. Minneapolis, Minn., 1952.
Marshall, Richard. *Alex Katz* (catalogue). Whitney Museum of American Art, New York, 1986.
Mongan, Agnes. *Andrew Wyeth: Dry-brush and Pencil Drawings* (catalogue). Fogg Art Museum, Harvard University, Cambridge, Mass., 1963.
Morgan, Charles H. *George Bellows, Painter of America*. New York, 1965.
Norman, Dorothy, ed. *Selected Writings of John Marin*. New York, 1949.
Perlman, Bennard B. *The Immortal Eight, American Painting from Eakins to the Armory Show (1870–1913)*. New York, 1962.
Prendergast, Maurice B. *Sketches, 1899*. Boston, 1960.
Rhys, Hedley Howell. *Maurice Prendergast, 1859–1924*. Cambridge, Mass., 1960.
Richardson, E. P. *Andrew Wyeth* (catalogue). The Pennsylvania Academy of the Fine Arts, Philadelphia, 1966–1967.
Rourke, Constance M. *Charles Sheeler, Artist in the American Tradition*. New York, 1938.
St. John, Bruce, ed. *John Sloan's New York Scene*. New York, 1965.
Seligman, Herbert J., ed. *Letters of John Marin*. New York, 1931.
Shannon, Martha A. *Boston Days of William Morris Hunt*. Boston, 1923.

PHOTOGRAPH CREDITS

The author and publisher would like to thank all the museums, libraries, and collectors whose works are reproduced in this book, as well as the following photographers, museums, and art galleries (numbers refer to figures):

Leo Castelli Gallery, New York, 180; Childs Gallery, Boston and New York, 11, 95, 97; 5000K Photography, Boston, 177; Hirschl & Adler Galleries, New York, 51; Professor Robert McGrath, 17; Richard Merrill, Saugus, Mass., 59; Mystic Seaport Museum, Mystic, Conn., 142; Old Dartmouth Historical Society and Whaling Museum, New Bedford, Mass., 128; Mark Sexton, Salem, Mass., 56–58, 60, 62, 63, 65, 66, 88, 144; Duane Suter, Baltimore, 83; Leonard Wickens, Magnolia, Mass., 114.